American Furniture Craftsmen Working Prior to 1920

American Furniture Craftsmen Working Prior to 1920

AN ANNOTATED BIBLIOGRAPHY

Compiled by
CHARLES J. SEMOWICH

Art Reference Collection, Number 7

Greenwood Press
Westport, Connecticut • London, England

Library of Congress Cataloging in Publication Data

Semowich, Charles J.
 American furniture craftsmen working prior to 1920.

 (Art reference collection, ISSN 0193-6867 ; no. 7)
 Includes indexes.
 1. Furniture industry and trade—United States—Bib-
liography. I. Title. II. Series.
Z5995.3.U6S45 1984 016.749213 84-4459
[TS805]
ISBN 0-313-23275-X (lib. bdg.)

Library of Congress Catalog Card Number: 84-4459
ISBN: 0-313-23275-X
ISSN: 0193-6867

First published in 1984

Greenwood Press
A division of Congressional Information Service, Inc.
88 Post Road West, Westport, Connecticut 06881

Printed in the United States of America

10 9 8 7 6 5 4 3 2 1

This book is dedicated to my loving parents: Zeekie Semowich and the late Alice L. Semowich.

CONTENTS

PREFACE

The lack of any book devoted to the bibliography of American furniture and its makers is the prime motive for presenting this volume. Books and articles about American furniture and its craftsmen do appear in some art, history, and collectors' bibliographic sources. However, none of these sources provide the needed annotated bibliographic references in such quantity as to be useful in the serious study of American furniture. It is hoped that this volume will provide the kind of bibliographic information that will help to reduce this lacuna.

Several problems occur in connection with the compilation of a bibliography containing materials in the field of American furniture. One difficulty centers on the nature of the literature, which includes forms other than books, such as periodical articles, exhibition catalogs, theses, and pamphlets. This diversity makes a unified corpus of literature difficult to identify. A second problem occurs when one considers the nature of relevant material. There are large numbers of works that are of little or no use to serious students in the field of American furniture. These works are often designed for interior decorators, antique collectors, furniture refinishers, and amateur woodworkers. It is necessary, therefore, that a method of selection be used that would reduce the large number of items of limited use.

Generally, the criterion used in this bibliography is that the focus of the materials selected should be about the craftsmen responsible for the creation of the furniture. Included in this selection are works that give biographical information about furniture craftsmen. Also included are works that contain discussions about the stylistic and aesthetic development of the furniture artisan. Works are included that examine the working conditions as well as the sociological, political, economic, and environmental factors relative to furniture craftsmen. Works about furniture factories and furniture retail businesses are also encompassed within this volume. Publications about clockmaking and other peripheral woodworking trades are included only if there is a strong pos-

sibility that furniture was also made. Selected general works that appear to be useful in the study of American furniture or are deemed to be necessary for completeness are included.

The format utilized in this volume consists of a main body, divided into four sections, with an appendix and three indexes. The first section consists of works that are mainly concerned with the life and work of individual craftsmen. These works vary considerably, ranging from lengthy monographs (e.g., number 582, *John and Thomas Seymour, Cabinetmakers in Boston, 1794–1816*) to brief notes (e.g., number 81, "Collector's Notes").

The second section is composed of literature that focuses on groups of furniture craftsmen. Each work included in this section is identifiably related to a specific geographical area and contains information about craftsmen and their products.

The third section encompasses those works that are of a general nature and that contribute to the study of American furniture. Among the items included in the third section are checklists, biographical dictionaries, collectors' manuals, selected interior design guides, bibliographies, furniture collection handbooks, and general furniture histories. Some primary sources, such as manufacturers' directories, are also listed in this section.

The fourth section contains furniture trade catalogs. Trade catalogs were published by furniture manufacturers and wholesalers as aids for salesmen and stores. These publications contain considerable information concerning the types of furniture produced by specific manufacturers. These catalogs are valuable resources for the study of American furniture during the years 1870–1920. This list of trade catalogs includes only citations for copies that are known to be extant. Obviously, some catalogs were issued in years other than the years listed in each citation. Furthermore, it should be noted that it is often difficult to ascertain whether a particular trade catalog publisher was a manufacturer, wholesaler, or retailer. Some libraries containing noteworthy collections of trade catalogs are: Library of Congress, H. F. du Pont Winterthur Library, Eleutherian Mills-Hagley Foundation Library, Henry Ford Museum Library, Carnegie Library of Pittsburgh, Smithsonian Institution Libraries, and the Library at the University of California, Santa Barbara.

The first part of the two-part appendix consists of a list of periodicals related to furniture. These periodicals are basically trade publications. However, they do contain data related to specific furniture manufacturers and to the furniture industry in general. Most of these periodicals were published during the years 1880–1930. The second part of the appendix is a brief listing of manuscript repositories that contain material relevant to furniture. This list should not be considered to be comprehensive because of the large number of possible institutions that may also be repositories of items dealing with furniture.

This volume contains three indexes. The Craftsman-Biographical Index lists all craftsmen and companies mentioned in the four main sections and in the appendix. Brief biographical data, stressing periods and places of activity, is given along with citation references. The Author-Title Index lists every author and title that appear in the book. The Subject Index refers to aspects of the field of American furniture but does not repeat the names of craftsmen appearing in the Craftsman-Biographical Index. The typical entries in the Subject Index reflect the subjects contained within the materials cited, including institutions and people who were not furniture producers. Citations that consist of very general works are not referenced in the Subject Index; nor are those that are specifically devoted to individual craftsmen. Subjects are organized so that a general heading is followed by headings of a specific nature. For example, the entry for "card tables" is found under "Tables"; references concerning cabinetmakers who worked in New York may be found under the subhead "New York" within the major listing for "Cabinetmakers."

The stylistic format of this volume generally conforms to directions contained in *The Chicago Manual of Style*, 13th edition, but some deviations are employed where it is felt that a clearer method should be used. A special problem occurs with regard to alphabetizing trade catalogs. These are treated as books, with the author and publisher considered to be the same. When the business name is in the name of an individual "and company" or in the names of partners and the first partner has both a given name and a surname, the first name is inverted and the given name is placed in parentheses. For example, the catalogs produced by Ludwig Baumann and Company for purposes of alphabetization are entered by author as Baumann (Ludwig) and Company rather than as Baumann, Ludwig, and Company. Thus, this is distinguished from the entry form Bardwell, Anderson, and Co., Anderson being the surname of the second partner.

In conclusion, the compiler hopes that this volume will be used as a reference for the study of American decorative arts. It is intended to be of value to librarians, students, historians, collectors, researchers, curators, connoisseurs, and the general public. It is the compiler's wish that this work will also encourage further research in the vast field of American furniture and its makers.

ACKNOWLEDGMENTS

Numerous persons and institutions gave invaluable assistance towards the preparation of this bibliography. Their contributions and support are greatly appreciated. The staffs of many libraries were cordial and very helpful. The following institutions deserve a special mention: American Antiquarian Society Library, Antiquarian and Landmarks Society, Inc., Binghamton Public Library, Cornell University Libraries, Henry Francis du Pont Winterthur Library, Library of Congress, New York State Library, SUNY–Albany Library, and SUNY–Binghamton Libraries. The following individuals were notable among the many who gave support, encouragement, and assistance: Richard Barons, Marilyn Brownstein, David Conway, Josephine Conway, Maryanne Davitt, Helena Gee, Ellen Hughes, Tully Lenihan, Jean McEvoy, Charles Muller, Bob Ondreyko, Josephine Osgood, Pamela J. Parry, Benjamin Rifkin, Richard Semowich, Zeekie Semowich, John Spencer, Kaethe Watkins, and Alva Worthington.

American
Furniture Craftsmen
Working
Prior to 1920

WORKS ABOUT INDIVIDUAL CRAFTSMEN

Citations are entered alphabetically by author within an alphabetical list of individual craftsmen.

Nehemiah Adams

1. Kimball, Fiske. "Salem Furniture Makers: II Nehemiah Adams." Antiques 24 (December 1933): 218-28. illus.

General biography on Adams with illustrations of documented pieces.

Thomas Affleck

2. Carson, Marion S. "Thomas Affleck, A London Cabinetmaker in Colonial Philadelphia." Connoisseur 167 (March 1968): 187-91. illus.

English influence on Affleck's work.

3. Comstock, Helen. "Thomas Affleck of Philadelphia." Connoisseur 96 (August 1935): 94-5. illus.

Review of an exhibition in which Affleck's work was included.

4. Keyes, Homer Eaton. "Affleck, Philadelphia Notable: Highboy and Lowboy made by T. Affleck." Antiques 28 (November 1935): 185-7. illus.

A short note on some Affleck furniture.

William Alexander

5. Jones, Karen, ed. "Collector's Notes." <u>Antiques</u> 123 (May 1983): 1074-75. illus.

 A discussion of this Pennsylvania cabinetmaker. There is also mention of the Meeks.

Amos Denison Allen

6. Bulkeley, Houghton. "Amos Denison Allen, Cabinetmaker." <u>Connecticut Historical Society Bulletin</u> 24 (April 1959): 60-64. illus.

 Discusses Allen's apprenticeship papers and his order book that spans the years 1796-1803.

7. ___. "An Important Labelled Bureau." <u>Connecticut Historical Society Bulletin</u> 30 (April 1965): 62-63. illus.

 Illustrates a labelled case piece made by Allen.

8. Chase, Ada R. "Amos D. Allen, Connecticut Cabinetmaker." <u>Antiques</u> 56 (August 1970): 146-47. illus.

 Short incomplete biography. Chairs made by Allen are shown.

Michael Allison

9. Norman-Wilcox, Gregor. "Michael Allison and a Sideboard." <u>Connoisseur</u> 171 (July 1969): 203-7. illus. notes.

 Allison worked during the period of activity of Phyfe, yet worked in the older Federal style.

Richard Allison

10. Flannery, Margo C. "Richard Allison and the New York City Federal Style." <u>Antiques</u> 103 (May 1973): 995-1001. illus.

 An examination of Allison's style and its relationship to other furniture makers, such as Samuel and William S. Burling, also of New York City.

Amana Community

11. Albers, Marjorie K. <u>Old Amana Furniture</u>. Shenandoah,
Iowa: Locust House, 1970. iii, 85 pp., illus.

 Information on the furniture produced by Amana, a
 communal sect of Buffalo, N.Y. and Iowa. The only book
 on Amana furniture.

12. Chaffee, Grace E. "An Analysis of Sectarian Community
Culture with Especial Reference to the Amana Society."
<u>Antiques</u> 16 (August 1929): 114-18. illus.

 Shows furniture from Amana. Does not contain depth or
 facts.

13. Chaffee, Grace E. "A Note on Amana Chests." <u>Antiques</u> 31
(April 1937): 180-82. illus.

 Discusses European chests at Amana.

14. Snyder, Ruth Geraldine. "Arts and Crafts of the Amana
Society." Master's thesis, University of Iowa, 1949.

Anonymous

15. Horton, Frank L. "The Work of an Anonymous Carolina
Cabinetmaker." <u>Antiques</u> 101 (January 1972): 169-176. illus.

 Seven pieces by an unidentified maker.

Nathaniel Appleton, Jr.

16. Kimball, Fiske. "Salem Furniture Makers: I Nathaniel
Appleton, Jr." <u>Antiques</u> 24 (September 1933): 90-92. illus.

 Short biography with documented pieces.

William Appleton

17. Comstock, Helen. "A Salem Secretary Attributed to
William Appleton." <u>Antiques</u> 80 (April 1966): 553-55. illus.

 Short article outlining a possible attribution to
 Appleton.

18. Montgomery, Charles F. Tambour Desks and the Work of
William Appleton of Salem. Portland, Maine: The Athenaeum,
1967. 6 pp. illus.

Reprint from the 1966 Walpole Society Notebook. Refutes
some stylistic attributes of the Seymour family of Salem
cabinetmakers and assigns these attributes to Appleton.

Gilbert Ash

19. Blackburn, Roderic H. "Gilbert Ash Inscriptions Recon-
sidered." Antiques 123 (February 1983): 428-31. illus.

A discussion of the pivotal signed Ash chair. Questions
the accepted date for the chair.

20. Keyes, Homer Eaton. "Editor's Attic." Antiques 27
(March 1935): 88-89. illus.

Reprints Ash's will.

Thomas Ashe

21. "Exhibitions and Sales." Antiques 26 (August 1934): 67.
illus.

Mentions the sale of Thomas Ashe's portrait.

Thomas Astens

22. Keyes, Homer Eaton. "Editor's Attic." Antiques 27
(March 1935): 88. illus.

Illustrates and discusses a pedestal table with Astens'
label on it.

Aurora Colony

23. McCarl, Robert Smith, Jr. "Aurora Colony Furniture: A
Model for Folklorist Interpretation of Museum Articles."
Master's thesis, University of Oregon, 1974. 194 pp.

The Aurora Colony was a 19th century commune located in
Oregon. This thesis discusses the furniture of the
community and its' interpretation in a museum environ-
ment.

Jacob Bachman and Family

24. Dreppard, Carl W. "Furniture Masterpieces by Jacob
Bachman." Lancaster County Historical Society Papers 49
(1945): 131-39. illus. (Also published in American Collector
14 (October 1945): 6-9, 16, 20. illus.)

 First major article on this furniture maker. Includes
 major pieces, but contains questionable attributions.

25. Dyke, Samuel E. "The Bachman Family of Cabinetmakers:
1776-1897." Journal of the Lancaster County Historical
Society 69 (December 1965): 168-180. illus.

 History of the entire family.

26. Snyder, John J. "The Bachman Attributions: A Reconsidera-
tion." Antiques 105 (May 1974): 1056-65. illus.

 Disputes both Dreppard and Dyke's attributions. Presents
 new information.

Stephen Badlam

27. Swan, Mabel Munson. "Gen. Stephen Badlam--Cabinetmaker
and Looking-glass Maker." Antiques 65 (May 1954): 380-83.
illus.

 A good biography with several documented pieces.

Joseph B. Barry

28. Trump, Robert T. "Joseph B. Barry, Philadelphia Cabinet-
maker." Antiques 107 (January 1975): 159-63. illus.

 A comprehensive study of this Dublin-born cabinetmaker.

George Beldon

29. Bulkeley, Houghton. "George Beldon and Erastus Grant,
Cabinetmakers." Connecticut Historical Society Bulletin 27
(July 1962): 65-73. illus.

 Biographies are included. Furniture made by these
 cabinetmakers is illustrated.

John Haley Bellamy

30. Safford, Victor. "John Haley Bellamy: Woodcarver of Kittery Point." <u>Antiques</u> 23 (March 1933): 102-6. illus.

 Biographical sketch of this eagle carver who did carve some furniture.

John Henry Belter

31. Barnes, Jairus B. "Rococo Revival Furniture at the Western Reserve Historical Society." <u>Antiques</u> 114 (October 1978): 788-93. illus.

 This article is mainly on Belter and Meeks furniture in this museum.

32. Bjerkoe, Ethel Hall. "John Henry Belter, 1800-1865." <u>Hobbies</u> 58 (January 1954): 62-63.

 A short non-illustrated biography on Belter.

33. Davis, Felice. "Victorian Cabinetmakers in America." <u>Antiques</u> 44 (September 1943): 111-15. illus.

 Mentions Belter, Phyfe, Hitchcock and Marcotte.

34. Douglas, Ed Polk. "A Belter Bounty." <u>New York-Pennsylvania Collector</u> 7 (December 1982): 26-27,31. illus.

 Belter furniture from the perspective of a collector.

35. ___ . "The Belter Nobody Knows." <u>New York-Pennsylvania Collector</u> 6 (October 1981): 11-16. illus.

 New biographical information on Belter. Illustrates several advertisements and discusses prices for Belter furniture.

36. ___ . "Built by Belter--Documented Work From A Great American Cabinetmaker." <u>New York-Pennsylvania Collector</u> 8 (April 1983): 3-4. illus.

 Discusses the problems of Belter attributions.

37. ___ . "Revelations Behind Those Rococo Roses." <u>New York-Pennsylvania Collector</u> 8 (April 1983): 20B-22B. illus.

 Examines new biographical data on Belter. Some information is based on the book, <u>American Furniture of the 19th Century</u> by Eileen and Richard Dubrow.

38. ___. "Rocking the Roses." New York-Pennsylvania Collector 6 (May 1981): 22B-23B. illus.

Discusses the Belter, Meeks, or Schreiber controversy. Discounts the role played by Schreiber.

39. ___. "The Rococo Revival Furniture of John Henry Belter." Arts and Antiques 3 (July/August 1980): 34-43. illus.

General article on Belter.

40. ___. "Rococo Roses." Parts 1-5. New York-Pennsylvania Collector 4 (January/February, April, August, September, December 1979). illus.

Parts 1 and 2 are devoted mainly to Belter. The remaining parts consist of information on Belter's contemporaries; Meeks, Henkels and Roux. This is an excellent series of articles containing a great deal of information.

41. ___. "Tabling the Issue, Built by Belter, Part II." New York-Pennsylvania Collector 8 (May 1983): 8-9. illus.

Discusses the tables made by Belter. Includes several labelled pieces.

42. Downs, Joseph. "John Henry Belter and Co." Antiques 54 (September 1948): 166-68. illus.

General article by this important author. A good introduction to Belter's work. Includes contemporary documentation.

43. Foote, Caroline C. "A Victorian Cabinetmaker." The Christian Science Monitor 19 October, 1933; 5.

Describes a documented Belter piece of furniture.

44. Franco, Barbara. "John Henry Belter: a Rococo Revival Cabinetmaker in the Limelight. 19th Century 6 (Summer 1980): 30-32. illus.

Review of Belter's work with a short discussion of his patent.

45. Gaines, Edith, ed. "Collector's Notes." Antiques 95 (March 1969) 398-99. illus.

A short note on Belter and William Appleton.

46. Hogrefe, J. "Belter and Rococo." Americana 9 (March/April 1981) 26-27. illus.

Current market trends in Belter furniture.

47. Ormsbee, Thomas H. "The Romantic Period in Furniture."
American Collector 7 (June 1938): 6-7. illus.

 Discusses Victorian furniture in the U. S. and Europe.
 Several examples of Belter furniture illustrated.

48. Roberts, M. F. "Victorianism as John H. Belter Expressed
It." Arts and Decoration 40 (April 1934): 51-2. illus.

 Review of the Belter exhibition at the Metropolitan
 Museum of Art.

49. Roth, Rodris. "Belter's Only Patent Model." Antiques 111
(May 1977): 1038-40. illus.

 Belter's 1858 Patent for a chair.

50. Schwartz, Marvin D. "Born-again Belter." Antiques World
2 (October 1980): 50-55. illus.

 General article. Reviews a Belter Exhibition.

51. ___. "The Manney Collection of Belter Furniture."
Antiques 119 (May 1981): 1164-73. illus.

 One Belter collection.

52. ___. "Master of the Rococo Style: John Henry Belter."
American Craftsman 40 (December 1980/January 1981): 36-9.

53. ___. "Notes on John Henry Belter." Brooklyn Museum
Bulletin 21 (Spring 1960): 14-15. illus.

 Documented bed by Belter, with a discussion of his role in
 lamination.

54. Schwartz, Marvin D., Edward J. Stanek, and Douglas K.
True. The Furniture of John Henry Belter and the Rococo
Revival: An Inquiry into Nineteenth-Century Furniture Design
Through a Study of the Gloria and Richard Manney Collection.
New York: E.P. Dutton, 1981. 88 pp. illus. bibl.

 A collection of several essays on Belter: his life,
 career, style, and techniques.

55. Stanek, Edward J., and Douglas K. True. "Belter, Meeks or
Schreiber?" Antique Trader 13 (April 1981): 42-44. illus.

 Claims that laminated furniture was not made by Belter.
 Considerable amount of information is from the book by
 these authors (see entry No. 54).

56. Trebay, Guy. "John H. Belter's Rococo Comeback." Village
Voice 18 March, 1981: 56.

 Belter furniture sales.

57. Vincent, Clare. John Henry Belter, Manufacturer of
all Kinds of Furniture. Charlottesville, Va.: University
Press of Virginia, 1974. 28 pp., illus.

 Reprinted from the 1973 Winterthur Conference Report.
 A scholarly study on Belter.

58. ___ . "John Henry Belter, Manufacturer of all Kinds of
Furniture." Master's thesis, New York University. 1963.

59. ___ . "John Henry Belter's Patent Parlor Furniture."
Furniture History 3 (1967): 92-99. illus.

 The only article on an American cabinetmaker to appear
 in this English periodical. A good scholarly discussion.
 The most complete discussion of the Belter patents.

60. Walker, Richard W. "Victorian Rising." Antiques World 3
(January 1982): 18. illus.

 Belter furniture on the antiques market.

Cotton Bennett

61. Fales, Dean A., Jr. "Cotton Bennett, Beverly Cabinetmaker:
a Discovery." Essex Institute Historical Collections." 100
(1964): 155-58. illus. footnotes.

 Shows a documented Bennett piece of furniture and gives
 a short biography.

Berkey and Gay

62. Nesbit, Wilber Dick. The Story of Berkey and Gay, a
Corporation Which is a Part of American History. Grand Rapids,
Michigan: Berkey and Gay Furniture Co., 1912.

 A promotional pamphlet which was reprinted with additions
 from Munsey's Magazine. This firm operated a large
 furniture factory.

J. Bertine

63. [Gottesman] Susswein, Rita. "New York-Made Windsor Found."
American Collector 3 (May 1935): 1, 11. illus.

 Short article on the late 18th century chair maker by the
 name of Bertine.

Bishop Hill Colony

64. Anderson, Theodore J., comp. 100 Years: History of Bishop Hill, 1846-1946. Chicago: Theodore J. Anderson, 1946. 251 pp. illus.

History of the community, very little on the furniture.

65. Mikkelsen, Michael A. Bishop Hill Colony. 1892. Reprint. Philadelphia: Porcupine Press, 1972.

A history of the commune. Does not mention furniture.

66. Morton, Stratford Lee. "Bishop Hill, an Experiment in Communal Living." Antiques 43 (February 1943): 74-77. illus.

Illustrates furniture made at the community.

67. Nelson, Ronald E. "Bishop Hill." Antiques 99 (January 1971): 140-47. illus.

History of the community with examples of furniture.

Robert Black

68. Ellesin, Dorothy E. "Robert Black, Middle Tenn. Cabinet-maker." Antiques 109 (May 1976): 950. illus.

Illustrates a documented chest dated 1819. Limited biographical data is given.

Peter Blin

69. Bulkeley, Houghton. "A Discovery on the Chests." Connecticut Historical Society Bulletin 23 (January 1958): 17-19. illus.

Discusses the Hartford sunflower chests; attributes one to Peter Blin. Also discusses Obadiah Dickinson and Benjamin Gilbert.

Pelatiah Bliss

70. "Queries and Questions." Antiques 18 (September 1930): 262. illus.

A Bliss chest is shown and briefly discussed.

Samuel Blyth

71. Little, Nina Fletcher "The Blyths of Salem: Benjamin in Crayons and Oil, and Samuel, Painter and Cabinetmaker." Essex Institute Collections 108 (1972): 49-57. illus.

 Discussion of two tradesmen of Salem. Samuel was a sail-maker as well as a painter and cabinetmaker.

Langley Boardman

72. Decatur, Stephen. "Langley Boardman, Portsmouth Cabinet-maker." American Collector 6 (May 1937): 4-5. illus.

 Short article that gives a brief biography. Illustrates some documented pieces.

73. "Langley Boardman." Newtown Bee 4 January 1952.

 This article was not examined by the author.

Booth Family

74. Bjerkoe, Ethel Hall. "Booth Family of Newtown and South-bury, Connecticut." Old-Time New England 48 (July 1957): 8-11.

 Uses contemporary documents and inventories to discuss the life and work of the Booth family. No illustrations.

Michel Bouvier

75. Fennimore, Donald L. "A Labeled Card Table by Michel Bouvier." Antiques 103 (April 1973): 761-63. illus.

 First known piece by this French-born cabinetmaker.

76. Dallett, Francis James. "Michel Bouvier, Franco-American Cabinetmaker." Antiques 81 (February 1962): 198-200. illus.

 Biographical and related information on this cabinetmaker, who was the great-great-grandfather of Jacqueline Onassis.

Nathan Bowen

77. Randall, Richard H., Jr. "An 18th Century Partnership."
Art Quarterly 23 (Summer 1960): 152-56. illus.

About Nathan Bowen and Ebenezer Martin.

Amos Bradley

78. Hawley, Ralph C. "Identifies New Connecticut Worker."
American Collector 1 (May 1934): 1, 6. illus.

Discusses a labelled chest by this maker.

Will Bradley

79. McDowell, Crosby, "Will Bradley and the Mission Style."
American Life Collector's Annual 5 (1965): 323-29. illus.

Only a few pieces designed by Bradley are shown.

80. Metropolitan Museum of Art Print and Drawing Gallery.
Will Bradley, American Artist and Craftsman. New York:
Metropolitan Museum of Art, 1972. 20 pp.

An exhibition catalog.

Joseph Brauwers

81. Gaines, Edith. "Collector's Notes." Antiques 83
(April 1963): 459. illus.

Information about a labelled card table by this maker,
The table contains interesting bronze mounts.

George Bright

82. Randall, Richard H. "George Bright, Cabinetmaker,"
Art Quarterly 27 (Spring 1964): 134-49. illus.

Career of this 18th century maker is discussed. A
bombe chest made by this maker is shown.

Thomas Brooks

83. Clement, Arthur W. "Chair by Thomas Brooks of Brooklyn."
Antiques 64 (December 1953): 491. illus.

 A short biography of this mid-19th century craftsman.

William Brown, Jr.

84. Bassett, Kendall H. "The Apprenticeship of William
Brown Jr. to D. Phyfe." Chronicle of the Early American
Industries Association 29 (December 1976): 61. illus.

 Discusses an 1802 indenture to Duncan Phyfe. Gives
 a very short biography.

Bruce and Dean

85. Comstock, Helen. "The Cabinetmaker in America: Two Early
Trade Cards." Connoisseur 94 (September 1934): 190. illus.

 Contains copies of trade cards of Bruce and Dean, and
 Thomas Ash, both of New York. Some biographical
 information is given.

John Budd

86. "Self-effacing John Budd." American Collector 5 (October
1936): 2. illus.

 Discusses a card table made by Budd.

Thomas Burling

87. Adair, W. "Another Burling Comes to Light." American
Collector 15 (March 1946): 5. illus.

 Short note on a Burling piece.

88. Granquist, Charles L. "Thomas Jefferson's 'Whirligig'
Chairs." Antiques 109 (May 1976): 1056-60. illus.

 Discusses Thomas Burling, New York.

89. Keyes, Homer Eaton. "Editor's Attic." _Antiques_ 29
(May 1936): 190-99. illus.

 Discusses a desk made by this craftsman.

90. "Thomas Burling." _American Collector_ 4 (June 1935).

Benjamin Burnham

91. Bulkeley, Houghton. "Benjamin Burnham of Colchester,
Cabinetmaker." _Connecticut Historical Society Bulletin_ 23
(July 1958): 85-89. illus. (Also published in _Antiques_ 76
(July 1959): 62-63. illus.)

Charles Buschor

92. Hawley, Henry. "Charles Buschor, Designer and Manufac-
turer of Furniture and Interior Decorations." Master's
Thesis, University of Delaware (Winterthur), 1960.

John Cahoone

93. Vibert, Jeanne Arthur. "The Market Economy and the
Furniture Trade of Newport, R.I.: The Career of John Cahoone,
Cabinetmaker, 1745-65." Master's Thesis, University of
Delaware (Winterthur), 1981. 106 pp.

John Carlile

94. Row, L. Earle. "John Carlile, Cabinetmaker." _Antiques_
6 (December 1924): 310-11. illus.

 Biographical and genealogical information is given.
 Documented pieces are shown.

Edward Jenner Carpenter

95. Gates, Winfred C. "Journal of a Cabinetmaker Apprentice."
Chronicle of the Early American Industries Association 15
(June, September 1962): 23-24, 35-36. illus.

 The diary of this maker is given. Active in
 Greenfield, Mass.

Carrere and Hastings

96. Blake, Channing. "The Early Interiors of Carrere and Hastings." Antiques 110 (August 1976): 344-51. illus.

Information on the interiors by these architects.

Chapin Family

97. Chapin, G. W. Chapin book of Genealogical Data. Hartford: Privately Printed, 1924.

A family genealogy book. No information on furniture.

98. Davis, Emily M. "Eliphalet Chapin." Antiques 35 (April 1939): 172-75. illus.

Good biographical study. Includes furniture illustrations and references.

99. Hoopes, Penrose R. "Aaron Chapin, Hartford Cabinetmaker." Antiques 24 (September 1933): 97-98. illus.

Discusses the work and career of this craftsman.

100. Keyes, Homer Eaton. "Editor's Attic." Antiques 31 (January 1937): 11.

Short note about the relationship between Aaron and Eliphalet Chapin.

101. Maynard, Henry P. "Eliphalet Chapin, The Resolute Yankee, 1741-1807." Wadsworth Atheneum Bulletin 6th Series, vol.1 (Fall 1965): 10-17. (Also published in Connoisseur 170 (February 1969): 126-29.) illus.

History of Chapin scholarship. Contains a good biography of the Chapin family. Questions many attributions.

102. Stein, Aaron Marc. "The Chapins and Connecticut Valley Chippendale." The Antiquarian 16 (April 1931): 21-24. illus.

Stylistic development of both Chapins is discussed.

103. Winchester, Alice. "Editor's Attic." Antiques 39 (February 1942): 84. illus.

Short note on Eliphalet Chapin. Shows a newspaper advertisement.

Silas E. Cheney

104. Ormsbee, Thomas H. "Silas E. Cheney, Litchfield Cabinetmaker." American Collector 6 (November 1937): 5. illus.

Illustrates a sideboard by Cheney. Discusses his account books.

James Chestney

105. Ellesin, Dorothy E., ed. "Collector's Notes." Antiques 106 (December 1974): 1033. illus.

Brief mention of this maker and of Samuel Durand.

Jonas Chickering

106. Hollis, Helen Ride. "Jonas Chickering: The Father of American Pianoforte Making." Antiques 104 (July 1973): 227-30. illus.

General discussion of Chickering's life and work.

Daniel Clay

107. "Labelled Daniel Clay Desk Given to Historic Deerfield." Antiques and the Arts Weekly 29 October 1982: 95. illus.

Discussion of a Clay desk. Includes some biographical material.

108. Rippe, Peter M. "Daniel Clay of Greenfield, Cabinet-maker." Master's Thesis, University of Delaware (Winterthur), 1962. 146 pp. illus.

The appendix contains a checklist of Greenfield, Mass. cabinetmakers.

109. Snow, Julia Sophronia. "Daniel Clay, Cabinetmaker of Greenfield." Antiques 25 (April 1934): 138-39. illus.

Poorly written but contains some useful biographical material.

Clemens Family

110. Keyser, Alen G. <u>Account Book of the Clemens Family of Lower Salford Township, Montgomery Co., Pa.</u> Breiningsville, Pa.: The Pennsylvania German Society, 1975.

 Reprint of account books by these cabinetmakers. The books were originally written in German and date 1749-1857.

Jeremiah Clement Cleveland

111. Jones, Karen M., ed. "Collector's Notes." <u>Antiques</u> 111 (May 1977): 936. illus.

 Short biography on this Hartford, Ct. maker.

William Chappel

112. Thomas, David, and Mary Lou Thomas. "A Tall Clock by William Chappel, Cabinetmaker of Danbury." <u>Connecticut Historical Society Bulletin</u> 31 (April 1966): 55-57. illus.

 A short article about a clock owned by the authors. Chappel was active 1790's to 1830's.

John Cogswell

113. Cogswell, Heath. "Solidity in Motion." <u>Antiques World</u> 4 (December 1981): 52-55. illus.

114. Downs, Joseph. "John Cogswell, Cabinetmaker." <u>Antiques</u> 61 (April 1952): 322-24. illus.

 Important article on this Boston craftsman. Discusses a significant bombe chest on chest.

115. Young, M. Ada. "Fine Secretaries and the Cogswells." <u>Antiques</u> 88 (December 1965): 478-85. illus.

 Discusses five secretaries attributed to John and James Cogswell. Disproves the father/son relationship of these two craftsman. This article uses primary documents and includes a genealogy.

Job Coit

116. Evans, Nancy Goyne. "The Genealogy of a Bookcase Desk."
Winterthur Portfolio 9 (1974): 213-22. illus.

 Discusses an important block-front bookcase desk. Gives
 a detailed provenance of the desk. Biographical informa-
 tion on Coit is given.

Henry Connelly

117. Carson, Marion Sadler. "Connelly and Haines, Two Phila-
delphia Sheraton makers and the Key to Their Individuality;
with Checklist of Furniture Included in the Exhibition."
Philadelphia Museum Bulletin 48 (Spring 1953): 35-47.

 Review of an exhibition, includes biographies on both
 cabinetmakers. The checklist includes non-furniture
 items.

118. ___. "Sheraton's Influence in Philadelphia. The
Parallel Works of Henry Connelly and Ephraim Haines." Antiques
63 (April 1953): 342-45. illus.

 Similar to No. 117.

119. Hornor, William M., Jr. "Henry Connelly, Cabinet and
Chair Maker." International Studio 93 (May 1929): 43-46.
illus.

 Discusses Connelly and the Federal style. Information
 on Connelly's career is also given.

120. ___. "Two Early American Cabinetmakers Compared."
Country Life 56 (September 1929): 47-8. illus.

 A very general review of the life and career of
 Henry Connelly and Duncan Phyfe.

121. Keyes, Homer Eaton. "Editor's Attic." Antiques 33
(June 1938): 310-11. illus.

 Discusses a chair attributed to Henry Connelly.

Thomas Cooper

122. Philbrick, Edward. "A Desk by Thomas Cooper of Long
Island." American Collector 1 (September 1940): 5. illus.

Three paragraphs about a desk made for Thomas Helm in 1770. This desk has unusual ovals in its design.

Walter Corey

123. Shettleworth, Earle G., Jr., and William D. Barry. "Walter Corey's Furniture Manufactory in Portland, Me." Antiques 121 (May 1982): 1199-1205. illus. notes.

A comprehensive history of this furniture factory. Illustrates documented chairs and related items.

Joseph Cox

124. Keyes, Homer Eaton. "Editor's Attic." Antiques 23 (April 1933): 123-24. illus.

Information about Cox, a New York upholsterer.

125. Ralston, Ruth. "Settee from the Workshop of Joseph Cox." Bulletin of the Metropolitan Museum of Art 27 (September 1932): 206-208. illus.

The most comprehensive article on Cox. Includes a copy of a Cox label.

126. "Settee from the Workshop of Joseph Cox." Connoisseur 90 (November 1932): 352-3. illus.

Review of the settee in the Metropolitan Museum of Art.

Mr. Cram

127. Wood, Charles B., III. "Mr. Cram's Fan Chair." Antiques 89 (February 1966): 262-64. illus.

Discusses a fan chair whose design is attributed to to Mr. Cram, as evidenced by a letter from Charles Wilson Peale.

Lemuel Curtis

128. Durfee, Walter H. "Clocks of Lemuel Curtis." Antiques 4 (December 1922): 281-85. illus.

Discusses the life and work of Curtis.

Job Danforth

129. Pillsbury, William M. "Earning a Living, 1788-1818:
Job Danforth, Cabinetmaker." <u>Rhode Island History</u> 31
(Spring 1972): 81-93. illus.

 Based on an account book in the collection of the
 Rhode Island Historical Society.

William Danforth

130. Whitmore, Mrs. Charles. "A Documented Desk of 1760."
<u>Antiques</u> 5 (May 1924): 239-40. illus.

 Discusses a desk made by William Danforth.

A. H. Davenport and Co.

131. Farnam, Anne. "A. H. Davenport and Co., Boston Furni-
ture makers." <u>Antiques</u> 109 (May 1976): 1048-55. illus.

 This firm produced furniture 1845-1906. The author
 points out major commissions.

Alexander Jackson Davis

132. Andrews, Wayne. "American Gothic." <u>American Heritage</u>
22 (October 1971): 26-47, 97. illus.

 Discusses both the furniture and buildings designed by
 Davis.

133. Davies, Jane B. "Gothic Revival Furniture Designs of
Alexander J. Davis." <u>Antiques</u> 111 (May 1977): 1014-25. illus.

 Shows many documented examples based on Davis' designs.

134. McClinton, Katherine Morrison. "Furniture and Interiors
Designed by A. J. Davis." <u>Connoisseur</u> 70 (January 1969):
54-61. illus.

 Davis as a furniture designer. Original drawings are
 shown as well as furniture from Lyndhurst.

135. Mallach, Stanley. "Gothic Furniture Designs by
Alexander Jackson Davis." Master's Thesis, University
of Delaware (Winterthur), 1966. 169 pp.

136. Pearce, John N. "A. J. Davis' Greatest Gothic."
Antiques 87 (June 1965): 684-89. illus.

 Mostly on the furniture at Lyndhurst.

"German" Davis

137. Dockstader, Mary Ralls. "Introducing 'German' Davis,
Itinerant Georgia Cabinetmaker." Antiques 31 (January 1937):
19-21. illus.

 Poorly documented article on an Athens, Georgia
 maker of the second half of the 18th century.

Thomas Day

138. Barfield, Rodney. "Thomas Day, Cabinetmaker." 19th
Century 2 (August 1976): 23-32. illus.

 A complete article on this black craftsman.

139. Gunter, Caroline Pell. "Tom Day--Craftsman."
The Antiquarian 11 (September 1928): 60-62. illus.

 The first article about this cabinetmaker.

140. North Carolina Museum of History. Thomas Day, 19th
Century North Carolina Cabinetmaker. Raleigh, N.C.: North
Carolina Museum of History, 1975. 75 pp. illus.

 Exhibition catalog of an exhibition of furniture and
 decorative carvings.

141. "Thomas Day, Cabinetmaker." Colonial Homes 8 (January/
February 1982): 106-111. illus.

 A general article with no new information.

Thomas Dennis

142. Bjerkoe, Ethel Hall. "Thomas Dennis of Ipswich, Mass."
Hobbies 62 (August 1957): 56-57. illus.

 A short biography on this maker.

143. Keyes, Homer Eaton. "Dennis or a Lesser Light."
Antiques 34 (December 1938): 290-300. illus.

 Discusses the problems of attributions among Dennis,
 John Alden and Kenelm Winslow.

144. Little, T. W. "Thomas Dennis; Land Genealogy of Col.
Thomas Dennis--His Forebears and Descendants." Connecticut
State Library, Hartford. Typescript.

145. Lyon, Irving P. "The Oak Furniture of Ipswich, Mass."
Parts 1,2,3,4,5,6. Antiques 32,33,34 (November, December 1937,
February, April, June, August 1938): 230-33, 298-301, 73-75,
198-205, 322-25, 79-81. illus.

> This six-part article discusses 17th century New England
> furniture. Each part examines a specific type of
> furniture. Most of the furniture is attributed to
> Dennis. Biographical information on Dennis is also
> included.

146. Park, Helen. "Thomas Dennis, Ipswich Joiner--A Re-
examination." Antiques 78 (July 1960): 40-44. illus.

> Reduces the number of attributions to Dennis. Redefines
> Dennis' stylistic characteristics. Good scholarship.

John De Witt

147. Kindig, Joe III. "Upholstered Windsors." Antiques 61
(May 1952): 52-53. illus.

> Mentions several Windsor chair makers, including John
> De Witt, William Galatian and James Zwister.

Nicholas Disbrowe

148. Lockwood, Luke Vincent. "Nicholas Disbrowe, Hartford
Joyner." Bulletin of the Metropolitan Museum of Art 18
(May 1933): 118-23. illus.

> Establishes the reputation for this 17th century maker.

149. Luther, Clair Franklin. "Hadley Chest." Antiques 16
(October 1928): 338-40. illus.

> Gives a biography on Disbrowe.

150. ___ . "New Delvings in Old Fields." Antiques 18
(August 1930): 152-54. illus.

> Consists of a short biography.

151. "Original Distribution of the Lands in Hartford Among
the Settlers, 1639." Collections of the Connecticut
Historical Society 14.

> Land records that mention Disbrowe.

John Doggett

152. "Riddles and Replies." Antiques 32 (October 1937): 208.

Short note on this looking-glass maker.

153. Swan, Mabel M. "Doggett Furniture." Old-Time New England 25 (October 1934): 73. illus.

Dominy Family

154. Hummel, Charles F. "The Rural Craftsman: Evidence from the Dominy Family of East Hampton, N.Y." Antiques 93 (March 1968): 334-41. illus.

Excerpts from Hummel's book.

155. ___ . With Hammer in Hand: The Dominy Craftsmen of East Hampton, New York. Winterthur, Delaware: H.F.duPont Winterthur Museum, 1968. xiv, 424 pp. illus. bibl.

A review of the careers and lives of the Dominy family of Long Island. A great deal of information is given on the manufacturing processes in the 18th century. The tools of the Dominy craftsmen are discussed.

Nathaniel Dowdney

156. Stockwell, David. "Nathaniel Dowdney, Philadelphia Cabinetmaker." American Collector 6 (October 1937): 5.

The only article on this craftsman. Documented pieces are shown with the craftsman's signature.

Dunlap Family

157. Currier Gallery of Art, Manchester, New Hampshire. The Dunlaps and Their Furniture. Manchester, New Hampshire: Currier Gallery of Art, 1970. vi, 310 pp. illus. bibl.

An exhibition catalog that examines the life and work of Major John Dunlap, the patriarch of this famous family of craftsmen. A large number of pieces attributed to this family are illustrated and discussed. This is the most comprehensive work on this important family.

158. Dibble, A. W. "Major John Dunlap: The Craftsman and His Community." Old-Time New England 68 (Winter/Spring 1978): 50-58. illus.

Gives the life and work of Major John Dunlap.

159. Garvin, Donna-Belle. "Two High Chests of the Dunlap School." Historic New Hampshire 35 (1980): 163-85. illus.

Review of the progress of research on Dunlap. Makes two attributions.

160. Parsons, Charles S. "Dunlap Furniture." Maine Antique Digest 4 (December 1976): 12A-14A. illus.

161. Parson, Charles S., and David S. Brooke. "The Dunlap Cabinetmakers." Antiques 98 (August 1970): 224-31. illus.

Provides new information on the Dunlap family. Gives a clear genealogical chart.

162. Winchester, Alice. "The Dunlap Dilemma; Notes on Some New Hampshire Cabinetmakers." Antiques 46 (December 1944): 336-38. illus.

Discusses several problems with Dunlap attributions. Uses contemporary sources.

163. ___. "Editor's Attic." Antiques 47 (March 1945): 168. illus.

Mentions a chair made by Samuel Dunlap.

John and Samuel Durand

164. Forman, Benno M. "The Crown and York Chairs of Coastal Connecticut and the Durands of Milford." Antiques 105 (May 1974): 1145. illus.

Illustrates 18th century chairs; attributes them to either John or Samuel Durand.

W. P. Eaton

165. Robinson, Olive Crittenden. "Signed Stenciled Chairs by W.P. Eaton." Antiques 56 (August 1949): 112-13. illus.

Eaton, of Boston, Mass., worked in the 19th century as a decorator. Best article on this painter/decorator.

Economy Colony

166. Ramsey, John. "Economy and its Crafts." Antiques 57 (May 1950): 366-67. illus.

Short general article about this Pennsylvania Utopian community. Includes examples of Economy furniture.

167. Reibel, Daniel B. "Harmonist Tables." Ohio Antique Review 4 (October 1978): 8. illus.

About Economy produced furniture.

Peter Eddleman

168. Beckerdite, Luke. "City Meets Country: The Work of Peter Eddleman, Cabinetmaker." Journal of Early Southern Decorative Arts 6 (November 1980): 59-73. illus.

Information is given on this North Carolina cabinetmaker. Attributions are made.

Matthew Egerton

169. Hornor, William M., Jr. "Three Generations of Cabinet-makers: 1. Matthew Egerton, 1739-1802." Antiques 14 (September 1928): 217-19. illus.

Information on this and other New Brunswick, N.J. cabinet-makers is given. Labelled pieces are shown.

Matthew Egerton, Jr.

170. Horner, William M., Jr. "Three Generations of Cabinet-makers: 2. Matthew Egerton, Jr. and his Sons." Antiques 14 (November 1928): 417-21. illus.

Excellent article on this craftsman and his sons. Uses contemporary inventories.

171. ___. "Matthew Egerton, Jr., Cabinetmaker of New Jersey." Antiquarian 15 (December 1930): 50-53, 114. illus.

Discusses the life and work of this cabinetmaker and joiner. Tries to date some work, including a kas and tall-case clock.

Thomas Elfe

172. "Account Book of Thomas Elfe, 1768-1775." South Carolina Historical and Genealogical Magazine 25-42 (1934-1941).

Reprint of the account book by this important maker.

173. Burton, E. Milby. Thomas Elfe, Charleston Cabinet Maker. Charleston, South Carolina: Charleston Museum, 1952. 34 pp. illus.

Biography of this 18th century craftsman. Examples of his work are shown.

174. Kolbe, John C. "Thomas Elfe, 18th Century Charleston Cabinetmaker." Master's Thesis, University of South Carolina, 1980.

175. Rauschenberg, Bradford. "The Royal Governor's Chair Evidence of the Furnishing of South Carolina's First State House." Journal of Early Southern Decorative Arts 6 (November 1980): 1-32. illus, footnotes.

Scholarly article; discusses a chair that was once owned by the royal governor and is attributed to Elfe.

176. Rose, Jennie Haskell. "Thomas Elfe, Cabinetmaker, The Account Book, 1768-1775." Antiques 25 (April 1934): 147-49. illus.

Discusses the information contained in the Elfe account book.

John Elliott, Sr. and John Elliott, Jr.

177. Ellesin, Dorothy. "Collector's Notes." Antiques 105 (May 1974): 1068-71. illus.

Short note on John Elliot, Sr. and Henry Bruner. Also mentions Allen and Brother and A. Vandoorn.

178. Gaines, Edith. "Collector's Notes." Antiques 91 (April 1967): 518-19. illus.

179. Gaines, Edith. "Collector's Notes." Antiques 92 (October 1967): 563-65. illus.

Information on both Elliotts.

180. Hornor, William M. "Diverse Activities of John Elliott."
International Studio 93 (August 1929): 21-25. illus.

Claims that Elliott made furniture as well as looking-
glasses.

181. Hughes, Judith Coolidge. "Labels of John Elliott, Jr."
Antiques 91 (April 1967): 514-17. illus.

The best and most complete discussion of the work and
labels of this important looking-glass maker and
importer.

182. Keyes, Homer Eaton. "Editor's Attic." Antiques 6
(September 1924): 131-33. illus.

Some notes on Elliott.

183. ___. "Editor's Attic." Antiques 5 (January 1924):
11-12. illus.

Short note on John Elliott as a looking-glass maker.

184. Yehia, Mary Ellen [Hayward]. "Elliotts of Philadelphia:
Emphasis on the Looking-glass Trade, 1755-1810." Master's
Thesis, University of Delaware (Winterthur).

Harvey Ellis

185. France, Jean. "Genius in Shadows: The Furniture Designs
of Harvey Ellis." The New York-Pennsylvania Collector 6
(April 1981): 1B-4B. illus.

Review of the exhibition of Ellis' work. Includes
an assessment of Ellis' career and work.

186. Gorden, Hugh M.G. "Harvey Ellis, Designer and Draughts-
man." Architectural Review 15 (December 1908): 184-86.

187. Jorden-Volpe Gallery. Genius in the Shadows; The Furni-
ture Designs of Harvey Ellis. New York: Jorden-Volpe Gallery.
1981. 16 pp. illus. bibl.

188. Memorial Art Gallery, University of Rochester.
A Rediscovery--Harvey Ellis, Artist and Architect.
Rochester: Memorial Art Gallery, University of Rochester. 1973.
56 pp. illus. bibl.

Exhibition catalog of a 1972 exhibition.

189. Sanders, Berry. "Harvey Ellis: Architect, Painter,
Furniture Designer." Arts and Antiques 4 (January 1981): 28-76.

General Article on Ellis. Ellis worked for G. Stickley.

Erick Engesaeter

190. Nelson, Marion. "The John Ericksen Cupboard." <u>Minne-apolis Institute of Arts Bulletin</u> 63 (1976-77): 66-73. illus.

 A cupboard dated 1870 is attributed to the Norwegian-American furniture maker, Erick Engesaeter.

Enterprise Chair Mfg. Co.

191. Muller, Charles. "They Look Like Shaker, but..." <u>Ohio Antique Review</u> 8 (March 1982): 6+. illus.

 Discusses chairs made by the Enterprise Chair Mfg. Co. of New York State.

David Evans

192. "Excerpts from the Day Book of David Evans, Cabinet-maker, Philadelphia, 1774-1811." <u>Pennsylvania Magazine of History and Genealogy</u> 27 (1903): 49-55.

193. Gillingham, Harold E. "New Delvings in Old Fields." <u>Antiques</u> 21 (February 32): 94-96. illus.

 Excerpts from Evans' Day Book.

194. Hunter, Dard Jr. "David Evans, Cabinetmaker, His Life and Work." Master's Thesis, University of Delaware (Winter-thur), 1954. illus.

 This thesis is composed of two volumes. The second volume contains a directory of cabinetmakers and allied trades in Philadelphia prior to 1820.

195. Keyes, Homer Eaton. "Editor's Attic." <u>Antiques</u> 20 (December 1931): 335. illus.

 Mentions David Evans and J. Huey.

Anson T. Fairchild

196. Gaines, Edith. "Collector's Notes." <u>Antiques</u> 75 (May 1959): 461. illus.

 Discusses a sideboard made by Fairchild of Northampton, Mass.

Finch

197. Winchester, Alice. "Editor's Attic." Antiques 41
(June 1942): 376-77. illus.

 Information on an Amish furniture maker known only by
 the name of Finch.

Adam Finger

198. Cetin, Frank. "The Adam Finger High Chair." Chronicle
of the Early American Industries Association 6 (June 1970):
35-36. illus.

 A discussion about a high chair made in 1856 by this
 Milwaukee furniture producer.

Fink and Schindler Co.

199. "Diamond Anniversary, Fink and Schindler Co.: Pioneers
in Fine Wood Craftsmanship." Architect and Engineer 212
(March 1958): 22-25. illus.

 A short history of this firm, which was active in San
 Francisco. Shows furniture made by this firm in 1958.

John and Hugh Finlay

200. Paul, J. G. D. "Art, History and a Baltimore Cabinet-
maker: Drawing Room Furniture by J. and H. Finlay." Baltimore
Museum News 6 (June 1944): 4-5. illus.

 Discusses a settee made by a Finlay.

201. Pilling, Ronald W. "John and Hugh Finlay, Baltimore
Cabinetmakers: Painted and Gilt in Most Fanciful Manner."
American Art and Antiques 3 (September/October 1980): 86-93.
illus.

Andrew Fisher

202. Gilborn, Craig. "Rustic Furniture in the Adirondacks,
1875-1925." Antiques 109 (June 1976): 1212-19. illus.

 Discusses rustic furniture and Andrew Fisher.

Isaac Fitch

203. Warren, William L. <u>Isaac Fitch of Lebanon, Connecticut:
Master Joiner, 1734-1791</u>. Hartford: Antiquarian and Landmark
Society of Connecticut, Inc., 1976. 88 pp. illus.

Mostly about Fitch as a builder, but does mention his
furniture.

204. ___. "Isaac Fitch Revisited (As Cabinetmaker)." <u>Con-
necticut Antiquarian</u> 31 (September 1979): 19-27. illus.

Describes two pieces of furniture made by Fitch.

Jacob Foster

205. Keyes, Homer Eaton. "Editor's Attic." <u>Antiques</u> 16
(December 1929): 481. illus.

Examines a labelled table made by Foster.

Fredericks and Farmington

206. "A New York Presentation Chair." <u>American Collector</u>
3 (January 1935): 2. illus.

A paragraph on a chair by this firm.

Benjamin Frothingham

207. "A Block Front Desk by Benjamin Frothingham." <u>Connois-
seur</u> 89 (January 1932): 69-70. illus.

A labelled desk by Frothingham is discussed.

208. Comstock, Helen. "Frothingham and the Question of
Attributions." <u>Antiques</u> 63 (June 1953): 502-505. illus.

Presents a scholarly approach to attributions. Contains
details and is well written.

209. Dexter, Edwin Spalding. "Benjamin Frothingham of
Charlestown, Cabinetmaker and Soldier." <u>Antiques</u> 14
(December 1928): 536-37.

Short article using contemporary references. Discusses
an important labelled desk.

210. Keyes, Homer Eaton. "Editor's Attic." _Antiques_ 17 (May 1930): 409-10. illus.

Discusses the fact that there were three cabinetmakers by the name of Frothingham.

211. ___. "Editor's Attic." _Antiques_ 13 (March 1930): 211. illus.

Discusses more pieces of furniture made by Frothingham.

212. "Matched Highboy and Lowboy found with Early Frothingham Signature." _American Collector_ 7 (December 1936): 1, 17. illus.

213. Swan, Mabel Munson. "Major Benjamin Frothingham, Cabinet-maker." _Antiques_ 57 (November 1952): 392-95. illus.

Short biography on this maker. Shows documented pieces.

Gaines Family

214. Comstock, Helen. "An Ipswich Account Book, 1707-1762." _Antiques_ 66 (September 1954): 188-92. illus.

Account books of John Gaines and Thomas Gaines. Also mentions Joseph Bates, Jebez Sweet, Nathaniel Lord, Anthony Smith, Philip Fowler, Robert Lord, Thomas Wade, Henry Wise, John Dennis, John Wait, Francis Cogswell, Benjamin Study and Francis Goodhue.

215. Decatur, Stephen. "John and George Gaines of Ports-mouth, New Hampshire." _American Collector_ 7 (November 1938): 6-7. illus.

Illustrates chairs by these two chair makers.

216. Hendrick, Robert E. "John Gaines II and Thomas Gaines I, 'Turners' of Ipswich, Mass." Master's Thesis, University of Delaware (Winterthur), 1960. 386 pp.

217. Gaines, John. "Account Book, 1711-1758." Winterthur Museum Library. Photocopy.

Copy of this important account book.

Elijah Galusha

218. Eberlein, Harold Donaldson. "Elijah Galusha was Troy's Master Cabinetmaker." _American Collector_ 5 (December 1936): 4-5. illus.

Information on this 19th century craftsman.

Samuel Gardiner

219. Keyes, Homer Eaton. "Editor's Attic." Antiques 2
(October 1922): 164. illus.

Short note about this Geneseo, N. Y., furniture maker.

Gardner and Co.

220. Ames, Kenneth. "Gardner and Company of New York."
Antiques 100 (August 1971): 252-55. illus.

Gives a history of this furniture manufacturer.
Illustrates pages from a trade catalog.

W. M. Gaylord

221. "Queries and Opinions." Antiques 18 (July 1930):
66-67. illus.

Information is provided about this important 19th
century looking-glass maker from Utica, N. Y.

David S. George

222. George, David S. "Artistic Rustic Furniture." Country
Life 16 (May 1909): 69. Illus.

Describes George-designed furniture made from tree
branches. Gives instruction on how to construct
such furniture.

James Gheen

223. Weekley, Carolyn. "James Gheen, Piedmont North
Carolina Cabinetmaker." Antiques 103 (May 1973): 940-944.
illus.

Discusses the life and work of this maker. Of the 14
case pieces attributed to Gheen, 4 are illustrated.
This craftsman worked in Rowen Co. during the last
half of the 18th century.

Charles Gillam

224. Warren, William L. "Were the Guilford Painted Chests
Made in Saybrook?" Connecticut Historical Society Bulletin
23 (January 1958): 1-10. illus.

Examines the decoration on the so-called Guildford chests.
Attributes these chests to Gillam.

James Gillingham

225. Bondome. "Shop Talk." Antiques 17 (May 1930): 450.
illus.

Illustrates a Gillingham chair.

226. Gillingham, Harrold E. "James Gillingham, Philadelphia
Cabinetmaker." Antiques 29 (May 1936): 200-10. illus.

Discusses the life and work of this craftsman.
Illustrates an important bill of sale.

John Gillingham

227. Gillingham, Harrold E. "New Delvings in Old Fields,
John Gillingham, Uncle of James." Antiques 19 (June 1931):
472-78. illus.

A good biography on John is presented. A 1794 inventory
is discussed.

Peter Glass

228. Ahlborn, Richard. "Peter Glass, A Maker of American
Marquetry." Antiques 104 (December 1973): 1096-110.
illus.

Glass, a German immigrant who worked in Massachusetts,
did interesting marquetry work. He was active during
the last half of the 19th century.

Albert G. Glidden

229. Glidden, Albert G. Hand-made Furniture and How To Make it. Spokane, Washington: Privately Printed, 1910. 62 pp. illus.
 A how-to book on furniture designed by Glidden.

Goddard-Townsend

230. Bulkeley, Houghton. "John Townsend and Connecticut." Connecticut Historical Society Bulletin 25 (July 1960): 80-83. illus.

 Suggests that this craftsman produced furniture while living in Connecticut.

231. Bowen, Donald F. "A Clock Case by John Goddard." The Antiquarian 15 (August 1930): 37,74.

232. "Card Table by John Goddard." Minneapolis Institute Bulletin 27 (November 1938): 145-47. illus

233. Casey, Elizabeth T. "Early Newport Furniture." Rhode Island School of Design Bulletin 24 (April 1936): 25-29 illus.

 Reviews the stylistic characteristics of the Goddard-Townsend School of cabinetmaking.

234. ___ . "A Goddard Knee-hole Desk." Rhode Island School of Design Bulletin 22 (October 1934): 28-61. illus.

 Examines a dressing table attributed to Goddard.

235. ___ . "Tall Case Clock with Works by Caleb Wheaton, Case Attributed to J. Goddard." Rhode Island School of Design Bulletin 24 (January 1936): 3-6. illus.

 The attribution is questionable.

236. Comstock, Helen. "Newly Discovered Tea Table by John Goddard." Connoisseur 99 (April 1937): 210-22. illus.

 A short discussion of a very important tea table.

237. Cornelius, Charles O. "Goddard, Savery and Phyfe." The Arts 4 (July 1923): 33-44. illus.

 A very general sketch about the three well-known cabinetmakers.

238. ___. "John Townsend, An 18th Century Cabinetmaker."
In Metropolitan Museum Studies, vol.1, pt.1. 72-80. New York:
Metropolitan Museum of Art, 1928. bibl.

Presents a good biography.

239. Downs, Joseph. "The Furniture of Goddard and Townsend."
Antiques 52 (December 1947): 427-31. illus.

Gives an indispensable history of the scholarship
in relation to these cabinetmakers. Also discusses
stylistic developments in the careers of the Goddard-
Townsend families.

240. Dyer, Walter A. "John Goddard and His Block Fronts."
Antiques 1 (May 1922): 203-208. illus.

The first serious study on this cabinetmaker. Special
mention is made of the block front design characteristics.

241. Gaines, Edith, ed. "Collector's Notes."
(July 1961): 58. illus.

A correction of information in Mabel Swan's article.

242. Garrett, Wendell D. "The Family of Goddard and Townsend
Joiners: More Random Biographical Notes." Walpole Society
Notebook (1972): 33-42.

Supplements the information that was published in
the September, 1968, Antiques.

243. ___. "The Goddard and Townsend Joiners: Random
Biographical Notes." Antiques 94 (September 1968): 391-93.
illus.

An excellent attempt to clarify the genealogy of the
Goddard-Townsend families.

244. Heckscher, Morrison H. "John Townsend's Block and Shell
Furniture." Antiques 121 (May 1982): 1144-1155. illus.

Attributes the block front style to John Townsend rather
than to John Goddard.

245. Isham, Norman Morrison. "A Goddard Tea Table."
The Antiquarian 14 (January 1930): 51. illus.

A documented John Goddard table is examined. Some
biographical information is given.

246. ___. "John Goddard and His Work." Rhode Island School
of Design Bulletin. 15 (April 1927): 14-24. illus.

A comprehensive article on this cabinetmaker. Gives a
good biography and illustrates seven case pieces.

247. Keyes, Homer Eaton. "Editor's Attic." Antiques 24 (July 1933): 3-4. illus.

Illustrates a documented John Goddard table.

248. ___. "Editor's Attic." Antiques 15 (April 1929): 247-77. illus.

Discusses a secretary made by John Goddard.

249. ___. "Two Branches of the Newport Townsends." Antiques 31 (June 1937): 308-10. illus.

Discusses John and Christopher Townsend, as well as John Goddard and Job Townsend.

250. Ott, Joseph K. "John Townsend, a Chair and Two Tables." Antiques 94 (September 1968): 388-90. illus.

Examines three pieces made by John Townsend.

251. Mooz, R. Peter. "The Origins of Newport Block-front Furniture Design." Antiques 99 (June 1971): 882-886. illus.

Reviews the possible sources for the block-front design.

252. Moses, Liza, and Michael Moses. "Authenticating John Townsend's and John Goddard's Queen Anne and Chippendale Tables." Antiques 121 (May 1982): 1180-1143. illus.

Profusely illustrated study with construction details.

253. ___. "Authenticating John Townsend's Later Tables." Antiques 119 (May 1981): 1152-1163. illus.

A good study on making proper attributions.

254. Norton, Malcolm. "More Light on the Block-Front." Antiques 3 (February 1923): 63-66. illus.

Information on the Goddard-Townsend block front.

255. ___. "Three Block-Front Secretaries." Antiques 9 (March 1927): 192-94. illus.

Brief mention of Goddard-Townsends.

256. Nutting, Wallace. "A Sidelight on John Goddard." Antiques 30 (September 1936): 120-21. illus.

Illustrates and discusses a desk made by John Goddard.

257. Ralston, R. "Card-Table Made by Stephen and Thomas Goddard." Metropolitan Museum of Art Bulletin 24 (August 1929): 199-201. illus.

258. Rhode Island School of Design. <u>Rhode Island Tercentenary</u>
<u>Celebration: A Catalog of an Exhibition of Paintings by</u>
<u>Gilbert Stuart, Furniture by the Goddard and Townsends, Silver</u>
<u>by Rhode Island Silversmiths.</u> Providence: Rhode Island School
of Design. 1936. 48 pp. illus.

259. Schoeder, Francis de N. "Makers of Tradition: John
Goddard." <u>Interiors</u> 109 (April 1950): 100-103. illus.

 Short history of Goddard furniture. Very general
 article.

260. Stone, Stanley. "Documented Newport Furniture: A John
Goddard Desk and a John Townsend Document Cabinet in the
Collection of Mr. and Mrs. Stanley Stone." <u>Antiques</u> 103
(February 1973): 319-21. illus.

 Discusses two documented pieces.

261. Stow, Charles Messer. "John Goddard." <u>The Antiquarian</u> 7
(February 1927): 19-21. illus.

 Short review of John Goddard's life and work.

262. Swan, Mabel M. "The Goddard and Townsend Joiners." Parts
1,2. <u>Antiques</u> 49 (April, May 1946): 228-31, 292-95. illus.

 Part one contains information on John Goddard and Job and
 Christopher Townsend. It also includes pages from
 18th century account books. Part two concentrates
 on John Townsend. Excellent.

263. ___ . "John Goddard's Sons." <u>Antiques</u> 57 (June 1950):
448-49. illus.

 Examines the Federal-Style work of the three sons of
 John Goddard.

264. Winchester, Alice. "Documented Goddard." <u>Antiques</u> 24
(July 1933): 2-4. illus.

 A stone-top table made by John Goddard is examined.

265. ___ . "Editor's Attic." <u>Antiques</u> 60 (October 1951):
310. illus.

 A short note on a John Townsend card table.

<u>Ansel Goodrich</u>

266. Howe, Florence Thompson. "Brief Career of Ansel
Goodrich." <u>Antiques</u> 18 (July 1930): 38-39. illus.

 Information on this Massachusetts cabinetmaker.

James and David Gordon

267. Baxley, Bennett. "Early Artisans: The Gordons of Black Mingo." South Carolina Historical Magazine 81 (April 1980): 122-130.

 Biographical information is given on both cabinetmakers. Documented furniture is illustrated.

Jonathan Gostelowe

268. Brazer, Clarence Wilson. "Jonathan Gostelowe, Philadelphia Chair and Cabinetmaker." Parts 1,2. Antiques 9,10 (June, August 1926): 385-92, 125-32. illus.

 Pioneering series of articles on this maker. Includes biographical information, documented examples, and an exploration of Gostelowe's style.

269. Busselle, Alfred. An American Furniture Maker; Radio Talk No. 86. New York: Metropolitan Museum of Art, n.d.

270. Clark, Raymond B., Jr. "Jonathan Gostelowe." Master's Thesis, University of Delaware (Winterthur), 1955. 164 pp.

271. Keyes, Homer Eaton. "Editor's Attic." Antiques 18 (July 1930): 18-19. illus.

 Illustrates a labelled chair made by this craftsman.

272. Ormsbee, Thomas H. "Three Pieces Show Gostelowe's Individuality." American Collector 1 (June 1934): 3-5. illus.

John Gould, Jr.

273. Howe, Florence T. "John Gould, Jr., Cabinetmaker and Cabinet Master." The Antiquarian 14 (May 1930): 65. illus.

 Information is given on this maker who worked in New Hampshire and was an apprentice to Jonas Chickering.

John Henry Gould

274. Talbott, Page. "John Henry Gould; A New Breed of Furniture Dealer." Antiques 120 (December 1981): 1418-21. illus.

 Rare view of a furniture dealer who was active in the 1860s.

Samuel Gragg

275. Kane, Patricia E. "Samuel Gragg: His Bentwood Fancy
Chairs." Yale University Art Gallery Bulletin 33 (Autumn
1971): 27-37. illus.

 Most comprehensive article on this maker. Mentions his
 patent and explores possible sources for his designs.

Grand Rapids Chair Co.

276. Grand Rapids Chair Co. Reflections Commemorating 50
Years of Progress in Making of Furniture. Grand Rapids
Chair Co., 1922. 43 pp. illus.

 History of this firm 1872-1922. A promotional pamphlet.

Beriah Green

277. Mahler, Mary, and Frederick Mahler. "Beriah Green:
Chair and Cabinetmaker." Spinning Wheel 34 (March 1978):
32-34. illus.

Greene and Greene

278. Makinson, Randell L. Greene and Greene: The Architecture
and Related Designs of Charles Sumner Greene and Henry Mather
Greene, 1894-1934. Los Angeles: Municipal Art Gallery, 1977
39 pp. illus.

279. ___ . Greene and Greene: Furniture and Related Designs.
Santa Barbara, Calif.: Peregrine Smith, 1979. 162 pp. illus.
bibl.

 The Greene Brothers were architects in the Arts and
 Crafts tradition. They also designed furniture for
 their buildings. This book discusses their work and
 examines the influences on their work.

Peter Grinnell and Son

280. Ring, Betty. "Peter Grinnell and Son: Merchant-Craftsman
of Providence, Rhode Island." Antiques 117 (January 1980):
illus.

 Life and career of Peter and William Grinnell.

Ernest Hagen

281. Ingerman, Elizabeth. "Personal Experiences of an Old
New York Cabinetmaker." Antiques 84 (November 1963): 676.
illus.

 Discusses an autobiographical manuscript written by
 Hagen in 1908. Mentions Alexander Roux, Duncan Phyfe,
 and John H. Belter.

282. Ralston, Ruth. "Ernest Hagen's Order Books." Antiques
48 (December 1945): 356-7. illus.

 Hagen made reproductions of earlier styles. He was active
 during the 1880s.

283. ___. "New York Cabinetmaker's Reminiscences." Antiques
44 (December 1943): 284-5. illus.

 More on Hagen's personal recollections of 1908.

Adam Hains

284. Catalano, Kathleen, and Richard Nylander. "New Attribu-
tions to Adam Hains, Philadelphia Furniture Maker." Antiques
118 (May 1980): 1112-16. illus. footnotes.

 Attributes some Federal style furniture to Hains.

285. Williams, Carl M. "Adam Hains of Philadelphia, Master
Cabinetmaker of the Marlborough School." Antiques 51
(May 1947): 316-17. illus.

 The term 'Marlborough' is not appropriate because it
 refers to a style rather than to a cabinetmaking
 school. The article does contain a good biography and
 illustrates some documented pieces.

John Hall

286. Smith, Robert C. "John Hall, a Busy Man in Baltimore."
Antiques 92 (September 1967): 360-66. illus.

 Discusses the life and work of this craftsman. Of
 special interest is the examination of his books,
 including The Cabinetmaker's Assistant, of 1840, and
 his book on architecture.

William Hancock

287. Winchester, Alice. "Editor's Attic." _Antiques_ 35 (April 1939): 171. illus.

Short note on this Boston maker.

Feay Katherine Hanson

288. "Original and Beautiful American Furniture Designed and Executed by Feay Katherine Hanson." _The Touchstone_ 2 (October 1917): 1002.

John Harrison

289. Smith, Robert C., and E. Wolf. "Press for Penn's Pump." _Art Quarterly_ 24 (Autumn 1961): 226-48. illus.

Illustrates a case made for a pump owned by William Penn. The case was made by John Harrison in 1731.

Ebenezer Hartshorne

290. Randall, Richard H., Jr. "Ebenezer Hartshorne, Cabinet-maker." _Antiques_ 86 (January 1965): 78-79. illus.

Hartshorne was a maker of Queen Anne furniture with walnut veneers and inlaid stars. Documented pieces are shown.

John Hawks

291. Hawks, Susan. "A Deerfield Chest Dated 1699." _American Collector_ 8 (September 1941): 8-9. illus.

The author attributes this chest to John Hawks.

William Hayden and William Stewart

292. Stuemphig, Anthony. "William Hayden and William H. Stewart; Fancy Chairmakers in Philadelphia." _Antiques_ 104 (September 1973): 452-517. illus.

Uses family records of Reuben Hains to discuss these men.

George Henkels

293. Ames, Kenneth L. "Designed in France: Notes on the Transmission of French Style to America." Winterthur Portfolio 12 (1977): 103-14. illus.

 Mostly on the Philadelphia firm of George Henkels. Uses this firm as an example of how French styles migrated to America.

294. ___. "George Henkels, 19th Century Philadelphia Cabinetmaker." Antiques 104 (October 1973): 641-50. illus

 Henkels' biography is given. Pages from Henkels' catalog are illustrated.

295. Ellesin, Dorothy. "Collector's Notes." Antiques 105 (May 1974): 1068-71. illus.

 Discusses George Henkels, Henry Bruner, Allen and Bro., and A. Vandoorn.

296. ___. "Collector's Notes." Antiques 110 (August 1976): 276. illus.

 Explains the "1776" Style, as illustrated in a washstand made by George Henkels. This stand may have been exhibited at the Centennial Exhibition.

Henry Herrmann

297. Landis, Mary Ann. "Henry Herrmann, An American Manufacturer in London Furniture Trade." Antiques 119 (May 1981): 1174-77. illus.

 Herrmann was active during the second half of the 19th century. He exported American furniture to England. This article reexamines the foreign market.

Christian Herter

298. Bordes, M. J. "Christian Herter and the Cult of Japan." Princeton Museum Record 34 (1975): 20-27. illus

 Discusses the influence of Japanese culture on the furniture of Herter. Illustrates two interiors.

299. Hanks, David. "Christian Herter and the Aesthetic Movement in America." Arts Magazine 54 (May 1980): 138-39. illus.

Illustrates furniture made by Herter.

John Hewitt

300. Johnson, Marilynn A. " John Hewitt, Cabinetmaker." Winterthur Portfolio 4 (1969): 184-205. illus.

A comprehensive study of the life and career of this furniture maker and exporter. Based on a Hewitt account book dating 1809-1812.

Heywood-Wakefield

301. Heywood-Wakefield Co. A Completed Century: 1826-1926. The Story of the Heywood-Wakefield Co. Boston: Merrymount Press, 1926. 110 pp. illus.

A history about this important manufacturer.

Lambert Hitchcock

302. Berenson, Ruth. "Hitchcock Chairs." Arts and Antiques 4 (July/August 1981): 98-105. illus.

General survey of Hitchcock chairs.

303. Bjerkoe, Ethel H. "Hitchcock Chair." Hobbies 58 (December 1953): 56-57, 73. illus.

General article about this maker. Mentions other makers who worked in similar styles.

304. Fraser, Esther S. "Painted Furniture in America: II Period of Stencilling." Antiques 6 (September 1924): 141-46. illus.

A discussion of the nature of the decorations used by Hitchcock. The focus is on Hitchcock, but there is mention of other makers, such as John Tollman and Willard and Son.

305. ___ . "Random Notes on Hitchcock and His Competitors." Antiques 30 (August 1936): 63-67. illus.

A biography of Hitchcock is presented. His shop and competitors are discussed. Z. Willard Brooks is mentioned.

306. Freeman, Larry. "Hitchcock Chair." <u>Hobbies</u> 49
(February 1945): 72. illus.

A very general article.

307. Hall. P. "Stenciled Chairs: Hitchcock Chairs."
<u>American Home</u> 36 (July 1946): illus.

An article intended for interior decorators.
Not recommended.

308. Huntly, Richmond. "An Antiques Primer: The Hitchcock
Chair." <u>American Collector</u> 9 (February 1940): 12. illus.

309. Kenney, John T. <u>The Hitchcock Chair: The Story of a
Connecticut Yankee--L. Hitchcock of Hitchcocksville.</u>"
New York: C.N. Potter, 1971. x, 339 pp. illus. bibl.

The author now runs the modern Hitchcock Chair factory.
This book examines the history and production of the
19th century factory. The most comprehensive
and useful publication on this chair maker.

310. "Lambert Hitchcock of Hitchcocksville, Connecticut:
America's Most Famous Chair Maker and the Story of His Origi-
nal Manufacture." <u>Connecticut Antiquarian</u> 18 (July 1966):
9-16. illus.

311. Moore, Mabel Roberts. <u>Hitchcock Chairs.</u> 1933. Reprint.
Southampton, N. Y.: Cracker Barrel Press, n. d., 14 pp. illus.

Reprint of a publication of the Connecticut Tercentenary
Commission.

312. Priest, Elizabeth. "The Hitchcock Chair." <u>Old-time
New England</u> 42 (July/September 1951): 14-17. illus.

313. Sherrill, Sarah B. "Current and Coming." <u>Antiques</u> 102
(November 1972): 726.

About the Hitchcock Museum.

314. Thompson, Mrs. Guion. "Hitchcock of Hitchcocksville."
<u>Antiques</u> 4 (August 1923): 74-77. illus.

Uses contemporary documents in a discussion of the
work of this factory. Discusses the business climate
of the Hitchcock firm.

315. Walker, J. "Fancy Chair: Hitchcock Chair." <u>American
Home</u> 45 (April 1951): 44-54. illus.

Intended for the general public.

316. Winchester, Alice. "Editor's Attic." _Antiques_ 36 (September 1939): 115-17. illus.

Mentions a curled maple chair labelled by Hitchcock.

317. ___ . "Hornbook for Collectors: The ABC's of Hitchcock Chairs." _Antiques_ 42 (June 1942): 369-70. illus.

Collector orientated.

Holmes and Roberts

318. Keyes, Homer Eaton. "Editor's Attic." _Antiques_ 6 (November 1924): 244. illus.

A few paragraphs on this chair maker.

319. Nickerson, C.H. "Robertsville and Its Chair Makers." _Antiques_ 8 (September 1925): 146-49. illus.

Information on Holmes and Roberts, Samuel Roberts, and Union Chair Co.

Andrew Homer

320. Bondome. "Shop Talk." _Antiques_ 17 (May 1930): 448. illus.

Illustrates a signed piece of furniture made by Andrew Homer of Boston.

William Hook

321. Kimball, Fiske. "Salem Furniture Makers: III William Hook." _Antiques_ 25 (April 1934): 144-46. illus.

Documented examples of Hook's work are shown and discussed. Biographical information is given.

Thomas Hope

322. Keyes, Homer Eaton. "Editor's Attic." _Antiques_ 11 (January 1927): 26-27. illus.

A short biography is presented. Documented pieces are shown.

Gerrard Hopkins

323. "Gerrard Hopkins." American Collector 18 (June 1944).

324. Berkeley, Henry J. "New Delvings in Old Fields."
Antiques 26 (September 1934): 110-11. illus.

 Short article on this 18th century Baltimore cabinet-
 maker.

Joseph Hosmer

325. Cooper, Nancy. "Chats on Antiques." House Beautiful
66 (December 1929): 728-29+. illus.

 Information is given on Joseph, John, and Rufus Hosmer.
 Contains genealogical information on these makers.

326. Fales, Dean A., Jr. "Hosmer Family Furniture."
Antiques 85 (May 1964): 548-59. illus.

 Questions many traditional attributions to Hosmer.

327. Hosmer, George L. Hosmer Genealogy." Cambridge,
Mass.: Technical Composition Co., 1928. 271 pp. illus.

 The most complete genealogy on the Hosmer family.

328. Karnaghan, Anne W. "The House of a Revolutionary
Hero." House Beautiful 63 (April 1928): 444-46. illus.

 Discusses Hosmer's house in Concord.

329. Scott, Kenneth, and Russell H. Kettell. "Joseph
Hosmer, Cabinetmaker." Antiques 73 (April 1958): 356-59.
illus.

 The life and work of this maker. Includes stylistic
 analysis.

Hotchkiss Chair Mfg.

330. Fraser, Esther Stevens. "The Elimination of Hotchkiss:
A Study in Negative Evidence." Antiques 14 (October 1929):
303-6. illus.

 A very interesting article that attempts to disprove the
 operation of the Hotchkiss Chair Mfg.

Thomas Howard, Jr.

331. Monahon, Eleanore Bradford. "Thomas Howard, Jr.,
Providence Cabinetmaker." Antiques 87 (June 1965): 702-4.
illus.

 Biography is given on this maker. Documented examples
are shown.

Elbert Hubbard

332. Balch, David Arnold. Elbert Hubbard, Genius of Roycroft.
New York: Frederick A. Stokes, 1940. 320 pp. illus.

 Authoritative biography of Hubbard.

333. Champney, Freeman. Art and Glory: The Story of Elbert
Hubbard. New York: Crown publishers, 1968. 248 pp. illus.

 Another biography of Hubbard.

334. Denison, Lindsey. "Elbert Hubbard's Shop. An American
William Morris at Work in East Aurora." New York Sun,
29 October 1899.

335. Hamilton, Charles Franklin. As Bees in Honey Drown:
Elbert Hubbard and the Roycrofters. South Brunswick, N.J.:
A.S. Barnes, 1973. 253 pp. illus. bibl.

 A general book on Hubbard.

336. Hubbard, Elbert. The Notebook of Elbert Hubbard.
East Aurora, N.Y.: The Roycrofters, 1927. vi. 218 pp. illus.

 Hubbard's mottoes, sayings and platitudes.

337. ___. The Philosophy of Elbert Hubbard. East Aurora,
N.Y.: Roycrofters, 1916.

 This book was reprinted in 1930, 1927, 1939, 1941,
and 1917.

338. ___. The Roycroft Shop: Being a History. East Aurora,
N.Y.: The Roycrofters, 1908. 31 pp. illus.

 A contemporary account of this important shop.

339. Koch, Robert. "Elbert Hubbard's Roycrofters as Artist-
Craftsmen." Winterthur Portfolio 3 (1967): 67-82. illus.

 Discusses Hubbard's role in the Roycrofter's production.

340. Lane, Albert. Elbert Hubbard and His Work: A Biography,
A Sketch and A Bibliography. Worcester, Mass.: Albert Lane,
1901. 154 pp. illus.

A contemporary biography and an important bibliography.

341. Shay, Felix. Elbert Hubbard of East Aurora, N. Y.
New York: Wise and Co., 1926. 553 pp. illus.

A biography on this important Arts and Crafts figure.

342. Vidler, Virginia. "Hubbard's Roycroft." Antiques
Journal 24 (July 1969) 10-12. illus.

Discusses all aspects of Roycrofter industries. Shows
a desk that sold for $100.

Henry Hubon

343. Ormsbee, Thomas. "Henry Hubon, Last of the Salem
Cabinetmakers." American Collector 14 (February 1945): 4.
illus.

Information is provided on this 19th century cabinet-
maker. A documented desk is illustrated. There is also
a note about him in the August, 1939, American Collector.

J. Huey

344. "First-Born from Beyond the Alleghenies." Antiques 20
(December 1931): 336-37. illus.

Information is given on this Washington Co., Pa.,
maker. Very incomplete biographical data.

George Hunzinger

345. Flint, Richard W. "George Hunzinger, Patent Furniture
Maker." Arts and Antiques 3 (January/February 1980): 116-
23. illus.

This German-born cabinetmaker was active in New York
City during the 19th century. He was known for his
patent furniture.

E. W. Hutchings

346. Gaines, Edith. "Collector's Notes." Antiques 101
(May 1971): 880-81. illus.

A note on this new York cabinetmaker with some information
on the looking-glass maker, John Sweeney.

Benjamin Ilsley

347. Fales, Martha Gandy. "Benjamin Ilsley, Cabinetmaker in
Federal Portland." Antiques 105 (May 1974): 1066-67. illus.

A short article about this Maine craftsman.

Elias Ingraham

348. Bulkeley, Houghton. "Elias Ingraham, Cabinetmaker and
Clock Designer." Connecticut Historical Society Bulletin 31
(April 1966): 40-49. illus.

This maker is known mainly for his clocks. This article
includes a discussion of his work as a cabinetmaker and
illustrates a table made by him.

Johann Michael Jahn

349. Bassett, Preston R., and Pauline A. Pinckney. "Collec-
tor's Notes." Antiques 75 (May 1959): 460-63. illus.

Mentions this Texas cabinetmaker and A. Fairchild.

Edward James

350. Hornor, William M., Jr. "Edward James and Philadelphia
Chippendale." International Studio 92 (February 1929):
33-36, 94, 96. illus.

A clock made by James is discussed. Information about
his life and career is presented. The craftsman
lived in Philadelphia during the 18th century.

John Janvier

351. de Valinger, Leon, Jr. "John Janvier, Delaware Cabinetmaker." Antiques 41 (January 1942): 37-39. illus.

Includes illustations of drawings from Janvier's account book.

352. Norcine, Marilyn J. "John Janvier, Sr., Delaware Cabinetmaker." Antiques 123 (May 1983): 1062-68. illus.

A good scholarly review of this maker's career. Includes pages from the account book of Thomas Janvier.

353. Sharp, Lynne Corwin. "The Janvier Family of Cabinet-makers." Master's thesis, University of Delaware (Winterthur), 1980. 235 pp.

John Jelliff

354. Johnson, J. Stewart. "John Jelliff, Cabinetmaker." Antiques 102 (August 1972): 256-61. illus.

Examines the life and work of this craftsman. Illustrates examples of his shop drawings.

Henry W. Jenkins

355. Hill, John H. "Furniture Designs of Henry W. Jenkins and Sons, Co." Winterthur Portfolio 5 (1968): 154-87. illus.

A comprehensive discussion of this furniture factory and funeral home. The business is still operating as a funeral home. Tne article focusses on the furniture aspects of this business from 1799 to 1904. Shows some of the 2500 drawings extant from this firm's 19th century production.

356. Entry deleted.

Edmund Johnson

357. Kindig, Joe III. "The Perspective Glass." Antiques
65 (June 1954): 567-68. illus.

Mentions this craftsman in a brief note.

Johnson Family

358. Wright, R. Lewis. "The Johnsons: Chair Making in
Mecklenburg County, Virginia." Journal of Early Southern
Decorative Arts 6 (November 1980): 33-47. illus.

Examines a kind of slat-backed chair called the 'Johnson
chair.'

Johnston and Rea

359. Swan, Mabel M. "The Johnstons and the Reas: Japanners."
Antiques 43 (May 1943): 211-13. illus.

Uses an 18th century account book to discuss the
activities of these craftsmen.

George H. Jones

360. "George H. Jones as Craftsman." Craftsman 4 (July
1903): 295-97.

Short description of Jones and his work. No biographical
data is given.

Norman Jones

361. Jones, N.C. "Norman Jones, Vermont Cabinetmaker."
Antiques 111 (May 1977): 1028.

This cabinetmaker made Federal and Empire furniture
during the 19th century. Documented examples are
shown and biographical information is provided. A copy
of Jones' price book is illustrated.

Josiah

362. Leach, Mary James. "Josiah and Other Kentucky Cabinet-makers." Antiques 65 (February 1954): 138-39. illus.

 Josiah was a Kentucky cabinetmaker whose last name is not known. He was active 1776-1825. A very useful article.

363. Morgan, Keith W. "Josiah Reconsidered: A Green County School of Inlaid Cabinetmaking." Antiques 105 (April 1974): 883-93. illus.

 Attempts to disprove the attributions to Josiah. Suggests that a distinctive school of furniture making was operating in Green County.

William Kerwood

364. Woodhouse, Samuel W., Jr. "New Delvings in Old Fields." Antiques 22 (August 1932): 75-76. illus.

 A short note on this Trenton, N.J., cabinetmaker.

William Key

365. Keyes, Homer Eaton. "Editor's Attic." Antiques 12 (September 1927): 201-3. illus.

 Information is given on a clock made by this Salem craftsman.

Abraham Kimball

366. Catalano, Kathleen M. "Abraham Kimball (1798-1890), Cabinetmaker." American Art Journal 11 (April 1979): 62-70. illus.

 The life and work of this maker. This craftsman made furniture in a number of revival styles and was active until 1845. Kimball worked with another cabinetmaker named Winthrop Sargent.

Kimbel and Cabus

367. Hanks, David H. "Kimbel and Cabus: 19th Century Cabinet-
Makers." Art and Antiques 3 (September/October 1980): 44-53.
illus.

 Anthony Kimbel and Joseph Cabus of New York City ran a
furniture making business in the 19th century. They
produced Eastlake style furniture.

William King

368. Golovin, Anne Castrodale. "William King, Jr., George-
town Furniture Maker." Antiques 111 (May 1977): 1032-37.
illus.

 Biography is given and documented examples are shown.

Charles B. Knapp

369. Tice, Patricia M. "The Knapp Dovetailing Machine."
Antiques 123 (May 1983): 1070-72. illus.

 Presents information on the Knapp Patent Dovetail
Machine.

Kneeland and Adams

370. Wolcott, William Stuart. "A Kneeland and Adams Mirror."
Antiques 13 (January 1928): 31-32. illus.

 Samuel Kneeland and Lemuel Adams made looking-glasses.
They were partners prior to 1793.

Caleb Knowlton

371. Davidson, Ruth. "Current and Comming." Antiques 88
(August 1965): 146.

 Discusses an exhibition at the Essex Institute, in
which examples of furniture made by Knowlton are
shown. This maker was active from the 1780's to 1814.

Ebenezer Knowlton

372. Ormsbee, Thomas H. "A New Boston Worker Identified."
American Collector 1 (December 1933): 1,10. illus.

 A short article on the life and work of this Boston
 and Ipswich, Massachusetts craftsman.

Johannes Krause

373. Horton, Frank L. "Johannes Krause: Master Joiner of
Salem." Antiques 88 (July 1965): 92-93. illus.

 This maker was born in Germany in 1742 and died in
 Salem in 1807. A brief biography is given and an
 example of his work is illustrated.

Samuel Lane

374. Fraser, Esther Stevens. "Pioneer Furniture from Hampton,
New Hampshire." Antiques 17 (April 1930): 312-16. illus.

 Examines the 18th century furniture of this craftsman.
 Some biographical data is given.

375. Entry deleted.

Charles-Honore Lannuier

376. Gaines, Edith. "Lannuier Pieces in Hiding." Antiques
76 (August 1959): 145. illus.

 Inquires as to the possible location of furniture
 made by Lannuier.

377. Graigmyle, Mary Martin. "Chairs by Lannuier at New
York's City Hall." Antiques 97 (February 1970): 258-59.
illus.

 Discusses 24 chairs made by Lannuier. Documented chairs
 by this maker are rare.

378. Jones, Edward V. "Charles-Honore Lannuier and Duncan Phyfe, Two Creative Geniuses of Federal New York." American Art Journal 9 (May 1977): 4-14. illus.

Discusses the differences and similarities between Phyfe and Lannuier. Illustrated with several fine photographs.

379. Ormsbee, Thomas H. "The Furniture of Lannuier and His Successor." Antiques 23 (June 1933): 224-26. illus.

Information on Lannuier and John Gruez.

380. ___. "A Franco-American Cabinetmaker: Charles-Honore Lannuier." Antiques 13 (May 1933): 166-67. illus.

First major discussion on this important craftsman.

381. Pearce, Lorraine Waxman. "American Empire Furniture in the White House." Antiques 81 (May 1962): 515-519. illus.

Mentions furniture made by this maker.

382. ___. "The Distinctive Characteristics of the Work of Lannuier." Antiques 86 (December 1964): 712-17. illus.

Information on Lannuier and his style.

383. ___. "French Influence on American Decorative Arts of the Early 19th Century: The Work of Charles-Honore Lannuier." Master's Thesis, University of Delaware (Winterthur), 1958. 241.pp.

384. ___. "The Lannuier Brothers, Cabinetmakers." Antiques 72 (August 1957): 441-43. illus.

Discusses the French influence on Lannuier's work. Also mentions Lannuier's brother, who lived in France.

385. ___. "Lannuier in the President's House." Antiques 81 (January 1962): 94-96. illus.

A short biography and a discussion of Lannuier's furniture at the White House.

386. ___. "The Work of Charles-Honore Lannuier, French Cabinetmaker in New York." Maryland Historical Society Magazine 55 (1960): 14-29. illus. footnotes.

Excellent scholarly discussion on this maker. This craftsman's style is explained.

387. Tracy, Berry B. "For 'one of the most genteel residences in the city.'" Bulletin of the Metropolitan Museum of Art 25 (April 1967): 283-91. illus.

Information on Philip Hones' house and a Lannuier table.

388. Vincent, Gilbert. "Singing Swans and Gilt Gods."
Portfolio 3 (July/August 1981): 56-58. illus.

Discusses the work of Lannuier.

Henry Lapp

389. Lapp, Henry. A Craftsman's Handbook. Philadelphia:
Philadelphia Museum of Art, 1975. illus.

A reproduction of the drawing book of this craftsman.
Shows many pieces in styles long out of fashion.

Stillman Lathrop

390. Spinney, Frank O. "A Tale of Two Mirrors." New-England
Galaxy (Summer 1959): 20-22. illus.

A fictional account of the purchase of two mirrors.

Benjamin Henry Latrobe

391. Raley, R.L. "Interior Designs by Benjamin Henry
Latrobe for the President's House." Antiques 75 (June 1959):
568-79. illus.

Emphasis is given on the furniture designed by this
important American architect. The Greek revival
is especially noteworthy in Latrobe's designs.

Drew Lausch

392. Whitnack, Shirl. "Drew Lausch: Pennsylvania Chair
Maker." Spinning Wheel 34 (July/August 1978): 12-13. illus.

Gabriel Leaver

393. Ellesin, Dorothy E. "Collector's Notes." Antiques 110
(September 1976): 560-61. illus.

Information is provided on this 18th century Savannah
cabinetmaker.

Chapman Lee

394. Spinney, Frank O. "Chapman Lee, Country Cabinetmaker"
New-England Galaxy (Winter 1960): 34-38. illus.

 Information is provided on this Charlton, Mass., cabinet-
 maker. Excerpts from his account book, which is now
 located in the Charlton Village Library, are included.

Benjamin Lehman

395. Gillingham, Harrold E. "Benjamin Lehman, A Germantown
Cabinetmaker." Pennsylvania Magazine 54 (October 1930):
269-306. illus.

 Studies the life and work of this 18th century cabinet-
 maker.

396. ___. "New Delvings in Old Fields." Antiques 18
(September 1930): 246. illus.

 Mentions a 1786 manuscript price list.

Lejambre Family

397. Strickland, Peter L. "Furniture by the Lejambre Family
of Philadelphia." Antiques 108 (March 1978): 600-613. illus.

 Detailed information is provided on this mid-19th century
 family of furniture makers. These makers were noted for
 Rennaissance Revival furniture.

Levi Nelson Leland

398. Smith, Mrs. C. "Leland, Levi Nelson." Old-Time New
England 37 (October 1946): 263.

 A short note on this little-known furniture maker.

Thomas Lincoln

399. "Ignored Pieces Show Lincoln's Skill." American Collector
2 (Feburary 1934): 1,5. illus.

 Discusses the work of the father of Abraham Lincoln.

William Little

400. Horton, Frank L. "William Little, Cabinetmaker of North Carolina." _Journal of Early Southern Decorative Arts_ 4 (November 1978): 1-25. illus.

 A comprehensive examination of the life and work of this Sneedsborough, N.C., cabinetmaker.

401. Stanback, F. Q. "Southern Furniture: A North Carolina Cabinetmaker." _Antiques_ 67 (June 1955): 506-7. illus.

William Lloyd

402. Howe, Florence Thompson. "The Decline and Fall of William Lloyd." _Antiques_ 17 (Feburary 1930): 121. illus.

 Uses newspaper advertisements to examine the life and work of this craftsman.

403. Huntley, Richmond. "Lloyd Typifies Country Work." _American Collector_ (May 1935): 1,7,. illus.

 Reviews the work of this Springfield, Mass., furniture maker. Includes some biographical data.

H. B. Longacre

404. Longacre, H.B. "How I Made Some Good Furniture." _Ladies Home Journal_ 20 (November 1903): 29. illus.

 A how-to article by this furniture designer.

Fenwick Lyell

405. Frelinghusen, Elizabeth. "Collector's Notes." _Antiques_ 97 (January 1970): 119-299. illus.

 Information from the Monmouth Co. Historical Association. The article focuses on the life and work of Lyell, but does include information about Slover, Taylor, and Phyfe.

Isaac McClelland

406. William, Stephen R. "A Cabinetmaker and His Work."
Craftsman 20 (July 1911): 418-20. illus.

 McClelland was active in Butler Co., Ohio, during the
 19th century. This article reviews his life and work.

William McCracken

407. Jones, Karen M., ed. "Collector's Notes." Antiques
119 (May 1981): 1086-88.

 Information is provided on this New Orleans maker.

James McDowell

408. Hornor, William M. "James McDowell, A Delaware Cabinet-
maker." Antiquarian 15 (November 1936): 64-67. illus.

 The work of this Smyrna, Delaware, craftsman is discussed
 and illustrated.

Samuel McIntire

409. Allen, E. B. "Old Gateways of New York." International
Studio 78 (1923): 139-42. illus.

 Mentions McIntire.

410. Brown, Frank Chouteau. "Gardner-White-Pingree House
Built in Salem, Mass. in 1804 by Samuel McIntire, Architect."
Pencil Points 21 (1940): 515-30. illus.

411. Comstock, Helen. "McIntire in Antiques." Antiques 71
(April 1957): 338-41. illus.

 Reviews articles that have appeared in Antiques.

412. ___. "McIntire Serving Table." Connoisseur 96 (October
1935): 235. illus.

 Examines a table attributed to McIntire.

413. ___ . "Samuel McIntire: New Facts." Connoisseur 141 (April 1958): 132. illus.

Short review of information on McIntire. No new facts presented.

414. Cooper, Wang. "Furniture Carving of Samuel McIntire." House Beautiful 69 (February 1931): 194. illus.

Two paragraphs on McIntire.

415. Cousins, Frank, and P. M. Riley. The Woodcarver of Salem, Samuel McIntire. Boston: Little, Brown and Co., 1916. 168 pp. illus.

An early biography on this craftsman.

416. Downs, Joseph. "Derby and McIntire." Metropolitan Museum of Art Bulletin ns. 6 (October 1947): 73-80. illus.

Disputes some of the McIntire attributions at the Elias Derby House.

417. Frankfurter, Alfred M. "The Furniture of Samuel McIntire, Master Carver." The Antiquarian 15 (November 1930): 41-45, 96, 104. illus.

Examines the corpus of furniture attributed to McIntire.

418. Hawley, H. H. "McIntire Chair." Cleveland Museum Bulletin 50 (November 1963): 249-51. illus.

Examines a chair in the collection of the Cleveland Museum.

419. Hipkiss, Edwin J. "Notes on Samuel McIntire and Elias Hasket Derby's Furniture." Boston Museum Bulletin 32 (February 1934): 13-16. illus.

Questions the attributions of chairs to McIntire.

420. ___ . Three McIntire Rooms from Peabody, Mass. Boston: Museum of Fine Arts, 1931. 93 pp. illus.

Discusses three rooms at the Boston Museum of Fine Arts as well as other work by McIntire. Compares McIntire with other carvers of his time.

421. Keyes, Homer Eaton. "Milton, Beverly, and Salem." Antiques 22 (April 1933): 142-43. illus.

Examines the carvings by McIntire and Simeon Skillin.

422. Kimball, Fiske. "A Chest-on-Chest with Carvings by Samuel McIntire. " Old-Time New England 21 (October 1930): 87-89. illus.

423. ___. "The Estimate of McIntire." Antiques 21 (January 1932): 23-25. illus.

> Rebuttal to Mabel Swan's article in December 1931 Antiques. Interesting for the use of excellent scholarship.

424. ___. "Furniture Carvings by Samuel McIntire." Parts 1, 2, 3, 4, 5. Antiques 18,19 (November, December 1930 January, February, March 1931): 388-92, 498, 30-31, 117-19, 207-10. illus.

> Part 1 contains a general review of the craftsman's life, and includes contemporary documents. Part 2 discusses sofas; Part 3 examines chairs. Part 4 discusses non-furniture pieces, while Part 5 includes information on case pieces.

425. ___. Mr. S. McIntire, The Architect of Salem. Portland, Maine: Southworth-Anthoesen Press for the Essex Institute, 1940. xiii, 157 pp. illus.

> Some information on furniture is provided.

426. ___. "Samuel McIntire's Portrait of Washington." Art in America 12 (1923): 68. illus.

427. Labaree, Benjamin W., ed. Samuel McIntire: A Bicentennial Symposium, 1757-1957. Salem: Essex Institute, 1957. vii, 118 pp. illus. bibl.

> A collection of essays on the life and career of this important wood carver. References are made to McIntire's achievements in furniture and architecture. Authors include Fiske Kimball, Mabel Swan, and Dean Fales.

428. Powell, Lydia. "Influence of English Design Books on American Furniture VI." Apollo 70 (September 1959): 45-50. illus.

> Discusses the Federal style and the role played by McIntire.

429. Stow, Charles Messer. "Samuel McIntire of Salem." The Antiquarian 12 (February 1929): 36-38, 66, 68. illus.

> A general discussion of this craftsman.

430. Swan, Mabel M. "McIntire: Check and Countercheck." Antiques 21 (February 1932): 86-87. illus.

> Continuance of the McIntire controversy.

431. ___. "McIntire Vindicated: Fresh Evidence of the Carvers of Salem." Antiques 26 (October 1934): 130-32. illus.

> Provides proof that McIntire actually carved furniture in Salem.

432. ___. "A Revised Estimate of McIntire." Antiques 20 (December 1933): 338-43. illus.

Shows how Stephen Badlam carved some of the pieces usually attributed to McIntire. Excellent scholarship.

433. ___. Samuel McIntire, Carver, and the Sandersons, Early Salem Cabinet Makers. Salem, Mass.: Essex Institute, 1934. 44 pp. illus.

Makes new attributions based on scholarship. Uses contemporary documents such as correspondences and advertisements.

434. ___. "Where Elias Hasket Derby Bought his Furniture." Antiques 20 (November 1931): 280-82. illus.

Questions some McIntire furniture attributions.

Samuel Field McIntire

435. Kimball, Fiske. "Furniture Carved by Samuel Field McIntire." Antiques 23 (February 1933): 56-58. illus.

Examines the life and work of this craftsman, who was the son of Samuel McIntire. Also mentions Nathaniel Appleton.

Andrew and Robert McKim

436. Cromwell, Giles. "Andrew and Robert McKim: Windsor Chair Makers." Journal of Early Southern Decorative Arts 6 (May 1980): 1-20. illus.

Documented examples are illustrated that were made in the workshops of these leading Richmond, Va., craftsmen.

Arthur and Lucia Mathews

437. Allman, Paul R. "Arthur and Lucia Mathews: Unknown Aesthetes of a Boisterous Age." Art Gallery 15 (May 1972): 33-35,90-91. illus.

Review of an exhibition.

438. Oakland Museum. Mathews: Masterpieces of the California Decorative Style. Essay by Harvey Jones. Oakland, Ca.: Oakland Museum, 1972. 105 pp. illus. bibl.

An exhibition catalog on this important furniture and interior design shop.

Meeks Family

439. Douglas, Ed Polk. "Blessed are the Meeks." New York-Pennsylvania Collector 4 (August 1979): 1, 10-14. illus.

Examines the work of the Meeks.

440. Gaines, Edith, ed. "Collector's Notes." Antiques 90 (September 1966): 358-60. illus.

Discusses the founding members of the Meeks family.

441. ___. "Collector's Notes." Antiques 98 (July 1970): 127.

Discusses the Meeks in Indiana.

442. Otto, Celia Jackson. "Piller and Scroll: Greek Revival Furniture of the 1830's." Antiques 81 (May 1962): 504-7. illus.

Examines the Greek Revival Style, with emphasis on Meeks.

443. Pearce, John N., and Lorraine W. Pearce. "The Meeks Family of Cabinetmakers." Antiques 85 (April 1964): 414-20. illus.

Discusses three generations of the Meeks family. Labelled examples are shown. An excellent genealogy is given.

444. ___. "More on the Meeks Cabinetmakers." Antiques 90 (July 1966): 69-73. illus.

New information is provided on these cabinetmakers.

Moses Mellen and Jacob and George Smith

445. Fales, Dean A. "Two Boston Cabinetmakers of the 1820's." Antiques 103 (May 1973): 1002-3. illus.

Short article on these two cabinetmakers.

George W. Miller

446. Ellesin, Dorothy E. "Collector's Notes." Antiques 104 (November 1973): 830. illus.

Paragraphs on this New York City cabinetmaker.

Mitchell and Rammelsberg

447. Pierce, Donald C. "Mitchell and Rammelsberg: Cincinnati Furniture Manufacturers 1847-1881." Winterthur Portfolio 13 (1979): 209-29. illus.

> Studies the development of the business of these two craftsmen.

448. ___. "Mitchell and Rammelsberg, Cincinnati Furniture Makers." Master's Thesis, University of Delaware (Winterthur), 1975. 192 pp. illus.

Jesse Needham

449. Bivins, John, Jr. "A Piedmont North Carolina Cabinet-maker: The Development of a Regional Style." Antiques 103 (May 1973): 968-73. illus.

> Examines a body of work attributed to this Randolph Co., cabinetmaker.

John Needles

450. Montgomery, Charles F. "John Needles: Baltimore Cabinet-maker." Antiques 65 (April 1954): 292-95 illus.

> Uses documented examples to illustrate the life and career of this maker. Three labels are shown.

451. Wright, Edward, ed. "John Needles (1786-1878): An Autobiography." Quaker History 58 (1969): 3-21.

> A rare example of an autogiobraphy of a craftsman.

Benanial Ogden

452. American Collector 7 (April 1939).

> A note about this maker who resided in West Chester, Pa.

Francis Omer

453. Ellesin, Dorothy, ed. "Collectors' Notes." Antiques 108 (September 1975): 532-33. illus.

> A short note about this French-born craftsman.

Abraham Overholt and Peter Ranck

454. Keyser, Alen G., ed. Account Books of Abraham Overholt
and Peter Ranck. Sources and Documents of the Pennsylvania
Germans. Breinigsville, Pa.: Pennsylvania German Society,
1978. 238 pp.

 Translated from the German.

Daniel Pabst

455. Hanks, David. "Daniel Pabst, Philadelphia Cabinetmaker."
Art and Antiques 3 (January/February 1980): 94-101. illus.

 Information from the Philadelphia Museum Bulletin.

456. ___. "Reform in Philadelphia: Frank Furness, Daniel
Pabst, and 'Modern Gothic.'" Art News 74 (October 1975):
52-54. illus.

 A review of 19th century furniture in Philadelphia
 with emphasis on Pabst, a furniture maker and Furness,
 a furniture designer.

457. Hanks, David A., and Page Talbott. "Daniel Pabst:
Philadelphia Cabinetmaker." Philadelphia Museum Bulletin
73 (April 1977): 3-24. illus.

 The most comprehensive study on this important 19th
 century furniture maker.

John Parsons

458. Keyes, Homer Eaton. "Editor's Attic." Antiques 34
(November 1938): 237-38. illus.

 Only one paragraph.

John Ritto Penniman

459. Swan, Mabel Munson. "John Ritto Penniman." Antiques
39 (May 1941): 246-48. illus.

 Penniman was an oil painter who painted on furniture.

Duncan Phyfe

460. Allison, R. "Furniture Styles and How to Recognize Them: Duncan Phyfe, 1768-1854." Better Homes and Gardens 19 (June 1941): 67. illus.

Claims that Phyfe developed a new style. A very general article.

461. Allston, Maria. "Duncan Phyfe." The Mentor 11 (June 1923): 37. illus.

An article intended for the high school student.

462. Blum, E. W. "Bot of D. Phyfe." Antiques 54 (August 1948): 109. illus.

Illustrates a documented work table and a bill of sale.

463. Boicourt, Jean. "For the Collector, Duncan Phyfe." Antiques 59 (June 1951): 473-75. illus.

This article is directed at collectors.

464. Brown, Michael Kevin. "Duncan Phyfe." Master's thesis, University of Delaware (Winterthur), 1978. 101 pp. illus.

Examines the work of Phyfe in light of new information. With so many general articles on this cabinetmaker, this thesis is very useful.

465. Carson, Marion S. "The Duncan Phyfe Shop by John Rubens Smith, Artist and Drawing Master." American Art Journal 11 (February 1979): 69-78. illus.

On a painting of Phyfe's shop. No mention of the work of Phyfe.

466. Cornelius, Charles Over. "The Distinctiveness of Duncan Phyfe." Antiques 2 (November 1922): 204-8. illus.

Discusses Phyfe's style in relation to the important exhibition held at the Metropolitan Museum of Art.

467. ___. "Furniture from the Workshop of Duncan Phyfe." American Magazine of Art 13 (December 1922): 521-28. illus.

An overall review of the life and work of Phyfe.

468. ___. Furniture Masterpieces of Duncan Phyfe. Garden City, N.Y.: Doubleday, Page and Co., 1923. Reprint. New York: Dover, 1970. xii, 86 pp. illus.

A biography is given as well as analysis of Phyfe's style and influences.

469. ___. "New Light on Duncan Phyfe, Cabinetmaker."
Country Life 42 (September, October 1922): 4, 44-46. illus

Information from Cornelius' book.

470. Davis, Felice. "The Furniture of Duncan Phyfe."
The Antiquarian 4 (June 1925): 7-11. illus.

Discusses the Mr. and Mrs. Harry H. Benkard Collection.

471. Downs, Joseph. "Gift of New York Furniture and a Pair
of Footstools from the Workshop of Duncan Phyfe." Bulletin
of the Metropolitan Museum of Art 37 (May 1942): 137-39. illus.

472. Drew, Marion. "First Name in American Furniture: Duncan
Phyfe." Hobbies 46 (July 1951): 92-93, 96. illus.

No new information on Phyfe, but there is mention of
John Alden.

473. Dyer, Walter A. "Duncan Phyfe Furniture." House
Beautiful 37 (March 1915): 120-5. illus.

Life and career of Phyfe. Interesting because of the
early date of publication.

474. ___. "Three Early American Cabinetmakers." The
Antiquarian 8 (April 1927): 29-33. illus.

Brief mentions of Phyfe, Savery and Goddard.

475. Eaton, Esther. "Phyfe, Last Master of his Craft."
International Studio 76 (January 1923): 333-37. illus.

Review of Phyfe's work in light of an exhibition at
Metropolitan Museum of Art.

476. Eberlein, Harold Donaldson, and Abbot McClure.
Good Furniture 4 (1914): 123-27.

Mentions Phyfe briefly.

477. "Elegant Furniture for a Grecian Parlor by Duncan
Phyfe." Life 39 (August 1955): 60-1. illus.

Part of a series on Greek Revival furniture. Includes
mention of Phyfe. A popularized study.

478. "The Essence of Duncan Phyfe." Antiques 15 (May 1929):
391-93. illus.

Photographs of Phyfe furniture.

479. "Ford's Phyfe Furniture Now Displayed at Edison Museum."
American Collector 2 (September 1934): 1, 5. illus.

A review of an exhibition. See also May 1929, January 1935.

480. "A Glimpse of Duncan Phyfe." Antiques 25 (April 1934): 135-37. illus.

 Illustrates several pieces by Phyfe.

481. Harness, Paul. "Versatility of Duncan Phyfe." House and Garden 57 (April 1930): 118-19. illus.

 Includes a history of the research on Phyfe.

482. Harris, Helen. "Duncan Phyfe--America's Last Great Craftsman." Town and Country 131 (March 1977): 144+. illus.

483. Hornor, William M., Jr. "New Estimation of Duncan Phyfe." The Antiquarian 14 (March 1930): 37-40. illus.

 New facts on Phyfe.

484. ___. "Two Early American Cabinetmakers Compared: Duncan Phyfe and Henry Connelly of Philadelphia." Country Life 56 (September 1929): 47-48. illus.

 Compares the styles of these craftsmen.

485. Keyes, Homer Eaton. "Duncan Phyfe: Artist or Mechanic." Antiques 2 (May 1922): 203. illus.

 Aesthetics of Phyfe's work are discussed.

486. ___. "Editor's Attic." Antiques 25 (April 1934): 129-130. illus.

 Mentions two attributions of Phyfe's furniture.

487. Levy, F. N. "Phyfe Furniture in the Hudson-Fulton Exhibition at the Metropolitan Museum of Art." Architectural Record 26 (December 1909): 455-61. illus.

488. McClelland, Nancy. Duncan Phyfe and the English Regency, 1795-1830. New York: William R. Scott, 1939. Reprint. New York: Dover Publication, 1980. xxix, 364 pp. illus. bibl.

 Part One discusses the development of the English Regency. Part Two compares the English Regency with the work of Duncan Phyfe. Examines the competitors of Phyfe and Phyfe's customers. Excerpts from court records are included.

489. Margon, Lester. "Magic of Duncan Phyfe." Workbench 35 (May 1979): 14+.

490. Marshall, James Collier. "Duncan Phyfe, American Cabinetmaker." Country Life 25 (April 1915): 48-50. illus.

 Biography of Phyfe is given. Somewhat limited in scope.

491. Metropolitan Museum of Art. Loan Exhibition of Duncan
Phyfe Furniture. New York: Metropolitan Museum of Art, 1922.
10 pp. illus.

 A small exhibition catalog.

492. Miller, V. Isabelle. "New York Drawing Rooms of the
Federal Period." American Collector 11 (January 1943): 11-13.
illus.

 On Duncan Phyfe.

493. "On Wall Street in the Days of Duncan Phyfe: Pearsall
Drawing Room at the Museum of the City of New York."
Art News 41 (January 1943): 19. illus.

 Similar information to be found in March 1943 Antiques.
 Reviews an exhibition.

494. Ormsbee, Thomas H. "Autographed Duncan Phyfe Furniture."
American Collector 11 (March 1942): 5. illus.

 Examines a pair of benches with Phyfe's autograph.

495. ___. "Phyfe ne Fife." Antiques 16 (December 1929):
496-99. illus.

 Information is provided as the result of new research.

496. ___. "Phyfe's Able Competitors." American Collector 4
(June 1927): 7-10+. illus.

 Studies the cabinetmakers who were working at the time
 of Phyfe. Mentions Thomas Timpson, Thomas Burling, George
 Woodruff, Lannuier, and Mills and Deming.

497. Price, Matlack. "D. Phyfe--America's Classicist."
American Collector 4 (October 1935): 4-5. illus.

 Short discussion on the importance of Phyfe.

498. "Recent Purchase: Piano Attributed to the Workshop of
Duncan Phyfe." Brooklyn Museum Bulletin 11 (Spring 1950):
28. illus.

 One-page discussion about a Geib piano.

499. Reese, Richard Dana. "Duncan Phyfe and Charles-Honore
Lannuier: Cabinetmakers of Old New York." Art and Antiques 5
(September/October 1982): 56-61. illus.

500. Richardson, H. "Living Furniture Periods: This is
Duncan Phyfe." Better Homes and Gardens 25 (July 1947):
106. illus.

 One page review of Phyfe. Intended for designers.

501. Rogers, Meyric R. "The Phyfe Style Abroad: A Note on Chair Design." _Antiques_ 3 (April 1923): 170-72. illus.

A discussion of European makers who were working in styles similar to Phyfe.

502. Schroeder, Francis De N. "Makers of Tradition: Duncan Phyfe." _Interiors_ 109 (November 1949): 106-9. illus.

This article is aimed at interior decorators. Reproductions of Phyfe furniture are illustrated.

503. Schwartz, Marvin D. "The Regency Side of Federal Furniture in New York and Boston." _Connoisseur_ 200 (April 1979): 250-55. illus.

The influence of the British Regency on the cabinetmakers, Phyfe and the Seymours,

504. Seal, Ethel. "Duncan Phyfe Comes into Its Own." _Ladies Home Journal_ 44 (March 1927): 66+. illus.

On decorating with Phyfe-style furniture.

505. Semel, Daniel. "A First Look at D. Phyfe's Tool Chest." _Chronicle of Early American Industries_ 29 (December 1976): 56-60. illus.

Examines Phyfe's tool chest at the New-York Historical Society.

506. Sowers, J. I. "Duncan Phyfe, The Great American Furniture Maker." _Industrial Arts and Vocation Educator_ 30 (June 1941): 255. illus.

A general review of Phyfe's work. Phyfe's tool chest is illustrated.

507. Stow, Millicent. "Duncan Phyfe: Fashionable New York Cabinetmaker." _American Home_ 15 (January 1936): 32-36. illus.

Fifth in a series of articles on antiques.

508. Stuart, Charles. "Duncan Phyfe, Chairmaker." _The Antiquarian_ 12 (July 1929): 47-49, 74. illus.

Discusses a chair possibly designed by Phyfe.

509. Van Vick, Cornelius J. "Duncan Phyfe, The Cabinetmaker: Why we Should Cherish his Designs." _House Beautiful_ 61 (April 1927): 534+. illus.

A very general article, not recommended.

510. Valentine, Uffington. "Duncan Phyfe and the American Empire." International Studio 94 (November 1929): 42-44. illus.

The role of Phyfe in taking French styles to the American public.

John Pimm

511. Fraser, Esther Stevens. "A Pedigreed Lacquered Highboy." Antiques 15 (May 1929): 398-401. illus.

A discussion of a chest-on-frame made by Pimm. Some biographical information is given.

Pinkerton Family

512. Sikes, Jane E., and Robert M. Andrews. "The Pinkerton Family of Cabinetmakers and Silversmiths." Ohio Antique Review 9 (February 1983): 29+. illus.

A history of this family that resided in McConnelsville, Ohio.

George Platt

513. Jandl, H. Ward. "George Platt, Interior Decorator." Antiques 107 (June 1975): 1154-57. illus.

Platt designed furniture and lived in New York City.

David Poignand

514. "In Evidence of Transplanted Traditions." Antiques 43 (February 1943): 87-88. illus.

Shows a few pieces made by this maker.

515. Rogers, M. R. "David Poignand, Cabinetmaker." St. Louis Museum Bulletin 22 (June 1937): 5-9. (Also published in Art News 35 (December 1936): 13.) illus.

Illustrates six examples by this maker and a portrait of the maker.

R. Prescott and Co.

516. Prescott--Our 1st 100 and 1 Years. Keeseville, N. Y.:
R. Prescott and Co., 1954. 28 pp. illus.

 A promotional pamphlet about this company. Gives a
 history, 1853-1954.

Joseph Proud

517. Scotti, N. David, and Joseph Ott. "Notes on Rhode
Island Furniture." Antiques 87 (May 1965):572.

 Information on Proud's account book in the Rhode Island
 Historical Society.

Anthony G. Querville

518. "Queries and Opinions." Antiques 27 (May 1935): 198-99.
illus.

 A short note on this maker.

519. Smith, Robert C. "The Furniture of Anthony G. Querville."
Parts 1-5. Antiques 103, 104, 105 (May, July, August 1973,
January, March 1974): 984-94, 90-98, 260-68, 180-93, 512-21.
illus.

 Each part deals with specific furniture types by this
 important Philadelphia cabinetmaker. This is an important
 series of articles.

520. ___. "Philadelphia Empire Furniture by Antoine
Gabriel Querville." Antiques 86 (September 1974): 304-9.
illus.

 Reconstructs the career of this Paris-born craftsman.

Radford Brothers

521. Shettleworth, Earle G., Jr. "The Radford Brothers:
Portland Cabinetmakers of the Federal Period." Antiques
106 (August 1974): 284-89. illus.

 Biographical information is given on William and
 Daniel Radford of Portland, Maine. Documented examples
 are shown.

William Randall

522. Randall, Richard. "William Randall, Boston Japanner."
Antiques 105 (May 1974): 1127-31. illus.

This maker was active during the 18th century in Boston.

Benjamin Randolph

523. Albers, Marjorie K. "Benjamin Randolph, Cabinetmaker."
Design 72 (Spring 1971): 8-9. illus.

Review of Randolph's work, based on the research of Samuel
Woodhouse.

524. "Benjamin Randolph." Pennsylvania Museum Bulletin 20
(January 1925.)

525. Busselle, Alfred. An American Furniture Maker: Radio
Talk # 86. New York: Metropolitan Museum of Art.

526. Woodhouse, Samuel W., Jr. "Benjamin Randolph of
Philadelphia." Antiques 11 (May 1925): 366-71. illus.

An excellent article on this cabinetmaker. Contains
a biography and analyzes the craftsman's style.

527. ___ . "More About Benjamin Randolph." Antiques 18
(January 1930): 21-25. illus.

Follow-up to the article in May 1925 Antiques. Scholarly.

Rawson Family

528. Cooper, Nancy. "Chats on Antiques: Rawson Shops."
House Beautiful 67 (February 1930): 196. illus.

Important article, because the information on Rawson is
based on a letter from the Great-granddaughter of Joseph
Rawson.

529. ___ . "Two Recently Discovered Cabinetmaker's Labels."
House Beautiful 66 (July 1929): 70-71. illus.

Information is on Joseph Rawson of Providence, R.I.

530. Monahon, Eleanore Bradford. "The Rawson Family of
Cabinetmakers." Antiques 118 (July 1980): 134-47. illus.

On Grindal Rawson, Joseph Rawson and family.

H. H. Richardson

531. "American Furniture Designer Discovered." The Antiques Journal 17 (March 1962): 16. illus.

Short discussion of furniture designed by this architect.

532. Museum of Fine Arts. The Furniture of H. H. Richardson. Boston: Museum of Fine arts, 1962. 4 pp. illus.

An exhibition catalog of furniture designed for buildings.

Aaron Roberts

533. Bulkeley, Houghton. "The Aaron Roberts Attributions." Connecticut Historical Society Bulletin 28 (July 1963): 65-75. illus.

Illustrates case furniture by Roberts.

534. ___. "Aaron Roberts; His Life and Times." Connecticut Historical Society Bulletin 22 (April 1957): 46-50.

A biography on this important cabinetmaker.

535. Comstock, Helen. "Aaron Roberts and the Southeastern Connecticut Cabinetmaking School." Antiques 86 (October 1943): 437-440. illus.

Information mostly from articles that have appeared in the Connecticut Historical Society Bulletin.

Candace Roberts

536. DeVoe, Shirley Spaulding. "Candace Roberts, 1785-1806." Connecticut Historical Society Bulletin 27 (January 1962): 85-92. illus.

Information on this 18th century japanner and ornamenter.

Charles Rohlfs

537. Bolger, Nancy. "Charles Rohlfs--A Rising Reputation." New York-Pennsylvania Collector 8 (September 1981): 3-4. illus.

538. Moffitt, Charlotte. "The Rohlfs Furniture." House Beautiful 7 (December 1899).

539. Rohlfs, Charles. "My Adventures in Wood-Carving."
Art Journal (October 1925): 21-22.

Rose Valley

540. Bolger, Nacy. "Rose Valley Furniture: Mission with
a Difference." New York-Pennsylvania Collector 8 (March
1983): 4B-5B. illus.

 Short history of furniture of this craftsm·n colony.
 Discusses Will Price and Hawley McLanahan.

541. Brandywine Museum. A Good Sort of Heaven, A Poor Sort
of Earth; The Rose Valley Arts and Crafts Experiment. Chadds
Ford, Pa.: The Brandywine Museum, 1983. illus.

 A series of articles on Rose Valley. Only a few of the
 articles are on furniture.

Alexander Roux

542. Hauserman, Dianne D. "Alexander Roux and his 'Plain and
Artistic Furniture.'" Antiques 94 (February 1968): 210-17.
illus.

 The most complete article on this craftsman. Illustrates
 Gothic Revival furniture.

543. Schwartz, Marvin D. "Alexander Roux: A Variety of
Styles." Art News 75 (March 1976); 126-28. illus.

 Discusses Roux and his contemporaries. Examines the
 problems of researching this craftsman.

Roycroft

544. Bland, Ann S. "Built Roycrofter." Spinning Wheel 32
(November 1976): 22-24. illus.

545. Brady, Nancy H., ed. Roycroft Hand Made Furniture.
East Aurora, N.Y.: Roycrofters, 1912. Reprint. East Aurora,
N.Y.: House of Hubbard, 1973. 61 pp. illus.

 Compares examples of original Roycroft work with
 photographs in the catalog. Important book on this
 maker.

546. Burchfield Center. The Roycroft Movement: "A Spirit for Today." Buffalo: Burchfield Center, State University College at Buffalo, 1977. 16 pp. illus. bibl.

An exhibition catalog written by Edna Lindemann. Includes a chronology of Roycroft and an article on Elbert Hubbard.

547. Edwards, Robert. "The Roycrofters: Their Furniture and Crafts." Art and Antiques 4 (November/December 1981): 80-87. illus.

Discusses the work by Roycrofters prior to 1938.

548. Farrar, Francis, and Abigail Farrar. The Book of the Roycrofters. East Aurora, N.Y.: Roycrofters, 1907.

549. Hamilton, Charles F. Little Journeys to the Homes of the Roycrofters. East Aurora: S.-G. Press, 1963.

550. Hunter, Dard. My Life with Paper. New York: Alfred A. Knopf, 1958.

Autobiography by a Roycrofter.

Ruggles and Dunbar

551. Kihn, Phyllis. "Ruggles and Dunbar, Looking-glass Manufacturer." Connecticut Historical Society Bulletin 25 (April 1960): 36-60. illus.

On Nathan Ruggles and Azell Dunbar of Hartford, Conn.

Elijah and Jacob Sanderson

552. Belknap, Henry Wyckoff. "Furniture Exported by Cabinetmakers of Salem." Essex Institute Historical Collections 85 (1949): 335-59. illus.

Mainly on the Sandersons. Uses original documents.

553. Ormsbee, Thomas H. "The Sandersons and Salem Furniture." American Collector 8 (August, September 1939): 6-7, 10-11+. illus.

Illustrates several documented examples. Gives a check-list of Salem cabinetmakers.

554. Swan, Mabel Munson. "Elijah and Jacob Sanderson." Essex Institute Historical Collections 70 (1934): 323-364. illus.

William Savery

555. Busselle, Alfred. An American Furniture Maker: Radio Talk No. 86. New York: Metropolitan Museum of Art.

On William Savery.

556. Cescinsky, Herbert. "William Savery of Philadelphia." International Studio 91 (October 1928): 55-58. illus.

A reconsideration of some Savery attributions.

557. Cornelius, Charles O. "Goddard, Savery, Phyfe, Cabinet-makers." The Arts 4 (July 1923): 33-44. illus.

558. Downs, Joseph. "A Savery Chest." Antiques 15 (February 1929): 137-38. illus.

An examination of a mediocre chest with a Savery label.

559. Dyer, Walter A. "Furniture of William Savery." Architural Record 49 (March 1921): 249-52. illus.

Illustrations of several examples of high style furniture attributed to Savery.

560. ___. "Three Early American Cabinetmakers." The Antiquarian 8 (April 1927): 33. illus.

On William Savery, John Goddard and Duncan Phyfe. Not a scholarly article and not recommended.

561. Farrington, F. "Who was William Savery?" Hobbies 51 (April 1946): 66+. illus.

562. Halsey, R. T. H. "William Savery, the Colonial Cabinet-maker and his Furniture." Arts and Decoration 10 (February 1919): 201-203,237-38. (Also published in the Bulletin of the Metropolitan Museum of Art 13 (December 1918): 254-67.) illus.

Makes questionable attributions. This article is probably the reason for the over-estimatation of this craftsman.

563. Hornor, William M., Jr. "William Savery: 'Chairmaker and Joiner.'" The Antiquarian 15 (July 1930): 29+. illus.

New examination of the work of this maker. Re-evaluates the life and work of Savery. Shows early invoices.

564. ___. "William Savery and Philadelphia Maple." House Beautiful 64 (December 1928): 722+. illus.

Indicates that Savery used maple. Includes excerpts from an account book.

565. Keyes, Homer Eaton. "Cobwebs and Dust." Antiques 3
(February 1923): 60-61. illus.

A little information on William Savery and William
Wayne.

566. ___. "Editor's Attic." Antiques 14 (October 1928):
309-10. illus.

Some brief notes on Savery.

567. Teall, Gardner. "Cabinetmaker of Colonial America:
William Savery." House and Garden 44 (August 1923): 44+.
illus.

Considers Savery to be an outstanding craftsman.
Based on the Halsey article.

568. "William Savery." Pennsylvania Museum Bulletin 23
(1928): 13.

569. Woodhouse, S. W., Jr. "18th Century Philadelphia
Cabinetmakers." American Magazine of Art 18 (October 1927):
535-39. illus.

Mostly on William Savery.

Schindler, Roller and Co.

570. Strickland, P. L. L. "Schindler, Roller and Co.,
An Unknown New York Cabinetmaker." 19th Century 9 (Autumn
1980): 39-43.

Only article available on this maker.

Isaac E. Scott

571. Hanks, David A. "Isaac E. Scott, Craftsman and
Designer." Antiques 105 (June 1974): 1307-13. illus.

A study of the life and career of this craftsman-
designer. Mentions the Glessner family commissions.

572. ___. Isaac E. Scott: Reform Furniture in Chicago.
Chicago: Chicago School of Architecture Foundation, 1974.
31 pp. illus.

A biographical study. Discusses his most famous work.

Francois Seignouret

573. Hill, Amelia Leavitt. "Francois Seignouret." House and Garden 50 (November 1926): 172+. illus.

Presents documented examples of this craftsman's work and gives a biography.

574. Ronstrom, Maud O'Bryan. "Seignouret and Mallard, Cabinetmaker." Antiques 46 (August 1944): 79-81. illus.

Best information on this New Orleans cabinetmaker. Includes information on Prudent Mallard.

Christian Selzer and Peter Rank

575. Fraser, Esther S. "Pennsylvania Bride Boxes and Blanket Chests." Antiques 10 (August 1925): 79-84. illus.

Mostly on Selzer.

576. ___. "Pennsylvania German Dower Chests." Parts 1, 2, 3. Antiques 11 (February, April 1927, June 1927): 119, 280-83, 474-5. illus.

Part one examines signed chests. Part two gives genealogies. Part three discusses some problems. A follow-up note appears in June, Antiques.

John and Thomas Seymour

577. Biddle, James. "Piece of Great Utility." Bulletin of The Metropolitan Museum of Art 25 (April 1967): 308-13. illus.

About a sideboard, in the Metropolitan Museum, that is attributed to Seymour.

578. Hipkiss, Edwin. "A Seymour Bill Discovered." Antiques 51 (April 1947): 244-45. (Also published in the Boston Museum of Fine Arts Bulletin 45 (February 1947): 12-14.) illus.

Announces the discovery of an original bill of sale for the Derby chest in the Karolik Collection.

579. Keyes, Homer Eaton. "A Note on Seymour Manner." Antiques 32 (October 1937): 176-80. illus.

Attempts to establish a Seymour style.

580. Norman-Wilcox, G. "Seymour Sideboard." Los Angeles Museum of Art Bulletin 12 (1960) 10-15. illus.

581. Randall, Richard H., Jr. "Seymour Furniture Problems." Boston Museum of Fine Arts Bulletin 57 (1959): 102-13. illus.

 Discusses the problems of making Seymour attributions. Attempts to separate the styles of John and Thomas.

582. Stoneman, Vernon C. John and Thomas Seymour, Cabinet-makers in Boston, 1794-1816. Boston: n.p., 1959. 393 pp. illus. bibl.

 A important study of these cabinetmakers. Contains 291 illustrations of Seymour furniture, biographical information and stylistic considerations. This book is the main source for Seymour attributions.

583. ___. "The Pedimented Tambour Desk of the Seymours." Antiques 74 (September 1958): 22-25. illus.

 Excerpts from Stoneman's book.

584. ___. A Supplement to John and Thomas Seymour, Cabinet-makers in Boston. Boston: n.p. , 1965. illus.

 Contains information located since the publication of the book on this subject in 1959.

585. Swan, Mabel M. "John Seymour and Son, Cabinetmakers." Antiques 32 (October 1937): 176-79. illus.

 A general article on these makers.

586. Winchester, Alice. "A Chair Ascribed to the Seymours: An Editorial Footnote." Antiques 40 (September 1941): 149.

 Discusses a painted chair (with convincing documentation to a Seymour attribution).

Shaker

587. Allen, Minnie Catherine. A Full Century of Communism: The History of the Alethians, Formally Called Shakers. Pittsfield, Mass.: Press of Eagle Publishing Co., 1897. 16 pp.

 Booklet on the philosophy of the Shakers.

588. Andrews, Edward Deming. The Community Industries of the Shakers. Albany: University of the State of New York, 1933. 322 pp. illus.

 First important book on Shaker crafts. Includes a list of items in the Andrews' collection.

589. ___ . "Designed for Use--The Nature of Function in Shaker Craftsmanship." New York History 31 (July 1950): 331-41. illus.

590. ___ . "Furniture of a Religious Sect." Antiques 15 (April 1929): 292-96. illus.

A general article.

591. ___ . "An Interpretation of Shaker Furniture." Antiques 23 (January 1933): 6-9. illus.

Explores the role of function and religion in Shaker furniture.

592. ___ . "The Kentucky Shakers." Antiques 52 (November 1947): 356-57. illus.

Discusses the crafts of the two Kentucky Shaker communities.

593. ___ . The People Called Shakers. 1953. Reprint. New York: Dover Publications, 1963. Revised, Gloucester, Mass.: Peter Smith, 1964.

Discusses all aspects of Shakers.

594. ___ . "Shaker Furniture." Interior Design 25 (May 1954): 60-66. illus.

Designed for interior decorators.

595. ___ . "The Shakers in a New World." Antiques 72 (October 1957): 340-43. illus.

General article of little interest.

596. Andrews, Edward D., and Faith Andrews. "Craftsmen of American Religious Sect: Notes on Shaker Furniture." Antiques 14 (April 1928): 132-36. illus.

An overview on Shaker Furniture.

597. ___ . Religion in Wood: A Book of Shaker Furniture. Bloomington, Indiana: Indiana University Press, 1966. 106 pp. illus. bibl.

This book is a revised edition of Shaker Furniture... originally published in 1937 (see no. 593).

598. ___ . Shaker Furniture: The Craftsmanship of An American Communal Sect. New Haven, Connecticut: Yale University Press, 1937. Reprint. New York: Dover Publications, 1950. xi, 133 pp. Illus. bibl.

This is the pivotal book on Shaker furniture. Includes a discussion on the function and manufacture of furniture.

599. ___ . Work and Worship: The Economic Organization of the
Shakers. Greenwich, Conn.: New York Graphic Society, 1974.
illus.

This is a new and reworked edition of Andrews' 1933
book, The Community Industries of the Shakers.

600. Barzarov, K. "Shakers: Life and Products of a Community
in the Pioneering Days of America." Art and Artist 10
(June 1975): 27-30. illus.

Review of an exhibition at the Victoria and Albert
Museum.

601. Berkshire Museum. Shaker Exhibition; Furniture,
Industrial Material and Textiles of the Shakers of New
England and New York. Pittsfield: Berkshire Museum, 1930?.
4 pp. illus.

The catalog is by William Winter and the text by
Edward D. Andrews.

602. ___ . Shaker Art and Craftsmanship. Pittsfield:
Berkshire Museum, 1940. 8 pp. illus.

Exhibition catalog.

603. Bjerkoe, Ethel H. "Shakers and Their Furniture." Parts
1,2. Hobbies 58,59 (February, March 1954): 60-61, 57-59. illus.

An exhibition catalog.

604. Bowdoin College. Hands to Work and Hearts to God:
The Shaker Tradition in Maine. Brunswick, Maine: Bowdoin
College, 1969. illus. bibl.

The catalog of an exhibition of furniture from the
Sabbathday Lake Shaker Community. Information on the
Maine Shaker community is less plentiful than information
on the New York and Massachusetts communities.

605. Carpenter, Mary Grace, and Charles H. Carpenter, Jr.
"The Shaker Furniture of Elder Henry Green." Antiques 105
(May 1974): 1119-25. illus.

Information about a specific Alfred, Maine, Shaker
cabinetmaker.

606. Coomaraswamy, Ananda K. "Shaker Furniture." The Art
Bulletin 21 (1939): 200-6. illus.

Review of Andrews' book.

607. Cornforth, John. "The Isolation of Shaker Design."
Country Life 153 (May 1975): 1248-59. illus.

608. Dyer, Walter A. "The Furniture of the Shakers: A Plea
for its Preservation as Part of Our National Inheritance."
House Beautiful 65 (May 1929): 650, 669-73. illus.

609. "Elegant Designs of Shaker Furniture." San Francisco Bay
Guardian, 19 May 1977. 11-32.

610. Force, Juliana. Catalogue of a Private Sale of Shaker
Furniture from the Collection of Mrs. Willard Burdette
Force, at "Shaker Hollow", South Salem, Westchester County,
N.Y., May 18 and 19, 1937.

 A sale catalog with no bibliographic information.
 Important because of its early date.

611. Franco, Barbara. Shaker Arts and Crafts. Rochester:
Memorial Art Gallery, 1971. illus.

 Short pamphlet.

612. "Hancock Shaker Village." Craft Horizon 30 (May 1970):
44-43. illus.

 Some information on furniture.

613. Handberg, Ejner. Shop Drawings of Shaker Furniture
and Woodenware. Stockbridge, Mass: Berkshire Traveller Press,
1973. illus.

 A collection of detailed drawings of Shaker items.
 Uses extant examples as models.

614. Jones Library. Exhibition of Shaker Craftsmanship.
Amherst, Mass.: Jones Library, 196-. 6 pp. illus.

 Catalog of an exhibition. Contains an article by
 Edward Deming Andrews.

615. Kassay, John. The Book of Shaker Furniture. Amherst:
University of Massachusetts, 1980. xxii 265 pp. illus.

 A general survey of Shaker furniture.

616. Klamkin, Marian. Hands to Work: Shaker Folk Arts and
Industries. New York: Dodd Mead, 1972. 250 pp. illus.

 Examines all Shaker industries.

617. Kramer, Fran. "Shakers at Sonyea." Parts 1,2,3.
New York-Pennsylvania Collector 6 (August, September,
October 1981): 1+, 1B-3B, 1B+. illus.

 A history of the relatively unknown Shaker community.
 Some mention of cabinetmakers.

618. Lenox Library Association. <u>Exhibit of Shaker Furniture</u>. Lenox, Mass.: Lenox Library Association, 1934. 4 pp.

 Small exhibition catalog with an essay by Edward Deming Andrews.

619. MacLean, John P. <u>Bibliography of Shaker Literature</u>. Reprint. New York: Burt Franklin, 1970.

 On Ohio Shakers.

620. Mang, Karl, Wend Fischer, and Charles Nordhoff. <u>Shaker:</u> <u>Leben und Produktion Einer Commune in der Pioniezeit Amerikas</u>. Munich, Germany: Neue Sommlung, 1974. 164 pp., bibl.

 A German language book on Shaker crafts.

621. Meader, Robert F., comp. <u>Catalog of the Emma B. King</u> <u>Library of the Shaker Museum</u>. Old Chatham, N. Y.: Shaker Museum Foundation, Inc., 1970. illus.

622. ___ . <u>Illustrated Guide to Shaker Furniture</u>. New York: Dover, 1972. ix, 128 pp. illus.

 A book about documented Shaker furniture and related objects. Includes a copy of a chair catalog Mt. Lebanon.

623. Melcher, Marguerite F. "Shaker Furniture." <u>Philadelphia</u> <u>Museum Bulletin</u> 57 (Spring 1962): 89-92.

 Contains an exhibition catalog of an exhibition at The Philadelphia Museum of Art. Only Melcher's essay deals exclusively with Shaker furniture.

624. Mendel, Karl. "What Makes Shaker Furniture Shaker?" <u>Clarion</u> (Fall 1979): 68-71. illus.

625. Muller, Charles R. <u>The Shaker Way</u>. Worthington, Ohio: Ohio Antique Review, 1979. 143 pp. illus.

 A group of articles reprinted from <u>Ohio Antique Review</u>.

626. Neal. Julia. "Regional Characteristics of Western Shaker Furniture." <u>Antiques</u> 98 (October 1970): 611-17. illus.

 Mostly photographs of Shaker furniture. Examines regional characteristics.

627. Ormsbee, Thomas H. "The Shakers and Their Furniture." <u>American Collector</u> 6 (June 1937): 8. illus.

 A very short history of Shaker communities and furniture.

628. Peason, E. Ray., and Hinman L.P. Kealy. "Unusual Forms in Shaker Furniture." Antiques 98 (October 1970): 606-10. illus.

Discusses and illustrates unusual furniture.

629. Peladeau, Marius B. "Shakers of Maine." Antiques 107 (June 1975): 1144-53. illus.

Discusses all aspects of the Shaker communities in Maine. Shows furniture and gives a history of each community.

630. ___. "Characteristics of Early Shaker Chairs." Historic Preservation 22 (October 1970): 31-36. illus.

This article claims that some Shaker chairs can be attributed to certain communities while others cannot.

631. Peter, John. "Shaker Influence." Look, America's Family Magazine 18 (March 1954): 76-78. illus.

An article intended for the general public.

632. Ray, Marylyn. "A Reappraisal of Shaker Furniture and Society." Winterthur Portfolio 8 (1973): 107-30. illus.

Disputes the current idea that Shaker styles resulted from the Shaker theology. Claims that Shaker styles came from non-Shaker influences. Examines the progress of Shaker production methods.

633. ___. True Gospel Simplicity: Shaker Furniture in New Hampshire. Concord, New Hampshire: New Hampshire Historical Society, 1974. 31 pp. illus.

An exhibition catalog that illustrates Shaker furniture from Canterbury and Enfield, New Hampshire.

634. Raycraft, Don, and Carol Raycraft. Shaker, A Collector's Source Book. Des Moines, Iowa: Wallace-Homestead Book Co., 1980. 140 pp. illus.

Designed for the collector's market.

635. Reist, Henry G. "Products of Shaker Industry." New York History 13 (July 1932): 264-70. illus.

636. Renwick Gallery. Shaker: Furniture and Objects from the Faith and Edward Deming Andrews Collections. Washington, D.C.: Smithsonian Institution Press, 1973. 88 pp. illus.

An exhibition catalog with an essay consisting, in part, of an interview with Faith Andrews.

637. Richmond, Mary L. comp. Shaker Literature, A Bibl-
graphy. 2 vols. Hancock, Mass.: Shaker Community, Inc.,
1977. 591 pp.

 Contains bibliographical information on all aspects
 of Shakerism. Consists of approximate 4000 entries.

638. Rose, Millan, and Emily M. Rose. A Shaker Reader.
New York: Universe Books, 1975. 125 pp. illus.

 A collection of articles from Antiques magazine.

639. Rourke, Constance. The Roots of American Culture and
Other Essays. New York: Harcourt, Brace and Co., 1942.

 Pages 195 to 237 relate to the Shakers.

640. Rubin, Cynthia Elyce. "Shaker Industries." Clarion
(Fall 1979): 46-57. illus.

641. Memorial Art Gallery. Shakers Arts and Crafts.
Rochester, N.Y.: Memorial Art Gallery of the University of
Rochester, 1970. 36 pp. illus. bibl.

642. "Shaker Craftsmanship." Hobbies 48 (December 1943):
40-41.

643. Shea, John G. The American Shakers and Their
Furniture. New York: Van Nostrand Reinhold Co., 1971. xv,
208 pp. illus.

 Contains a history of the Shaker movement and chapters
 on the construction, design and purpose of Shaker
 furniture. Useful measured drawings are also included
 in this volume.

644. Smith College Museum of Art. Work of Shakers' Hands.
Northampton, Mass.: Smith College Museum of Art, 1961. 9 pp.
illus.

 From the collection of Dr. and Mrs. Edward Deming
 Andrews. Includes a short essay by Dr. Andrews.

645. Sprigg, June. By Shaker Hands: The Art and the World
of the Shakers--The Furniture and Artifacts and the Spirit
and Precepts Embodied in their Simplicity, Beauty and
Functional Practicality. New York: Alfred A. Knopf, 1975.
illus.

 Advances the idea that Shaker furniture was the natural
 result of Shaker philosophy.

646. ___. "Marked Shaker Furnishings." Antiques 115
(May 1979): 1048-58. illus.

> Examines marked furniture, boxes, baskets, and textiles
> made by the Shakers. Concentrates on furniture. Illus-
> trated with colored photographs. Contains only a few
> paragraphs of text.

647. Wellman, Rita, and Holger Cahill. "American Design."
House and Garden 74 (July 1938): 15-43. illus.

> Illustration of Shaker crafts from the Index of American
> Design.

648. Whitney Museum of American Art. Shaker Handicrafts.
New York: Whitney Museum of American Art, 1935. 15 pp.
illus.

> Exhibition catalog, with an introduction by Edward
> Deming Andrews.

649. William Benton Museum of Art. Simple Gifts: Hands to
Work and Hearts to God; a Loan Exhibition of Shaker Craftsman-
ship Primarily from Hancock Shaker Village. Storrs, Conn.:
William Benton Museum of Art at the University of Connecticut,
1978. illus.

650. Williams, John S. Consecrated Ingenuity. The Shakers
and Their Inventions. Old Chatham, N.Y.: Shaker Museum
Foundation Inc, 1957.

> Short pamphlet on Shaker inventions.

651. Williams, Stephen G. Chosen Land: The Sabathday Lake
Shakers. Boston: David R. Godine, 1975.

> On this Maine Shaker community.

652. Worcester Art Museum. Exhibition of Shaker Arts and
Crafts. Worcester, Mass: Worcester Art Museum, 1938. illus.

> An exhibition catalog of an exhibition organized and
> assembled by Mr. and Mrs. Edward Deming Andrews.
> an essay by Andrews.

Sharrock Family

653. Dahill, Betty. "The Sharrock Family: The Newly Dis-
covered School of Cabinetmakers." Journal of Early Southern
Decorative Arts 2 (November 1976): 37-51. illus.

> Discusses a family of cabinetmakers who were active in
> Northampton, North Carolina. Biographies are presented
> and documented examples are shown.

F. Shaw

654. Winchester, Alice. "Editor's Attic." Antiques 37
(May 1940): 248-49. illus.

Mentions briefly an F. Shaw who may have been a cabinet-
maker.

John Shaw

655. American Collector 18 (May 1944).

A short note.

656. Bartlett, Lu. "John Shaw, Cabinetmaker of Annapolis."
Antiques 111 (February 1977): 362-377. illus.

An excellent comprehensive review of the life and
career of this maker. Original documents and
labelled examples are shown.

657. Beirne, Rosamond Randall. "John Shaw, Cabinetmaker."
Antiques 78 (December 1960): 554-58. illus.

Information is provided on this 19th century Maryland
cabinetmaker.

658. Hornor, William M., Jr. "John Shaw of the Great
Days of Annapolis." International Studio 98 (March 1931): 44-
47. illus.

A biography is given on this maker.

659. Swan, Mabel M. "Wings of Baltimore." Antiques 62
(July 1942): 16-18. illus.

Examines eagle-decorated Baltimore furniture with
special references to John Shaw.

John Shearer

660. Snyder, John J., Jr. "John Shearer, Joiner of Martins-
burgh." Journal of Early Southern Decorative Arts 1 (1979):
1-25. illus.

First article on this West Virginia cabinetmaker. Gives
construction details and biographical information.

George Shipley

661. Rogers, Meyric R., and Martha Gandy Fales. "George Shipley: His Furniture and His Label." Antiques 79 (April 1961): 374-75. illus.

Two short articles that illustrate documented pieces. A Shipley label is shown.

Short Family

662. Fales, Martha Gandy. "Shorts, Newburyport Cabinet-makers." Essex Institute Historical Collections 102 (July 1966): 224-40. illus.

A comprehensive account of this family of cabinetmakers. The family included Joseph, Stephen, John, Sowall, and other Shorts. Gives genealogical information.

M. and H. Shreinkheisen

663. "The Manufacture of Parlor Furniture: M. and H. Shreinkheisen." Scientific American 43 (October 1880): 223-229. illus.

Fascinating series of engravings showing the making of furniture in this New York City firm. There is a two-column description of the factory.

William Sinclair

664. Gillingham, Harrold E. "William Sinclair, A Pennsylvania Cabinetmaker." Antiques 16 (October 1929): 298-99. illus.

Discusses a desk made by this craftsman.

John and Simeon Skillin

665. "Another Skillin Sculpture Identified." Antiques 28 (October 1935): 28. illus.

666. Keyes, Homer Eaton. "Editor's Attic." Antiques 22 (July 1934): 6-7. illus.

Mentions both Skillins.

667. Swan, Mabel M. "Simeon Skillin, Sr.: The First
American Sculptor." _Antiques_ 46 (July 1944): 21. illus.

Short article on the sculptor.

668. Thwing, Leroy L. "The Four Carving Skillins."
Antiques 33 (July 1938): 326-28. illus.

Information on Simeon, Jr., Simeon, Sr., John, and
Samuel Skillin. Best article on this family of
carvers who carved furniture as well as other items.

Slaugh Family

669. Seitz, Albert F. "Furniture Making by the Slaugh Family
of Lancaster, Pennsylvania." _Journal of the Lancaster County
Historical Society_ 71 (January 1969): 1-25. illus.

Gives a history of this furniture making family and
illustrates examples of their work.

Slover and Taylor

670. Warren, Phelps. "Setting the Record Straight: Slover
and Taylor, New York Cabinetmaker." _Antiques_ 84 (October
1961): 350-51. illus.

Corrects the misspelled name of Slover, which
had been spelled as 'Stover' or 'Storer.' Gives a
good history of this firm.

Eliakim Smith

671. Luther, Clair Franklin. "A Late Hadley Chestmaker."
Antiques 14 (September 1929): 202-3. illus.

A poorly written article about this 18th century
Hadley, Mass. craftsman. Contains a biography and
lists sources.

William Henry Snow

672. Thomas, David N. "Getting Started in High Point."
Forest History 11 (April 1967): 22-32.

Furniture making began in High Point, North Carolina, in
1889 by William Henry Snow. Other manufacturers
began operating at a later date.

Spencer and Gilman

673. Huntley, Richmond. "Spencer and Gilman, Hartford Mirror Makers." American Collector 8 (June 1939): 5. illus.

 A short note about these early 19th century looking-glass makers.

Johannes Spitler

674. Walters, Donald. "Johannes Spitler, Shenandoah County Virginia Furniture Decorator." Antiques 108 (October 1975): 730-3. illus.

 Spitler decorated chests in a Pennsylvania German style. Biographical information is given.

Gustav Stickley

675. "Art: Revival of Mission Style; Designer Gustav Stickley." New Yorker 55 (December 1979): 36-7. illus.

 A discussion of two exhibitions of Stickley furniture. Discusses the influence of the Englishman, Edward Carpenter.

676. Bavaro, Joseph, and Thomas L. Mossman. The Furniture of Gustav Stickley. New York: Van Nostrand Reinhold Co., 1982. 175 pp. illus.

 Part One contains information on Craftsmen Furniture. Part Two consists of measured drawings of Craftsmen Furniture. This book is the most complete study of this important maker.

677. Bland, Ann S. "Stickley's Craftsman Furniture." Spinning Wheel 32 (September 1976): 20-23. illus.

678. Bohdan, Carol Lorraine, and Todd Mitchell Volpe. "The Furniture of Gustav Stickley." Antiques 111 (May 1977): 984-9. illus.

 Short article on Stickley. Documented examples are shown.

679. Cathers, David M. Furniture of the American Arts and Crafts Movement: Stickley and Roycroft Mission Oak. New York: New American Library, 1981. x. 275 pp. illus.

 About both Stickley and Roycroft. Excellent.

680. Cunico, Rozanne. "Stickley: Hallmark of American Furniture." <u>Hobbies</u> 86 (August 1981): 86-88. illus. notes.

Reviews Stickley furniture; includes a photograph of Stickley's signature. Separates the work of the Stickley Brothers.

681. "Decorative Acquisition: A Sideboard by Gustav Stickley." <u>St. Louis Art Museum Bulletin</u> 15 (April/June 1979): 181-84. illus.

Examines a piece in the St. Louis Art Museum.

682. Freeman, John Crosby. <u>The Forgotten Rebel: Gustav Stickley and His Craftsman Mission Furniture.</u> Watkins Glen, N.Y.: Century House, 1966. 112 pp. illus. bibl.

This is the pivotal study on this maker. Based on a master's thesis. Gives a biography of this craftsman and discusses the output of the Craftsman shop. Examples of Stickley's catalogues are included.

683. Gray, Stephen, and Robert Edward, eds. <u>Collected Works of Gustav Stickley</u>. New York: Turn of Century Editions, 1981. 165 pp.

Reprints of Stickley's catalogues with editorial notes.

684. "A Progressive Step in American Cabinetmaking." <u>Craftsman</u> 30 (September 1916): 624-27.

About Gustav Stickley and Chromewald Furniture as advertised in the <u>Craftsman</u>.

685. Sanders, Barry. "Gustav Stickley's 'Craftsman' Furniture." <u>American Arts and Antiques</u> 4 (July/August 1979): 46-53. illus.

General review of the life and work of Stickley.

686. Smith, Mary Ann. <u>Gustav Stickley, The Craftsman.</u> Syracuse: Syracuse University Press, 1983. 208 pp. illus.

A serious study of this designer-craftsman. Examines his influences on architecture and the decorative arts.

687. Stickley, Gustav. <u>Craftsman Homes: Architecture and Furnishings of the American Arts and Crafts Movement</u>. New York: Craftsman Publishing Co., 1909. Reprint. New York: Dover, 1979. 205 pp. illus.

Gives Stickley's views of aesthetics.

688. ___. <u>The Craftsman's Story</u>. Syracuse: Mason Press, 1905. 32 pp. illus.

689. ___. "Ornament: Its Use and Its Abuse." Craftsman 7 (February 1905): 580-88.

690. ___. More Craftsman Homes. New York: Craftsman Publishing Co., 1912. Reprint. New York: Dover, 1982. 210 pp. illus.

691. ___. "The Structural Style in Cabinet-Making." House Beautiful 15 (December 1903): 19-23.

An aesthetic basis for Stickley's designs.

692. ___. What is Wrought in the Craftsman Workshop. Syracuse: Homebuilders Club, 1904. 92 pp. illus.

L. and J. G. Stickley

693. Gray, Stephen, ed. The Mission Furniture of L. and J.G. Stickley. New York: Turn of Century Editions, 1983. 189 pp. illus.

Brief essays by Mary Ann Clegg Smith and Robert Edwards. Reprints of Stickley catalogues.

694. Muller, Charles. "It Looks Shaker, It's Called Shaker, But it's Stickley." Ohio Antique Review 8 (April 1982): 8+.

Shows that L. and J.G. Stickley, younger brothers of Gustav Stickley, made furniture that looks like Shaker.

695. Stickley, Inc. The Story of a Developing Furniture Style; Its Inspiration, Its Objectives. Fayetteville, N.Y.: L. and J.G. Stickley, 1950. 52 pp. illus.

Short history of this firm. A promotional booklet published by Stickley.

Reuben Swift

696. Bordes, Marilynn Johnson. "Reuben Swift, Cabinetmaker of New Bedford." Antiques 112 (October 1977): 750-52. illus.

Based on a tambour desk at the Metropolitan Museum of Art. The first article on this maker.

Swisegood School

697. Museum of Early Southern Decorative Arts. The Swisegood School of Cabinetmaking. Winston-Salem, N.C.: Museum of Early Southern Decorative Arts, 1973. 50 pp. illus.

Taylor Chair Company

698. Taylor Chair Company. Sesquicentennial, 1816-1966.
Bedford, Ohio: 1966. 63 pp. illus.

This company-published booklet contains the research of
Blanche Nightingale.

699. "Sesquicentennial Anniversary Book." Interiors 126
(January 1967): 116-17. illus.

Review of the Sesquicentennial booklet.

Elias Thomas

700. "New York Mirror of 1820." American Collector 3 (April
1935): 2. illus.

Discusses a labelled looking-glass made by Thomas.

701. "Riddles and Replies." Antiques 32 (July 1937): 38-39.
illus.

Examines one looking-glass by this maker.

Tobey Furniture Co.

702. Triggs, Oscar L. About Tobey Handmade Furniture. Chicago:
Tobey Furniture Co., 1906. 26 pp. illus.

A promotional booklet that gives an indication of how
this firm worked and what its products were.

James Todd and Jacob Foster

703. "Pedigreed Antiques." Antiques 7 (June 1925): 316-17.
illus.

Brief information on James Todd, looking-glass maker and
Jacob Foster, cabinetmaker. Some biographical information
is given.

Abner Toppan

704. Dexter, Edwin Spalding. "Abner Toppan, Cabinetmaker."
Antiques 15 (June 1929): 493-95. illus.

Gives some biographical information on this Newburyport,
Mass., cabinetmaker.

Ebenezer Tracy

705. Chase, Ada R. "Ebenezer Tracy, Connecticut Chair-
maker." Antiques 30 (December 1936): 266-69. illus.

Good article on this Windsor chairmaker. Also mentions
Elisha Tracy.

706. Evans, Nancy Goyne. "The Tracy Chairmakers Identified."
The Connecticut Antiquarian 33 (December 1981): 14-21. illus.

The most complete article on the Tracy family. Identifies
the craftsmen whose names appear on Windsor chairs.

707. Gaines, Edith, ed. "Collector's Notes." Antiques 91
(February 1971): 268-70. illus.

Mentions Ebenezer Tracy, F.W. Hutchings, and T. Tolley.

Daniel Trotter

708. Golovin, Anne C. "Daniel Trotter: Eighteenth-Century
Philadelphia Cabinetmaker." Winterthur Portfolio 6 (1970):
151-84. illus.

A comprehensive study of the life and work of this
maker. A discussion of his work includes examples of
both country and formal style furniture.

709. ___. "Daniel Trotter, Philadelphia Cabinetmaker."
Master's Thesis, University of Delaware (Winterthur), 1962.
216 pp.

710. Naeve, Milo M. "Daniel Trotter and His Ladder-back
Chairs." Antiques 76 (November 1959): 442-45. illus.

A good article on this craftsman. Includes biographical
information and documented examples.

711. Entry deleted.

Joseph True

712. Belknap, Henry Wycoff. "Joseph True, Woodcarver of Salem
and His Account Book." Essex Institute Historical Collections
78 (April 1942): 117-57. illus.

 Gives an excellent genealogy on True with extracts from
 his account book.

713. Clunie, Margaret Burke. "Joseph True and the Piecework
System in Salem." Antiques 111 (May 1977): 1006-13. illus.

 Examines his life and work. Includes an useful discussion
 the role of piece work and True's work for other cabinet-
 makers.

714. Farnam, Ann. "Essex County Furniture Carving: The
Continuance of a Tradition." Essex Institute Historical
Collections 116 (July 1980): 145-55. illus.

 Reviews the True account book and mentions his
 contemporary craftsmen, such as Israel Fellows and
 Cyrus Dodge.

Mrs. Truesdale

715. "The New Ideal of Homemaking in America: Illustrated
with Pictures of One Woman's Work." Craftsman 30 (May 1916):
179-87. illus.

 Decorated furniture by this unknown woman craftsman.

Francis Trumble

716. [Evans], Nancy Goyne. "Francis Trumble of Philadelphia:
Windsor Chair and Cabinetmaker. Winterthur Portfolio 1
(1964): 221-24. illus.

 An extensive study.

Charles Trute

717. Winchester, Alice. "Editor's Attic." Antiques 37
(January 1940): 15. illus.

 Notes on this piano maker.

Isaac Tryon

718. Walcott, William Stuart, Jr. "Isaac Tryon's Cherry
Highboy." Antiques 20 (August 1931): 99. illus.

 Discusses a labelled chest by Tryon.

Thomas Tufft

719. Brazer, Clarence W. "Early Pennsylvania Craftsman:
Thomas Tufft, 'Joyner'." Antiques (March 1928): 210-5. illus.

 A scholarly article on this craftsman. Contains contem-
 porary sources.

720. Williams, Carl M. "Thomas Tufft and His Furniture for
Richard Edwards." Antiques 54 (October 1948): 246-47. illus.

 Recent research on this craftsman. Documented examples
 are explained.

721. Winchester, Alice. "Editor's Attic." Antiques 37
(June 1940): 75. illus.

 Mentions a documented chest.

722. Woodhouse, Samuel W., Jr. "Thomas Tufft." Antiques 12
(October 1927): 292-93. illus.

 A short article on this cabinetmaker.

Joseph Twyman

723. Dewhurst, Frederick E. "Work of Joseph Twyman."
Architectural Record 18 (December 1905): 453-59. illus.

 A comprehensive article on this Arts and Crafts
 furniture maker who was a student of William Morris.

William Tygart

724. Barnes, Jairus B. "William Tygart: A Western Reserve Cabinetmaker." Antiques 101 (May 1972): 832-35. illus.

This maker was active in North Bloomfield, Ohio. A sketchy biography is given and documented examples are shown.

Joseph Vail

725. "Joseph Vail, New York City Cabinet and Chair Maker." Antiques 45 (February 1944): 96. illus.

Active during the 18th century.

Maskell Ware

726. Powers, Mabel Crispin. "The Ware Chairs of South Jersey." Antiques 9 (May 1926): 307-11. illus.

Discusses the entire Ware family which consisted of Maskell Ware, Rueben Ware, Daniel Ware, John Ware and Maskell's teacher, John Lanning.

727. Waters, Deborah D. "Wares and Chairs." Winterthur Portfolio 13 (1979): 161-73. illus.

Based on documentary evidence about the entire Ware family. A scholarly article concerning this 18th century family.

Hastings Warren

728. Deveikis, Peter M. "Hastings Warren: Vermont Cabinet-maker." Antiques 101 (June 1977): 1037-39. illus.

Examines the life and work of this Vermont cabinetmaker.

Jacob Wayne

729. Downs, Joseph. "Jacob Wayne, Cabinetmaker." Pennsylvania Museum Bulletin 25 (May 1930): 22-25.

Information about this late 18th century Philadelphia cabinetmaker.

730. Hornor, William M., Jr. "Documented Furniture by Jacob Wayne." International Studio 96 (June 1930): 40-43. illus.

Examines Federal Period furniture made by this maker. Illustrates an original bill of sale.

Wayne and Biddle

731. "Riddles and Replies." Antiques 40 (November 1941): 325.

A note on this looking-glass firm.

William Wayne

732. Wood, T. Kenneth. "Highboy of Samuel Wallis." Antiques 12 (September 1927): 212-14. illus.

Illustrates a chest-on-frame made by Wayne.

Holmes Weaver

733. Ralston, Ruth. "Holmes Weaver, Chair and Cabinetmaker of Newport." Antiques 41 (February 1942): 133-35. illus.

Short uninformative article about this contemporary of the Goddard-Townsend school.

John Welch

734. Brown, Mary Louise. "John Welch, Carver." Antiques 9 (January 1926): 28-30. illus.

Information on this carver who is credited with carving the Massachusetts Cod Fish in the State House. Also mentions a looking-glass carved by this maker.

John J. Wells

735. Bulkeley, Houghton. "John J. Wells, Cabinetmaker-Inventor," Connecticut Historical Society Bulletin 26 (July 1969): 65-75. illus.

Biographical information is given on this East Hartford, Conn. cabinetmaker. This craftsman also ran an ink and paint business.

Charles Haight White

736. Schwartz, Marvin D. "A Story of a Sideboard." Art News 73 (November 1974): 75.

An example of furniture made by this 19th Century craftsman.

L. White Chair Co.

737. Yehia, Mary Ellen. "Chairs of the Masses: A Brief History of the L. White Chair Co., Boston, Mass." Old-Time New England 63 (Fall 1972): 33-44. illus.

This chair factory was active 1864-69. The chair designs were from the designs of J. C. Loudon and Andrew Jackson Downing.

William Whitehead

738. Pierce, Donald C. "A Splendid Sideboard from New York." Antiques World 5 (Summer 1981): 58-59. illus.

Short article on this maker.

George Whitelock

739. Hornor, William M., Jr. "George Whitelock of Wilmington." Antiquarian 14 (January 1930): 30-31. illus.

Documented pieces that were made by this craftsman are shown. A biography is presented.

Aaron Willard

740. Cummins, Hazel E. "A Willard Clock of Unusual Interest."
Antiques 16 (July 1929): 46. illus.

Short article on the provenance of one clock.

Simon Willard

741. Swan, Mabel M. "The Man who Made Simon Willard's
Clock." Antiques 15 (March 1929): 196-200. illus.

Examines the life and work of both Willard and
John Doggett. Doggett was the maker of a clock
case for a Willard clock.

Christian William Wilmerding

742. Downs, Joseph. "Two Looking Glasses." Antiques 49
(May 1946): 299. illus.

Mentions two documented looking-glasses made by
this maker. Gives biographical data.

743. ___ . "Two Looking Glasses." Walpole Society Notebook
(1944): 45-47. illus.

Similar to the above article.

David Wilson

744. Winchester, Alice. "Editor's Attic." Antiques 48
(October 1945): 219. illus.

Biographical information is given. Documented examples
are shown.

James Wilson

745. Tuttle, Donald L. "James Wilson, A Pennsylvania Chair
Maker." Chronicle of Early American Industries 33 (December
1979): 53-57. illus. bibl.

Examines this craftsman's tools which are now in the
Meadowcroft Village.

Robert Wilson

746. McLinton, Mary Clay. "Robert Wilson, Kentucky Cabinet-
maker." Antiques 103 (May 1973): 945-49. illus.

This English-born cabinetmaker was active in Lexington,
Kentucky, 1792-1825.

George Woltz

747. Pinckney, Pauline. "George Woltz, Maryland Cabinet-
maker." Antiques 35 (March 1939): 124-26. illus.

This cabinetmaker was active in Maryland. Illustrates
documented examples.

Wooton

748. Walters, Betty L. The King of Desks: Wooten's Patent
Secretary. Washington, D.C.: Smithsonian Institution Press,
1969. 32 pp. illus.

History of this maker who is known for the Wooten desk,
a large folding desk with many compartments. Contains
photographs of examples and newspaper advertisements.

D. Workman

749. "Queries and Opinions." Antiques 29 (May 1936): 225.

A note on this North Adams, Mass.

Frank Lloyd Wright

750. Amaya, M. "Frank Lloyd Wright and American Furniture."
Connoisseur 200 (January 1979): 54-57. illus.

Information on the furniture designs by this important
architect. Examines his role in the Arts and Crafts
Movement.

751. Committee of Architectural Heritage. Frank Lloyd Wright, Vision and Legacy. Champaign: University of Illinois, 1965. 30 pp. illus.

A pamphlet for an exhibiton held in 1965 at the University of Illinois Gallery. Wright furniture is shown.

752. Hanks, David A. The Decorative Designs of Frank Lloyd Wright. New York: E. P. Dutton, 1979. 232 pp. illus.

Extensive book on the non-architecture designs by Wright, including furniture.

753. Heckscher, Morrison. "Frank Lloyd Wright's Furniture for Francis W. Little." Burlington Magazine 117 (December 1975): 871-72. illus.

Review of an exhibition of Wright's furniture at an exhibition at the Metropolitan Museum of Art.

754. Heckscher, Morrison, and Elizabeth G. Miller. Architect and his Client: Frank Lloyd Wright and Francis W. Little. New York: Metropolitan Museum of Art, 1973. 24 pp. illus. bibl.

An exhibition catalog.

755. Koplas, Janel. "Wright's Furniture: Form Verus Function." New Art Examiner 6 (February 1979): 10. illus.

756. Pearce, J.N. "Furniture and Decorations (Pope-Leighey House by Frank Lloyd Wright.)" Historic Preservation 21 (April 1969): 91-99. illus.

Samuel Wing

757. Harlow, Henry J. "The Shop of Samuel Wing: Craftsman of Sandwich, Mass." Antiques 93 (March 1968): 372-77. illus.

The article is based on information related to the remaining tools of this craftsman. His account book and furniture are discussed.

Vose and Coats

758. Nylander, Jane. "Vose and Coats, Cabinetmaker." Old-Time New England 64 (January June 1974): 89-91. illus.

Information on the life and career of this firm which was active in Boston.

Zoar Community

759. Ramsey, John. "Zoar and Its Industries." <u>Antiques</u> 46 (December 1944): 33-35. illus.

760. Snyder, Tricia, Gil Snyder, and Paul Goudy. <u>Zoar Furniture</u>. New Philadelphia, Ohio: Tuxcarawas County Historical Society, 1978. 128 pp. illus.

 The most important publication on the furniture of this Ohio utopian community.

WORKS ABOUT GROUPS OF CRAFTSMEN

Citations are entered alphabetically by author within a geographical arrangement. First are listed sources relating to regions: Mid-Atlantic, New England, South, and West; there follow works entered under an alphabetical list of states.

Mid-Atlantic

761. Behrens, Dorothy W. "When Pittsburgh was Superior to New York in Furniture Style." American Collector 14 (March 1945): 8-10. illus.

Examines early 19th century cabinetmaking in these two cities. Some cabinetmakers are mentioned.

New England

762. Brockton Art Center. The Wrought Covenant. Brockton, Mass.: Brockton Art Center, 1979. 132 pp. illus. bibl.

Studies the furniture from southeastern New England, from the perspective of furniture as cultural evidence. Contains a 20-page bibliography.

763. Chinnery, Victor. Oak Furniture: The British Tradition; A History of Early Furniture in British Isles and New England. Woodbridge, Great Britain: Antique Collector's Club, 1979. 579 pp. illus. bibl.

Includes a discussion of New England 17th century furniture.

764. Cummings, Abbott Lowell. Rural Household Inventories Establishing the Names, Uses and Furnishing of Rooms in the Colonial New England Home, 1675-1775. Boston: Society for the Preservation of New England Antiquities, 1964. xl, 306 pp. illus.

Corrects some mistaken nomenclature.

765. Greenlaw, Berry A. New England Furniture at Williams-burg. Williamsburg, Va.: Williamsburg Foundation, 1974. viii, 195 pp. illus.

 A catalog of the important New England furniture in the collections at Colonial Williamsburg. Each entry is well researched.

766. Harlow, Henry J. "Decorated New England Furniture at Old Sturbridge Village." Antiques 116 (October 1979): 860-71. illus.

 Review of the furniture of New England origin at this famous museum. Mentions James Todd and Lambert Hitchcock.

767. ___. "Signed and Labelled New England Furniture." Antiques 116 (October 1979): 872-79. illus.

 Illustrates 17 signed 18th and 19th century pieces of furniture, some in color. No useful biographical information is provided.

768. Hosley, William H., Jr., and Philip Zea. "Decorated Board Chests of the Connecticut River Valley." Antiques 119 (May 1981): 1156-51. illus.

 Analyzes 40 chests from Massachusetts and Connecticut that were made about 1700.

769. Kettell, Russell Hawes. The Pine Furniture of Early New England. Garden City, N.Y.: Doubleday, Doran and Co., 1929. Reprint. New York: Dover Publications, 1949. 370 pp. illus.

 Deals with all aspects of pine furniture the nature of pine wood, pine trees, and the construction of pine furniture. Does not contain much information about furniture makers.

770. Lovell, M. M. "Blockfront: Its Development in Boston, Newport, and Connecticut." Fine Woodworking 23 (July/August 1980): 45-47.

771. Lyon, Irving Whitall. The Colonial Furniture of New England: a Study of the Domestic Furniture in Use in the Seventeenth and Eighteenth Centuries. Boston: Houghton Mifflin, 1924. Reprint. New York: E. P. Dutton, 1977. xii, 285 pp. illus.

 A history of New England furniture. Includes several contemporary references but, contains only brief mention of craftsmen.

772. North Andover Historical Society. The Collection of
Samuel Dale Steven. North Andover, Mass.: North Andover
Historical Society, 1971.

 Short exhibition catalog of a small collection of
 New England furniture.

773. Ormsbee, Thomas H. "New England Produced Its Own Type
of Small Cupboard." American Collector 4 (July 1936): 7.
illus.

 About sideboards.

774. Trent, Robert F. "New England Furniture, Joinery and
Turning Before 1700." Art and Antiques 6 (July/August 1982):
72-79. illus.

 Some 17th century craftsmen are mentioned.

775. University of Massachusetts Art Gallery. The Connecticut
Valley at Home: One Hundred Years of Domestic Art. Amherst:
University of Massachusetts Press, 1970. 41 pp. illus. bibl.

 An exhibition that included examples of furniture
 as well as other items.

776. Winchester, Alice. "Early New England Furniture in the
Shelburne Museum." Connoisseur Yearbook (1957): 34-41. illus.

 Examines the furniture at Shelburne Museum.

South

777. Anglo-American Art Museum. Southern Furniture and Silver:
The Federal Period, 1788-1830. Baton Rouge, Louisiana:
Anglo-American Art Museum of the Louisiana State University,
1968. 35 pp. illus. footnotes. chronology.

 An exhibition catalog that contains a small amount of
 information on Jared Chestnut and Elisha Warner.

778. Burroughs, Paul H. Southern Antiques. Richmond, Va.:
Garett and Masie, 1931. xi, 191 pp. illus.

 Concentrates on southern furniture including a history
 of furniture making and a discussion of woods used.
 Claims to know of 700 southern cabinetmakers, but fails
 to list them.

779. Comstock, Helen. "Discoveries in Southern Furniture:
Virginia and North Carolina." Antiques 65 (February 1954):
131-34. illus.

 Uses newspaper advertisements and contemporary documents
 as sources for new information.

780. ___. "Furniture of Virginia, North Carolina, Georgia, and Kentucky." Antiques 62 (January 1952): 58-99. illus.

Discusses furniture in each of these states. Contains information on the cabinetmakers of these states.

781. ___. "Southern Furniture since 1952." Antiques 91 (January 1967): 102-19. illus.

Presents research on southern furniture that the author has uncovered since her article in the same magazine in 1952. Very little information on cabinetmakers.

782. Davis, L. "Plantation Furniture: Georgia and South Carolina." Antiquarian 13 (November 1927): 27-29. illus.

Examines the survival of southern furniture.

783. Dockstader, Mary R. "Simple Furniture of the Old South." Antiques 20 (August 1931): 83-86. illus.

A general article with only passing mention of craftsmen.

784. Hogrefe, Jeffrey. "Southern Furniture." Americana 7 (January/February 1980): 14-16.

Examines the market for southern furniture.

785. Museum of Early Southern Decorative Arts. Museum of Early Southern Decorative Arts. Winston-Salem, North Carolina: Old Salem, 1970. 46 pp. illus.

A catalog of this important museum's collections. Poor illustrations.

786. Ritter, Christine. "Life in Early America: Southern Furniture Makers." Early American Life 8 (November/December 1977): 32-35. illus.

Discusses the work of 18th century southern cabinetmakers.

787. Virginia Museum of Fine Arts. Southern Furniture, 1640-1820. Richmond, Virginia: Virginia Museum of Fine Arts, 1952. 64 pp. illus.

An exhibition catalogue held in 1952. Contains several essays, including one by E. Milby Burton, on Charleston furniture.

788. Welker, Dorothy. "White Pine--A Northern Immigrant at Home on the Southern Coast." Journal of Early Southern Decorative Arts 3 (May 1977): 11-26. illus.

Examines the use of white pine in southern furniture. In the past white pine was considered to be used mainly in the northern states. Discusses James Rockwood and Walter W. Hannan, cabinetmakers.

789. Winchester, Alice, ed. Southern Furniture, 1640-1820.
New York: Antiques, 1952. 64 pp. illus.

A collection of articles on southern furniture, with
considerable mention of furniture of South Carolina.
Examples of furniture are illustrated and a discussion
of the characteristics of southern furniture is given.

West

790. Colorado Springs Fine Arts Center. Hispanic Craftsmen
of the Southwest. Colorado Springs: Colorado Springs Fine
Arts Center, 1977. 118 pp. illus. bibl. footnotes.

Examines all crafts of the Southwest. Some mention of
furniture.

791. "Decorative Arts of the Old Northwest Territories."
Antiques 87 (March 1965): 310-29. illus.

Based on an exhibition at the Henry Ford Museum.
Contains some information on cabinetmakers in Ohio
and Michigan.

792. Museum of Fine Arts, Frontier America: The Far West.
Boston: Museum of Fine Arts, 1975. 232 pp. illus. bibl.

Contains an important essay entitled, "Furniture of
the Frontier" by Elizabeth Sussman. Only a few pieces
of furniture are shown.

Arizona

793. Hilpert, Bruce. "Proper in Any Parlor: Furnishing
Styles in Frontier Tucson." Journal of Arizona History
22 (Spring 1981): 129-46. illus.

Examines furniture used in the 1880s in Tucson. Not
useful for information on cabinetmakers.

California

794. Anderson, Timothy J., C.M. Moore, and Robert W. Hunter.
California Designs, 1910. Pasadena, California: Pasadena
Center,1974. 150 pp. illus. footnotes, chronology.

Abourt the Arts and Crafts Movement.

Colorado

795. Fine Arts Center. The Way West: American Furniture in the Pikes Peak Region, 1872-1972. Colorado Springs: Fine Arts Center, 1972. 36 pp. illus.

Examines Victorian and later furniture. Some mention of craftsmen.

796. Olson, Sarah M. "Furnishing a Frontier Outpost." Colorado Magazine 54 (August 1977): 138-68. illus.

Discusses the restoration of an old fort and the sources used in documenting the possible furnishings of the fort.

Connecticut

797. Baker, Muriel C. "Decorated Furniture and Furnishings." Connecticut Historical Society Bulletin 25 (July 1960): 65-73. illus.

Reviews an exhibition of painted furniture and tin ware. No new information.

798. Barbour, Frederick K. "Some Connecticut Case Furniture." Antiques 83 (March 1963): 434-37. illus.

General article on Connecticut case pieces.

799. ___. The Stature of Fine Connecticut Furniture. n.p.: n.p., 1959. unpaged.

A short general book.

800. Bissell, Charles S. Antique Furniture in Suffield, Connecticut, 1670-1835. Hartford: Connecticut Historical Society, 1956. ix, 128 pp. illus.

History of furniture making in Suffield. Works of 72 craftsmen are shown and discussed. Some biographical information is given.

801. ___. "Furniture and Cabinetmakers of a New England Town." Antiques 70 (April 1956): 326-29. illus.

Excerpts from the book by this author.

802. Brainard, Newton C. Connecticut Chairs in the Collection of the Connecticut Historical Society. Hartford: Connecticut Historical Society, 1956. 67 pp. illus.

Pamphlet on this important collection.

803. ___. "The Deerfield Chests." Walpole Society Notebook (1951): 18-20.

Short discussion about two sunflower chests.

804. Brainard, Newton C., Houghton Bulkeley, and Phyllis Kihn. "Connecticut Cabinetmakers." Parts 1, 2. Connecticut Historical Society Bulletin 32, 33 (October 1967, January 1968): 97-144, 1-40. illus.

Important check list of more than 350 Connecticut furniture makers.

805. Brown, Michael K. "Scalloped-Top Furniture of the Connecticut Valley." Antiques 117 (May 1980): 1092-99. illus.

Mentions several cabinetmakers.

806. Bulkeley, Houghton. Contributions to Connecticut Cabinetmaking. Hartford: Connecticut Historical Society, 1967. 97 pp. illus.

A collection of articles written by Bulkeley that has appeared in the Connecticut Historical Society Bulletin.

807. ___. "The Norwich Cabinetmakers." Connecticut Historical Society Bulletin 29 (July 1964): 76-85. illus.

Contains an important check list of 57 Norwich craftsmen. Includes dates of activity and sources.

808. Comstock, Helen. "Cabinetmakers of the Norwich Area." Antiques 87 (June 1965): 696-99. illus.

Based on Bulkeley's article. Contains a check list.

809. Connecticut Historical Society. George Dudley Seymour's Furniture Collection in the Connecticut Historical Society. Hartford: Connecticut Historical Society, 1958. 141 pp. illus.

A catalog of the famous Seymour collection at the Connecticut Historical Society. Gives provenance of each piece.

810. Cooke, Edward Strong, Jr. "The Selective Conservative Taste: Furniture in Stratford, Connecticut, 1740-1800." Master's thesis, University of Delaware (Winterthur.) 145 pp.

811. Craftsmen and Artists of Norwich. Norwich, Conn.: The Society of the Founders of Norwich, Connecticut, Inc., 1965.

This work was not examined by the author.

812. Darmstadt, Jo., et al. Craftsmen and Artists of Norwich--Furniture, Paintings, Clocks, Silver, Pewter, and Pottery. Stonington, Connecticut: Pequot Press, 1965.

813. Dyer, Walter A. "Connecticut Valley Craftsmen Pro-
duced Painted Chests." <u>American Collector</u> 3 (June 1935): 1+.
illus.

 Examines chests from the 17th, 18th and early 19th
 centuries. Not much information on craftsmen.

814. Erving, Henry Wood. "The Connecticut Chest." <u>Old-Time
New England</u> 12 (July 1921): 14-18. illus.

 Discusses the so-called Connecticut chest.

815. ___. <u>The Hartford Chest</u>. Hartford: Tercentenary
Commission of the State of Connecticut, 1934. 12 pp. illus.

 Important pamphlet on the 17th century oak chests now
 referred to as Hartford chests. Claims that they were
 originally made in Hartford.

816. ___. <u>Random Notes on Colonial Furniture: A Paper Read
before the Connecticut Historical Society in 1922 and
Now Revised</u>. Hartford: Privately Printed, 1931. 60 pp. illus.

 Only 200 printed.

817. Forman, Benno M. "The Crown and York Chairs of Coastal
Connecticut and the Work of the Durands of Milford."
<u>Antiques</u> 105 (May 1974): 1147-54. illus.

 On Andrew and Samuel Durand who made country chairs.
 Includes a checklist of furniture makers who were
 active in Connecticut.

818. Ginsburg, Benjamin. "Connecticut Cherry Furniture with
an Affinity for the Oriental." <u>Antiques</u> 58 (October 1950):
274-76. illus.

819. Grave, Alexander. <u>Three Centuries of Connecticut Folk
Art</u>. Hartford: Wadsworth Atheneum, 1979. 104 pp. illus.
bibl.

820. Hoopes, Penrose R. "Notes on Some Colonial Cabinet-
makers of Hartford." <u>Antiques</u> 23 (May 1933): 171-72. illus.

 Mentions several Hartford craftsmen including Nicholas
 Disbrowe, Thomas Spencer, Jarard Spencer, Benjamin
 Cheney, Seth Youngs, and the Phelps Family.

821. Kane, Patricia E. "The Joiners of 17th Century Hartford
County." <u>Connecticut Historical Society Bulletin</u> 35 (July
1970): 65-85. illus.

 Major article on the furniture of the Hartford
 area. Gives biographical information on 31 joiners.
 Includes information from documents.

822. ___. "The 17th Century Case Furniture of Hartford County, Connecticut and Its Makers." Master's Thesis, University of Delaware (Winterthur), 1968. 196 pp.

823. Keyes, Homer Eaton. "Individuality of Connecticut Furniture." Antiques 28 (September 1935): 110-13. illus.

Discusses regionalism in Connecticut furniture. Makes several attributions to the Chapin family.

824. Kirk, John T. "The Distinctive Characteristics of Connecticut Furniture." Antiques 92 (October 1967): 524-29. illus.

About regionalism.

825. Koda, Paul. Frederick K. and Margaret R. Barbour's Furniture Collection. Hartford: Connecticut Historical Society, 1963. 71 pp. illus.

A catalog of this important collection of Connecticut furniture. Each object is described, with information given concerning its woods, condition and provenance.

826. ___. Frederick K. and Margaret R. Barbour's Furniture Collection: A Supplement. Hartford: Connecticut Historical Society, 1970. 31 pp. illus.

Contains information on another 14 examples of Connecticut furniture.

827. Litchfield Historical Society. Litchfield County Furniture: 1730-1850. Litchfield, Conn.: Litchfield Historical Society, 1969. 124 pp. illus.

Claims that there is an identifiable style for Litchfield Co. furniture. Gives information on furniture craftsmen from Litchfield.

828. Lyman Allyn Museum. New London County Furniture. New London, Conn.: Lyman Allyn Museum, 1974. 134 pp. illus. bibl. appendix.

An exhibition catalog that contains an excellent check list of New London cabinetmakers. Catalog entries contain construction details and related information.

829. Mattatuck Museum. Fiddlebacks and Crooked-backs. Elijah Booth and Other Joiners of Woodbury and Newtown, 1750-1820. Waterbury, Conn.: Mattatuck Museum, 1982. 96 pp. illus.

An exhibition catalog of an exhibition that was held in 1982. Contains an essay that discusses the work and lives of 33 joiners and 41 carpenters who have not been previously identified. Includes a history of the communities in which the craftsmen worked.

830. Myers, Minor. "The Migration of a Style: Blockfront Furniture in Connecticut Towns." Arts and Antiques 3 (March/April 1980): 80-87. illus.

Explains the movement of the blockfront furniture feature from Boston to New London, Conn., via Rhode Island.

831. New Haven Colony Historical Society. Furniture of the New Haven Colony: The Seventeenth Century Style. New Haven, Conn.: New Haven Colony Historical Society, 1973. 93 pp. illus.

An exhibition catalog of a 1973 exhibition. Each catalog entry contains considerable detail including provenance, characteristics, and reasons for attributions.

832. ___ . Hearts and Crowns: Folk Chairs of the Connecticut Coast, 1720-1840, as Viewed in the Light of Henri Facillon's 'Introduction to Art Populaire.' New Haven, Conn.: New Haven Colony Historical Society, 1977. 101 pp. illus. bibl.

An excellent book that deals mainly with banister-back and other 18th century chairs.

833. Richards, Nancy E. "Furniture of the Lower Connecticut River Valley: The Hartford Area, 1785-1810." Winterthur Portfolio 4 (1968): 1-25. illus.

Examines the furniture and craftsmen of the Federal style. Mentions John Wells, John Porter, Samuel Kneeland, Lemuel Adams, and Wood and Watson.

834. Schwartz, Marvin D. "Connecticut Furniture Reconsidered." Connoisseur 169 (September 1968): 67-64. illus.

Uses the information from the Wadsworth Atheneum's Connecticut furniture exhibition.

835. Semon, Kurt M. "A Fine American Chippendale Secretary Desk." American Collector 16 (August 1947): 5+. illus.

A documented Connecticut chest is examined.

836. Sherman, Frederic Fairchild. East Connecticut Artists and Craftsmen. New York: Privately Printed, 1925. 78 pp.

Includes all crafts. Furniture makers are discussed on pages 5 to 8.

837. Stow, Charles M. "Southern New England Furniture." Antiquarian 10 (March 1928): 30-34. illus.

Mostly on Connecticut furniture.

838. Tercentenary Commission of the State of Connecticut.
Three Centuries of Connecticut Furniture, 1635-1935.
Hartford: Tercentenary Commission of the State of Connecti-
cut, 1935. 30 pp. illus.

 An exhibition catalog that contains 273 objects. Mainly
 a grouping of furniture rather than a scholarly work.

839. Wadsworth Atheneum. Connecticut Furniture: Seventeenth
and Eighteenth Centuries. Hartford: Wadsworth Atheneum,
1967. xvi, 156 pp. illus. bibl.

 An exhibition catalog that examines the stylistic
 development of Connecticut furniture. A scholarly
 work that gives new insights into the area of
 Connecticut decorative arts.

840. Warren, William L. "More About Painted Chests, Part II."
Connecticut Historical Society Bulletin 23 (April 1958):
50-60.

 A discussion of Connecticut chests. Part I is mainly on
 the craftsman: Charles Gillam, q.v.

 Delaware

841. Dorman, Charles G. Delaware Cabinetmakers and Allied
Artisans 1655-1855. Wilmington, Del.: Historical Society of
Delaware, 1960. 107 pp. illus.

 A biographical dictionary of individual craftsmen.
 Each entry gives the location, active dates, and
 related information. Uses contemporary inventories,
 documents and newspaper advertisements. Originally
 published in the October 1960 Delaware History.

842.Hancock, Harold B. "Furniture Craftsmen in Delaware
Records." Winterthur Portfolio 9 (1974): 175-212.

 A checklist of craftsmen working in Delaware. Gives
 location of activity, dates active, and references.
 Also contains a list of apprentices and some inventories.

843. Keyes, Homer Eaton. "Delaware Furniture." Antiques 58
(August 1950): 118-123. illus.

 A general review of Delaware furniture.

844. Scafidi, Polly J. "Notes on Delaware Cabinetmakers."
Delaware History 14 (October 1971): 262-79.

 Based on her dissertation that dealt with the impact of
 change on craftsmen. Adds names to the check.
 by Charles Dorman.

845. Wilmington Medical Center, Junior Board of Delaware,
Inc. <u>Delaware Antiques Show, Nov. 30-Dec. 2, 1972</u>.
Wilmington, Delaware, 1972. 116 pp. illus.

 A program guide to an antiques show. Contains an
 article on Delaware cabinetmakers

District of Columbia

846. Golovin, Anne Castrodale. "Cabinetmakers and Chair-
makers of Washington, D.C.--1791-1840." <u>Antiques</u> 107
(May 1975): 888-922. illus.

 Includes a checklist of over 100 craftsmen who lived
 and worked in the district. An important and useful
 article.

847. Klapthor, Margaret B. "Furniture in the Capital:
Desks and Chairs Used in the Chamber of the House of
Representatives, 1819-1857." <u>Records of the Columbia
Historical Society</u> (1969-70): 190-211. illus.

Georgia

848. Green, Henry D. "Furniture of the Georgia Piedmont
Before 1830." <u>Antiques</u> 110 (September 1976): 550-59. illus.

 Regional styles are discussed. Information is given on
 some cabinetmakers.

849. ___. "Furniture of the Georgia Piedmont Before 1820."
<u>Art and Antiques</u> 5 (January/February 1982): 80-87. illus.

850. Gross, Katharine Wood. "The Source of Furniture Sold
in Savannah, 1789-1815." Master's Thesis, University of
Delaware (Winterthur), 1967. xiii, 189 pp. illus.

851. Theus, Mrs. Charlton M. "Concise Guide to Savannah
Furniture and Cabinetmakers." <u>Connoisseur</u> 169 (October
1968): 124-37. illus.

 Comprehensive review of Savannah Furniture. Includes
 a list of cabinetmakers.

852. ___. "Furniture and Cabinetmakers of Early Coastal
Georgia." <u>Georgia Historical Quarterly</u> 36 (September 1952):
220-30. illus.

 A checklist of cabinetmakers. Examines the question
 of the importation of furniture from New York.

853. ___. "Furniture and Cabinetmakers of Coastal Georgia."
Antiques 65 (February 1959): 135-37. illus.

Lists 44 cabinetmakers of Savannah working prior to 1820.
Mentions J.B. Barry, a cabinetmaker.

854. ___. "Furniture in Savannah." Antiques 92 (March 1967):
364-69. illus.

Examines 18th century Savannah furniture. Uses newspaper
advertisements to discuss the careers of the craftsmen.

855. ___. Savannah Furniture, 1735-1825. Savannah, Ga.:
Privately printed, 1967. xi, 100 pp. illus.

The most complete book on the furniture of Savannah.
Gives a history of furniture making in this city.
Examines the kinds of woods used and the styles
employed. Gives biographies of about 50 craftsmen and
explores the importation of furniture.

Illinois

856. Hanks, David. "Chicago Furniture: From 'Modern
Gothic' to Prairie School." American Art and Antiques 2
(September/October 1979): 64-69. illus.

Evolution of furniture in Chicago to the turn of the
century.

857. ___. "In the 19th Century; Furniture Manufacturers
of Chicago." 19th Century (January 1975): 18-22. illus.

Lists many 19th century furniture makers and gives short
histories.

858. Kalec, Donald. "The Prairie School Furniture."
Prairie School Review 1 (Fourth Quarter, 1964): 5-15. illus.

About the Prairie School of architects and the furniture
designed by them. Includes information on the role
of Frank Lloyd Wright.

859. Madden, Betty I. Art, Crafts, and Architecture in
Early Illinois. Champaign, Ill.: University of Illinois
Press, 1974. 310 pp. illus. notes, index.

Indiana

860. Gilborn, Craig. "Adirondack Hickory Furniture." Arts and Antiques 4 (January/February 1981): 44-49. illus.

 Hickory furniture is discussed. Mentions the Old Hickory Chair Co., Rustic Hickory Furniture Co., and Indiana Hickory Furniture Co.

861. Walters, Betty L. Furniture Makers of Indiana, 1793-1850. Indianapolis: Indiana Historical Society, 1977. 244 pp. illus.

 History of furniture making in Indiana. Includes information on individual cabinetmakers and manufacturers.

862. Whallon, Arthur. "Indiana Cabinetmakers and Allied Craftsmen, 1813-1860." Antiques 98 (July 1970): 118-25. illus.

 Important checklist on furniture craftsmen from this state. Based on information in city directories, newspapers, and related sources.

Iowa

863. Vincent, Arlene Steffer. "Survey and Summary of Iowa Crafts and Craftsmen." Master's Thesis, Iowa State University, 1968.

Kentucky

864. Clark, Thomas D., Eleanor Hume Offutt, and Alice Winchester. "Kentucky Furniture." Antiques 52 (November 1947): 358-63. illus.

 Four short articles entitled: "The Woods," "The Styles," "The Makers," and "The Pieces of Kentucky Furniture." Mentions 12 cabinetmakers. Highly illustrated, but of limited use.

865. Elliott, Mary Jane. "Lexington Kentucky 1792-1820: The Athens of the West." Master's Thesis, University of Delaware (Winterthur), 1973. 78 pp.

866. Jones, Michael Owen. "Folk Art Production as a Business." Parts 1, 2. Kentucky Folklore Record 17, 18 (October/December 1971, January/March 1972): 73-77, 5-12.

 Not seen by the compiler.

867. Leach, Mary Jones. "Cabinetmakers of Kentucky."
Antiques 67 (February 1954): 138-39. illus.

 List of cabinetmakers in this state. Based on Edna T.
 Whitley's list.

868. Olcott, Lois L. "Kentucky Federal Furniture."
Antiques 105 (April 1974): 87-82. illus.

 Includes a discussion of furniture makers who worked
 in the Federal style.

869. Shuey, Mary Willis. "Early Kentucky Cabinetmakers."
Antiques 39 (June 1941): 306-8. illus.

 Mentions six craftsmen who have been identified by the
 1806 Census.

870. Speed Art Museum. Kentucky Furniture. Louisville, Ky.:
Speed Art Museum, 1974. 100 pp. illus.

 An exhibition catalog consisting mainly of photographs.
 Contains furniture of the 18th and 19th centuries.
 Several craftsmen are mentioned. Some pieces are
 attributed.

871. Whitley, Edna T. A Checklist of Kentucky Cabinet-
makers from 1775-1859. Paris, Ky.: Privately printed, 1969.
155 pp. illus.

 This is the major reference on furniture makers of
 Kentucky. Includes an alphabetical biographical
 dictionary. Entries give information about
 dates of activity and location. Contains examples
 of identifiable works.

Louisiana

872. Bacot, H. Parrott. "Louisiana Furniture Made Before
1835." Arts Quarterly 2 (April/June 1980): 9-27.

873. Hill, Anelia L. "American French Colonial Furniture."
Old Furniture 8 (September 1929): 33-38. illus.

 The first article on the French-influenced furniture of
 New Orleans. Mentions Francois Seignouret.

874. Louisiana State Museum. Early Furniture of Louisiana,
1750-1830. New Orleans: Louisiana State Museum, 1972. xviii,
85 pp. illus. bibl.

 An exhibition catalog that explores the styles used in
 making French-influenced furniture of Louisiana.

875. Nott, G. William. "Old New Orleans Furniture and Its Makers." The Antiquarian 11 (November 1928): 80+. illus.

A general article on the Furniture from this city. Prudent Mallard and Joseph Seignouret are mentioned.

876. Poesch, Jessie. "Furniture of the River Road Plantation in Louisiana." Antiques 111 (June 1977): 1184-93. illus.

Examines furniture styles. Shows a piece by D. Barjon.

877. Van Ravenswaay, Charles. "The Forgotten Arts and Crafts of Colonial Louisiana." Antiques 64 (September 1953): 192-95. illus.

Mentions several French-American cabinetmakers. Other arts are discussed.

Maine

878. Dyer, Walter A. "Historic and Documented Antiques from Maine." The Antiquarian 14 (May 1930): 60+. illus.

Examines furniture made by William Saxton, Andrew Homer, and Andrew Brimmer.

879. Maine State Museum. Simple Forms and Vivid Colors. Augusta, Maine: Maine State Museum, 1983. 117 pp. illus.

An exhibition catalog published to accompany a Maine furniture exhibition. Includes a check list.

880. Shettleworth, Earle G., Jr. "A Checklist of Portland, Maine Cabinetmakers, 1785-1825." A paper written for the Boston University Graduate School Seminar on American Furniture, 1972.

Maryland

881. Baltimore Museum of Art. Baltimore Furniture, The Work of Baltimore and Annapolis Cabinetmakers from 1760-1810. Baltimore: Baltimore Museum of Art, 1947. 195 pp. illus.

An exhibition catalog that consists of several essays and a listing of works in the exhibition. 125 pieces are illustrated and discussed. Mention is made of Stitcher and Clemens of Baltimore and John Shaw of Annapolis.

882. ___ . Baltimore Painted Furniture, 1800-1840. Baltimore:
Baltimore Museum of Art, 1972. 132 pp. illus. bibl.

An exhibition catalog that contains an essay by
William Elder and an illustrated catalog of painted
furniture. Contains a useful checklist of furniture
craftsmen.

883. ___ . Maryland Queen Anne and Chippendale Furniture of
the Eighteenth Century. Baltimore: Baltimore Museum of Art,
1968. 128 pp. illus.

An exhibition catalog on an important exhibition of
18th century Maryland furniture. Includes a checklist
of Maryland cabinetmakers.

884. Berkeley, Henry J. "Early Maryland Furniture." Antiques
18 (September 1930): 209-11. illus.

Signed and attributed examples are illustrated. Informa-
tion is given on John Shaw, Stitcher and Clemmens, Thomas
Renshaw, and John Simonson.

885. ___ . "A Register of the Cabinetmakers and Allied
Trades in Maryland as Shown by the Newspapers and Directories,
1746-1820." Maryland Historical Society Magazine 25 (March
1930): 1-27.

List of names of cabinetmakers as gleaned from newspapers
and directories.

886. Bordley, James. "Articles and Speeches on Furniture and
Glassmaking in Baltimore in the 17th and 18th Centuries."
Unpublished paper in the Maryland Historical Society
Library, Baltimore, Maryland.

887. Breeskin, Adelyn D. "Characteristics of Baltimore
Cabinetmakers, 1760-80." American Collector 17 (April 1948):
14-16. illus.

888. Elder, William Voss, III. "Maryland Furniture, 1760-
1840." Antiques 111 (February 1977): 354-61. illus.

An overview of Maryland furniture. Mentions the
major craftsmen.

889. Forman, H.C. Old Buildings, Gardens and Furniture in
Tidewater, Maryland. Cambridge, Maryland: Cornell Maritime,
1967. illus.

890. Hill, John Henry. "The Furniture Craftsmen in Baltimore,
1783-1823." Master's thesis, University of Delaware (Winter-
thur), 464 pp.

891. Huntley, Richmond. "Sheraton as Followed in Baltimore."
American Collector 7 (August 1938): 5. illus.

Examines a fine secretary. Limited in scope.

892. Metropolitan Museum of Art. Baltimore Federal
Furniture in the American Wing. New York: Metropolitan
Museum of Art, 1972. illus.

An exhibition catalog.

893. Ormsbee, Thomas H. "Distinctive Furniture of Baltimore."
American Collector 7 (April 1938): 6-7. illus.

Examines regionalism associated with Baltimore.

894. Pinkerton, Eleanor. "Federal Furniture of Baltimore."
Antiques 37 (May 1940): 233-35.

Some cabinetmakers are mentioned, albeit briefly.

895. Raley, R.L. "Irish Influences in Baltimore Decorative
Arts, 1785-1815." Antiques 79 (March 1961): 276-79. illus.

All decorative arts are discussed. Mentions James
McCormick, cabinetmaker from Dublin.

896. Somerville, Romaine S. "Furniture at the Maryland
Historical Society." Antiques 109 (May 1976): 970-89. illus.

Documented examples of Maryland furniture are shown.

897. Walters Art Gallery. Maryland Heritage--Five Baltimore
Institutions Celebrate the American Bicentennial. Baltimore:
Walters Art Gallery, 1976. 265 pp.

Examines all crafts including furniture.

 Massachusetts

898. Beede, C. G. An Early Queen Anne Escritoire, 1715-39.
Boston: Privately printed, 1929. 10 pp. illus.

A pamphlet on one piece of furniture.

899.Belknap, Henry Wyckoff, comp. Artists and Craftsmen of
Essex County, Massachusetts. Salem, Mass.: Essex Institute,
1927. viii, 127 pp. illus.

A checklist of craftsmen, separated by types of
craftsmen. Includes craftsmen prior to 1860;
gives biographical data on each one. Lacks some
source information.

900. ___ . Trades and Tradesmen of Essex County, Massachu-
setts: Chiefly of the Seventeenth Century. Salem, Mass.:
Essex Institute, 1929. 96 pp.

 An extraction of records from the probate and court
 records of Essex County.

901. Benes, Peter, ed. The Bay and the River: 1600-1900.
Boston: Boston University, 1982. 144 pp. illus.

 Reports from the 6th Annual Dublin Seminar for New
 England Folklife. Of special interest are articles by
 Robert Trent on regionalism in the 17th century, and
 Myrna Kaye's discussion of Concord furniture.

902. Brazer, Esther Steven. "The Early Boston Japanners."
Antiques 43 (May 1943): 208-11. illus.

 About the furniture japanners of Boston. Mentions
 several japanners.

903. Burroughs, Paul H. "Two Centuries of Massachusetts
Furniture." American Collector 6 (September 1937): 4+. illus.

 Review of Massachusetts furniture. Several documented
 examples are shown. A two-page checklist of cabinetmakers
 is provided.

904. Clunie, Margaret B. "Furniture Craftsmen of Salem,
Massachusetts in the Federal Period." Essex Institute
Historical Collections 113 (July 1977): 191-203.

 Based on the 1784-1819 "Diary" of William Bentley.

905. ___ . "Salem Federal Furniture." Master's Thesis,
University of Delaware (Winterthur), 1976. 322 pp. illus.

906. Clunie, Margaret Burke, Anne Farnam, and Robert F.
Trent. Furniture at the Essex Institute. Salem, Mass.:
Essex Institute, 1980. 64 pp. illus.

 A booklet on the furniture at the Essex Institute.

907. Colonial Society of Massachusetts. Boston Furniture
of the 18th Century. Boston: Colonial Society of
Massachusetts, 1974. 306 pp. illus.

 The book is the result of an exhibition and conference
 held by the Colonial Society. Contains an essay on
 Benjamin Frothingham, a checklist of Boston cabinet-
 makers, and other essays.

908. Comstock, Helen. "Craftsmen of the Springfield
Region." Connoisseur 98 (July 1936): 42 pp. illus.

 Reviews an exhibition at the Springfield Museum of Fine
 Arts. Mentions William Lloyd.

909. Cooke, Edward S. "Boston Furniture Industry in 1880." Old-Time New England 70 (Winter 1980): 82-98. illus.

The best article on furniture from Boston during this period.

910. Cooper, Nancy. "Some Documented Salem Furniture." House Beautiful 69 (March/April 1931): 280+. illus.

Furniture made by S. McIntire and Nehemiah Adams. Illustrates pieces owned by Mrs. Warren Stearns that were purchased prior to 1810.

911. Dow, George Francis. The Arts and Crafts in New England, 1704-1775: Gleanings from Boston Newspapers. Topsfield, Mass.: Wayside Press, 1927. Reprint, New York: DaCapo Press, 1967. xxxii, 325 pp.

Reprints newspaper advertisements. Good as a source of information on the 18th century craftsmen.

912. Dyer, Walter A. "Luther's Hadley Chest Hunt Passes Hundred Mark." American Collector 1 (December 1933): 3+. illus.

Progress report on Clair Luther's study of Hadley area chests.

913. "Early Furniture and Household Furnishings, References Gleaned from 18th Century Boston Newspapers." Old-Time New England 15 (July 1924): 14-17.

Twenty-four advertisements related to furniture are reprinted.

914. Essex Institute. Essex County Furniture: Documented Treasures from Local Collections, 1660-1860. Salem, Mass.: Essex Institute, 1965. unpaged. illus.

An exhibition catalog of a loan exhibition held in 1965. Identifies special characteristics of Massachusetts furniture. Gives information about 76 documented pieces of furniture.

915. Fales, Dean A., Jr. The Furniture of Historic Deerfield. New York: E.P. Dutton and Co., 1976. 294 pp. illus, index.

A detailed catalog of the collections at Deerfield.

916. Farnam, Anne. "Essex County Furniture Carving: The Continuance of a Tradition." Essex Institute Historical Collection 116 (July 1980): 145-55. illus.

From a symposium entitled "Furniture in Victorian America." Information about Joseph True and Israel Fellows is given.

917. Farnam, Anne. "Furniture at the Essex Institute, Salem, Mass." Antiques 111 (May 1977): 958-73. illus.

Mostly Massachusetts 17th and 18th century furniture.

918. Forman, Benno M. The 17th Century Case Furniture of Essex County Massachusetts and Its Makers. Salem, Mass.: Privately printed, 1968. 160 pp. illus.

Based on the master's thesis by the author. Focuses on William and Mary examples.

919. ___. "The 17th Century Case Furniture of Essex County, Massachusetts and Its Makers." Master's Thesis, University of Delaware (Winterthur), 1968. 160 pp.

920. Fraser, Esther Stevens. "The Tantalizing Chests of Taunton." Antiques 23 (April 1933): 135-38. illus.

Examines Taunton 18th century chests. Gives biographical information on decorator Robert Crosman.

921. "The Furniture." Antiques 70 (September 1956): 224-37. illus.

Information on furniture of Historic Deerfield.

922. Greene, Richard Lawrence. "Fertility Symbols on the Hadley Chests." Antiques 112 (August 1977): 250-59. illus.

Examines the meanings of some carvings on the Hadley chests.

923. Hall, Elton W. "New Bedford Furniture: Checklist of New Bedford Cabinetmakers and Related Craftsmen, 1792-1870." Antiques 113 (May 1978): 1105-27. illus.

Contains a valuable 12-page checklist of craftsmen. Major craftsmen are examined in more detail.

924. Hill, John H. "The History and Technique of Japanning and the Restoration of the Pimm Highboy." American Art Journal 8 (November 1976): 59-84. illus.

A good explanation of how japanning was done.

925. Jobe, Brock W. "Boston Furniture Industry, 1725-1760." Master's Thesis, University of Delaware (Winterthur), 1976. 143 pp.

926. Kane, Patricia. "Furniture Owned by the Massachusetts Historical Society." Antiques 109 (May 1976): 960-69. illus.

Some cabinetmakers are mentioned.

927. Keno, Leigh. "The Windsor-Chair Makers of North-
ampton, Massachusetts, 1790-1820." Antiques 118 (May 1980):
1100-1107. illus.

 Contains an excellent checklist of chairmakers in
 Northampton.

928. Kimball, Fiske. "Salem Secretaries and Their Makers."
Antiques 13 (May 1933): 168-70. illus.

 Gives information on secretaries made by Edmund Johnson.
 Nehemiah Adams, Mark Pitman and Nathaniel Adams.

929. "Local Work Shown at Springfield." American Collector
5 (June 1936): 1+. illus.

 Review of an exhibition.

930. Lovell, Margaretta Markle. "Boston Blockfront Furni-
ture." Master's thesis, University of Delaware (Winterthur),
1975. 97 pp.

931. Luther, Clair Franklin. "Found, Three More Hadley
Chests." American Collector 6 (March 1937): 3+. illus.

 More on Hadley chests.

932. Luther, Clair Franklin. The Hadley Chest. Hartford,
Conn.: Lockwood and Brainard, 1935. xxii, 144 pp. illus.
bibl.

 The most important reference on the so-called Hadley
 chests. Lists all known chests in the Hadley style.
 Still considered the definitive work on these
 17th and early 18th century pieces.

933. ___. Supplemental List of Hadley Chests Discovered
Since Publication of the Book in 1935, Together with
Changes in Ownership as Reported. Hartford, Conn.:
Case, Lockwood, and Brainard, 1938. 4 pp.

934. "Mirrors of Newburyport." Antiques 2 (October 1922):
153. illus.

 Short note on Barnard Cermenati, looking-glass maker.

935. Montgomery, Charles. A Word About Arts and Crafts of
Old Salem. New York: Walpole Society, 1964. 6 pp. illus.

 Reprinted from the Walpole Society Notebook.

936. Museum of Fine Arts. A Bit of Vanity: Furniture of
18th Century Boston. Boston: Museum of Fine Arts, 1972.
30 pp. illus.

 An exhibition catalog.

937. ___. <u>Paul Revere's Boston: 1735-1818</u>. Boston: Museum of Fine Arts, 1975. 234 pp. illus. bibl.

Some furniture is shown in this exhibition catalog.

938. Park, Helen. "17th Century Furniture of Essex County and Its Makers." <u>Antiques</u> 78 (October 1960): 350-55. illus.

Discusses 17th Century regional styles of Essex Co. Mentions several joiners and chairmakers.

939. Peladeau, Marius B. "A Hadley Chest Reconsidered." <u>Antiques</u> 117 (May 1980): 1084-86. illus.

Discusses the 'M.S.' that appears in Luther's book. Suggests that this chest has a different provenance.

940. Pillsbury, William M. "The Joiners and Joinery of Middlesex County, Massachusetts, 1630-1730." Master's thesis, University of Delaware (Winterthur), 1975. 173 pp. illus.

941. Randall, Richard H., Jr. "Boston Chairs." <u>Old-Time New England</u> 54 (Summer 1963): 12-20. illus.

Discusses the "Boston" chair, a maple and leather chair made during the 18th century. Such chairs were made in places outside other than Boston.

942. ___. "Works of Boston Cabinetmakers, 1795-1825." Parts 1, 2. <u>Antiques</u> 81 (February, April 1962): 186-89, 412-15. illus.

Discusses the furniture and makers in Boston. Makes several attributions and questions some older attributions.

943. Rhoades, Elizabeth, and Brock Jobe. "Recent Discoveries in Boston Japanned Furniture." <u>Antiques</u> 105 (May 1974): 1082-91. illus.

Discusses three previously unpublished high chests with japanning. Japanner Robert Davis is mentioned.

944. St. George, Robert. "Styles and Structure in the Joinery of Dedham and Medfield, Massachusetts." Master's thesis, University of Delaware (Winterthur), 1978. 114 pp. illus.

945. ___. "Style and Structure in the Joinery of Dedham and Medfield, Massachusetts, 1635-1685." <u>Winterthur Portfolio</u> 13 (1979): 1-46.

Identifies the work of John Houghton and John Thurston. Contains a biographical checklist of furniture makers who worked in these towns.

946. "Salem Cabinetmakers Produced Much Fine Distinctive Furniture." <u>American Collector</u> 3 (December 1934): 3+. illus.

Examines Salem cabinetmakers other than McIntire.

947. Smith, Nancy A. "Pianoforte Manufacturing in 19th Century Boston." <u>Old-Time New England</u> 69 (Summer/Fall 1978): 37-47. illus.

History of piano making in Boston. Major craftsmen are examined.

948. Swan, Mabel M. "Boston's Carvers and Joiners." Parts 1, 2. <u>Antiques</u> 53 (March, April 1948): 198-201, 281-85. illus.

Part I deals with pre-Revolutionary, and part II deals with post-Revolutionary, craftsmen. Contains a long checklist of makers.

949. ___. "Furniture Makers of Charlestown." <u>Antiques</u> 46 (October 1944): 203-6. illus.

Contains an important checklist of cabinetmakers and chairmakers working prior to 1775. Uses contemporary documents.

950. ___. "Newburyport Furniture Makers." <u>Antiques</u> 47 (April 1945): 22-25. illus.

Lists about 100 cabinetmakers and related craftsmen who were active in Newburyport, Mass. Gives dates of activity and occupations. A correction appears in May, 1945, <u>Antiques</u>.

951. ___. "Some Men from Medway." <u>Antiques</u> 17 (May 1930): 417-21 illus.

Mentions cabinetmakers, including Elisha Richardson, Luther Metcalf, Eleazar Daniels, Samuel Benjamin, Calvin Plympton, and Stephen Adams.

952. Talbott, Page E. "Boston Empire Furniture." Parts 1, 2. <u>Antiques</u> 107, 119 (May 1975, May 1976): 878-87, 1004-13. illus.

History of furniture making in the early part of the 19th century. Many craftsmen are discussed and biographical information is given.

953. ___. "The Furniture Industry in Boston, 1810-35." Master's thesis, University of Delaware (Winterthur), 1974. 274 pp.

954. Vaughan, Malcolm. "Made in Boston or Philadelphia."
American Collector 15 (April 1946): 5+. illus.

Examines the problems of regional attributions.

955. Whitmore, Elizabeth. "The Wedding Furniture of Anna
Barnard." Antiques 10 (November 1926): 5+. illus.

Information on Abner Barnard and the wedding furniture
given to his daughter. Illustrates 18th Century
furniture.

Michigan

956. Ames, Kenneth L. "Grand Rapids Furniture at the Time
of the Centennial." Winterthur Portfolio 10 (1975): 23-50.
illus.

Early history furniture making in this city. Mentions
Berkey and Gay, Phoenix, and Nelson, Matter and Co.

957. Bradshaw, James S. "The Furniture Industries in
Grand Rapid to 1880." Unpublished student paper at the
Michigan History Collection, University of Michigan.
37 pp.

958. ___. "Grand Rapids Furniture Beginnings." Michigan
History (Winter 1968): 279-98. illus. notes.

About Grand Rapids furniture, 1836-1870. Contains
information on craftsmen, prices and related items.

959. Buchner, William E. "The Grand Rapids Furniture
Strike of 1911." Student paper at the Michigan History
Collection at the University of Michigan, 1961. 29 pp.

960. Detroit Institute of Art. Arts and Crafts in Detroit:
The Movement, The Society, The School. Detroit: Founder's
Society, Detroit Institute of Arts and Center for Creative
Studies, 1976. 296 pp. illus. bibl.

An exhibition catalog. Brief references to
furniture craftsmen.

961. The Furniture Career of Grand Rapids--A Brief Story
Compiled by the City's Furniture Interests. Grand Rapids:
n.p., 1941. 17 pp. illus.

962. Grand Rapids Market Association. The Furniture Capital
of America: The Story of Grand Rapids Furniture Market.
2 vols. Grand Rapids, Mich.: Grand Rapids Market Association,
1921-1923.

Historical sketches of manufacturers in Grand Rapids.

963. H. C. White and Co. Furniture Directory of Grand
Rapids. Grand Rapids, Mich.: H. C. White and Co., 1893.

964. Horton, Russell M. "All in the Family." Chronicle
of the Early American Industries Association 16 (March 1980):
17-22. illus.

 Furniture industries in Grand Rapids, 1885-1916.

965. Ransom, Frank Edward. The City Built on Wood. A
History of the Furniture Industry in Grand Rapids, Michigan,
1850-1950. Ann Arbor, Michigan: Edwards Brothers, 1955.
101 pp. illus.

966. White, Arthur S. "Grand Rapids Furniture Centennial."
Michigan History Magazine 12 (April 1928): 267-79.

 About the famous semi-annual furniture makret show in
 Grand Rapids. Histories of several companies are given.

 Missouri

967. "Missouri-Made Furniture." Antiques 73 (January 1958):
74. illus.

 Two pieces of Missouri-made furniture are shown.

968. Van Ravenswaay, Charles. "The Anglo-American Cabinet-
makers of Missouri, 1800-1850." Missouri Historical Society
Bulletin 15 (April 1958).

 Includes a useful checklist of craftsmen working in
 St. Louis. Discusses the furniture made in and imported
 to the St. Louis area.

969. ___ . The Arts and Architecture of German Settlements in
Missouri; A Survey of a Vanishing Culture. Columbia, Missouri:
University of Missouri Press, 1977. 560 pp. illus. bibl.

 Chapter 13, consisting of 183 pages, is about furniture.
 Does not claim to have developed a regional style.
 Several furniture makers are discussed.

970. ___ . The Creole Arts and Crafts of Upper Louisiana.
St. Louis: Missouri Historical Society, 1956. illus.

 A reprint from the Missouri Historical Society Bulletin.

971. ___ . "Missouri River German Settlements, Part II: The
Decorative Arts, 1830-1900." Antiques 113 (February 1978):
394-409. illus.

 All decorative arts are discussed. Some cabinetmakers
 including William Kunze, are discussed.

New Hampshire

972. Buckeley, Charles E. "Fine Federal Furniture Attributed
to Portsmouth." Antiques 83 (February 1963): 195-200. illus.

 A general article on the history of furniture making in
Portsmouth. Does mention several craftsmen.

973. ___. "The Furniture of New Hampshire: A Bird's Eye
View From 1725-1825." Antiques 86 (July 1964): 56-61. illus.

 A review of an exhibition. Makes several attributions.

974. Burroughs, Paul H. "Furniture Widely Made in New Hamp-
shire." American Collector 6 (June 1937): 6+. illus.

 Checklist of furniture craftsmen working in New Hampshire
prior to 1830. Some craftsmen are examined in detail.

975. Currier Gallery of Art. The Decorative Arts of New
Hampshire. Manchester, New Hampshire: Currier Gallery of
Art, 1964. 73 pp. illus.

 An exhibition catalog in which 92 pieces are illustrated.
Information is given on some cabinetmakers including
the Dunlap family.

976. ___. Eagles, Urns, and Columns: Decorative Arts of the
Federal Period. Manchester, New Hampshire: The Currier
Gallery of Art, 1979.

 An exhibition catalog.

977. "Discovery and Checklists." Historic New Hampshire 12
(December 1956): 28-29.

 Mentions Solomon Wardwell and Elliot Hill, cabinetmakers.

978. Kaye, Myrna. "Marked Portsmouth Furniture." Antiques
113 (May 1978): 1098-1104. illus.

 Examines the furniture that is identified with Portsmouth
either by owner or maker.

979. New Hampshire Historical Society. The Decorative Arts
of New Hampshire: a Sesquicentennial Exhibition. Concord,
New Hampshire: 1973. 64 pp. illus.

 An exhibition catalog that illustrates and discusses
37 examples of New Hampshire furniture.

980. ___ . <u>Plain and Elegant, Rich and Common</u>. Documented <u>New Hampshire Furniture 1750-1850</u>. Concord, New Hampshire: New Hampshire Historical Society, 1979. 153 pp. illus.

 An exhibition catalog of a 1978 exhibition. Gives biographical information on 47 craftsmen. Major examples are illustrated and documented.

981. [Nylander], Jane C. Giffen. "New Hampshire Cabinetmakers and Allied Craftsmen, 1790-1850." <u>Antiques</u> 94 (July 1968): 78-87. illus.

 A significant checklist of New Hampshire cabinetmakers. Includes information from early documents.

982. Page, John F. "Documented New Hampshire Furniture, 1750-1850." <u>Antiques</u> 115 (May 1979): 1004-15. illus.

 Illustrates and discusses 25 examples of documented furniture. Gives information about some cabinetmakers. Two bills of sale and seven labels are shown.

983. Rhoades, Elizabeth Adams. "The Furniture of Portsmouth Houses." <u>Historic New Hampshire</u> 28 (April 1973): 1-19. illus.

 Uses inventories to help explain the nature of furniture in 18th century Portsmouth.

984. ___ . "Household Furnishings in Portsmouth, New Hampshire: 1750-1775." Master's thesis, University of Delaware (Winterthur), 1972. 172 pp.

985. Stow, Charles Messer. "Northern New England Furniture." <u>The Antiquarian</u> 10 (May 1928): 32-37. illus.

 Discusses regional styles of northern New England. Concentrates on New Hampshire. Mentions some craftsmen.

986. Watts, Melvin E. "New England Furniture in the Currier Collection." <u>Currier Gallery of Art Bulletin</u> (July/September 1969): 1-19. illus.

 Mostly on New Hampshire furniture.

<div align="center">New Jersey</div>

987. "Crafts and Craftsmen of New Jersey, 1684-1850." <u>Antiques</u> 62 (Septebmer 1952): 198-99. illus.

 Lists 13 furniture makers from New Jersey.

988. Hanson, Frederick G. "The Interior Architecture and
Household Furnishings of Bergen County, New Jersey, 1800-
1860." Master's thesis, University of Delaware (Winterthur),
1959. 195 pp.

989. Hopkins, Thomas S., and Walter S. Cox. Colonial
Furniture of West New Jersey. Haddonfield, N.J.: Historical
Society of Haddonfield, 1936. 113 pp. illus.

 Illustrates and discusses furniture which orginated in
 west New Jersey.

990. Johnson, Marilynn Ann. "Clockmakers and Cabinetmakers
of Elizabethtown, New Jersey, in the Federal Period."
Master's thesis, University of Delaware (Winterthur), 1963.
260 pp.

991. Lyle, Charles T. New Jersey Arts and Crafts: The
Colonial Expression. Lincroft, New Jersey: Monmouth
Museum, 1972.

992. Lyle, Charles T., and Philip D. Zimmerman. "Furniture
of the Monmouth County Historical Association." Antiques 117
(January 1980): 186-205. illus.

 Several pieces of furniture that have been identified
 by maker.

993. MacDonald, William H. "Central New Jersey Chairmaking
of the 19th Century." Proceedings of the New Jersey
Historical Society 79 (1959): 185-207. illus.

 Contains biographies on 42 chairmakers. Some biographies
 are as long as two pages.

994 ___ . "Central New Jersey Chairmaking of the 19th Century."
Chronicle of the Early American Industries Association 3
(January/April 1946): 54-63. illus.

 Focuses on the making of chairs rather than the makers.

995. ___ . Nineteenth Century Chair Makers of Central
New Jersey. Freehold, N.J.: Privately printed, 1960. 59 pp.

 Reprinted from the Proceedings of the New Jersey
 Historical Society. Attempts to correct attributions
 of furniture usually assigned to Philadelphia or
 New York.

996. Newark Museum. Century of Revivals." Newark, N.J.:
Newark Museum, 1983. 64 pp. illus.

 An exhibition catalog that contains pieces made by
 New Jersey furniture makers, including Jelliff.

997. ___. Early Furniture Made in New Jersey, 1690-1870.
Newark,N.J.: Newark Museum, 1958. 89 pp. illus. bibl.

An exhibition catalog that was compiled by Margaret E.
White. Contains information on 85 pieces of furniture
and a highly important biographical check list of over
1000 furniture makers. There is also an excellent
essay on early New Jersey furniture.

998. New Jersey State Museum. From Tenape Territory to
Royal Province, New Jersey 1600-1750. Trenton, N.J.:
New Jersey State Museum, 1977. 88 pp. illus.

An exhibition catalog that examines all decorative arts
of this period.

999. ___. The Royal Province, New Jersey, 1738-1776.
Trenton, N.J.: New Jersey State Museum, 1973. 133 pp. illus.

An exhibition catalog that includes information on
furniture and furniture makers.

1000. White, Margaret E. The Decorative Arts of Early
New Jersey. Princeton, N.J.: D. Van Nostrand, 1964. 137 pp.
illus.

Includes information on all arts and crafts in New Jersey.
Contains some errors.

1001. ___. "Further Notes on Early Furniture of New Jersey."
Antiques 78 (August 1960): 136-39. illus.

Mentions newly discovered information concerning
New Jersey furniture and furniture makers.

1002. ___. "Some Early Furniture Makers of New Jersey."
Antiques 74 (October 1958): 322-25. illus.

Based on information from an exhibition of New Jersey
furniture. Maskell Ware, Oliver Parsell, and John
Jelliff are some craftsmen discussed.

New Mexico

1003. Boyd, E. Popular Arts of Spanish New Mexico. Santa Fe,
N.M.: University of New Mexico Press, 1974. 518 pp. illus.
bibl. appendix.

Furniture is only briefly mentioned.

1004. Culin, Stewart. "The Story of the Carved Pilasters
From the Franciscan Church of Our Lady of Guadalupe at Zuni,
New Mexico." Good Furniture (April 1916): 233-39. illus.

Discusses the Indian influence on Mission furniture.

1005. Mather, Christine. "The Arts of the Spanish in New Mexico." _Antiques_ 113 (February 1978): 422-31. illus.

Only a few pieces of furniture are shown.

1006. Vedder, Alan C. _Furniture of Spanish New Mexico_. Santa Fe, N.M.: Sunstone Press, 1977. 96 pp. illus.

Examples of furniture are discussed and shown. The only book exclusively devoted to furniture of this state.

New York

1007. Albany Institute of History and Art. _New York Furniture before 1840_. Albany, N.Y.: Albany Institute of History and Art, 1962. 63 pp. illus. bibl.

An exhibition catalog of New York furniture. Each piece is illustrated and discussed. Not as complete as one would hope.

1008. Behrens, Dorothy W. "Birth of Victorian Fashions in New York, 1842." _American Collector_ 14 (May 1945): 8-9. illus.

Victorian designs in published material.

1009. Blackburn, Roderic H. "Branded and Stamped New York Furniture." _Antiques_ 119 (May 1981): 1130-45. illus.

States that branded and stamped furniture is more common for New York furniture. Several examples are shown. An excellent chart of known stamps and brands is provided.

1010. ___ . _Cherry Hill: The History and Collections of a Van Rensselaer Family_. Albany, N.Y.: Historic Cherry Hill, 1976. vii, 176 pp. illus. bibl.

A catalog of the furniture in this important New York State family.

1011. ___ . "Dutch Material Culture; Furniture." _Halve Maen_ 54 (1979): 3-5.

1012. Bolger, Stuart B. _Early Arts in the Genesee Valley, 18th and 19th Century_." Geneseo, N.Y.: Genesee Valley Council on the Arts, 1974. 158 pp. illus.

Contains an essay by Mary Warner Marex on furniture of the area.

1013. Butler, Joseph T. "Dutch and English Influence on Pre-Revolutionary New York Furniture." Art and Antiques 3 (May/June 1980): 66-73. illus.

 States that the English influence is greater than usually believed. Examines the furniture from the Hudson River area.

1014. Cairns, Kathleen. "Chair Makers in Orange Co." New York History 26 (October 1945): 4.

 List of chair makers in Orange County, N.Y.

1015. Calder, Jacqueline. "Westchester County, New York Furniture." Antiques 121 (May 1982): 1195-98. illus.

 Several documented pieces are shown. Some information on craftsmen is given.

1016. Cassidy, Anne Ricard. "Furniture in Upstate New York, 1760-1840: The Glen-Sanders Collection." Master's thesis, University of Delaware (Winterthur), 1981.

1017. Cathers, David. Furniture of the American Arts and Crafts Movement: Stickley and Roycroft Mission Oak. New York: New American Library, 1981. ix, 275 pp. illus. bibl.

 Focuses on the furniture production of both Stickley and Roycroft. Illustrates numerous examples of furniture made by these firms.

1018. Downs, Joseph. "New York Furniture." Bulletin of the Metropolitan Museum of Art 29 (January/February 1934): 2-6. (Also published in Art News 32 (February 1934): 3+.) illus.

 Review of an exhibition. Includes information on Gilbert Ash, Thomas Burling, Phyfe, and others.

1019. Dunn, James Taylor. Pioneer Cabinetmakers of Cooperstown. Cooperstown, N.Y.: Privately printed, 1955. 5 pp.

 A short checklist of craftsmen in Cooperstown.

1020. Fabend, Firth H. "Two 'New' 18th Century Grisaille Kasten." Clarion 10 (Spring/Summer 1981): 44-49. illus.

 Examines two pieces of New York furniture.

1021. Failey, Dean F. "The Furniture Tradition of Long Island's South Fork, 1640-1800." American Art Journal 11 (January 1979): 49-64. illus.

 Compares the furniture of Long Island and New England. Illustrates and discusses examples of South Fork furniture including a piece by Timothy Mulford.

1022. Franco, Barbara. "New York City Furniture Bought for the Fountain Elms by James Watson Williams." Antiques 114 (September 1973): 462-67. illus.

Discusses the documented furniture at the Fountain Elms. Includes receipts from New York City makers.

1023. Freeman, Larry. "Victorian Cabinetmakers of New York." Hobbies 49 (July 1944): 39-40.

1024. Gilborn, Craig. "Rustic Furniture in the Adirondacks, 1875-1925." Antiques 109 (June 1976): 1212-219. illus.

Review of an exhibition of rustic furniture.

1025. Gillingham, Harrold. "Some New York Cabinetmakers of the 18th Century." New-York Historical Society Quarterly 14 (October 1930): 95-99. illus.

Discusses several 18th century New York cabinetmakers. Includes copies of receipts and related materials.

1026. Ginsburg, Benjamin. "Some Observations on Pre-Revolutionary New York Furniture." Antiques 70 (November 1956): 456-58. illus.

About high style furniture from New York. Regional distinctions are compared and some craftsmen are reviewed.

1027. Gottesman, Rita Susswein, comp. The Arts and Crafts in New York, 1726-1776: Advertisements and News Items from New York City Newspapers. New York: New-York Historical Society, 1938. xviii, 450 pp.

Information on all of the arts and crafts as gleaned from New York newspapers. Important as primary sources.

1028. ___ . The Arts and Crafts in New York, 1777-1799: Advertisements and News Items from New York City Newspapers. New York: New-York Historical Society, 1954. xix, 484 pp.

The sequel to the book in the previous entry.

1029. ___ . "Pre-Revolutionary Furniture Makers of New York City." Antiques 25 (January 1934): 6+. illus.

Examines the style, construction and makers of 18th century New York City cabinetmakers. 74 craftsmen listed.

1030. Held, Huyer. "Chests from Western Long Island." Antiques 36 (January 1939): 14-15. illus.

Discusses 18th century chests. No mention of individual makers.

1031. Hendrick, Robert E. "New York High-Style Furniture, 1750-1775." Brooklyn Museum Annual 8 (1966): 103-111. illus.

Focuses on the work of the most well known 18th Century cabinetmakers.

1032. Johnson, J. Stewart. "New York Cabinetmakers Prior to the Revolution." Master's thesis, University of Delaware (Winterthur), 1964. 123 pp.

1033. Johnston, Fred F. "Ulster County Cabinet and Glass Makers." New York History 17 (January 1936): 70-74.

Mostly on glass making with only two paragraphs devoted to furniture makers.

1034. Keyes, Homer Eaton. " A Clue to New York Furniture." Antiques 21 (March 1932): 122-23. illus.

New York's regional style is discussed. Gilbert Ash is mentioned.

1035. "Location of New York Cabinetmakers Before the Revolution." American Collector 15 (October 1946): 4+.

1036. Metropolitan Museum of Art. New York State Furniture. New York: Metropolitan Museum of Art, 1934. xxiii, 28 pp. illus.

An exhibition catalog for a loan exhibition. Lists 256 objects and describes them. Contains contemporary references. Compiled by Joseph Downs and Ruth Ralston.

1037. Miller, V. Isabelle. "Furniture by New York Cabinet-makers." Connoisseur 142 (October 1958): 128-31.

Review of an exhibition at the Museum of the City of New York.

1038. Museum of the City of New York. Furniture by New York Cabinetmakers, 1650-1860. New York: Museum of the City of New York, 1956. 84 pp. illus.

A descriptive exhibition catalog of an important exhibition held in 1956 and 1957. Contains information on 144 pieces. Each entry contains data on maker, size, provenance and bibliographical source, when available.

1039. Newman, J.F. "How New York Cabinetmakers and Chair-makers Set Their Scale of Wages." American Collector 13 (September 1944): 12-13.

Interesting for the information about craftsmen's wages.

1040. Norman-Wilcox, G. "Hudson River Chippendale Chairs."
Connoisseur 171 (June 1969): 126-32. illus.

 Uses original documents to discuss the history of
 furniture making in the two decades before the
 Revolutionary War.

1041. Patterson, Jerry E. "New York Furniture." Art Gallery
16 (October 1972): 23-25. illus.

 A very general article on collecting New York furniture.
 Mentions most major N.Y. craftsmen.

1042. Pierce, Donald. "New York Furniture at the Brooklyn
Museum." Antiques 115 (May 1979): 994-1003. illus.

 Some New York cabinetmakers are mentioned.

1043. Price, Lois Olcott. "Furniture Craftsmen and the Queen
Anne Style in 18th Century New York." Master's thesis,
University of Delaware (Winterthur), 1977. 164 pp.

1044. Rozario, Pedro de., comp. "Cabinetmakers and Chair-
makers of New York." Unpublished paper in the Library at
the Metropolitan Museum of Art, 1940. 76 pp. bibl.

 Part of a WPA project that was done under the direction
 of V. Isabelle Miller.

1045. Scherer, John L. "Labeled New York Furniture at
the New York State Museum, Albany." Antiques 119 (May 1981):
1113-129. illus.

 Review of an exhibition. Several labeled
 pieces are illustrated.

1046. ___ . "New York State Furniture." Connoisseur 207
(August 1981): 308-312. illus.

 Based on the 1981 exhibition at the New York State
 Museum.

1047. Schild, Joan L. "Furniture Makers of Rochester, New
York." New York History 37 (January 1956): 97-106.

 A check list of cabinetmakers and chairmakers of
 Rochester and nearby areas. Some documented examples
 are illustrated.

1048. Schwartz, Marvin D. "Antiques: The Essence of New
York Style Furniture at the New-York Historical Society."
Art News 75 (April 1976): 106+. illus.

 A review of a show at the New-York Historical Society.

1049. Semowich, Charles J. "Cabinetmakers and Furniture Makers in Central New York State, Working Prior to and Including 1915." Ph.D. diss., International College, 1981. 370 pp. appendix.

 Lists approximately 3500 craftsmen from 11 upstate New York counties.

1050. Sherrill, Sarah B., ed. "Current and Coming." Antiques 109 (March 1976): 414. illus.

 Reviews a show of New York furniture. Three pieces are illustrated.

1051. Smith, James L. "Oldtime Chairmakers of Erin." New York History 36 (October 1955): 446-53. illus.

 Contains the personal recollections of the author concerning six furniture makers active in Erin, Chemung County.

1052. Society for the Preservation of Long Island Antiquities. Long Island is my Nation: The Decorative Arts and Crafts, 1640-1830. Setauket, N.Y.: Society for the Preservation of Long Island Antiquities, 1976. 304 pp. illus. bibl.

 An exhibition catalog that includes information on furniture.

1053. Storey, W. R. "New York Heritage of Furniture Craft." Parnassus 6 (March 1934): 12+.

1054 Stow, Charles Messer. "New York Furniture." New York History 25 (April 1944): 256-58.

 Short discussion of New York furniture.

1055. Ward, Barbara M., and W. R. Gerald. "The Furniture of Sir William Johnson, A Report." Copy in the Albany Institute of Art and History.

North Carolina

1056. Beckerdite, Luke. "The Development of Regional Style in Catawba River Valley: A Further Look." Journal of Early Southern Decorative Arts 7 (November 1981): 31-48. illus.

 Mentions several craftsmen in a study of regionalism. Excellent information on construction details.

1057. Bivins, John, Jr. "Baroque Elements in North Carolina Moravian Furniture." Journal of Early Southern Decorative Arts 1 (May 1976): 38-63. illus.

The furniture of 18th century Moravian craftsmen. Some specific makers are identified.

1058. ___. "A Piedmont North Carolina Cabinetmaker: The Development of Regional Style." Antiques 108 (May 1973): 968-73. illus.

Examines the regional style in Randolph County, North Carolina, and the craftsmen who made the furniture.

1059. Craig, James Hicklin. The Arts and Crafts in North Carolina, 1699-1840. Winston-Salem, North Carolina: Museum of Early Southern Decorative Arts, Old Salem, Inc., 1965. vii, 480 pp. illus. bibl.

Data obtained from newspapers. Includes information on all crafts. Entries 585 to 1426 are on furniture.

1060. Crane, Alexander. "North Carolina Furniture, 1685-1835." Typescript copy in the North Carolina State Department of Archives and History.

1061. Horton, Frank L. "Carved Furniture of the Albemarle: A Tie with Architecture." Journal of Early Southern Decorative Arts 1 (May 1975): 14-20. illus.

Explores 18th century North Carolina furniture in the Albemarle region and some cabinetmakers.

1062. Museum of Early Southern Decorative Arts. North Carolina Furniture. Winston-Salem, North Carolina: Museum of Early Southern Decorative Arts. 56 pp. illus.

An exhibition catalog. Mentions cabinetmakers Mordica Collins, Jonathan Long, and Jesse Clodfelter.

1063. North Carolina Museum of Art. Two Hundred Years of the Visual Arts in North Carolina. Raleigh, N.C.: North Carolina Museum of Art, 1976. 146 pp. illus.

An exhibition catalog written by Mousa M. Domit, Louise Hall, Claude Howell, Benjamin F. Williams, and John Bivens, Jr. Contains information on all of the arts including some discussion of North Carolina furniture.

1064. North Carolina Museum of History. <u>North Carolina Furniture 1700-1900</u>. Raleigh, North Carolina: North Carolina Museum of History Associates, 1977. xiii, 77 pp. illus.

An exhibition catalog for a 1977 exhibition. Explores 200 years of furniture styles in this state. Includes essays on each period. Each catalog entry contains information on dates, locations, measurements, and related data on the furniture.

1065. Smith, Michael. "North Carolina Furniture, 1700-1900." <u>Antiques</u> 115 (June 1979): 1266-77. illus.

General discussion on North Carolina furniture. Mentions aspects of regional styles, with only a brief review of craftsmen.

1066. Swan, Mabel Munson. "Moravian Cabinetmakers of a Piedmont Crafts Center." <u>Antiques</u> 59 (June 1951): 456-59. illus.

Examines Salem, North Carolina, cabinetmakers, who were active during the latter part of the 18th century. The checklist of 20 craftsmen is very useful.

Ohio

1067. Ellis, Anita. "Cincinnati Art Furniture." <u>Antiques</u> 121 (April 1982): 930-39. illus.

Examines the Aesthetic Movement in relation to furniture making in the 1870s. Illustrates several fine examples.

1068. McDermitt, Monty. "Ohio Furniture: New Bremen, Auglaize County, Ohio." <u>Ohio Antique Review</u> 9 (April 1983): 18-22. illus.

Information on furniture makers from this area The major reference is the 1860 U. S. Census.

1069. Sikes, Jane E. <u>The Furniture Makers of Cincinnati, 1790-1849</u>. Cincinnati, Ohio: Privately printed, 1978. 264 pp. illus. bibl.

A survey of the furniture of this city, with a comprehensive checklist of over 1000 furniture makers and dealers. Uses primary materials, such as newspapers, government documents, and related sources.

1070. Streifthau, Donna L. "Cincinnati Cabinet and Chair Makers, 1819-1830." Ph.D. diss., Ohio State University, 1970.

1071. ___ . "Cincinnati Cabinet and Chair Makers, 1819-1830." Antiques 99 (June 1971): 896-905. illus.

 A comprehensive study of the furniture of Cincinnati. Includes seven pages of useful biographies.

1072. ___ . "Fancy Chairs and Finials: Cincinnati Furniture Industry, 1819-1830." Cincinnati Historical Society Bulletin 29 (1971): 171-200. illus.

 Excerpts from the author's dissertation.

1073. Western Reserve Historical Society. American Furniture in the Western Reserve 1680-1830. Cleveland: Western Reserve Historical Society, 1972. 133 pp. illus.

 An exhibition catalog of furniture from the early period of Ohio.

1074. Wilson, C. R. "Cincinnati: A Southern Outpost." Mississippi Valley Historical Review 24 (1937): 473-82.

 Includes brief mention of Cincinnati furniture.

 Pennsylvania

1075. "All by Philadelphia Cabinetmakers." American Collector 3 (April 1935): 5+. illus.

 One page of labelled furniture is illustrated.

1076. Benson, Evelyn A. "Early Furniture of Western Pennsylvania." Antiques 39 (February 1941): 72-75. illus.

 Comprehensive article on the furniture makers of the Pittsburgh area. Information is given about Freeman and Saverin, William Earl, John Buckingham, Thomas Lukens, Griffen and Thorn, Samuel Brown, and others.

1077. Bjerkoe, Ethel H. "The Furniture of Philadelphia." Spinning Wheel 19 (April 1963): 18-19.

1078. ___ . "Philadelphia Made Chairs of the Chippendale Period." Hobbies 63 (April 1958): 60-61. illus.

 Contains information on most of the noted chair makers of Philadelphia.

1079. Brendlinger, Edna. "It's Not Johnstown...It's Soap Hollow." Parts 1-2. Ohio Antique Review 6 (October, November 1980): 37+, 37+, illus.

1080. Cain, Helen, and Charles F. Hummel. "The Carnation Chests: New Discoveries in Pennsylvania--German Art." Antiques 122 (September 1982): 552. illus.

1081. Carson, Marion S. "Philadelphia Chippendale at Its Best." American Collector 16 (November 1947): 10-13. illus.

 Philadelphia styles in the 18th century.

1082. Catalano, Kathleen Matilda. "Cabinetmaking in Philadelphia, 1820-1840." Master's thesis, University of Delaware (Winterthur), 1972. 197 pp.

1083. ___. "Cabinetmaking in Philadelphia 1820-1840: Transition from Craft to Industry." Winterthur Portfolio 13 (1979): 81-138. illus.

 Contains a checklist of over 2000 furniture craftsmen who worked in Philadelphia. Biographical information is given on each maker.

1084. ___. "Furniture Making in Philadelphia, 1820-40." American Arts and Antiques 2 (November/December): 116-23. illus.

 Examines Philadelphia as a furniture making center. Includes information on the economic factors of furniture making.

1085. Chillingworth, Peter W. "Inlaid Furniture of South-west Pennsylvania, 1790-1820." Antiques 123 (May 1983): 1040-43. illus.

 Short article that does mention some craftsmen.

1086. Cummings, John. "Painted Chests from Bucks County." Pennsylvania Folklife 9 (Summer 1958): 22-23. illus.

1087. Downs, Joseph. "The de Forest Collection of Work by Pennsylvania German Craftsmen." Bulletin of the Metropolitan Museum of Art 29 (October 1934): 163-69. illus.

 Contains information on all of the decorative arts from Bucks County. Illustrates some decorated chests.

1088. ___. A Picture Book of Philadelphia Chippendale Furniture, 1750-1780. Philadelphia: Pennsylvania Museum of Art, 1931. 19 pp. illus.

 Mostly photographs of 18th century furniture.

1089. Ducoff-Barone, Deborah. "Design and Decoration on Early 19th Century American Furniture: A Case Study of a Philadelphia Secretary Bookcase." Decorative Arts Newsletter 9 (March 1983): 1-8. illus.

Examines the French influence on Philadelphia furniture. Mentions Joseph Barry.

1090. Dundore, Roy H. Pennsylvania German Painted Furniture. Plymouth Meeting, Pa.: Keyser, 1946. 38 pp. illus.

Discusses the nature of Pennsylvania German furniture. Examines the background and sources of designs.

1091. Dyer, Walter A. "Brides' Chests Had Both Color and Variety." American Collector 37 (December 1934): 2+. illus.

On Pennsylvania German chests.

1092. Eberlein, Harold Donaldson, and Cortland Van Dyke Hubbard. "Eighteenth Century Bucks County Was Partial to Walnut Furniture." American Collector 5 (October 1936): 5+. illus.

Illustrates some case pieces. Not full of information on makers.

1093. ___ . "Pennsylvania Dutch." Arts and Decoration 54 (December 1941): 27-36. illus.

A very general article.

1094. ___ . "Pennsylvania Dutch Furniture Combines Color and Vigor." American Collector 6 (February 1937): 6-7. illus.

Another very general article of negligible use.

1095. [Evans], Nancy Ann Goyne. "Furniture Craftsmen in Philadelphia: Their Role in a Mercantile Society." Master's thesis, University of Delaware (Winterthur), 218 pp. illus.

1096. Fabian, Monroe. The Pennsylvania Decorated Chest. New York: Universe Books, 1978. 230 pp. illus. bibl.

Examines the characteristics of the Pennsylvania German chests. Gives information about construction, woods, and possible decorators. The most complete study on this form.

1097. ___ . "Sulfur Inlay in Pennsylvania German Furniture." Pennsylvania Folklife 27 (Fall 1977): 2+.

Interesting article on the unusual decoration on some Pennsylvania chests.

1098. Forman, Benno M. "Delaware Valley 'Crookt Foot' and Slat-back Chairs: The Fussell-Savery Connection." Winterthur Portfolio 15 (Spring 1980): 41-64. illus.

Uses a leger owned by Solomon Fussell, a Philadelphia chairmaker, Examines the appearance of Queen Anne style in Philadelphia.

1099. Gamon, Albert T. Pennsylvania Country Antiques. Englewood Cliffs, N.J.: Prentice-Hall, 1968. 189 pp. illus. bibl.

Discusses all country antiques of Pennsylvania. Intended as a guide for collectors.

1100. Garvan, Beatrice B. The Pennsylvania German Collection. Philadelphia: Philadelphia Museum of Art, 1982. xxvii, 372 pp. illus.

A handbook of the collection at the Philadelphia Museum of Art. Contains 43 examples of furniture.

1101. Gerry, Roger G. "Some Early Pianos in Philadelphia." Chronicle of the Early American Industries Association 6 (July 1953): 11-28. illus.

Discusses most of the major piano makers of Philadelphia, who worked during the 19th century.

1102. Gillingham, Harrold. "New Delvings in Old Fields: Furniture from Philadelphia." Antiques 29 (May 1936): 261+. illus.

Using contemporary sources, examines the export of furniture from Philadelphia. No specific information on craftsmen is provided.

1103. ___. "The Philadelphia Windsor Chair." Pennsylvania Magazine of History and Biography 55 (October 1931): 301-32. illus.

A scholarly article that explores the factors of the exportation of Philadelphia Windsor chairs. Uses shipping documents and related materials to discuss the shipping of Philadelphia furniture. Several craftsmen are mentioned.

1104. Gunnison Vernon S. "The Pennsylvania-German Schrank." Antiques 123 (May 1983): 1022-25. illus.

On the Pennsylvania kas.

1105. Hanks, David A. "Gothic Revival Furniture in Philadel-
phia." Antiques 109 (May 1976): 1024-31. illus.

Examines the work of the most well known Philadelphia
cabinetmakers of the Gothic Revival. Mentions Joseph B.
Barry and Son., Anthony G. Querville, and Crawford Riddell.
Reproduces some bills of sale.

1106. ___. "Reform in Philadelphia: 19th Century Furniture."
Art News 74 (October 1975): 52+. illus.

On Gothic Revival furniture. Reviews the work of Frank
Furness and Daniel Pabst.

1107. Heckscher, Morrison H. "The Organization and Practice
of Philadelphia Cabinetmaking Establishments, 1790-1820."
Master's thesis, University of Delaware (Winterthur), 1964.
216 pp. illus.

1108. Historical Society of York County. The Philadelphia
Chair. York, Pennsylvania: Historical Society of York County,
1978. 108 pp. illus. bibl.

A catalog published to accompany a 1978 exhibition.

1109. Hornor, William MacPherson, Jr. Blue Book of
Philadelphia Furniture, William Penn to George Washington;
with Special Reference to the Philadelphia-Chippendale School.
Philadelphia: Privately printed, 1935. Reprint. New preface
by Marina Carson. New York: Highland House, 1978. 502 pp.
illus.

Still considered to be the most important and useful
book on Philadelphia furniture. Examines the work of
18 important craftsmen, who worked during the 18th century.
Illustrates and documents 500 pieces of furniture.

1110. ___. "Quaker Craftsmanship: Early Philadelphia
Cabinetmakers." Country Life 60 (September 1931): 63-4. illus.

On the Sheraton influence in Philadelphia.

1111. ___. "Some Early Philadelphia Cabinetmakers."
The Antiquarian 16 (March 1931): 42+. illus.

Several good brief biographies are provided on major
cabinetmakers.

1112. Hummel, Charles F. "The Influence of English Design
Books Upon the Philadelphia Cabinetmaker, 1760-1780."
Master's thesis, University of Delaware (Winterthur), 1955.
150 pp. illus.

1113. Kauffman, Henry J. Pennsylvania Dutch American Folk
Art. New York: American Studio Books, 1946. Reprint. New
York: Dover, 1964. 136 pp. illus. bibl.

1114. Kimball, Fiske. "The Sources of the Philadelphia Chippendale." Pennsylvania Museum Bulletin 21 (1926): 183-93.

1115. Leibundguth, Arthur W. "The Furniture-Making Crafts in Philadelphia, c. 1730-1760." Master's thesis, University of Delaware (Winterthur), 1964. 136 pp. illus.

1116. Lichten, Frances. "A Masterpiece of Pennsylvania-German Furniture." Antiques 77 (February 1960): 176-78. illus.

Describes some major pieces.

1117. McDermott, Robert W. "Early Furniture of Western Pennsylvania." Antiques 102 (August 1972): 244-50. illus.

Examines the furniture and craftsmen of the Pittsburgh area. Infers that there was a regional style.

1118. ___. "Early Furniture of Western Pennsylvania: Or the Avocation of an Internist." Western Pennsylvania Historical Magazine 53 (October 1970): 249-53. illus.

Explores American furniture made prior to 1830 in Western Pennsylvania.

1119. McElroy, Cathryn J. "Furniture of the Philadelphia Area: Forms and Craftsmen before 1730." University of Delaware (Winterthur), 1970. 235 pp. illus.

1120. ___. "Furniture in Philadelphia: The First Fifty Years." Winterthur Portfolio 13 (1979): 61-80. illus.

Uses wills and inventories from Philadelphia to examine the kinds of furniture made and used during the late 17th and early 18th centuries.

1121. Martin, Shirley. "Craftsmen of Bucks County, Pennsylvania, 1750-1800." Master's thesis, University of Delaware (Winterthur), 1956. 207 pp. illus.

1122. Mooney, James E. "Furniture at the Historical Society of Pennsylvania." Antiques 113 (May 1978): 1034-43. illus.

Philadelphia furniture.

1123. Naeve, Milo M. "An Aristocratic Windsor in 18th Century Philadelphia." American Art Journal 11 (July 1979): 67-74. illus.

Discusses one walnut Windsor chair and the importance of the Windsor chair in 18th century Philadelphia.

1124. O'Donnell, Patricia Chapin. "The Cabinetmaker in Philadelphia, 1760-1810." Master's thesis, University of Delaware (Winterthur), 1980. 100 pp.

1125. Ormsbee, Thomas H. "Philadelphia Workmanship Reflects Its Planned Founding." <u>American Collector</u> 6 (May 1936): 4+. illus.

A general article on Philadelphia 18th century furniture.

1126. Philadelphia Museum of Art. <u>A Loan Exhibition of Authenticated Furniture of the Great Philadelphia Cabinet-makers</u>. Philadelphia: Philadelphia Museum of Art, 1935. 20 pp. illus.

A 1935 exhibition catalog. Useful, although some-what dated.

1127. ___ . <u>Pennsylvania Germans, A Celebration at the Philadelphia Museum of Art</u>. Philadelphia: Philadelphia Museum of Art. 192 pp. illus. bibl.

1128. ___ . <u>Philadelphia: Three Centuries of American Art</u>. Philadelphia: Philadelphia Museum of Art, 1976. xxiv, 665 pp. illus. bibl. index.

A comprehensive catalog of a major exhibition on all of the arts and crafts of Philadelphia. About 10% of the catalog deals with furniture.

1129. Prime, Alfred Coxe. "Craftsmen of Philadelphia." <u>Antiques</u> 8 (July 1925): 121. illus.

Reprints cabinetmaker's trade cards.

1130. Quimby, Ian M.G. "Apprenticeship in Colonial Philadelphia." Master's thesis, University of Delaware (Winterthur), 1963. 207 pp.

1131. Richman, Irwin. <u>Pennsylvania Decorative Arts in the Age of Handicraft</u>. University Park, Pennsylvania: The Pennsylvania Historical Society, 1978. 76 pp. illus.

1132. Robacker, Earl F. "The Paint-Decorated Furniture of the Pennsylvania Dutch." <u>Pennsylvania Folklife</u> 13 (Fall 1962): 2-8. illus.

Examines the designs used on the furniture of the Pennsylvania German furniture makers.

1133. Robson, Charles, ed. <u>Manufactures and Manufacturers of Pennsylvania of the 19th Century</u>. Philadelphia: Galaxy Publishing Co., 1875. 533 pp. illus.

A directory of all manufacturers.

1134. Rogers, Meyric R. "Philadelphia Via Dublin: Influences in Rococo Furniture." _Antiques_ 79 (March 1961): 272-75. illus.

Examines Irish architectural details in Philadelphia furniture.

1135. Schiffer, Margaret B. _Chester County, Pennsylvania, Inventories, 1684-1750_. Exton, Pa.: Schiffer Publishing Co., 1975.

Important collection of early inventories. Only an occasional mention of craftsmen.

1136. ___. _Furniture and Its Makers of Chester County, Pennsylvania_. Philadelphia: University of Pennsylvania Press, 1966. 440 pp. illus. bibl.

An excellent biographical dictionary of craftsmen in this county. Each entry is well documented. Many pieces of signed and attributed furniture are illustrated.

1137. Scott, G. W., Jr. "Lancaster and Other Pennsylvania Furniture." _Antiques_ 115 (May 1979): 984-993. illus.

Explores regionalism in the Lancaster area.

1138. Shea, John G. _Pennsylvania Dutch and Their Furniture_. New York: Van Nostrand Reinhold Co., 1980. 229 pp. illus. bibl.

Most useful for its detailed measured drawings.

1139. Shepherd, Raymond, Jr. "Cliveden and Its Philadelphia-Chippendale Furniture: A Documented History." _American Art Journal_ 8 (November 1976): 2-16. illus.

Explores the documented furniture of this famous house. Important because documented 18th century furniture is very rare. Attributes some pieces to Thomas Affleck.

1140. Smith, Robert C. "Finial Busts on 18th Century Philadelphia Furniture." _Antiques_ 100 (December 1971): 900-5. illus.

A very specific and limited article.

1141. Snyder, John J., Jr. "Carved Chippendale Case Furniture from Lancaster, Pennsylvania." _Antiques_ 107 (May 1975): 964-75. illus.

Information is provided on George Burkhart, organ case builder; Peter Frick; and Conrad Lind.

1142. ___. "Chippendale Furniture of Lancaster County, Pennsylvania, 1760-1810." Master's thesis, University of Delaware (Winterthur), 1976. 162 pp. illus.

1143. ___. Philadelphia Furniture and Its Makers. New York: Universe Books, 1975. 160 pp. illus.

A collection of articles reprinted from Antiques.

1144. Starry, D. E. "Rocking Chair Capital of the World: Adams County, Pennsylvania." Antiques Journal 34 (December 1947): 27-29. illus.

Examines the chair manufacturers in Adams County. Limited information on individual makers.

1145. Stockwell, David. "Aesop's Fables on Philadelphia Furniture." Antiques 60 (December 1951): 522-25. illus.

Examines 18th century furniture with designs based on Aesop's fables.

1146. ___. "Chester County Cabinetmakers." American Collector 8 (April 1939): 6+. illus.

Several cabinetmakers are discussed receipts are shown.

1147. ___. "Irish Influence in Pennsylvania Queen Anne Furniture." Antiques 79 (March 1961): 269-71. illus.

Explains that the Irish influence is noticeable in Philadelphia furniture. Lists ten Irish-American craftsmen.

1148. ___. "Notes on the Construction of Philadelphia Cabriole Chairs." Antiques 58 (October 1950): 286-88. illus.

Excellent discussion of the details of the construction of Philadelphia chairs.

1149. Stoudt, John Joseph. Early Pennsylvania Arts and Crafts. New York: A. S. Barnes, 1964. 364 pp. illus.

A general book.

1150. Talbott, Page. "Cheapest, Strongest and Best: Chairmakers in 19th Century Philadelphia." Parts 1,2. Chronicle of the Early American Industries Association 33 (July, September 1980): 41-45. illus.

Examines the life and work of several chair makers. A scholarly work with new information.

1151. ___. "Philadelphia Furniture, 1850-1880." Ph.D. diss., in preparation in 1977.

It has not been determined if this has been completed.

1152. Trice, Harley N. "Decorative Furniture of Soap Hollow, Somerset County, Pennsylvania." Antiques 123 (May 1983): 1036-39. illus.

About 19th century Mennonite cabinetmakers.

1153. Wainwright, Nicholas B. Colonial Grandeur in Philadelphia: The House and Furniture of General John Cadwalader. Philadelphia: Historical Society of Pennsylvania, 1964. xii, 169 pp. illus.

Studies the furniture of this important 18th century house.

1154. Wick, Wender. "Stephen Girard, A Patron of the Philadelphia Furniture Trade." Master's thesis, University of Delaware (Winterthur), 1977.

1155. Woodhouse, Samuel W., Jr. "18th Century Philadelphia Cabinetmakers." American Magazine of Art 18 (October 1927): 535-39. illus.

A survey of the major furniture craftsmen working in Philadelphia. Includes information on Benjamin Randolph, William Savery, and Jonathan Gostelowe.

1156. Zimmerman, Philip Douglas. "The Artifact as Historical Source Material: A Comparative Study of Philadelphia Chippendale Chairs." Master's thesis, University of Delaware (Winterthur), 1980.

1157. ___. "A Methodological Study in the Identification of Some Important Philadelphia Chippendale Furniture." Winterthur Porfolio 13 (1979): 193-208. illus.

Makes a case for attributions based on construction details and original documents. Scholarly and interesting.

Rhode Island

1158. Bjerkoe, Ethel Hall. "The Furniture of Newport." Spinning Wheel 20 (November 1964): 22-29. illus.

1159. Bolhouse, Mrs. Peter. "More Newport Craftsmen: A List Compiled by Mrs. Bolhouse." Antiques 68 (July 1955): 62.

Gives data on 13 previously unlisted cabinetmakers who worked in Newport.

1160. Carpenter, Ralph E., Jr. <u>The Arts and Crafts of Newport, Rhode Island, 1640-1820</u>. Newport, R.I.: Preservation Society of Newport County, 1954. xiii, 218 pp. illus. bibl.

An exhibition catalog for a 1953 exhibition held at the Nichols-Wanton-Hunter House. Attempts to examine the entire range of the arts in the Newport area. Most of the catalog is devoted to furniture.

1161. ___. "Discoveries in Newport Furniture and Silver." <u>Antiques</u> 68 (July 1955): 44-49. illus.

Contains new information obtained after the exhibition catalog for the 1953 exhibition was published. Information is provided on furniture makers.

1162. ___. "The Newport Exhibition." <u>Antiques</u> 64 (July 1953): 38-45. illus.

A review of the major 1953 Newport exhibition. Illustrates several pieces of documented furniture.

1163. Casey, E. T. "Early Chests in the Museum." <u>Bulletin of the Rhode Island School of Design</u> 20 (July 1933): 40-44. illus.

Concerns 17th century New England chests.

1164. Comstock, Helen. "Rhode Island Block-Front Furniture." <u>Connoisseur</u> 131 (July 1953): illus.

A very general article of only marginal use.

1165. Garrett, Wendell D. "The Newport Cabinetmakers: A Corrected List." <u>Antiques</u> 73 (June 1958): 558-59. illus.

Corrects information in Mabel M. Swan's article on the Goddard-Townsend. Adds new names of craftsmen.

1166. ___. "The Newport, Rhode Island, Interior, 1780-1800." Master's thesis, University of Delaware (Winterthur): 1957. 172 pp.

1167. ___. "Providence Cabinetmakers, Chairmakers, Upholsterers, and Allied Craftsmen." <u>Antiques</u> 90 (October 1966): 514-19. illus.

Contains an excellent biographical dictionary on the craftsmen of Providence.

1168. ___, comp. "Speculations on the Rhode Island Block-Front in 1928." <u>Antiques</u> 99 (June 1971): 887-891. illus.

A compilation of 1928 suggestions as to the possible sources of the block-front design.

1169. Monahon, Eleanore B. "Providence Cabinetmakers."
Rhode Island History 23 (January 1964): 1-22.

 Discusses a large number of Providence craftsmen who
 were working in the 18th and 19th centuries. Draws
 from the Crawford papers in the Rhode Island Historical
 Society.

1170. ___. "Providence Cabinetmakers of the 18th and Early
19th Centuries." Antiques 87 (May 1965): 573-79. illus.

 Using documented examples, makes attributions of
 several pieces. Mentions the Rawson family of cabinet-
 makers.

1171. Ott, Joseph K. "Export of Furniture, Chaises, and
Other Wooden Forms from Providence and Newport." Antiques 107
(January 1975): 135-141. illus.

 Explores the economics of exporting Rhode Island
 furniture.

1172. ___. "Lesser-Known Rhode Island Cabinetmakers: The
Carliles, Holmes Weaver, Judson Blake, the Rawsons, and
Thomas Davenport." Antiques 121 (May 1982): 1156-63. illus.

 Using documented examples, the author examines the lives
 and production of these craftsmen.

1173. ___. "More Notes on Rhode Island Cabinetmakers and
Their Work." Rhode Island History 28 (Spring 1969): 49-52.

 Presents information on 10 previously unlisted cabinet-
 makers. Uses manuscript sources in the Rhode Island
 Historical Society. Reprints a 2 page price list from
 1756.

1174. ___. "Recent Discoveries Among Rhode Island Cabinet-
makers and Their Work." Rhode Island History 28 (Winter 1969):
1+. illus.

 This three part article presents a large amount of informa-
 tion. Contains many names of cabinetmakers, who have not
 been known previously. Provides new data on other
 craftsmen.

1175. ___. "Rhode Island Furniture Exports, 1783-1800."
Rhode Island History 36 (Winter 1977): 2-14.

 Includes information on trade practices of furniture
 makers. This article is similar to one in Antiques by the
 same author. However, there are additional illustrations.

1176. ___. "Some Rhode Island Furniture." Antiques 107 (May
1975): 940-51. illus.

 Mentions little-known Rhode Island craftsmen.

1177. ___ . "Still More Notes on Rhode Island Cabinet-
makers and Allied Craftsmen." Rhode Island History 28
(Fall 1969): 11-121.

> Lists 17 craftsmen who have not been previously
> identified. Provides new information on other
> craftsmen.

1178. Ott, Joseph, and N. David Scotti. "Notes on Rhode
Island Cabinetmakers." Antiques 87 (May 1965): 572.

> Two short notes about the Prouds and
> William Barker.

1179. Rhode Island Historical Society. The John Brown House
Loan Exhibition of Rhode Island Furniture Including Some
Notable Portraits, Chinese Export Porcelain and Other Items.
Providence: Rhode Island Historical Society, 1965. 178 pp.
illus.

> An exhibition catalog that contains numerous examples
> of documented furniture.

1180. Richardson, George H. "Scrapbooks." Unpublished
materials at the Newport Historical Society.

> Contains information about cabinetmakers.

1181. Schwartz, Marvin D. "Newport Cabinetmakers." Art
News 73 (November 1974): 74-75. illus.

> A review of the cabinetmakers working in Newport.
> Concentrates on makers of high-style furniture.

1182. Stone, Stanley. "Rhode Island Furniture at Chipstone."
Parts 1, 2. Antiques 91 (February, April, 1967): 207-213,
508-13. illus.

> Furniture from this historic house. Makes several
> attributions.

South Carolina

1183. Burton, E. Milby. "Charleston Furniture." Antiques 97
(June 1970): 910-14. illus.

> Reviews the life and work of most Charleston craftsmen.
> Illustrates an advertisement of Richard Magrath.

1184. ___ . Charleston Furniture, 1700-1825. Charleston,
S.C.: Charleston Museum, 1955. ix, 150 pp. illus. bibl.

> The most comprehensive and useful publication on furniture
> from this city. Gives an alphabetical biographical
> dictionary of craftsmen.

1185. ___ . "Furniture of Charleston." Antiques 57 (January 1952): 44-57. illus.

A comprehensive survey of the furniture and furniture makers of Charleston. Reprinted from the Walpole Society Notebook.

1186. Keyes, Homer Eaton. "The Present State of Early Furniture in Charleston, South Carolina." Antiques 29 (January 1936): 17-21. illus.

Reviews the state of current research about Charleston furniture. Some discussion of craftsmen.

1187. Montgomery, Charles F. "Charleston Furniture." Walpole Society Notebook (1956): 28-31. illus.

Reviews a trip of Walpole Society's members.

1188. Rose, Jennie Haskell. "Pre-Revolutionary Cabinetmakers of Charlestown." Parts 1, 2. Antiques 23 (April, May 1933): 126-28, 184-85. illus.

Uses contemporary documents in discussing the cabinet-makers of this important furniture center. Includes a list of 69 craftsmen with some discussed in detail.

1189. Walsh, Richard. Charleston's Sons of Liberty: A Study of the Artisans, 1763-1789. Columbia, S.C.: University of South Carolina Press, 1959. xii, 166 pp. illus.

Two thousand craftsmen and artisans of the 18th century are included in this study.

Tennessee

1190. Beasley, Ellen. "Tennessee Cabinetmakers and Chair-makers through 1840." Antiques 100 (October 1971): 612-21. illus.

A Checklist of Tennessee cabinetmakers, chairmakers, and related craftsmen as compiled from census records and newspapers. Some advertisements are illustrated.

1191. ___ . "Tennessee Furniture and Its Makers." Antiques 100 (September 1971): 425-31. illus.

Claims that there is a regional style for Tennessee furniture. Many documented examples are shown.

1192. McCulley, Lou Ann. "A Survey of the Crafts and Crafts-men of Ten Upper East Tennessee Counties." Master's thesis, University of Tennessee, 1968.

Texas

1193. Burgess, Sue Irene. "A Catalogue of American Victorian Chairs and Sofas at Dallas Old City Park Restoration Village." Master's thesis, Texas State University, 1975. 63 pp.

1194. Lawrence, Jennifer. "Texas' Old Style Cabinetmakers." Texas Homes 6 (January/February 1982): 131.

 Not seen by the compiler.

1195. Meyer, Wendy Haskell. "Texas Primitives." Houston Homes 4 (August 1978): 76-83.

 Not seen by the compiler.

1196. Taylor, Lonn, and David B. Warren. Texas Furniture. Austin: University of Texas Press, 1975. xi, 387 pp. illus. bibl.

 The most important and comprehensive publication on Texas furniture. Gives a history of furniture making between 1840 and 1880. Lists a significant number of craftsmen.

1197. Peeter, Tom. "Texas Primitives: Basics at Their Best." Texas Homes 2 (May/June 1978): 28-31. illus.

 Not seen by the compiler.

1198. Witte Memorial Museum. Early Texas Furniture and Decorative Arts. San Antonio: Trinity University Press, 1973. viii, 263 pp. illus.

 An exhibition catalog that includes information on all of the decorative arts.

Utah

1199. Morningstar, Connie V. Early Utah Furniture. Logan, Utah: Utah State University Press, 1976. 93 pp. illus. bibl.

 Contains a useful alphabetical biographical dictionary on Utah cabinetmakers who were active prior to 1870. Gives a history of Utah furniture making and illustrates sixty documented examples of furniture. The only book available on Utah furniture.

Vermont

1200. Hebb, Caroline. "A Distinctive Group of Early Vermont Painted Furniture." Antiques 104 (March 1975): 458-61. illus.

A general review of Vermont furniture.

1201. Houghton, Janet. "Household Furnishings in Southern Vermont, 1780-1800." Master's thesis, University of Delaware(Winterthur), 1975. 82 pp.

Virginia

1202. Bailey, Worth, and Zora F. Tolley. "Cabinetmaking in Alexandria." Antiques 47 (February 1945): 76-80. illus.

Examines George Washington's "Ledger A" and an order of chairs from Adam Stephen. Mentions other Alexandria craftsmen of the 18th century. Documented examples are illustrated.

1203. Brown, Miles. The Cabinetmaker in 18th Century Williamsburg. Williamsburg, Va.: Colonial Williamsburg, 1970. ii, 40 pp. illus.

1204. Carson, Marion S. "Washington Furniture at Mt. Vernon." Parts 1, 2. American Collector 14 (May, July 1947): 4+, 9+. illus.

Studies some contemporary documents and mentions a few cabinetmakers.

1205. Chrysler Museum. Eastern Shore, Virginia, Raised Panel Furniture, 1730-1830. Norfolk, Va.: Chrysler Museum, 1982. 135 pp. illus. bibl.

An exhibition catalog that contains mostly cupboards.

1206. Colonial Williamsburg. Furniture of Eastern Virginia: Product of Mind and Hand. Williamsburg, Va.: Colonial Williamsburg Foundation, 1978. 31 pp. illus.

Furniture of Williamsburg during the years, 1650-1790.

1207. Decatur, Stephen. "George Washington and His Presidential Furniture." American Collector 10 (February 1941): 8+. illus.

About documented Washington furniture.

1208. Dibble, Ann W. "Fredericksburg--Falmouth Chairs of the Chippendale Period." Journal of Early Southern Decorative Arts 4 (May 1978): 1-24. illus.

An examination of the stylistic development of Virginia chairs.

1209. Dustan, William E., III. "The Colonial Cabinetmaker in Tidewater, Virginia." Virginia Cavalcade 20 (Summer 1970): 34-46. illus.

Discusses 18th century furniture makers and gives specific information on some craftsmen. Claims that there were more cabinetmakers working in the South than previously believed.

1210. Fede, Helen M. Washington Furniture at Mount Vernon. Mount Vernon, Va.: Mount Vernon Ladies Association of the Union, 1966. 72 pp. illus.

A guidebook to the furniture owned by George Washington. Includes examples of both European and American furniture.

1211. Gusler, Wallace. "The Arts of Shenandoah County, Virginia, 1770-1825." Journal of Early Southern Decorative Arts 2 (November 1979): 6-35. illus.

A general article on furniture of this area. Mentions several craftsmen, including George Fravel.

1212. ___ . "Queen Anne Desks from the Virginia Piedmont." Antiques 104 (October 1973): 665-73. illus.

Discusses regionalism in Virginia.

1213. Gusler, Wallace, and Harold B. Gill, Jr. "Some Virginia Chairs: A Preliminary Study." Antiques 101 (April 1972): 716-21. illus.

Examines Virginia regionalism.

1214. Gusler, Wallace, and Sumpter Priddy, III. "Furniture of Williamsburg and Eastern Virginia." Antiques 114 (August 1978): 282-93. illus.

Contains a number of pieces from the collection of Colonial Williamsburg. Data is given about Peter Scott, Anthony Hay, and Benjamin Bucktrout.

1215. Harris, Marleine R. Virginia Antiques. New York: Exposition Press, 1953. viii, 183 pp. illus.

A general survey of Virginia furniture. Not a scholarly book.

1216. Heuvel, Johannes. The Cabinetmaker in Eighteenth-Century Williamsburg. Williamsburg, Va.: Colonial Williamsburg, 1963. 40 pp. illus.

 Based on the research of Miles Brown. Gives a biographical check list of 13 craftsmen.

1217. Hume, Ivor Noel. Williamsburg Cabinetmaker: The Archaeological Evidence. Williamsburg, Va.: Colonial Williamsburg Foundation, 1971. 48 pp. illus.

1218. Locke, Louis G. "Antique Furniture of the Shenandoah Valley." Virginia Cavalcade 24 (Winter 1975): 108-15. illus.

 Contains an essay about the history of cabinetmaking in the Shenandoah Valley during the 18th and 19th centuries.

1219. Lynch, Ernest C. Furniture--Antiques Found in Virginia. Milwaukee, Wis.: Bruce Publishing Co., 1954. 95 pp. illus. bibl.

 Mostly a collection of measured drawings of Virginia furniture.

1220. Moore, J. Roderick. "Painted Chests from Wythe County, Virginia." Antiques 122 (September 1982): 516-21. illus.

 About German craftsmen who made decorated chests. Mentions John Huddle, decorator.

1221. Virginia Museum of Fine Arts. Furniture of Williamsburg and Eastern Virginia, 1710-1790. Richmond, Va.: Virginia Museum of Fine Arts, 1979. xxi, 194 pp. illus. bibl.

 An exhibition catalog.

West Virginia

1222. Di Bartolomeo, Robert E. "Wheeling's Chairs and Chairmakers, 1828-1864." Spinning Wheel 26 (May 1970): 14-16, 50. illus.

 Gives a history of chair manufacture in Wheeling. Lists several craftsmen with biographical information.

GENERAL WORKS

1223. Ames, Kenneth. "The Battle of the Sideboards."
Winterthur Portfolio 9 (1974): 1-27. illus.

A scholarly discussion of sideboards.

1224. ___. "Meaning in Artifacts: Hall Furnishings in
Victorian America." Journal of Interdisciplinary History 9
(Summer 1978): 19-46. illus.

1225. ___. "Renaissance Revival Furniture in America."
Master's thesis, University of Pennsylvania, 1970. 560 pp.

1226. ___. "The Rocking Chair in 19th Century America."
Antiques 103 (February 1973): 322-27. illus.

Gives a history of the rocking chair. Discusses
several craftsmen. Includes pages from some
catalogs.

1227. American Collector 10 (May 1936).

A note about Prudent Mallard, William Sampson, and others.

1228. Arkell and Douglas. Illustrated Polyglot Catalogue of
American Manufacturers. New York: J. J. Little, 1886.
378 pp. illus.

Includes illustrations of furniture.

1229. Aronson, Joseph. The New Encyclopedia of Furniture.
New York: Crown Publishers, 1967. cix, 484 pp. illus. bibl.

About world-wide furniture.

1230. Asher and Adams. <u>Asher and Adams Pictorial Album of</u>
<u>American Industry, 1876</u>. Reprint. New York: Rutledge
Books, 1976. 192 pp. illus.

 Reprint of an 1876 book. Includes many manufacturers and
 Illustrates their wares.

1231. Aslin, Elizabeth. <u>The Aesthetic Movement, Prelude to</u>
<u>Art Nouveau</u>. New York: Frederick A. Praeger, 1969. 196 pp.
illus. bibl.

 All arts are discussed.

1232. Ayers, James. "The American Chippendale Style."
<u>Discovering Antiques</u> 43 (1971): 1028-32. illus.

 A short review of the Chippendale style in America.
 Contains color photographs.

1233. Baird, Henry Carey. <u>Cabinet Maker's Album of Furniture</u>:
<u>Comprising a Collection of Designs for the Newest and Most</u>
<u>Elegant Styles of Furniture.</u> Philadelphia: H.C. Baird,1868.
illus.

 An important design book.

1234. ___ . <u>Victorian Gothic and Renaissance Revival Furniture</u>:
<u>Two Victorian Pattern Books Published by Henry Carey Baird</u>
<u>with a New Introduction by David Hanks</u>. Philadelphia:
Athenaeum Library of 19th Century America, 1977. illus.

 Reprint of two important pattern books. Baird was the
 publisher, not a craftsman.

1235. Ball, William, Jr. "Evolution of American Furniture
Mounts. <u>American Collector</u> 4 (October 1935): 7+. illus.

 Examines handles, brasses, etc. of the 17th and 18th
 centuries.

1236. Beck, Doreen. <u>Book of American Furniture</u>. Feltham,
England: Hamlyn, 1973. 96 pp. illus.

 A general survey of American furniture.

1237. Benrly, Garth, ed. <u>The Seng Handbook: Furniture Facts</u>
<u>Commemorating 80 Years of Service to the Furniture Industry</u>,
<u>1874-1954</u>. Chicago: Seng Co., 1954.

 A dictionary of furniture facts.

1238. Berry, Morris. <u>Early American Furniture Including</u>
<u>Many Collector's Pieces of Rich Veneer and with Inlay</u>.
New York: American Art Association, 1930. 147 pp. illus.

 An important auction catalog of American furniture.

1239. Bienenstock, Nathan F. _A History of American Furniture_. East Stroudsburg, Pa. and New York: Towse Publishing Co., 1936. Reprint. New York and High Point, N.C.: 1970. 283 pp. illus.

A general review. Contains pages from catalogs of reproduction furniture.

1240. Binstead, Herbert Ernest. _The Furniture Styles_. Chicago: Trade Periodical Co., 1909.

A trade promotional booklet, with a chapter by Stickley.

1241. Bishop, John L. _A History of American Manufacture from 1608-1860_. 3d ed. 3 vols. Philadelphia: E. Young, 1868. Reprint. New York: Johnson Reprint Co., 1967. 1930 pp. illus.

1242. Bishop, Robert C. _American Furniture, 1620-1720_. Dearborn, Mich.: Greenfield Village and Henry Ford Museum, 1975. 32 pp. illus.

A catalog of the collection at Greenfield Village.

1243. ___ . _Centuries and Styles of the American Chair, 1640-1970_. New York: E. P. Dutton and Company., 1972. 516 pp. illus. bibl.

Survey of major styles in American chairs.

1244. ___ . _How to Know American Antique Furniture_. New York: E. P. Dutton and Co., 1973. 244 pp. illus. bibl.

A collector's manual.

1245. Djerkoe, Ethel II. _The Cabinetmakers of America_. Garden City, N.Y.: Doubleday and Co., 1957. xvii, 252 pp. illus. bibl. glossary.

Contains an essay entitled: "The Cabinetmaking as it Developed in America." The rest of the book is a biographical dictionary of American furniture makers. Although the dictionary does no contain as many names as it could have, it is the most complete check list of American furniture craftsmen yet published.

1246. Black, Mary. _The New York Cabinetmaker and His Use of Space_. New York: New-York Historical Society, 1976.

This booklet is not widely available.

1247. Blake, Channing. "Architects as Furniture Designers." _Antiques_ 109 (May 1976): 1046-47. illus.

Mentions the architects: McKim, Mead, and White, and Carrere and Hastings. Examines the role of the architect as furniture designer.

1248. Boas, George, and James D. Brechenridge. <u>The Age of Elegance: The Rococo and Its Effect</u>. Baltimore: The Baltimore Museum of Art, 1959.

1249. Boger, Louise A. <u>The Complete Guide to Furniture Styles</u>. New York: Charles Scribner's Sons, 1959. x, 488 pp. illus. bibl.

 A book about furniture styles of the world.
 Chapters 22-24 deal exclusively with American Furniture.

1250. Bohdan, Carol L. "Egyptian-Inspired Furniture 1800-1922. <u>Art and Antiques</u> 3 (November/December 1980): 64-71. illus.

 Examines Egyptian revival furniture in England and America.

1251. Bridenbaugh, Carl. <u>The Colonial Craftsman</u>. New York: New York University Press, 1950. xii, 214 pp. illus. bibl.

 A study on the economic and social aspects about the lives of colonial craftsmen. Only brief mention of cabinet-makers.

1252. Brooklyn Museum. <u>The American Renaissance, 1876-1917</u>. New York: Brooklyn Museum, 1979. illus.

 An exhibition catalog.

1253. ___ . <u>Victoriana: An Exhibition of the Arts of the Victorian Era in America</u>. New York: The Brooklyn Institute of Arts and Sciences, 1960. illus.

1254. Butler, Joseph T. <u>American Antiques, 1800-1900</u>. New York: The Odyssey Press, 1965. 203 pp. illus.

 Discusses all antiques of the 19th century. A general survey.

1255. ___ . <u>American Furniture from the First Colonies to World War I.</u> London: Tribune Books, 1973. 144 pp. illus. bibl.

 A survey of furniture styles in America. Designed for the casual collector.

1256. Calder, Jacqueline. "Piller and Scroll Furniture." <u>New York-Pennsylvania Collector</u> 7 (December 1982): 18-19. illus.

 A general review of late Empire furniture.

1257. Callahan, Kevin. Early American Furniture. New York:
Drake Publications, 1975. 158 pp. illus.

A general book.

1258. Callen, Anthea. Women Artists of the Arts and Crafts
Movement, 1870-1914. New York: Pantheon Books, 1979. 232 pp.
illus. bibl.

Chapter 6 is about woodcarvers and furniture designers.
Examines both English and American designers.

1259. Campbell, Christopher. American Chippendale Furniture,
1755-1796. Dearborn, Mich.: Greenfield Village and Henry
Ford Museum, 1975. 44 pp. illus.

1260. Cescinski, Herbert. "American Furniture Problems."
Burlington Magazine 54 (June 1929): 308-315. illus.

Discusses the role of various trades involved in
furniture making in America.

1261. ___ . English and American Furniture. Garden City
and New York: Garden City Publishing Co, Inc., 1929. 307 pp.
illus. bibl. glossary.

Presents a comparison of both English and American
furniture. Short biographical sketches are given on
some American furniture makers.

1262. Chandor, Mary A. Chairs Made for American Children.
Morristown, N.J.: Morris Museum of Arts and Sciences, 1975.

1263. Christensen, Erwin O. The Index of American Design.
New York: Macmillen, xvii, 229 illus. bibl.

From the WPA program in which artists were commissioned
to paint examples of American design, including furniture.

1264. Clark, Victor S. History of Manufactures in the
United States, 1607-1860. 3 vols., 1929. Reprint. Magnolia,
Ma.: Peter Smith, 1949. 1640 pp.

Each volume discusses the industry of America during
a specific period. All manufacturers are examined.

1265. Comstock, Helen. "American Furniture in the 18th
Century, with a List of Furniture Makers." Connoisseur 135
(February 1955): 63-71. illus.

A general review of 18th century furniture with a one
page list of the most famous cabinetmakers.

1266. ___ . American Furniture, Seventeenth, Eighteenth,
and Nineteenth Century Styles. New York: Viking Press, 1962.
366 pp. illus. bibl.

 Still considered to be the main textbook for American
 furniture. Gives a chronological survey of the major
 styles; discusses the major craftsmen. Many examples are
 illustrated. There is a six-page bibliography.

1267. ___ . "The Bellflower in Furniture Design." Antiques 68
(August 1957): 130-33. illus.

1268. ___ . "The Looking-Glass in America." Parts 1-3.
Antiques 86 (March, April, June 1964): 314-19, 438-40,
670-85. illus.

 Gives a history of mirrors. Discusses major makers.

1269. ___ . The Looking Glass in America, 1700-1825. New
York: Viking Press, 1968. 128 pp. illus.

 Contains a check list of looking-glass makers.

1270. ___ , "Old Mirrors: England and America." American
Collector 15 (July 1946): 8+. illus.

1271. ___ . "Portraits of American Craftsmen." Antiques 77
(October 1959): 321-23. illus.

 Marinus Willett, Ebenezer Tracy, Samuel McIntire,
 Henry Connelly, and Thomas Ash.

1272. ___ . "Sources of American Chair Design." American
Collector 16 (February 1947): 12+. illus.

 Uses information from English design books.

1273. ___ , ed. The Concise Encyclopedia of American
Antiques. 2 vols. London: The Connoisseur, 1958. 464 pp.
illus.

 About all kinds of antiques, including furniture.

1274. Conger, Clement E. "Chippendale Furniture in the
Department of State Collection." American Art Journal 8
(May 1976): 84-98. illus.

 A review of this famous collection.

1275. Conger, Clement E., and Jane W. Pool. "Some Eagle-
Decorated Furniture at the Department of State." Antiques
105 (May 1974): 1072-81. illus.

1276. Cook, Clarence. The House Beautiful: Essays on Beds
and Tables, Stools and Candlesticks. New York: Scribner,
Armstrong and Co., 1878. illus.

1277. Cooper, Wendy A. "American Chippendale Chairback Settees: Some Sources and Related Examples." American Art Journal 9 (November 1977): 34-45. illus.

A scholarly article about this rare furniture form.

1278. ___. In Praise of America: American Decorative Arts, 1650-1830. 50 Years of Discovery Since the 1929 Girl Scouts Loan Exhibition. New York: Alfred A. Knopf, 1980. 280 pp. illus. bibl.

Reviews the progress of research in American decorative arts since 1929, with emphasis on furniture.

1279. Corbin, Patricia. All About Wicker. New York: E. P. Dutton, 1978. 122 pp. illus.

Designed as a collector's manual. Includes information on the Heywood-Wakefield Company and other makers.

1280. Cornelius, Charles O. Early American Furniture. New York: Century Co., 1926. xx, 278 pp. illus. bibl.

A general survey of early furniture. Discusses some early cabinetmakers.

1281. Da Costa, John C. Historic Family Furnishings of John C. Da Costa, III. Philadelphia: Morley, 1930. 27 pp.

A sale catalog of this collection. It includes documented examples made by Jacob Wayne and Edward James.

1282. Davidson, Marshall B. The Bantam Illustrated Guide to American Furniture. New York: Antiques and Fine Arts Books Club, 1980. 421 pp. illus. bibl.

Designed for the amateur collector.

1283. Davidson, Ruth B. "American Gaming Tables." Antiques 63 (March 1953): 294-96. illus.

A history of the American card table.

1284. Davis, Felice. "Victorian Cabinetmakers in America." Antiques 44 (September 1943): 11-15. illus.

Examines the lives and works of the major 19th century cabinetmakers.

1285. Detroit Institute of Arts. American Decorative Arts from the Pilgrims to the Revolution. Detroit: Detroit Institute of Arts, 1967. 48 pp. illus.

Includes furniture from Detroit area collections.

1286. Detroit Public Library. Furniture--A List of Books in the Detroit Public Library, Fine Arts Department. Detroit: Detroit Public Library, 1929.

 Includes books on furniture from all over the world.

1287. Devoe, Shirley Spaulding. American Decorated Chairs. Bridgewater, Conn.: Privately printed, 1947.

 Pamphlet on how to decorate chairs.

1288. Doud, R. K. "Scottish Cabinetmakers in 18th Century America." Scottish Art Review 12 (January 1969): 1-12.

 The only study devoted to this subject.

1289. Downing, Alexander J. Furniture for the Victorian Home. 1850. Reprint, Watkins Glen, N.Y.: American Life Foundation, Century House, 1968. 212 pp. illus.

 Reprint of this important design book. Designs in this book were the basis for furniture made by many craftsmen.

1290. Downs, Joseph. American Furniture: Queen Anne and Chippendale Period, in the Henry DuPont Winterthur Museum. New York: Macmilllan Publishing Co., 1952. xlvi, unpaged. illus.

 A catalog of the collection at the Winterthur Museum. Important as a pioneering scholarly work. Still considered to be the major book on American 18th century furniture.

1291. ___. "American Japanned Furniture." Bulletin of the Metropolitan Museum of Art 28 (March 1933): 42-48. illus.

 A review of the history of japanning in American furniture. Mentions Thomas Johnson, japanner.

1292. ___. "American Japanned Furniture." Bulletin of the Metropolitan Museum of Art 35 (July 1940): 145-48. illus.

1293. ___. "The Greek Revival in United States." American Collector 12 (November 1943): 6+. illus.

 Includes information on both furniture and architecture.

1294. Dreppard, Carl W. Handbook of Antique Chairs. New York: Doubleday and Co., 1948. unpaged. illus.

 Contains a history of chairmaking in America. Includes a checklist of chair craftsmen who worked from 1660 to 1850. Illustrates some early advertisements.

1295. Drepperd, Carl. W. The Primer of American Antiques.
Garden City, N.Y.: Doubleday and Co., 1944.

A general guide to all American antiques. The
first 68 pages contain furniture information.

1296. Dubrow, Richard and Eileen. American Furniture of the
19th Century, 1840-1880. Exton, Pa.: Schiffer Publications,
1983. 224 pp. illus. bibl.

A study of furniture from the middle of the 19th century.
Gives biographical data on 70 cabinetmakers.

1297. ___ . Furniture Made in America, 1875-1905. Exton, Pa.:
Schiffer Publications, 1982. 320 pp. illus.

Contains reprints of catalogs and advertisements.

1298. Duncan, Alastair. Art Nouveau Furniture. New York:
Crown Publishers, 1982, 208 pp. illus.

Includes information on both American and non-American
furniture.

1299. Dyer, Walter A., comp. "Collector's Biographical
Dictionary." Parts 1-3. Antiques 2 (September, October,
December 1922): 136-38, 183-84, 285-91. illus.

A biographical dictionary of cabinetmakers, clock-
makers and other craftsmen. 17 cabinetmakers are
discussed.

1300. ___ . Early American Craftsmen. New York: Century Co.,
1915. 387 pp. illus. bibl.

Contains a chapter on American furniture makers;
mentions makers of New York and New England. Separate
chapters are on Samuel McIntire, Duncan Phyfe, and
Windsor chairs.

1301. ___ . Handbook of Furniture Styles. New York: Century
Co., 1910. xiv, 155 pp. illus. bibl.

An early short book on furniture styles.

1302. Dyer, Walter A., and Esther S. Fraser. The Rocking
Chair, An American Institution. New York: Century Co., 1928.
xiv, 127 pp. illus.

Gives a history of the origin, use and development of
the rocking chair. Includes information on decorative
techniques and specific styles.

1303. Early, Marcia Andrea. "The Craftsman (1901-1916) as the Principal Spokesman of the Craftsman Movement in America, with a Short Study of the Craftsman House Projects." Master's thesis, New York University, 1963.

On the Stickley magazine, The Craftsman.

1304. Eberlein, Harold Donaldson, and Abbot McClure. The Practical Book of Period Furniture. Philadelphia and London: J. B. Lippincott Co., 1914. ii, 371 pp. illus. bibl.

On English and American furniture.

1305. Erving, Henry W. Random Notes on Colonial Furniture. Hartford, Conn.: Privately printed, 1931. 60 pp. illus.

Contains some contemporary references.

1306. Ettema, Michael. "Technological Innovation and Design Economics in Furniture Manufacture." Winterthur Portfolio 16 (Summer/Autumn 1981): 197-223. illus.

Examines the role of machinery and related technologies in the development of furniture styles.

1307. Evans, Nancy A. Goyne. "American Windsor Chairs: A Style Survey." Antiques 95 (April 1969): 538-43. illus.

Concentrates on the role of regionalism in Windsor chairs. Several chairmakers are mentioned.

1308. ___. "The Bureau Table in America." Winterthur Portfolio 3 (1967): 25-36. illus.

A history of this particular furniture form. Information is given about David Evans and other craftsmen who made furniture in this form.

1309. Fairbanks, Jonathan L., and Elizabeth Bidwell Bates. American Furniture, 1620 to Present. New York: Richard Marek Publishers, 1981. 561 pp. illus. bibl. glossary.

A monumental volume designed to be a complete survey of American furniture. Concentrates on high-style furniture. A bibliography by Wendell Garrett and Allison Eckardt consists of 15 pages and covers all of American furniture periods.

1310. Fairchild, Jennifer. "Patent Furniture in America from 1850 to 1890. A Study of Counter-Heroic Tendencies in American Inventions." Master's thesis, Cornell University, 1969. 242 pp.

1311. Fales, Dean A. American Painted Furniture, 1660-1880.
New York: E. P. Dutton and Co., 1972. 298 pp. illus. bibl.

The most complete book on American painted furniture.
Especially good for examples of fancy painted 19th
century furniture.

1312. Fennimore, Donald L. "Neo-Classical Furniture and
European Antecedents." American Art Journal 13 (Autumn
1981): 49-65. illus.

Explores the stylistic development of the neo-classical
style with an occasional reference to craftsmen.

1313. Fitzgerald, Oscar P. Three Centuries of American
Furniture. Englewood Cliffs, N.J.: Prentice Hall, Inc.,
1982. xii, 323 pp. illus. bibl. appendix.

Presents a general survey of American furniture. Designed
to be a textbook. Some craftsmen are discussed.

1314. Flayderman, Philip. Colonial Furniture, Silver, and
Decorations.... New York: American Art Association, Anderson
Galleries, 1930. unpaged. illus.

The sale catalog for the dispersion of the famous
Flayderman collection. Includes documented
examples.

1315. Franklin, Linda Campbell. Art and Collectibles: A
Bibliography of Works in English, 16th Century to 1976.
Metuchen, N. J. and London: Scarecrow Press, 1978. xxiii,
1091 pp.

About all aspects of antiques. Not comprehensive.

1316. Freeman, Graydon L. (Larry). Edwardian 1900. Antique
Furniture Handbooks Series, vol. 7. Watkins Glen, N.Y.:
Century House, 1969. illus.

1317. ___. Federal-Empire. Antique Furniture Handbooks Series,
vol. 3. Watkins, Glen, N. Y. : Century House, 1956. 80 pp.
illus.

An illustrated collector's guide to the furniture of the
early 19th century.

1318. Freeman, Ruth, and Graydon L. (Larry) Freeman.
Victorian Furniture. Watkins Glen, N.Y.: Century House, 1950.
112 pp. illus.

A collector's guide, now outdated.

1319. Furniture Record Directory of Furniture Manufacturers
of the United States and Canada. Grand Rapids, Mich.:
Periodical Publishing Co., 1920.

1320. Gaines, Edith, ed. "Collectors' Notes." Antiques 89 (June 1966): 838-45. illus.

Short notes about eight cabinetmakers.

1321. ___, ed. "Collectors' Notes." Antiques 98 (October 1970): 629-31.

Short notes about four cabinetmakers from New York, Maine, and Vermont.

1322. ___, ed. "Collectors' Notes." Antiques 103 (May 1973): 963-67.

Short notes about five furniture craftsmen.

1323. ___. "The Rocking Chair in America." Antiques 99 (Feburary 1971): 238-40. illus.

A general survey of the history of the rocking chair.

1324. Gaines, Edith, and Dorothy H. Jenkins. Dictionary of Antiques Furniture. Princeton, N. J.: Pyne Press, 1974. 80 pp. illus.

Reprint of articles from Woman's Day.

1325. Garrett, Wendell, ed. "Clues and Footnotes." Antiques 103 (May 1973): 890+. illus.

Short notes on some craftsmen.

1326. ___. "The Price Book of the District of Columbia Cabinetmakers, 1831." Antiques 107 (May 1975): 888-897. illus.

Based on a manuscript in the Library of Congress. The price book was a listing of prices that the cabinetmaker would charge for each piece.

1327. Gayler, Julius F. Furniture, Yesterday and Today: The Principal Periods of Furniture. New York: Currier and Hartford, Ltd., 1926. 60 pp. illus.

Not a useful source.

1328. Gilborn, Graig A. American Furniture, 1660-1725. London: Hamlyn, 1972. 64 pp. illus.

A survey of American furniture with a limited discussion of regionalism and English sources.

1329. Ginsburg, Benjamin. "English Sources of 18th Century American Furniture Design." American Collector 12 (June 1943): 6+. illus.

1330. Gloag, John. The Chair: Its Origins, Design and
Social History. New York: A. S. Barnes, 1967. 221 pp.
illus. bibl.

　　A world-wide history of the chair, from ancient times
　　to the modern era.

1331. ___ . A Short Dictionary of Furniture Revised and
Enlarged Edition. London: Allen and Unwin, 1969. 813 pp.
illus. bibl.

　　A general dictionary on all kinds of furniture.

1332. Gottshall, Franklin H. Simple Colonial Furniture.
New York: Brace Publishing Co., 1935. Reprint. New York:
Bonanza Books, 1965. 124 pp. illus.

　　A general book with some fine illustrations.

1333. Gowans, Alan. Images of American Living: Four
Centuries of Architecture and Furniture as Cultural
Expression. Philadelphia: J. B. Lippincott, 1964. 498 pp.
illus. bibl.

　　Explores the uniqueness of American furniture and
　　the economic factors of furniture making.

1334. Grand Rapids Public Library. List of Books on
Furniture.... Grand Rapids, Mich.: Grand Rapids Public
Library, 1928. 142 pp.

　　An annotated bibliography.

1335. ___ . "Furniture Books Added from 1929 to April 1949."
Mimeographed. 11 pp.

　　Supplement to Number 1334.

1336. Grand Rapids Public Museum. Renaissance Revival Furni-
ture. Grand Rapids, Mich.: Grand Rapids Public Museum, 1976.
30 pp. illus.

　　An exhibition catalog. Most of the furniture is from
　　the Strong Museum in Rochester, N.Y.

1337. Grotz, George. The New Antiques: Knowing and Buying
Victorian Furniture. Garden City, N. Y.: Doubleday and Co.,
1964. 224 pp. illus.

　　A collectors' guide to furniture of the late 19th century.

1338. Hagler, Katharine Bryant. American Queen Anne Furniture, 1720-1755. Dearborn, Mich.: Greenfield Village and Henry Ford Museum, 1976. 52 pp. illus.

An exhibition catalog.

1339. Halsey, R. T. H., and Charles O. Cornelius. A Handbook of the American Wing. Rev. ed. New York: Metropolitan Museum of Art, 1938. xxiv, 312 pp. illus.

A revision of the handbook that was first published in 1924. Consists of a guide to the collection at the Metropolitan Museum of Art. Includes all arts.

1340. Halsey, R. T. H., and Elizabeth Tower. The Homes of Our Ancestors, as Shown in the American Wing of the Metropolitan Museum of Art, From the Beginning of New England through the Early Days of the Republic. Garden City, N.Y.: Doubleday, Page and Co., 1925.

1341. Hanks, David A. "The Arts and Crafts Movement in America, 1876-1916." Antiques 104 (August 1973): 220-26. illus.

Examines all aspects of this movement, including the furniture designers.

1342. ___. "Between the Fairs, 1873-76: Revival, Innovation and Reform in American Decorative Arts." Arts Magazine 55 (April 1981): 104-8. illus.

Discusses the rapid change in American decorative arts that occurred in the time period between the New York Exhibition of Industry of All Nations in 1853 and the Philadelphia Centennial Exhibition.

1343. ___. Innovative Furniture in America from 1800 to the Present. New York: Horizon Press, 1981. 200 pp. illus.

An exhibition catalog for a SITES traveling exhibition. The book is divided into chapter that are concerned with the construction, style, and comfort of furniture which represented new directions in furniture making.

1344. Harkness, Douglas W. Catalog of Unrecorded American Antiques, Furniture and Decorations. Glens Falls, N.Y.: Privately printed, 1967. 75 pp. illus.

1345. Harrington, James Robert. "Spanish Revival in the United States: Its Influence on Interior and Furniture Design." Master's thesis, Southern Illinois University, 1969.

1346. Harvard Tercentenary Exhibition. Catalogue of Furniture, Silver, Pewter, Glass,.... Cambridge, Mass.: Harvard University Press, 1936. ix, 114 pp. illus.

1347. Hewitt, Benjamin A. "Regional Characteristics of Inlay on American Federal Card Tables." <u>Antiques</u> 121 (May 1982): 1162-71. illus.

Useful for possible attributions of furniture.

1348. Hickley, F. Lewis. <u>Directory of the Historic Cabinet Woods</u>. New York: Crown Publishers, 1960. 186 pp. illus. bibl.

Useful for information about woods used in furniture.

1349. Hill, Amelia Leavitt. "American Beds of Other Days." <u>Old Furniture</u> 5 (September 1928): 94-101. illus.

A good article on beds made in America prior to 1840.

1350. Hill, Conover. <u>Antique Wicker Furniture: An Illustrated Value Guide</u>. Paducah, Kent.: Collector Books, 1975. 137 pp. illus.

A price guide that uses old illustrations of wicker furniture.

1351. ___ . <u>Value Guide to Antique Oak Furniture</u>. Paducah, Kent.: Collector Books, 1978. illus.

A price guide for collectors.

1352. Hipkiss, Edwin J., Henry R. Rossiter, and Maxim Karolik. <u>Eighteenth-Century American Arts: The M. and M. Karolik Collection of Paintings, Drawings, Engravings, Furniture, Silver, Needlework and Incidental Objects Gathered to Illustrate the Achievements of American Artists and Craftsmen of the Period from 1720 to 1820</u>. Boston and Cambridge: Harvard University Press, 1941. xvii, 366 pp. illus. bibl.

In 1950, a second edition was published. This is a catalog of this important and famous collection. An early approach to scholarly study of American decorative arts with 275 objects discussed and shown.

1353. Holloway, Edward Stratton. <u>American Furniture and Decoration: Colonial and Federal</u>. Philadelphia and London: J. B. Lippincott Co., 1928. 191 pp. illus.

A relatively complete book in spite of the early year of publication. Gives a history of furniture styles.

1354. Honour, Hugh. <u>Cabinetmakers and Furniture Designers</u>. New York: G. P. Putman's Sons, 1969. 320 pp. illus. bibl.

On craftsmen in both America and Europe. Includes chapters about John Goddard, Benjamin Frothingham, Samuel McIntire, Duncan Phyfe, and John Belter.

1355. Howe, Florence Thompson. "Labeled Clock Cases."
Antiques 30 (July 1936): 22-23. illus.

About clock cases made by David Goodell, Erastus Grant,
Levi Prescott, and Daniel and Nathaniel Monroe.

1356. Howe, Katherine S. "The Gothic Revival Style in
America, 1830-1890." Antiques 109 (May 1976): 1014-23. illus.

Discusses all aspects of the Gothic Revival style with
some mention of major designers.

1357. Hudson River Museum. Eastlake Influenced American
Furniture, 1870-1890. Yonkers, N.Y.: Hudson River Museum,
1974. 66 pp. illus. bibl.

An exhibition catalog of American furniture influenced
by Charles Lock Eastlake, an English designer.

1358. Hummel, Charles F. "Queen Anne and Chippendale
Furniture in the H. F. du Pont Winterthur Museum." Parts 1-3
Antiques 97, 98, 99 (June, December 1970, January 1971):
196-903, 900-9, 99-107. illus.

Contains information based on new research on the
furniture in the Winterthur museum since the
publication of Joseph Downs' catalog.

1359. ___ . Winterthur Guide to American Chippendale
Furniture--Middle Atlantic and Southern Colonies. New York:
Crown Publishers, 1976. 144 pp. illus. bibl.

A short guide to the furniture at Winterthur.

1360. Hunt, Katharine C. "The White House Furnishings of
the Madison Administration 1809-1817." Master's thesis,
University of Delaware (Winterthur), 1971. 255 pp. illus.

1361. Huntley, Richmond. "The Windsor, A Perfect Designed
Chair." American Collector 14 (September 1945): 12+. illus.

Includes information about some craftsmen.

1362. Iverson, Marion D. The American Chair, 1630-1890.
New York: Hastings House, 1959. 241 pp. illus. bibl.

Gives a history of chairs in America with information
on style changes. Gives some contemporary quotations
and provenances.

1363. Johnson, Axel P., and Marta K. Sironen, comp. Manual
of Furniture Arts and Crafts. Grand Rapids, Mich.: A. P.
Johnson Co., 1928. 899 pp. illus. bibl.

Contains a useful bibliography.

1364. Johnston, William R. "Anatomy of the Chair: American Regional Variations in the 18th Century Styles." Metropolitan Museum of Art Bulletin New Series 21 (November 1962): 118-29. illus.

Explores the regional styles of New England, New York, and Philadelphia.

1365. Jones, E. Alfred. "Some American Furniture-Makers." Old Furniture 5 (November 1928): 157-58. illus.

Uses English documents to examine the work and lives of 18th century Loyalist cabinetmakers. Mentions Benjamin Ogden, Weart Banta, John Johnson, John Edwards, Gibbs Atkins, William Black, William Watson and others.

1366. ___. "Some Watch and Clock Makers in America." Antiques 16 (January 1929): 48-50.

1367. Jones, Karen M., ed. "Collectors' Notes." Antiques 107 (May 1975): 1128+. illus.

Mentions Henry Beares, Amariah T. Prouty, and Rufus Pierce.

1368. Kane, Patricia E. 300 Years of American Seating Furniture. Boston: New York Graphic Society, 1976. 356 pp. illus.

Explores the history of American chairs from the 17th to 20th centuries. Discusses regionalism and sources of designs. Examples from the Yale University Collection.

1369. Karpel, Bernard. Arts in America--A Bibliography. 4 vols. Washington, D.C.: Smithsonian Institution Press, 1980. 2800 pp.

Volume 1 contains bibliographic entries on furniture.

1370. Kebabian, Paul B., and William Lipke, ed. Tools and Technologies: America's Wooden Age. Hanover, N. H.: University Press of New England, 1979. 119 pp. illus.

Pages 64-79 contain information about furniture making.

1371. Kennedy Galleries. Age of the Revolution and Early Republic in Furniture and Decorative Arts: 1750-1824. New York: Kennedy Gallery, 1977. 122 pp. illus.

1372. Kerr, Joellen Ayerson. "American Cottage Furniture." Master's thesis, Florida State University, 1969.

1373. Keyes, Homer E. "A Clue to New York Furniture."
Antiques 21 (March 1932): 122-23. illus.

About regional variations. Mentions Gilbert Ash.

1374. ___. "Editor's Attic." Antiques 32 (July 1937): 8-9.
illus.

Examines a notebook that has receipts from William Ash,
Alex Robertson, Duncan Phyfe and William Palmer.

1375. ___. "Editor's Attic." Antiques 22 (August 1933):
48-49.

About a sideboard attributed to McIntire. Mentions a
piece by Vannevar.

1376. Kimball, Fiske. The Creation of the Rococo Decorative
Style. Philadelphia: Philadelphia Museum of Art, 1943.
Reprint. New York: Dover Publications, 1980. xvii, 242 pp.
illus. bibl.

About 18th century styles.

1377. Kimerly, William Lowing. How to Know Period Styles in
Furniture. Grand Rapids, Mich.: Periodical Publications Co.,
1917. 147 pp. illus.

Also published in 1931. Designed for interior decorators.

1378. Kirk, John T. American Chairs: Queen Anne and Chippen-
dale. New York: Alfred A. Knopf, 1972. xi, 208 pp. illus.

A scholarly and well researched volume about the chairs
of 18th century America. Gives construction details,
stylistic variations, and regional characteristics.

1379. ___. American Furniture and the British Tradition to
1830. New York: Alfred A. Knopf, 1982. 398 pp. illus.

Makes a point that most characteristics of
American furniture are the results of European sources.
Includes a 1500-item photographic visual survey of
British and American Furniture.

1380. ___. Early American Furniture. New York: Alfred A.
Knopf, 1970. xi, 209 pp. illus.

Designed for the serious collector. Examines the
proportions, forms, construction details, and sources
that would be useful in furniture identification.

1381. ___. "Regional Characteristics of American Chairs."
Master's thesis, Yale University, 1963.

1382. Kovel, Ralph M., and Terry H. Kovel. _American Country Furniture, 1780-1875_. New York: Crown Publishers, 1965. vii, 248 pp. illus. bibl.

Prepared for collectors.

1383. Lambourne, Lionel. _Utopian Craftsmen: The Arts and Crafts Movement from the Catswalds to Chicago_. Layton, Ut.: Peregrin Smith Books, 1980. 234 pp. illus. bibl.

Deals with all products of the Arts and Crafts Movement.

1384. Lazeare, James. _Primitive Pine Furniture_. Watkins Glen, N.Y.: Century House, 1951. illus.

Includes information on Shakers.

1385. Lea, Zilla Rider, ed. _The Ornamented Chair: Its Development in America, 1700-1890_. Rutland, Vt.: Charles E. Tuttle Co., 1960. 173 pp. illus. bibl.

Contains essays by seven authorities on both American and English furniture. Specific kinds of chairs are discussed in detail.

1386. Litchfield, Frederick. _Illustrated History of Furniture_. Boston: Eastes and Lauriat, 1893.

About world furniture.

1387. Little, Nina Fletcher. _Neat and Tidy: Boxes and Their Contents Used in Early American Households_. New York: E. P. Dutton, 1980. 208 pp. illus. bibl.

About all kinds of boxes, including some that should be considered to be furniture.

1388. Lockwood, Luke Vincent. _Colonial Furniture in America_. 2 vols. 3rd edition. New York: Charles Scribner's Sons, 1926. Vol. 1: xxiv, 398 pp. Vol 2: xx, 354 pp. illus.

Published in 1913 and 1921, as well as 1926. Contains photographs of over 800 furniture examples. Important for its early date of publication.

1389. ___. _Furniture Collector's Glossary_. New York: Walpole Society, 1913. viii, 55 pp. illus.

200 copies printed.

1390. Lockwood, Sarah M. _Antiques_. Garden City, N.Y.: Doubleday, Doran and Co., 1936. 161 pp. illus. bibl.

A selection of short essays

1391. Lyon, R. P., comp. Standard Reference Book of the Furniture Trade and Kindred Branches. 1885.

A directory of furniture dealers.

1392. McClelland, Nancy. Furnishing the Colonial and Federal House. Philadelphia: J. B. Lippincott Co., 1947. 178 pp.

A guide for interior decorators.

1393. McClinton, Katharine Morrison. "American Furniture in Family Portraits of the 18th and 19th Centuries." Apollo New Series 89 (March 1969): 226-29. illus.

Excellent article because it shows how furniture was used.

1394. ___ . An Outline of Period Furniture. New York: Clarkson N. Potter, 1972. viii, 278 pp. illus. bibl. glossary.

A review of all styles from several countries.

1395. McNerney, Kathryn. Victorian Furniture-Our American Heritage. Paducah, Ky.: Collector's Books, 1981. 252 pp. illus.

A collector's guide.

1396. McPherson, Robert. "Characteristics That Mark English and American Furniture." American Collector 4 (April 1936): 7+. illus.

1397. Madigan, Mary Jean Smith. "The Influence of Charles Locke Eastlake on American Furniture Manufacture, 1870-90." Winterthur Portfolio 10 (1975): 1-22. illus.

The information in this article is available in the exhibition catalog for an exhibition at the Hudson River Museum.

1398. ___ . 19th Century Furniture: Innovation, Revival, and Reform. New York: Art and Antiques, 1982. 160 pp. illus. bibl.

Explores American furniture from Empire to Art Nouveau. Contains chapters on furniture makers, styles, and related subjects. Information is given about George Hunzinger, John H. Belter, and others.

1399. Margon, Lester. Construction of American Furniture Treasures. New York: Home Craftsmen Publication, 1949. illus.

Measured drawings for the home workshop.

1400. ___ . Masterpieces of American Furniture, 1620-1840.
New York: Architectural Book Publishing Co., 1965. 256 pp.
illus.

Individual examples of American furniture are examined
in detail.

1401. ___ . More American Furniture Treasures, 1620-40.
New York: Architectural Book Publishing Co., 1971. 256 pp.
illus. bibl.

1402. Marsh, Moreton. The Easy Expert in Collecting and
Restoring American Antiques. Philadelphia: J. B. Lippincott
Co., 1960. 176 pp. illus. bibl.

A very general book about collecting antiques.

1403. Mayhew, Edgar deN., and Minor Myers, Jr. A Documentary
History of American Interiors: From the Colonial Era to 1915.
New York: Charles Scribner's Sons, 1980. 399 pp. illus.
bibl. plans, elevations.

Uses period paintings and photographs as sources of
information on how American furniture was used during the
periods.

1404. Maynard, Henry P. "Three Centuries of American Furni-
ture." Apollo 88 (December 1968): 454-65. illus.

About the collection at the Wadsworth Atheneum.

1405. Menz, Katherine Boyd. "Wicker in the American Home."
Master's thesis, University of Delaware (Winterthur), 1976.
97 pp.

1406. ___ . "Wicker Furniture: Four Centuries of Flexible
Furniture." American Art and Antiques 1 (September/October
1978): 84-91. illus.

Although wicker furniture is often thought of as belonging
only to the late 19th century, the author shows examples
from much earlier periods.

1407. Metropolitan Museum of Art. American Paintings,
Furniture, silver: Catalog of the Exhibition at the Hudson-
Fulton Celebration. 2 vols. New York: Metropolitan Museum
of Art, 1909. Vol. 1: 159 pp. Vol 2: 162 pp. illus.

Important early exhibition. Does not provide much
useful data.

1408. ___ . The Art of Joinery: 17th Century Case Furniture in
the American Wing. New York: Metropolitan Museum of Art,
1972. unpaged. illus.

An exhibition catalog.

1409. Miller, Edgar G., Jr. _American Antique Furniture_.
2 vols. Baltimore: Lord Baltimore Press, 1937. Reprint.
New York: Dover Publications, 1967. li, 1106 pp. illus.
bibl.

 With 2115 illustrations, this book's usefulness lies
 in the photographs. It is still considered a standard
 reference book in the field of American furniture.

1410. ___ . _The Standard Book of Antiques Furniture_. New
York: Greystone Press, 1950. 856 pp. illus.

 An abridgement of the above 2-volume work.

1411. Mipaas, Esther. "Cast-Iron Furnishings." _American
Arts and Antiques_ 2 (May/June 1979): 34-41. illus.

 About garden furniture. Some makers are mentioned.

1412. Molesworth, H. D., and John Kenworthy-Brown. _Three
Centuries of Furniture_. New York: Viking Press, 1972.
328 pp. illus. bibl.

 A history of world furniture, with some remarks on
 American furniture makers.

1413. Montgomery, Charles F. _American Furniture: The Federal
Period, in the Henry Francis du Pont Winterthur Museum._ New
York: Viking Press, 1966. 497 pp. illus. bibl.

 Probably the most important book on American Federal
 furniture. Examines the history, sources, construction,
 and related information on Federal furniture.
 Illustrates and discusses individual works. Includes
 a short biographical check list of craftsmen.

1414. ___ . _Cabinetmaker's Price Books, England and America_.
1966.

 The author was unable to locate a copy of this book.

1415. ___ . _A List of Books and Articles for the Study of
the Arts in America_. Winterthur, Del.: H. F. du Pont
Winterthur Museum, 1970. 136 pp. "Reprinted from
a Typescript copy."

 About all arts.

1416. Moody, Margaret J. "American Furniture at Dartmouth
College." _Antiques_ 120 (August 1981): 326-32. illus.

 Briefly mentions Michael Carleton and Robert Tracy.

1417. Moore, Hannah. _Old Furniture Book_. New York:
Frederick A. Stokes Co., 1903. 254 pp. illus.

 A very general and outdated book.

1418. Mooz, R. Peter. The Art of American Furniture: A
Portfolio of Furniture in the Collections of Bowdoin College.
Brunswick, Maine: Bowdoin College Museum of Art, 1974. 56 pp.
illus.

A catalog of the fine collection located at this
college. The book also explores the role of English
influences on American furniture.

1419. Mooz, R. Peter, and Carolyn J. Weekley. "American
Furniture at the Virginia Museum of Fine Arts." Antiques 113
(May 1978): 1052-63. illus.

1420. Morse, Frances C. Furniture of the Olden Time.
New York: Macmillan Co., 1903. xvii, 371 pp. illus.

Important because of its early publication. Useful
for the study of furniture collecting.

1421. Museum of Fine Arts. The Gothic Revival Style in
America, 1830-1870. Houston, Tx.: The Museum of Fine Arts,
1976. 101 pp. illus. bibl.

An exhibition catalog by Katherine S. Howe and David
Warren.

1422. Naeve, Milo M. Identifying American Furniture,
A Pictorial Guide to Styles and Terms, Colonial to Contempor-
ary. Nashville, Tenn.: American Association for State and
Local History, 1981. 87 pp. illus.

For beginning collectors.

1423. Nagel, Charles. American Furniture, 1650-1850.
New York: Chanticleer Press, 1950. 110 pp. illus. bibl.

A social and historical study of American furniture.
Examines sources and uses of furniture.

1424. Newark Museum. Classical America, 1815-45.
Newark, N.J.: Newark Museum Associates, 1963. 212 pp. illus.
bibl.

An exhibition catalog that includes information on all
of the arts and crafts of the Classical period.

1425. New York Public Library. List of Works in the New
York Public Library Relating to Furniture and Interior
Decoration. New York: New York Public Library, 1908. 32 pp.

Reprinted from the Bulletin of September 1908.

1426. Nind, J. Newton, and Gustav Stickley. The Furniture
Styles. Chicago: Trade Periodical Co., 1909.

Has chapters on the craftsmen of the Mission style.

1427. Nutting, Wallace. American Windsors. Framingham, Ma.:
Old American Co., 1917. Reprint. Southampton, N.Y.: Cracker
Barrel Press, 1972. 200 pp. illus.

 A serious study of Windsor chairs. Discusses styles,
 forms, and construction details.

1428. ___ . Furniture of the Pilgrim Century, 1620-1720,
Including Colonial Utensils and Hardware. Boston; Marshall
Jones Co., 1921. Reprint. New York: Dover Publications,1965.
ix, 587 pp. illus.

 The first study about 17th century furniture. Although
 some of the information is now considered to be
 erroneous. The book is still considered a major
 work on the subject.

1429. ___ . Furniture Treasury. 3 vols. Framingham, Ma.:
Old America Co., 1928-33. Vol. 1 and 2: 5000 Illustrations,
Vol. 3: 550 pp. illus.

 A massive book that contains mostly illustrations.
 The first two volumes contain illustrations grouped
 by furniture type. Volume 3 supplements the
 information in the other volumes and includes a
 section on clocks. Information on individual craftsmen
 is lacking and many attributions are very incorrect.
 However, this book is still needed by all students
 of American decorative arts. It has been reprinted
 several times.

1430. Nye, Alvan Crocker. A Collection of Scale-Drawings,
Details and Sketches of What is Commonly Known as Colonial
Furniture, Measured and Drawn from Antique Examples. New
York: William Helburn, 1895. 55 plates.

 Useful because of its early date and possible
 identification of early reproductions. No mention
 of craftsmen.

1431. Ormsbee, Thomas H. Early American Furniture Makers:
A Social and Biographical Study. New York: Thomas Y. Crowell
Co., Reprint. New York: Archer House, 1957. xviii, 183 pp.
illus. bibl.

 An unsuccessful attempt at a sociological study about
 the lives of furniture craftsmen. Mentions most major
 craftsmen. Not comprehensive.

1432. ___ . Field Guide to American Victorian Furniture.
Boston: Little, Brown and Co., 1952. xxxii, 429 pp. illus.
bibl.

 A collector's guide.

1433. ___ . Field Guide to Early American Furniture.
Boston: Little Brown and Co., 1951. xxxix, 464 pp. illus.
bibl.

A collector's guide with line drawings and prices.

1434. ___ . "New Delvings in Old Fields." Antiques 22
(September 1932): 109-12. illus.

Examines the shipping of furniture.

1435. ___ . The Story of American Furniture. New York:
Macmillan Co., 1934. xxi, 276 pp. illus.

A general book with no new information. Of little
use.

1436. ___ . The Windsor Chair. New York: Deerfield Books,
1962. 223 pp. illus.

Gives a useful checklist of American Windsor chair
makers.

1437. Osburn, Burl N. Measured Drawings of Early American
Furniture. Milwaukee, Wis.: Brace Publishing Co., 1936.
Reprint. New York: Dover Publications, 1974. 94 pp. illus.
bibl.

Each example is photographed, described, and illustrated
with a measured drawing.

1438. Otter, Paul Denniston. Furniture for the Craftsman,
A Manual for the Student and Mechanic.... New York: David
Williams Co., 1914. 306 pp.

A contemporary account on furniture making during the
age of the Arts and Crafts Movement.

1439. Otto, Celia J. American Furniture of the Nineteenth
Century. New York: Viking Press, 1965. 229 pp. illus.

A history of furniture during the 19th century. Attempts
to distinguish regional styles.

1440. Page, Marion. Furniture Designed by Architects.
New York: Watson-Guptill, 1980. 224 pp. illus. bibl.

On architects who designed furniture. Includes chapters
on some American architects, including Harvey Ellis.

1441. ___ . "Rediscovering the Furniture of Six American
Architects." American Art and Antiques 1 (July/August 1978):
32-41. illus.

About Thomas Jefferson, H. H. Richardson, Samuel McIntire,
Frank Lloyd Wright, Greene and Greene, Alexander J. Davis.

1442. Pearce, Lorraine Waxman. "Fine Federal Furniture at the White House." Antiques 82 (Septebmer 1962): 273-77. illus.

Mentions the craftsman, Joseph Burgess.

1443. Pelzel, Thomas. Arts and Crafts Movement in America. Riverside, Ca.: University of California at Riverside, 1972. 27 pp. illus. bibl.

1444. Pennington, David A., and Michael B. Taylor. A Pictorial Guide to American Spinning Wheels. Sabbathday Lake, Maine: Privately printed, 1975. 100 pp. illus, bibl.

Contains an important check list of spinning wheel makers. Many spinning wheel makers also made furniture.

1445. Peterson, Harold Leslie. Americans at Home: From the Colonists to the Late Victorians: A Pictorial Sourcebook of American Interiors. New York: Charles Scribner's Sons, 1971. xviii, 205 pp. illus.

1446. Philadelphia Museum of Art. Exhibition of American and English Furniture of the Sixteenth, Seventeenth, Eighteenth and Early Nineteenth Centuries. Philadelphia: Philadelphia Museum of Art, 1916. illus.

An early exhibition catalog.

1447. Powell, Lydia. "The Influence of English Design on American Furniture." Parts 1-6. Apollo 67, 68, 69, 70 (June, August, October, December 1958, February, August 1959): 191-95, 35-38, 104-8, 175-81, 38-43, 45-50. illus.

Important series about the English influence in high-style American furniture from the 17th to early 19th centuries. Major craftsmen are discussed.

1448. Price, Matlack. "A Sequence in American Furniture Forms." American Collector 4 (May 1935): 4+. illus.

Explains the origins of furniture styles.

1449. Princeton Art Museum. The Arts and Crafts Movement in America, 1876-1916. Princeton, N. J. : Princeton University Press, 1972. 190 pp. illus. bibl.

Includes five essays on aspects of this important art movement.

1450. Prime, Alfred Coxe, comp. The Arts and Crafts in Philadelphia, Maryland and South Carolina, 1721-1785: Gleanings from Newspapers. Philadelphia: The Walpole Society, 1929. xvi, 323 pp.

A very important book for documentary evidence. Contains information on all arts.

1451. ___ . The Arts and Crafts in Philadelphia, Maryland and South Carolina, 1786-1800: Series Two, Gleanings from Newspapers. Philadelphia: The Walpole Society, 1932. xii, 331 pp.

Sequel to the volume in the above entry.

1452. "Queries and Opinions." Antiques 17 (May 1930): 458-66.

Brief mention of Charles Marsh, John Goddard, and Tucker and Griffin.

1453. "Queries and Opinions." Antiques 14 (September 1928): 252-54. illus.

About William Lloyd, S. Buss, and S. H. Marks.

1454. Raeth, George Adolph. Home Furniture-Making for Amateurs. Chicago: F.J. Drake and Co., 1910, 233 pp. illus.

A how-to book for home furniture makers.

1455. Ralston, Ruth. "American Furniture in the Victorian Century." American Collector 12 (April 1943): 10-12. illus.

A review of American Victorian styles.

1456. Ramsey, L. G.G., and Helen Comstock, eds. The Connoisseur's Guide to Antique Furniture. London: Connoisseur, 1957. illus.

Consists of a collection of articles on American and European furniture. There are chapters on Victorian furniture, Shakers, Windsor chairs, country, and period furniture.

1457. Randall, Richard H., Jr. American Furniture in the Museum of Fine Arts, Boston. Boston: Museum of Fine Arts, 1965. xvii, 273 pp. illus. bibl.

A catalog of the major collection at the Boston Museum of Fine arts. 218 examples are described, illustrated and documented.

1458. Reese, Richard Dana. "American Chippendale: A Primer." American Art and Antiques 2 (January/February 1979): 66-75. illus.

Reviews regional characteristics.

1459. Reifsnyder, Howard. Colonial Furniture: The Superb Collection of Howard Reifsnyder, including Signed Pieces by Philadelphia Cabinetmakers.... New York: American Art Association, 1929. 275 pp. illus.

A sales catalog of the sale of a major collection.

1460. Renwick Gallery. <u>Paint on Wood: Decorated American Furniture Since the 17th Century</u>. Washington, D. C.: Smithsonian Institution Press, 1971. 36 pp. illus.

 An exhibition catalog that includes a discussion of the techniques of furniture painting. Each item in the exhibition is discussed.

1461. Ring, Betty. "Checklist of Looking-Glass Makers and Merchants Known by Their Labels." <u>Antiques</u> 119 (May 1981): 1178-95. illus.

 An excellent list of over 150 craftsmen and dealers working prior to 1860.

1462. Roe, F. Gordon. <u>Windsor Chairs</u>. New York: Pitman Publishing Corp., 1953. 96 pp. illus.

 Chapter IV is on American Windsor chairs.

1463. Roger, Meyric R. <u>American Interior Design: The Traditions and Development of Domestic Design from Colonial Time to the Present</u>. Reprint. New York: Arno Publishing Co., 1974.

1464. Rogers, Millard F., and Carol Macht. <u>Ladies, God Bless 'em--The Women in the 19th Century</u>. Cincinnati: Cincinnati Art Museum, 1976. 71 pp. illus. bibl.

 Furniture is only mentioned briefly.

1465. Roth, Rodris. "American Art: The Colonial Revival and 'Centennial' Furniture." <u>Art Quarterly</u> 27 (Spring 1964): 57-81. illus.

 Important article which claims that no colonial furniture was displayed at the Centennial Exhibition. Presents a case for identifying late 19th and early 20th century furniture made in the Colonial styles. Calls this furniture: Colonial Revival.

1466. Rubin, Cynthia, and Jerome Rubin. <u>Mission Furniture: Making It, Decorating with It, Its History and Place in the Antique Market</u>. San Francisco: San Francisco Chronicle Books, 1980. 160 pp. illus.

1467. Sack, Albert. <u>Fine Points of Furniture: Early American</u>. New York: Crown Publishers, 1950. xvi, 303 pp. illus.

 A guide for the collector.and connoisseur. Identifies furniture as good, better, and best. Contains about 800 illustrations.

1468. Sack, Harold. "Authenticity in American Furniture." <u>Art in America</u> 48 (February 1960): 72-75. illus.

 Connoisseurship of American furniture.

1469. [Sack, Harold, Albert M. Sack, and Robert M. Sack.]
American Antiques from Israel Sack's Collection. 6 vols.
Washington, D. C.: Highland House Publishers, 1979. illus.

Examples from the stock of this famous dealer.

1470. Sanders, Barry, ed. The Craftsman. Santa Barbara, Ca.:
Peregrine Smith, 1978, 328 pp. illus.

Reprints of articles from The Craftsman.

1471. Sandhurst, Phillip T., et al. The Great Centennial
Exhibition. Philadelphia and Chicago: P. W. Ziegler and Co.,
1876. 544 pp. illus.

Handbook to this important fair. Includes illustrations
of American furniture.

1472. Santore, Charles. "A Checklist of American Windsor
Chair Makers." Maine Antique Digest 9 (January 1981): 5A-6A.

A useful check list.

1473. ___. The Windsor Style in American Furniture: A
Pictorial Study of the History and Regional Characteristics
of the Most Popular 18th Century Furniture Form in America,
1730-1830. Philadelphia: Running Press, 1981, 215 pp.
illus.

A comprehensive book that makes use of recent research.

1474. Saunders, Richard. Collecting and Restoring Wicker
Furniture. New York: Crown Publishers, 1976. 118 pp. illus.

A collectors' book.

1475. Saylor, Henry Hodgman. Collecting Antiques for the
Home. New York: R. M. McBride and Co., 1938. 416 pp. illus.

A very general book on antiques collecting.

1476. Schiffer, Peter, and Herbert Schiffer. Miniature
Antique Furniture. Wynnewood, Pa.: Livingston Publishing Co.,
1973. illus.

About all kinds of antique miniature furniture.

1477. Schwartz, Marvin D. American Furniture of the Colonial
Period. New York: Metropolitan Museum of Art, 1976. xvi,
93 pp. illus. bibl.

A short general book with no new information.

1478. ___. American Interiors, 1675-1885, A Guide to American
Period Rooms in the Brooklyn Museum. Brooklyn: Brooklyn
Museum, 1968. vi, 114 pp. illus. bibl.

1479. ___ . Country Styles. New York: Brooklyn Museum, 1956. 43 pp. illus.

1480. Seale, William. The Tasteful Interlude: American Interiors Through the Camera's Eye, 1850-1917. New York: Praeger Publishers, 1975. 284 pp. illus.

Interesting collection of photographs showing how furniture was used and arranged.

1481. Seeger and Guernsey. Cyclopaedia of the Manufacturers and Products of the United States. New York: Seeger and Guernsey, 1890. clxxx, 259 pp. illus.

Includes furniture manufacturers. A second edition was published in 1891.

1482. Shackleton, Robert, and Elizabeth Shackleton. The Book of Antiques. Philadelphia: The Penn Publishing Co., 1938. 284 pp. illus.

1483. ___ . The Charm of the Antique. New York: Hearst's International Library, 1914. 300 pp. illus.

1484. Shanafelt, C. "Regional Characteristics in American Cabinetmakers." Country Life 71 (April 1937): 94.

1485. Shea, John G. American Country Furniture of North America. New York: Van Nostrand Reinhold Co., 1975. 228 pp. illus. bibl.

Divided into four sections: historical background, regional influences, construction of furniture, and measured drawings of examples.

1486. Shea, John G., and Paul N. Wenger. Colonial Furniture. Milwaukee: Bruce Publishing Co., 1935. 180 pp. illus. bibl.

Mostly of measured drawings.

1487. Shipway, Verna. Masterpieces of Furniture. 1931. Reprint. New York: Dover Publications, 1965. 115 pp. illus.

1488. Sigworth, Oliver F. The Four Styles of a Decade, 1740-1750. New York: New York Public Library, 1960. 33 pp. illus.

About the Chinese, Gothic, Palladian, and Rococo styles.

1489. Singleton, Esther. The Furniture of Our Forefathers. Garden City, N.Y.: Doubleday, Page and Co., 1913. 664 pp. illus.

An early book on collecting and furniture history. Full of errors and of limited use.

1490. Sironen, Marta K. A History of American Furniture.
East Stroudsburg, Pa.: Touse Publishing Co., 1936. 140 pp.
illus.

An anecdotal and outdated history of American furniture.

1491. Smith, Nancy A. Old Furniture: Understanding the
Craftsman's Art. Indianapolis and New York: Bobb-Merrill,
1975. 191 pp. illus. bibl.

This volume is divided into two parts with the first
part consisting of information on how American cabinet-
makers worked and the second part on the woods used.

1492. Smith, Robert C. "Architecture and Sculpture in 19th
Century Mirror Frames." Antiques 109 (February 1976):
350-59. illus.

Illustrates some American and English looking-glasses.

1493. ___. "China, Japan, and the Anglo-American Chair."
Antiques 96 (October 1969): 552-58. illus.

Explores the Oriental influence on American 18th century
furniture.

1494. ___. "Furniture of the Eclectic Decades, 1870-1900."
Antiques 76 (July 1959): 50-53. illus.

Examines the furniture from America and Europe.
Mentions some American craftsmen.

1495. ___. "Gothic and Elizabethan Revival Furniture, 1800-
1850." Antiques 75 (March 1959): 272-76. illus.

Illustrates furniture whose designs were copies
from English design books. Several major 19th century
cabinetmakers of America are discussed.

1496. ___. "Late Classical Furniture in the United States,
1820-1860." Antiques 74 (December 1958): 519-23. illus.

Mentions some American craftsmen.

1497. ___. "Rococo Revival Furniture, 1850-1870." Antiques
75 (May 1959): 470-75. illus.

Reviews the work of Belter, Pabst, and other craftsmen
working in the Rococo Revival style.

1498. "Some Furniture Types Were Also Made Late in Factories."
American Collector 1 (June 1934): 6+. illus.

Shows examples of furniture made in the 1890's, in
the earlier styles.

1499. Spratt, Charles E. comp. <u>Directory of Wholesale Furniture Manufacturers of the United States</u>. New York: Charles E. Spratt, 1906-08.

A useful directory of furniture makers of the early 20th century.

1500. Stayton, Kevin L. "Architects Look at Interior Design." <u>19th Century</u> 6 (Autumn 1980): 30-33. illus.

Examines the role of the architect in furniture design.

1501. Stephenson, Sue H. <u>Rustic Furniture: Picturesque Styles and Techniques</u>. New York: Van Nostrand Reinhold, 1979. 128 pp. illus. bibl.

Includes information on rustic furniture from England and America. Concentrates on furniture of the late 19th and early 20th centuries. Includes a section on how to make rustic furniture.

1502. Stewart, Patrick L. "The American Empire Style: Its Historical Background." <u>American Art Journal</u> 10 (November 1978): 97-105. illus.

Examines the sources and influences of American Empire furniture of the early 19th century.

1503. Stillinger, Elizabeth. <u>The Antiques Guide to the Decorative Arts in America, 1600-1875</u>. New York: E. P. Dutton, 1973. 480 pp. illus. bibl.

A review of all aspects of American decorative arts. Some cabinetmakers are mentioned very briefly.

1504. Stowe-Day Foundation. <u>A Selection of 19th Century American Chairs</u>. Hartford: Stowe-Day Foundation, 1973. 107 pp. illus.

An exhibition catalog with an essay by Anne S. MacFarland.

1505. Swan, Mabel M. "Artisan Leaders of 1788." <u>Antiques</u> 27 (March 1935): 90-91. illus.

About craftsmen who were active in political affairs. Several cabinetmakers are discussed.

1506. Sweeney, John A. H. "The Cabinetmaker in America." <u>Antiques</u> 70 (October 1956): 368-69. illus.

Concerns the organization of the furniture-making trade in 18th century America. Discusses certain craftsmen in some detail.

1507. ___ . <u>Great Winterthur Rooms</u>. Winterthur, Del.: H. F. du Pont Winterthur Museum, 1964. 43 pp. illus.

1508. ___ . "Some Regional Characteristics in American Queen Anne Furniture." Typescript copy at the H. F. du Pont Winterthur Museum.

1509. ___ . The Treasure House of Early American Rooms. New York: Viking Press, 1963. 179 pp. illus.

Some rooms from the Winterthur Museum. Rooms are arranged around themes and are not accurate.

1510. Swedberg, Robert W. Country Pine Furniture. Des Moines, Iowa: Wallace-Homestead, 1980. 152 pp. illus.

1511. Swedburg, Robert, and Harriet Swedburg. Victorian Furniture: Styles and Prices. Des ·Moines, Iowa: Wallace-Homestead, 1976. 139 pp. illus.

A price guide for collectors.

1512. Symonds, Robert W. "English Furniture and Colonial American Furniture--A Contrast." The Burlington Magazine 78 (June 1941): 182-87. illus.

An interesting article from the viewpoint of an authority on English furniture.

1513. Talbott, Page. "Innovative Furniture." Arts and Antiques 4 (March/April 1981): 108-13. illus.

Survey of American furniture that illustrates advances in design and construction methods.

1514. Taylor, Henry H. Knowing, Collecting and Restoring Early American Furniture. Philadelphia: 1930. 156 pp. illus.

Designed for the beginning collector.

1515. Theus, Will H. How to Detect and Collect Antique Furniture. New York: Alfred A. Knopf, 1978. 209 pp. illus. bibl.

A how-to book for the collector.

1516. Thwing, L. L. "Carpenter, Joiners, and Cabinetmakers." Chronicle of the Early American Industries Association 2 (March 1938): 31.

Explains the differences among these professions.

1517. Toller, Jane. Antique Miniature Furniture in Great Britain and America. Newton, Mass.: Charles T. Branford, 1966. 112 pp. illus. bibl.

The only book on this subject.

1518. ___. Papier-Mache in Great Britain and America.
Newton, Mass.: Charles T. Branford, 1962. 126 pp. illus.

Examines all forms of papier-maché.

1519. Tracy, Berry B. Federal Furniture and Decorative
Arts at Boscobel. New York: Boscobel Restorations and
Harry N. Abrams, 1981. 165 pp. illus.

Information on the collection at this Hudson River
historic house.

1520. ___. "Federal Furniture: Major Acquisitions and Special
Loans." Apollo 109 (May 1980): 362-69. illus.

Federal furniture at the Metropolitan Museum of Art.

1521. ___. "Federal Period Furniture." Connoisseur 192
(May 1976): 11-15. illus.

Reviews the Federal furniture at the White House. Some
cabinetmakers are mentioned.

1522. Trent, Robert, ed. Pilgrim Century Furniture: An
Historical Survey. New York: Universe Books, 1976. 168 pp.
illus.

Reprints of articles from Antiques.

1523. Triggs, Oscar Lovell. Chapters in the History of
the Arts and Crafts Movement. Chicago: The Bohemia Guild
of Industrial Art League, 1902. iv, 198 pp. illus.

An aesthetic statement on this important movement.
Mentions furniture, pottery, and related art forms.

1524. Tryon, Rolla Milton. House Manufacturers in the
United States, 1640-1860. Chicago: University of Chicago
Press, 1917. xii, 413 pp. illus. bibl.

From a Ph.D. dissertation. Examines all household
manufacturers.

1525. Tunis, Edwin. Colonial Craftsmen and the Beginning of
an Industry. Cleveland, Ohio: World Publishers, 1965. 159 pp.
illus.

About all industries.

1526. Tuten, Fern. "American Domestic Patented Furniture,
1790-1850." Ph.D. dissertation, Florida State University,
1969. 276 pp.

1527. United States Treasury Department. Documents Relative to the Manufactures in the United States. Collected and Transmitted to the House of Representative with a Resolution of January 19, 1832. 4 vols. Reprint. New York: Burt Franklin, 1969.

 Includes furniture.

1528. Van Lennep, Gustave A. A Guide to American Antique Furniture. Philadelphia: Macrae Smith Co., 1937. ix, 95 pp. illus.

 Dated and of very little use.

1529. Vincent, Jean Ann. "American Furniture Craftsmen." Interiors 115 (November 1955): 108-11. illus.

 A review of major cabinetmakers. Illustrated with reproductions made by Kaplan Furniture Co.

1530. Voss, Thomas M. Antique American Country Furniture: A Field Guide. Philadelphia: J. B. Lippincott, 1978. 145 pp. illus. bibl.

 A collector's manual that gives information on styles, woods used, construction, and related items.

1531. Waring, Jane . Early American Stencil on Walls and Furniture. New York: Dover publications, 1937.

 A book of stencil designs.

1532. Warren, David B. Bayou Bend--American Furniture, Painting, and Silver from the Bayou Bend Collection. Houston, Tx.: Museum of Fine Arts, 1975. 208 pp. illus. bibl.

 A catalog of the items in this important collection.

1533. Warren, David B., and Katherine S. Howe. "Gothic Revival Furniture in the United States, 1830-1870." Connoisseur 194 (January 1977): 56-61. illus.

 Information from a 1976 exhibition at the Houston Museum of Fine Arts.

1534. Watkins, C. Malcolm. "American Pianos of the Federal Period in the United States National Museum." Antiques 42 (January 1952): 58-61. illus.

 A general history of the piano in America is presented. Some makers are mentioned.

1535. Wenham, Edward. The Collector's Guide to Furniture Design. New York: Collectors Press, 1928. v, 382 pp. illus.

A general book about collecting English and American furniture.

1536. Weil, Martin E. "A Cabinetmaker's Price Book." Winterthur Portfolio 13 (1979): 175-92.

A reprint of a 1772 cabinetmaker's price book from Philadelphia.

1537. Weinhardt, Carl J. Indianapolis Collects: American Furniture 1700-1850. Indianapolis: Indianapolis Museum of Art, 1972. 32 pp. illus.

1538. Welsh, Peter. "Patents and the Decorative Arts: A Portent of a Changing Society." Antiques 82 (July 1962): 72-75. illus.

Examines patents in the decorative arts, including furniture. Patents by the following men are discussed: Isaac Eaton, Benjamin F. Hays, and William Wooley.

1539. White Printing Co. The White Directory of Manufacturers of Furniture and Kindred Goods in the United States and British Provinces. Grand Rapids, Mich.: White Printing Co., 1905.

A directory of furniture makers in 1905.

1540. Williams, N. Lionel. Country Furniture of Early America. Cranbury, N. J.: A. S. Barnes, 1970. 138 pp. illus.

A history of country furniture prior to 1850. Presents information on identification of styles and age. Includes 103 measured drawings.

1541. Williamson, Scott Graham. The American Craftsman. New York: Crown Publishers, 1940. xiv, 239 pp. illus.

An outdated study about craftsmen who worked with furniture, pottery, weavers, and other crafts.

1542. Winchester, Alice, et al. The Antiques Treasury of Furniture and Other Decorative Arts at Winterthur, Williamsburg, Sturbridge, Ford Museum, Cooperstown, Deerfield, and Shelburne. New York: E. P. Dutton, 1959. 320 pp. illus.

1543. Winchester, Alice, ed. Living with Antiques. New York: R. M. McBride and Co., 1941. iv, 152 pp. illus.

For interior decorators.

1544. [Windsor, Henry Haven.] Mission Furniture, How to
Make it. Chicago: Popular Mechanics, 1909. 5 pp. illus.

 A pamphlet on furniture making. Useful for
 research on the Arts and Crafts.

1545. Winterthur Museum. Winterthur Conference: Arts of
the Anglo-American Community in the 17th Century. Charlottes-
ville: University Press of Virginia, 1975. 299 pp. illus.

 A selection of papers delivered at the 1974 Winterthur
 Conference. Contains an essay on the Hadley chest by
 Patricia Kane and Robert Trent's article, "Joiners and
 Joinery of Middlesex Co., Mass. 1630-1730."

1546. ___ . Winterthur Conference: Country Cabinetmakers and
Simple City Furniture. Charlottesville: University Press of
Virginia, 1970. 311 pp. illus. bibl.

 One article is on the Dominy Family of East Hampton, N.Y.;
 another one is about the Dunlap Family. There
 is also a discussion on the simple furniture of Phila-
 delphia. Contains information on many craftsmen.

1547. ___ . Winterthur Conference: Technological Innovation
and the Decorative Arts. Charlottesville: The University
Press of Virginia, 1974. xiv, 373 pp. illus.

 Contains some information about furniture.

1548. Wolcott, William Stuart, Jr. "Ten Important American
Sideboards." Antiques 14 (December 1928): 156-62. illus.

 Sideboards by Mills and Deming, Silas E. Cheney, and
 Aaron Chapin.

1549. Worcester Art Museum. Colonial Epoch in America.
Worcester, Mass.: Worcester Art Museum, 1975. 83 pp. illus.

 A small exhibition catalog.

1550. Wright, Florence E. Three Centuries of Furniture.
Cornell Extension Bulletin 67. Ithaca: Cornell Extension
Service, 1950.

 The pamphlet contains unusable text, but has interesting
 photographs of pieces from private collections.

1551. Yale University Art Gallery. American Art: 1750-1800,
Towards Independence. New Haven, Conn.: Yale University
Press, 1976. 320 pp. illus. chronology.

 About all of the arts from the second half of the 18th
 century.

1552. ___ . The Work of Many Hands: Card Tables in Federal America, 1790-1820. New Haven, Conn.: Yale University Press, 1982. 198 pp. illus. charts. tables.

A scientific approach to the identification of card tables. Contains extensive statistical tables that are the result of close examinations of tables. Excellent.

1553. Yarmon, Morton. Early American Antique Furniture. Greenwich, Conn.: Fawcett Publications, 1952. 144 pp. illus.

A general guide for the collector.

TRADE CATALOGS

1554. Acme Company. Everything in Furniture, General Catalogue, No. 3. Chicago: Doul-Hartman Company, 1901. 242 pp. illus.

1555. Acme Kitchen Furniture Company. Illustrated Catalog. Chattanooga, Tenn.: Acme Kitchen Furniture Co., 1911. 20 pp.

This catalog is number 66.

1556. Allen (D. H.) and Co. Standorette Catalog. Kiamisburg, Ohio: D. H. Allen and Co., 1898. 13 pp. illus.

1557. Allen, F. Louis. Illustrated Catalog of Bric-a-brac, Tables, Chairs, Couches, etc. Philadelphia: Allen F. Louis, 1883. 16 pp. illus.

1558. Alms Manufacturing Co. Illustrated Catalogue. Cincinnati, Ohio: F. W. Alms Manufacturing Co., 1887. 62 pp. illus.

1559. American Desk Manufacturer. Illustrated Catalog of Furniture Home, Bank and Counting Houses, Desks, Stools, Etc. New York: American Desk Manufacturer, 1873. 54 pp. illus.

1560. ___. Illustrated Catalog of Designs for Writing Desks, Secretaries, Tables, Etc. New York: American Desk Manufacturer, 1875. 36 pp. illus.

1561. American Grass Twine Co. Furniture Catalogue. New York: American Grass Twine Co., 1903. 78 pp. illus.

1562. American Ottoman and Hassack Co. Ottomans and Hassocks. New York: American Ottoman and Hassack Co., 1885. 5 pp. illus.

1563. American Seating Company. Church Furniture. Chicago: American Seating Co., 1911. 60 pp. illus.

This is catalog number 31.

1564. American Shade Roller Co. Price List. Boston: American Shade Roller Co., 1877. 12 pp.

1565. Andrews (A. H.) and Company. Bed Catalogue. Chicago: A. H. Andrews and Co., 1891. 4 pp. illus.

1566. ___. Confidential Trade Price-List of the Andrews Folding Beds. Chicago: A. H. Andrews and Co., 1891. 1 p.

1567. ___. The Evolution of the Chair. Chicago: A. H. Andrews, 1882. 62 pp. illus.

1568. ___. Guide to Church Furnishings and Decorations, 1876-77. Chicago: A. H. Andrews and Company, 1876. 132 pp. illus.

1569. ___. Illustrations of Bank and Office Furniture and Fittings, Tables, Book Cases, and All Fine Work in Hardwoods for Offices, Public Buildings, Libraries, and Residences. Chicago: A. H. Andrews and Co., 1876. 132 pp. illus.

1570. ___. Illustrations and Descriptions of Opera Chairs. Chicago: A. H. Andrews and Co., 1886. 26 pp. illus.

1571. ___. Illustrations of Plain and Elaborate Office Desks, Tables, Chairs, Book Cases, Etc. Chicago: A. H. Andrews and Co., 1874. 94 pp. illus.

1572. Archer Manufacturing Co. Archer's Boot Blacking Stand. Rochester, N. Y.: Archer Manufacturing Co., 1880. 1 p. illus.

1573. ___. Archer's Gynecological Chairs. Rochester, N.Y.: Archer Manufacturing Co., 1885. 20 pp. illus.

1574. ___. Illustrated Price List of...Piano Stools. Rochester, N.Y.: Archer Manufacturing Co., 1886. 30 pp. illus.

1575. ___. Price Catalogue of the Archer Patent Barber Chairs, Etc. Rochester, N.Y.: Archer Manufacturing Co., 1890. 12 pp. illus.

1576. Arnold (C. N.) and Co. Illustrated Catalogue of Chairs. Poughkeepsie, N.Y.: C. N. Arnold and Co., 1886. 40 pp. illus.

1577. Art Bedstead Company. Art Bedstead Company. Makers of Art Style and Quality Brass and Iron Bedsteads. Catalogue Number 21. Chicago: Art Bedstead Company, 1907. 32 pp. illus.

1578. Atkinson (B. A.) and Co. Ash Sets, Cherry Sets, Black Walnut Sets, Boston: B. A. Atkinson and Co., 1887. 9 pp. illus.

1579. ___ . Special Catalogue of Parlor Furniture....
Boston: B. A. Atkinson and Co., 187-. 100 pp. illus.

1580. Aude Furniture Co. Illustrated Catalogue...Bedsteads
and Extension Tables. St. Louis, Mo.: Aude Furniture Co.,
1891. 144 pp. illus.

1581. ___ . Tables for the Dining Room.... St. Louis, Mo.:
Aude Furniture Co., 1900. 1 p. illus.

1582. Bagby Furniture Co. Illustrated Catalog of Furniture,
Mattresses, Chairs, Tables, Etc. Baltimore: Bagby Furniture
Co., 1899. 56 pp. illus.

1583. Baltimore Bargain House. Illustrated Catalogue of
Household Goods, Clothing, Toys, Tools, Leather Goods,
Clocks, Etc. Baltimore: Baltimore Bargain House, 1904.
232 pp. illus.

 This catalog is number 291.

1584. Banks, Morton C. Illustrated Catalog of Chamber,
Parlor and Dining Room Furniture. Baltimore: Morton C.
Banks, 1878. 130 pp. illus.

1585. Bardwell, Anderson, and Co. Illustrated Catalogue of
...Tables, Desks, and Pedestals. Boston: Bardwell, Anderson,
and Co., 1884, 1887, 1889. illus.

1586. Baumann (Ludwig) and Company. Catalogue, Section
No. 4 New York: Ludwig Baumann and Co., 189-. 660 pp. illus.

1587. ___ . Catalogue, Section No. 3. New York: Ludwig
Baumann and Co., 1890. 356 pp. illus.

1588. ___ . The Complete House Furnisher: An Illustrated
Guide to Housefurnishing. New York: Ludwig Baumann and Co.,
c. 1905. 222 pp. illus.

1589. ___ . The Twentieth Century Ideal Furniture Made from
the Prairie Grass of America. New York: Ludwig Baumann and
Co., 191-. 19 pp. illus.

1590. Baxter (C. O.) and Co. Illustrated Catalogue...Picture
Frames and Mouldings. St. Louis, Mo.: C. O. Baxter and Co.,
1891. 190 pp. illus.

1591. Baxter (Edward W.) and Company. Trade Price List of
Dining Room, Library, Parlor and Chamber Furniture. New York:
Edward W. Baxter and Co., 1871,1873. illus.

1592. Beal (T. M.) and Company. Italian Marble Top Centre
Tables. Boston: T. M. Beal and Co., 1886. 1 p. illus.

1593. Bennett (Charles) Furniture Company. <u>Charles Bennett</u>
<u>Furniture Co. Manufacturers of Cheap and Medium Priced</u>
<u>Chamber-Suits, Sideboards, Dressers, Commodes, Chiffoniers</u>.
Charlotte, Mich.: Charles Bennett Furniture Co., 190-, 1906.
illus.

1594. Berkey and Gay Furniture Co. <u>Furniture of Character</u>.
Grand Rapids, Mich.: Berkey and Gay Furniture Co., 1906.
.27 pp. illus.

1595. ___ . <u>Sales Catalog</u>. Grand Rapids, Mich.: Berkey and
Gay Furniture Co., 1910-17.

1596. Bhumgara (F. P.) and Co. <u>Catalog of Furniture for All</u>
<u>Rooms in the Home</u>. New York: F. O. Bhumgara and Co., c. 1890.
12 pp. illus.

1597. Bishop Furniture Co. <u>Catalogue</u>. Grand Rapids, Mich.:
Bishop Furniture Co., c. 1910.

 Catalog number 50.

1598. Bleecker and Van Dyke. <u>Catalogue of Handsome House-</u>
<u>hold Furniture, to be Sold by Bleecker and Van Dyke, on</u>
<u>Thursday, April 22, 1841</u>. New York: Printed by P. Hiller,
1841. 8 pp.

1599. Bonner and Paepke. <u>New Illustrated Catalog of Cribs</u>
<u>and Cradles with Price List Supplement</u>. New York: Bonner and
Paepke, 1886. illus.

1600. Boston Fancy Cabinet Co. <u>Illustrated and Priced</u>
<u>Catalog of Towel Racks, What-nots, Hat Trees, Etc</u>. Boston:
Boston Fancy Cabinet Co., 1884. 28 pp. illus.

1601. Boston Willow Furniture Co. <u>French Willow and Galatian</u>
<u>Rush Furniture</u>. Boston: Boston Willow Furniture Co., 1911.
32 pp.

1602. Bowman, J.R. <u>Catalog of Bowman's Scroll Saw Designs</u>.
New York: J. R. Bowman, 1887. 28 pp. illus.

1603. Bragg, Conant, and Co. <u>Looking Glasses</u> Boston:
Bragg, Conant and Co., c. 1875. 10 pp. illus.

1604. Brockway (C. A.) and Co. <u>Facts in Furniture</u>.
no place: C. A. Brockway and Co., 1892-93.

1605. Brooke, J. C. <u>Catalog of Church and School Furniture</u>.
Cincinnati, Ohio: J. C. Brooke, 1894. 38 pp. illus.

1606. Brooklyn Furniture Co. <u>Catalog of Furniture--Chairs,</u>
<u>Stands, Tables, Beds, Bureaus, Sofas, Etc</u>. Brooklyn, N.Y.:
Brooklyn Furniture Co., 1873. 64 pp. illus.

1607. Brooks Brothers. <u>Bedroom Suites</u>. Rochester, N.Y.:
Brooks Brothers, 1887. 2 pp. illus.

1608. Bub and Kipp. <u>New Illustrated Catalogue of Upholstered
Furniture</u>. Milwaukee, Wis.: 1887-88. 70 pp. illus.

1609. Buckstaff-Edwards Co. <u>Catalog of Case and Wood Seat
Chairs</u>. Oshkosh, Wis.: Buckstaff-Edwards Co., c. 1890.
170 pp. illus.

1610. Buffalo Metal Furniture Manufacturing Co. <u>Buffalo
Brand Metal Furniture. Catalog Co</u>. Buffalo, N.Y.: Buffalo
Metal Furniture Manufacturing Co., 190-. 65 pp. illus.

1611. Buffalo Upholstering Co. <u>Catalogue</u>. Buffalo, N.Y.:
Buffalo Upholstering Co., 1880. 28 pp. illus.

1612. Butler Brothers. <u>Supplementary Catalogue to "Our
Drummer." Specialties in Furniture</u>. New York: Butler
Brothers, 1891. 34 pp. illus.

1613. Cabinet Makers' Union. <u>Catalogue and Price List for
Furniture</u>. Indianapolis, Indiana: Cabinet Makers Union,
1887. 20 pp. illus.

1614. Cadillac Cabinet Company. <u>Our Latest Style Book</u>.
Detroit, Mich.: Cadillac Cabinet Company, 1905. 144 pp.
illus.

 Catalogue No. 3.

1615. Carondelet Ave. Furniture Manufacturing Co. <u>Catalog</u>.
St. Louis, Mo.: Carondelet Ave. Furniture Manufacturing Co.,
1886. illus.

1616. Central Furniture Co. <u>Catalogue 1890</u>. Rockford, Ill.:
Central Furniture Co., 1890. 34 pp. illus.

1617. Central Manufacturing Co. <u>Office and Library Furniture</u>.
Chicago: Central Manufacturing Co., c. 1880. 80 pp. illus.

1618. Champion Bed Lounge Co. <u>Semi-Annual Catalogue of...
Parlor Suits, Bed Lounges, Couches, Single Lounges, Platform
and Fancy Floor Rockers</u>. Chillicothe, Ohio: Champion Bed
Lounge Co., 1911. 32 pp. illus.

1619. Chase Brothers and Company. <u>Illustrated Catalogue of
Useful and Ornamental Bronzed Iron Goods, Comprising...
Bedsteads, Hat, Coat, and Umbrella Stands....</u> Boston: Chase
Brothers and Company, c. 1855. 62 pp. illus.

1620. Chipman (George) and Son. <u>Catalog of Chairs of All
Descriptions</u>. Baltimore: George Chipman and Son, c. 1885.
140 pp. illus.

1621. Chittenden and Eastman. Book Cases and All Kinds of
Furniture. Burlington, Iowa: Chittenden and Eastman, 1888.
1 p. illus.

1622. ___. Furniture Catalog. Burlington, Iowa: Chittenden
and Eastman, 1918. 1 p. illus.

1623. Cilley (J. A.) and Co. Pine Furniture of All Kinds.
Fairfield, Maine: J. A. Cilley and Co., c. 1880. 1 p.

1624. Clark Brothers and Co. Furniture Illustrations....
Philadelphia, 1887. 78 pp. illus.

1625. Clark (Carroll W.) and Co. Catalog of Furniture
Specialties, Beds, Elastic Mattresses, Desks, Chairs, Tables,
Etc. Boston: Carroll W. Clark and Co., c. 1880. 32 pp. illus.

1626. Clarke Brothers and Co. Fancy Cabinetware. Cincinnati,
Ohio: Clarke Brothers and Co., c. 1890. 1 p. illus.

1627. ___. Fancy Cabinetware. New York: Clarke Brothers and
Co., 1882-85. 4 pp. illus.

 Consists of four seperate broadsides.

1628. Clark and Hatch Auctioneers. Catalog of Supplies of
Cabinet Furniture, All Manufactured and Warranted by Mr.
William K. Bacall to be Sold at Auction at his Wareroom.
Boston: Clark and Hatch Auctioneers, 1851. 8 pp.

1629. Clearfield Novelty Works. Porch Swings, Lawn Settees,
Lawn Hose Reels. Clearfield, Pa.: Clearfield Novelty Works,
1910. 31 pp. illus.

1630. Colie and Son. Parlor Furniture. Buffalo, N.Y.:
Colie and Son, 1884. 30 pp. illus.

1631. Collingnon Brothers. Illustrated Catalog of Folding
Rockers, Settees and Stowe's Canvas Cots. Westwood, N.J.:
Collingnon Brothers, no date. 22 pp. illus.

1632. Columbian Adjustable Table and Desk Co. Catalog,
Adjustable Folding Tables and Desks. Chicago: Columbian
Adjustable Table and Desk Co., 1892. 20 pp. illus.

1633. Comins (George T.) Manufacturing. Illustrated
Catalog of Cradles. Boston and New York: George T. Comins
Manufacturing, no date. 24 pp. illus.

1634. Comstock (William T.) Company. Specimen Book of One
Hundred Architectural Designs.... New York: William T.
Comstock, 1878. 89 pp. illus.

 Includes designs for furniture and advertisements.

1635. Conant, Ball, and Co. Special Catalogue. West
Gardner, Mass.: Conant, Ball, and Co., 190-. 78 pp. illus.

1636. Connant's (F. H.) Sons. Catalog of Chairs, Rockers,
Stands, Tables.... Camden, N. J.: F. H. Connant's Sons,
1880. 36 pp. illus.

1637. Conner, Robert. The Cabinet Maker's Assistant.
New York: Faxon and Read, 1842. v, 47 pp. illus.

A book of designs.

1638. Connersville Furniture Company. Ye Old-Time Furniture;
Reproductions of Ye Olden Time in Ye Making of Which Modern
Methods are Used. Connersville, Ind.: Connersville Furniture
Company, 1907. 20 pp. illus.

1639. Conrades (J. H.) Chair and Parlor Furniture Co.
Illustrated Catalogue...Chairs, Lounges, Parlor Furniture,
Fancy Reed and Rattan Chairs and Rockers. St. Louis, Mo.:
J. H. Conrades Chair and Parlor Furniture Co., 1891. 118 pp.
illus.

1640. ___ . Illustrated Catalogue of the J. H. Conrades Chair
and Parlor Furniture Co., Jos. Peters Furniture Co., Aude
Furniture Co., Vornbrock Furniture Co., Wolf and Kraemer
Furniture Co., Globe Furniture Co., Western Furniture Co.,
Charles Sueme Co., C. O. Baxter and Co., Smith and Davis
Manufacturing Co., and David and Brazille Bedding Co. St.
Louis, Mo.: Printed by Buxton and Skinner, 1891. 198 pp.
illus.

1641. Converse Manufacturing Co. Furniture Department.
Grand Rapids, Mich.: c. 1880. 4 pp. illus.

1642. Coogan, James J. Illustrated Catalogue of Furniture,
Parlor and Chamber Suits. New York and Canton, Ohio:
James J. Coogan, c. 1876. 32 pp. illus.

1643. ___ . Illustrated Catalog of Parlor and Chamber Suites,
Carpeting, Spool Beds.... New York and Canton, Ohio:
James J. Coogan, 1875. 32 pp. illus.

1644. Coogan Brothers. Illustrated Catalogue of Furniture.
New York: Coogan Brothers, 1876?. 40 pp. illus

1645. ___ . Illustrated Catalogue of Fine Furniture. New
York: Coogan Brothers, 1869. 40 pp. illus.

1646. Cooper (James W.) and Brothers, Mfg. Catalog of
Fancy Cabinet Ware, Tables, Jardinieres Stands, Parlor
Easels, Music Stands.... Philadelphia: James W. Cooper and
Brothers, C. 1876. 60 pp. illus.

1647. ___ . Price List of Fancy Cabinet Ware, Tables,
Jardiniere Stands, Parlor Easels, Museum Cabinets.... Phila-
delphia: James W. Cooper and Brothers, 187-. 58 pp. illus.

1648. Cooper and Hall. Catalogue and Price List of Furniture.
Philadelphia: Cooper and Hall, 1873. 43 pp. illus.

1649. Crandall, Bennett, and Porter Co. Dining Tables.
Montoursville, Pa.: Crandall, Bennett, and Porter Co., 1911.
44 pp. illus.

1650. Crane (J. H.) Co. Catalog of Furniture. St. Louis,
Mo.: J. H. Crane Co., 1883. illus.

1651. Crocker Chair Co. Catalogue of Domestic and Export
Trade Chairs, Manufactured by the Crocker Chair Company.
New York; Sheboygan, Wis.; Antigo, Wis.; and Elton, Wis.:
Crocker Chair Company, 1913. 111 pp. illus.

1652. Cron, Kills, and Co. Catalogue...Wardrobes, Sideboards,
Cupboards, and Chiffoniers. Piqua, Ohio: Cron, Kills, and
Co., 1891. 15 pp. illus.

1653. ___ . Wardrobes, Sideboards, Cupboards, and Chiffoniers.
Piqua, Ohio: Cron, Kills, and Co., 1890. 23 pp. illus.

1654. Currier, W. A. Catalogue. W. A. Currier's Kitchen,
House Furnishings, and Stove Warehouse. Haverhill, Mass.:
W. A. Currier, c. 1850. 36 pp. illus.

1655. Cushman (H. T.) Manufacturing Co. Catalog of
Mission Furniture. North Bennington, Vt.: H. T. Cushman
Manufacturing Co., c. 1905. 62 pp. illus.

 Also published in 1904.

1656. Custine, P. Wholesale Price List of Furniture.
Philadelphia: P. Custine, 1867. 8 pp.

1657. Daniels, Badger, and Co. Chamber Furniture and Side-
boards. Boston: Daniels, Badger, and Co., 186-.
79 pp. illus.

1658. ___ . Furniture for the Chamber, Dining-Room, Parlor,
Hall, and Library. Boston: Daniels, Badger, and Co., 186-.
79 pp. illus.

1659. ___ . No. 76, Walnut Suit-Three Marble Tops, Ten
Pieces Complete. Boston: Daniels, Badger, and Co., 1876.
1 p. (broadside) illus.

1660. Danner, John. Danner's Illustrated Price List of
Revolving Book Cases.... Canton, Ohio: John Danner, 1876.
24 pp. illus.

 Also published c. 1884 and c. 1886.

1661. David and Brazill Bedding Company. Illustrated
Catalogue...Mattresses, Bedding, Feathers, Etc. St. Louis,
Mo.: David and Brazill Bedding Company, 1891. 1 p. illus.

1662. Davison, R. Concrete Pottery and Garden Furniture.
No place: R. Davison, 1910. 140 pp. illus.

1663. Deinzer (F.) and Son. Catalog of Upholstered
Furniture. Detroit, Mich.: F. Deinzer and Son, No Date.
20 pp. illus.

1664. Derby (George H.) and Co. The Derby Roll-Top Desk.
Boston: George H. Derby and Company, 1881. 16 pp.

1665. Derby (P.) and Company. Manufacturers of Chairs,
Rockers, Dining Chairs and Arm Chairs to Match. Mission
Furniture, Go-Carts, Portable Seatings, Reed, Reedmoor and
Rushmoor Furniture. Boston; New York; Gardiner, Mass.; and
Jersey City, N.J.: P. Derby and Company, 1913. 186 pp. illus.

1666. Derby and Kilmer Desk Co. Illustrated Catalog of the
Derby Roll-Top Desks. Boston: Derby and Kilmer Desk Co.,
1886. 16 pp. illus.

1667. Derby, Kilmer, and Pond Desk Co. 17th Illustrated
Catalog of Roll-Top Desks, Bank and Office Furniture....
Somerville, Mass.: Derby, Kilmer, and Pond Desk Co., 1893.
36 pp. illus.

 Successors to Derby and Kilmer Desk Company.

1668. Detroit House of Correction. Detroit House of
Correction Illustrated Catalogue of Chairs. Detroit,
Mich.: Detroit House of Correction, 1905. 98 pp. illus.

1669. Dexter (H. C.) Chair Co. Catalog of Fancy, Plush, and
Carpet Upholstered Rockers. Black River, N. Y.: H. C.
Dexter Chair Co., 1889. 60 pp. illus.

1670. Eagle Furniture Works. Illustrated Catalog of Walnut
and Poplar Chamber Suites, Buffets, Wardrobes, Beds, Stands,
Tables, Desks.... Baltimote: D. Wilson and Son, 1884.
24 pp. illus.

1671. Eberlee, Thomas J. Consumers' Price Guide. Cattaraugus,
New York: Thomas J. Eberlee, c. 1900. 600 pp. illus.

1672. Elastic Chair Co. Price List. Williamsport, Pa.:
Elastic Chair Company, 1882. 1 p.

1673. Emerson and Son. 8th Annual Catalog...Housekeeping Outfits, Beds, Chairs, Buffets for Parlor, Bedroom, and Bath. Milford, N.H.: Emerson and Son, 1897. 64 pp. illus.

1674. Emrich Furniture Co. Dining Room Suits. Indianapolis, Ind.: Emrich Furniture Co., 1911. 51 pp. illus.

1675. Erskine-Danforth Corp. Danersk Decorative Furniture. New York: Erskine-Danforth Corp., c. 1917. 91 pp. illus.

1676. Excelsior Furniture Co. Fancy Polished Rockers in Oak, Mahogany, and Light Cherry Finish. Rockford, Ill., 189-. 20 pp. illus.

1677. Excelsior School Furniture Mfg. Co. Catalog of School, Office, and Church Furniture. Cincinnati, Ohio: Excelsior School Furniture Mfg. Co., 1874. 86 pp. illus.

1678. Farwell, Osmun, Kirk, and Company. Section J: Furniture, Brass, and Iron Beds. St. Paul, Minn.: Farwell, Ozmun, Kirk, and Company, 1913. 235 pp. illus.

1679. Ferguson Brothers. Accent Furniture...All Pieces in Bentwood Oak, Some Painted. New York: Ferguson Brothers, c. 1890. illus.

1680. Field (Marshall) and Co. Illustrated Catalogue... Upholstered Furniture. Chicago: Marshall Field and Co., 1897. 16 pp. illus.

 Other catalogues were published by this retail store.

1681. Fiske, J. W. Illustrated Catalogue of Chairs and Settees, Ornamental Iron-Work of Every Description, Fountains, Vases, Statuary, Deer, Dogs, Lion, Etc. New York: J. W. Fiske, 1875. 28 pp. illus.

1682. Fogler (P. M.) and Co. Illustrated Catalogue of Bedsteads, Patent Bow Cradles, Folding Chairs, Etc. Boston: P. M. Fogler and Co., c. 1880. 52 pp. illus.

1683. Folan, J. and T. Ash and Painted Chamber Furniture and Chairs. Boston: J. and T. Folan, 20 pp. illus.

1684. Forest City Furniture Company. Illustrated Catalogue of Fine Furniture. Rockford, Ill.: Forest City Furniture Co., c. 1880. 26 pp. illus.

1685. Franklin Merchandise Company. Illustrated Catalogue of Textiles, Furniture, Stoves, Musical Instruments, Harness Equipment, Carriages, Farm Equipment, Watches, Clocks, Clothing, Etc. Chicago: Franklin Merchandise Company, c. 1902. 352 pp. illus.

1686. French, William C. Catalog of Hardwood Cottage and French Bedsteads, Patent Bow Cradles, Folding Cribs, Etc. Boston: William C. French, c. 1898. 37 pp. illus.

1687. Gardner and Co. Catalog of Patented Veneer Seats,
Chairs, Settees, Lodge Chairs, Railroad Station Settees, Etc.
New York: Gardner and Co., 1884. 68 pp. illus.

1688. ___ . Perforated Veneer Seats, Chairs, Settees, Etc.
New York: Gardner and Co., 1884. 72 pp. illus.

1689. Gear (A. S. and J.) and Co. Furniture. Boston:
A. S. and J. Gear and Co., c. 1860. 1 p. illus.

1690. Gerrish and O'Brien. Parlor Furniture. Boston:
Gerrish and O'Brien, 1880. 1 p. illus.

1691. Gilman, J. T. and L. J. Wholesale Price List of
Finished Furniture. Bangor, Me.: J. T. and L. J. Gilman,
1880. 3 pp. illus.

1692. Globe Furniture Co. Illustrated Catalogue...Bureaus,
Chiffoniers, and Ladies' Desks. St. Louis, Mo.: Globe
Furniture Co., 1891. 7 pp. illus.

1693. Gold Medal Camp Furniture Manufacturing Co. Metal
Folding Furniture Catalog. Racine, Wis.: Gold Medal Camp
Furniture Manufacturing Co., 1894. 18 pp. illus.

1694. Goodell Co. White Mountain Hammock Chair. Antrim,
N. H.: Goodell Co., c. 1880. 1 p. illus.

1695. Grand Central Wicker Shop, Inc. Catalogue. New York:
Grand Central Wicker Shop, Inc., 1920. 24 pp. illus.

1696. Grand Ledge Chair Co. Catalog of Chairs. Grand
Ledge, Ill.: Grand Ledge Chair Co., c. 1900. 80 pp. illus.

 Published in other years.

1697. Grand Rapids Bookcase and Chair Co. Catalogue.
Hastings, Mich.: Grand Rapids Bookcase and Chair Co., 1911.
illus.

 Catalog number 6.

1698. Grant (George H.) and Swain. Catalog of Chairs, Pews,
Pulpits, Settees, Tables, Etc. Richmond, Ind.: Richmond
Church Furniture Co., 1886. 32 pp. illus.

1699. Green, Alden. Basket Seat Chairs of All Kinds.
Norfolk, Conn.: Alden Green, c. 1870.

1700. Guild, The. Makers of Furniture of Quality: Grand
Rapids Chair Co., Fancy Chair Co., Imperial Furniture Co.,
The Luce Furniture Co., The Macey Co., Nelson Matter Furniture
Co., John D. Raab Chair Co., Stickley Brothers Co. Grand
Rapids, Mich.: The Guild, 1910. illus.

1701. Haberkorn (C. H.) and Co. Catalogue. Detroit, Mich.:
C. H. Haberkorn. illus.

1702. Hafner Furniture Co. Annual Catalog. Chicago:
Hafner Furniture Co., 1905. 48 pp. illus.

1703. Hale and Kilburn Mfg. Co. Catalog of Champion Folding
Beds and Cribs, Hale's Flexible Bed Springs, Chairs, Mirrors,
Rocking and Tilting Chairs, Settees, Etc. Philadelphia:
Hale and Kilburn Mfg. Co., c. 1870. 64 pp. illus.

1704. ___. Patented Furniture Specialities Including the
"Champion Automatic" Folding Bedstead.... Philadelphia:
Hale and Kilburn Manufacturing Co., 1880. 24 pp. illus.

1705. Hall and Stephen. Bedding, Spring Mattresses...Iron
and Brass Bedsteads. New York: Hall and Stephen, 1880.
52 pp. illus.

1706. Hammett, J. L. Illustrated Catalog of School
Furniture and School Apparatus. Boston: J. L. Hammett, 1886.
68 pp. illus.

1707. Hanson (A. C.) and Company. Furniture Catalogue B.
Racine, Wis.: A. C. Hanson and Co., c. 1905. 32 pp. illus.

1708. Hartley Reclining Chair Co. Reclining Chairs.
Chicago: Hartley Reclining Chair Co., 1885. 16 pp. illus.

1709. Harwood Manufacturing Co. Illustrated Catalogue of
Assembly Chairs and Settees for Churches, Halls, Opera
Houses, Lodge Rooms, Depots, Rings, Etc. Boston: Harwood
Manufacturing Co., 1888. 64 pp. illus.

1710. Haskell (William O.) and Son. Catalog of School
Furniture. Boston: William O. Haskell and Son, 1870.
101 pp. illus.

1711. Hayden Company. The Drawing Room in Belton House,
England Reproduced by the Hayden Company. New York:
The Hayden Company, 1919. 8 pp. illus.

1712. Hayes, Lewis S. Patent Folding Chairs. Cortland, N.
Y.: Lewis S. Hayes, 1882. 10 pp. illus.

1713. Hayes Chair Co. Spring Season 1889 Price List.
Cortland, N. Y.: Hayes Chair Co., 1889. 4 pp. illus.

1714. Heal and Son. Furnishings for the Middle Class; Heal's
Catalogues, 1853-1934. New York: St. Martin's Press, 1972.
illus.

1715. Hechinger Brothers and Co. Chairs, Reed and Rattan
Rockers. Baltimore: Hechinger Brothers and Co., 1900.
32 pp. illus.

1716. Heilman (A. H.) and Co. Cottage, Ash and American
Mahogany Chamber Furniture. Williamsport, Pa.: A. H. Heilman
and Co., 1886. 28 pp. illus.

1717. ___ . Eleventh Annual Catalogue of Cottage and Ash
Chamber Furniture. Williamsport, Pa.; A. H. Heilman and
Co., 1882.

1718. ___ . Illustrated Catalog and Price List of Chamber
Furniture, Chiffoniers, Bedside Tables, Stands, Etc.
Williamsport, Pa.: A. H. Heilman and Co., 1891. 33 pp.
illus.

1719. ___ . Trade Price List for 1876 of Cottage Chamber
Suits, Ash, Walnut Trimmed, Chamber Suits, Bureaus, Wash
Stands, Etc. Williamsport, Pa.: A. H. Heilman and Co., 1876.
20 pp. illus.

1720. Henkels, George J. Catalogue of Furniture in Every
Style Comprising Louis XIV, Louis XV, Elizabethan and Antique.
Philadelphia: George J. Henkels, 185-. 16 pp. illus.

1721. Herenden (A. S.) Furniture Co. The A. S. Herenden
Furniture Company, Manufacturers and Dealers in Furniture of
Every Description. Cleveland: A. S. Herenden Furniture Co.,
c. 1873. 15 pp. illus.

1722. Herkimer Manufacturing Co. Price-List of Desks.
Herkimer, N.Y.: Herkimer Manufacturing Co.

1723. Hersee and Co. Sideboards, Mirrors, Tables with
Marble Tops. Buffalo, N.Y.: Hersee and Co., c. 1880. 1 p.
illus.

1724. Heyman, George. Bedding, Woven Wire, and Upholstered
Spring Mattresses...Brass and Iron Bedsteads. New York:
George Heyman, 1890. 30 pp. illus.

1725. Heywood Brothers and Co. Illustrated Catalogue.
Gardner, Mass.: Heywood Brothers and Co., 1893. 144 pp.
illus.

1726. ___ . Illustrated Catalog of Cane, Rattan, and Reed
Furniture, Chairs, Childrens' Wagons, and Carriages, Etc.
Gardner, Mass.: Heywood Brothers and Co., 1883 84. illus.

1727. ___ . Supplementary Catalogue of Chairs. Boston:
Heywood Brothers and Company, 1889. 10 pp.

1728. Heywood Brothers and Wakefield Co. Heywood Brothers
and Wakefield Co., Makers of Reed and Rattan Furniture.
Chicago: Heywood Brothers and Wakefield Co., 1898. 212 pp.
illus.

1729. Heywood (Walter) Chair Company. Catalogue. New York,
Fitchburg, Mass.:Walter Heywood Chair Co., 1890. 54 pp. illus.

1730. ___. Decker Folding Chairs. New York: Walter Heywood Chair Co., 1883. 2 pp. illus.

1731. ___. Illustrated Catalog for September. New York: Walter Heywood Chair Co., 1893. 92 pp. illus.

1732. ___. Rattan, Wood, Cane, and Upholstered Chairs. New York: Walter Heywood Chair Co., 1895. 343 pp. illus.

1733. ___. Supplementary Catalogue, Including Children's Chairs for the Holidays, October 1894. New York: Walter Heywood Chair Co., 1894. 72 pp. illus.

1734. Higgins Furniture Manufacturing Co. Illustrated Catalog. Indianapolis, Ind.: Higgins Furniture Manufacturing Co., 1874. 32 pp. illus.

1735. Hildreth (G. W.) and Company. Illustrated Catalogue of School and Opera House Furniture. Lockport, N. Y.: G. W. Hildreth and Company, c. 1874. 24 pp. illus.

1736. Holiday Sheet Specialities. Parlor Furniture. Wheel Chairs, Tables, Etc. No place: Holiday Sheet Specialities, c. 1880. 1 p. illus.

1737. Holloway Co. The Holloway Reading Stand and Dictionary Holder. Cuyahoga Falls, Ohio: The Holloway Co., 1892. 16 pp. illus.

1738. Hoskins and Sewell. Illustrated Catalog of Brass and Iron Bedsteads. New York: Hoskins and Sewell, 1895. 16 pp. illus.

1739. Hughesville Furniture Co. Price List of Cottage, Ash, Oak, and Mahogany Chamber Suits. Hughesville, Pa.: Hughesville Furniture Co., 1887. 1 p.

1740. Hunzinger (George) and Son. Card Tables. New York: George Hunzinger and Son, c. 1920. 33 pp. illus.

1741. Hutchins and Mabbett. Illustrated Catalog of Gardner Patent Chairs and Seats for Railroad Cars, Stations, Offices, and Libraries. Philadelphia: Hutchins and Mabbett, 1874. 16 pp. illus.

1742. Indianapolis Chair Manufacturing Co. Spring Supplement. Indianapolis, Ind.: Indianapolis Chair Manufacturing Co., 1890. 16 pp. illus.

1743. Jamestown Bedstead Works. Illustrated Catalogue of Jamestown Bedstead Works. Jamestown, N.Y.: Jamestown Bedstead Works, 1878. 25 pp. illus.

1744. Jamestown Wood Seat Chair Company. Illustrated Catalogue. Jamestown, N. Y.: Jamestown Wood Seat Chair Co., 1876. 24 pp. illus.

1745. Johnson (A. J.) and Sons Furniture Company. Suggestions
for the Dining Room. Chicago: A. J. Johnson and Sons
Furniture Company, 1908. 88 pp. illus.

1746. Johnson, Charles E. Schermerhorn's Patent Towel Racks,
Towel Stands, Umbrella Stands, Etc. New York: Charles E.
Johnson, 1882. 1 p. illus.

1747. Johnson, Nathaniel. Catalog of School Furniture.
New York: Nathaniel Johnson, 1868. 24 pp. illus.

1748. Jordan and Moriarty. Illustrated Catalog of Furniture
in All Departments. New York: Jordan and Moriarty, 1886.
36 pp. illus.

1749. ___. Illustated Catalog of Furniture and Carpets,
Parlor and Bedroom Suites, Cribs, Sofas, Carved Walnut
and Marble Tops, Etc. New York: Jordan and Moriarty, 1883.
36 pp. illus.

1750. ___. Illustrated Catalog of Furniture, Etc. New York:
Jordan and Moriarty, c. 1885. 32 pp. illus.

1751. Kane (Thomas) and Co. School Furniture. Chicago:
Thomas Kane and Co., 1889. 3 pp.

1752. ___. Revolving Desks, Combination Bookcases,
Secretaries, Desks for Ladies or Lawyers in Cabinet, Gothic
or Cylinder Designs of Ash, Cherry, Maple, Mahogany, and
Walnut. Chicago: Thomas Kane and Co., No date. 4 pp. illus.

1753. Karpen (S.) and Brothers. Twenty-Seventh Annual
Catalogue of Guaranteed Upholstered Furniture. Chicago and
New York: S. Karpen and Brothers, 1907. 216 pp. illus.

1754. Keating, M. Keating's Patent Combination Crib.
Boston: M. Keating, c. 1880. 1 p. illus.

1755. Kehr, Peter. Wholesale Price List to the Catalogue of
Peter Kehr. New York: Peter Kehr, 1882. 1 p. illus.

1756. Keller, Sturm and Co. Pier and Mantel Frames, Hat
Trees. Chicago: Keller, Sturm and Co., 1883. 47 pp. illus.

1757. Keller, Sturm, and Ehman. Pier and Mantel Frames,
Mantels, Hat Trees, Cabinet, Etc. Chicago: Keller, Sturm,
and Ehman, 1885. 56 pp. illus.

1758. Kellner, John A. Illustrated Catalog of Desks, Writing
Desks, Tables, Secretaries,.... New York: John A. Kellner,
c. 1884. 24 pp. illus.

1759. Kent Furniture Manufacturing Co. Bedroom Suite. Grand
Rapids, Mich.: Kent Furniture Manufacturing Co., c. 1880.
1 p. illus.

1760. ___. Bedstead, Wardrobe, Sideboard, Tables. Grand Rapids, Mich.: Kent Furniture Manufacturing Co., 1887. 9 pp. illus.

1761. Kilborn, Whitman, and Co. Illustrated Catalogue... Parlor Furniture. Boston: Kilborn, Whitman, and Co., 1880. 64 pp. illus.

1762. ___. Parlor Furniture. Boston: Kilborn, Whitman, and Co., c. 1885. 7 pp. illus.

1763. ___. Wholesale Price List of...Parlor Furniture. Boston: Kilborn, Whitman, and Co., 1880. 16 pp. illus.

1764. Kimball, J. Wayland. Book of Designs, Furniture, and Drapery Drawings with Price List Appended. Boston: J. Wayland Kimball, 1876. 29 pp. illus.

1765. Kindel, George J. Bedding House. Denver, Co.: George J. Kindel, 1889. illus.

1766. Klein (A. S.) Company. Mirrors. Chicago: A. S. Klein Company, 1906. 48 pp. illus.

 Also published in 1907.

1767. ___. Supplementary Catalogue No. 41. Chicago: A. S. Klein Co., 1904. 48 pp. illus.

1768. Knipp and Co. One Hundred Years of Craftsmanship. No place: Knipp and Co., No date. 18 pp. illus.

1769. Knowlton, A. and H. C. Illustrated Catalog of Cane and Wood Seat Chairs, High Chairs. West Gardner, Mass.: A. and H. C. Knowlton, 1883-4. illus.

1770. Kohn, Jacob and Josef. Depot for U. S. A. New York: Jacob and Josef Kohn, No date. illus.

1771. Krause, F. W. Illustrated Catalog of Patent Gothic Chairs. Chicago: F. W. Krause, 1876. 16 pp. illus.

1772. Kreimer (C. and A.) Co. Bedroom Suites, Wardrobes, Washstands. Cincinnati, Ohio: C. and A. Kreimer Co., 1890. 49 pp. illus.

1773. Laconia Furniture Co. Illustrated Catalog of Rickert's Perfect Soft Center Bed Lounges-Various Designs. Laconia, N. H.: Laconia Furniture Co., c. 1880. 38 pp. illus.

1774. Lamb, J. and R. Illustrated Catalog of Church Furniture. New York: J. and R. Lamb, 1886. 72 pp. illus.

1775. ___. Illustrated Catalog of Ecclesiastical Furnishings. New York: J. and R. Lamb, 1876. 56 pp. illus.

1776. Lammert, Martin. Catalog of Furniture. St. Louis: Mo.: Martin Lammert, 1878. 160 pp. illus.

Also issued in 1882.

1777. Lammert Furniture Co. Catalog of Furniture. St. Louis, Mo.: Lammert Furniture Co., 1894. 204 pp. illus.

Also issued in 1895

1778. Lawrence, William E. Furniture Warehouse. Portsmouth, N. H.: William E. Lawrence, c. 1833. 1 p. illus.

1779. Leavens (G. M.) and Son. Cane and Wood Seat Chairs, Pine Furniture, Etc. Boston: G. M. Leavens and Son, c. 1880. 1 p. illus.

1780 Leominster Furniture Manufacturing Co. Ordway Swing Rocker Cradle. Leominster, Mass.: Leominster Furniture Manufacturing Co., c. 1880. 1 p. illus.

1781. Leominster Piano Stool Co. Catalogue and Price List. Leominster, Mass.: Leominster Piano Stool Co., 1882. 10 pp. illus.

1782. Lersch, Charles. Catalogue. New York: Charles Lersch, 1880. illus.

1783. Levenson and Zenitz. Illustrated Catalogue of Levenson and Zenitz. Baltimore: Levenson and Zenitz, c. 1910. 96 pp. illus.

1784. Lewisburg Chair Co. Chairs. Fall Catalogue Supplement, 1910. Lewisburg, Pa.: Lewisburg Chair Co., 1910. 56 pp. illus.

1785. Life-Time Furniture. Reprint. New York: Turn-of-the-Century Edition, 1981. 112 pp. illus.

1786. Lilley (M. C.) and Company. Lodge Furniture. Columbus, Ohio; c. 1910. 8 pp. illus.

1787. Limbert (Charles D.) Company. Limberts Holland Dutch Arts and Crafts Furniture. Holland, Mich.: Charles D. Limbert Company, c. 1905. 68 pp. illus.

1788. Limbert Furniture. Reprint. New York: Turn-of-the-Century Edition, 1981. 128 pp. illus.

1789. Luburg Manufacturing Co. Our Departments. Philadelphia: Luburg Manufacturing Co., c. 1892. 12 pp. illus.

1790. Lyman, G. W. Price List...of Pillar and Common Extension Tables.... Charlestown, Mass.: G. W. Lyman, 1881. 6 pp. illus.

1791. McClees and Warren. Manufacturers of School, Church, Hall and Office Furniture. Philadelphia: McClees and Warren, 1879?. 28 pp. illus.

1792. Macey (Fred) Co. Christmas Gifts. Grand Rapids, Mich.: Fred Macey Co., 1902?. 24 pp. illus.

1793. ___ . Macey Library Furniture. Grand Rapids, Mich.: Fred Macey Company, 1901. 54 pp. illus.

1794. McHugh (Joseph P.) and Co. The "Mission" Furniture of Joseph P. McHugh and Co. Its Origin and Some Opinions by Decorative Authorities. New York: Joseph P. McHugh and Co., 1901. 11 pp. illus.

1795. McKee and Harrington. Baby Carriages, Velocipedes, and Reed Chairs. Kingsland, N. J.: McKee and Harrington, 1890. 36 pp. illus.

1796. McLean (W. B.) Manufacturing Co. Catalog of Plates of Designs. Pittsburgh: W. B. McLean Manufacturing Co, c. 1880. 26 pp. illus.

1797. ___ . Illustrated Catalog of Designs, Couches, Lounges, Pittsburgh: W. B. McLean Manufacturing Co., c. 1880. 20 pp. illus.

1798. ___ . Wall Cases, Show Cases, Tables, and Chairs. Pittsburgh: W. B. McLean Manufacturing Co., 1921. 60 pp. illus.

1799. Maerckein (H.) and Co. A Collection of Drawings For Furniture and Draperies, Colored Lithographs, Photographs of Furniture,.... Hartford, Conn.: H. Maercklein and Co., c. 1870. 67 pp. illus.

1800. Mahoney, E. H. Folding Chairs and Rockers. Boston: E. H. Mahoney, 1880. 23 pp. illus.

1801. ___ . Twenty-Seventh Semi-Annual Illustrated Catalogue of...Fancy Antique, Plush and Leather Rockers...Patent Folding Chairs.... Boston: E. H. Mahoney, 1888. 58 pp. illus.

1802. Manhattan Reclining Chair Co. Illustrated Catalog of Patent Foot Rest Reclining Chairs, Reclining Lounges and Couches, and Specialties in Parlor Furniture, the Morris Chair. New York: Manhattan Reclining Chair Co., c. 1880. 12 pp. illus.

1803. Marietta Chair Co. Illustrated Catalog of Cane and Wood Seat Chairs, Stands, Tables, Bedsteads, Kitchen Safes-Tin Panelled. Marietta, Ohio: Marietta Chair Co., 1884. 98 pp. illus.

1804. ___ . Illustrated Catalogue, 1889-90. Marietta, Ohio: Marietta Chair Co., 1889. 125 pp. illus.

1805. ___ . High Grade Chairs and Rockers, Catalogue, 1911-1912.... Grand Rapids, Mich.: Marietta Chair Company, 1911. 72 pp. illus.

1806. Mason (J. W.) and Co. Illustrated Catalogue of Chairs and Furniture. New York: J. W. Mason and Co., 1877. 124 pp. illus.

1807. ___ . Illustrated Catalogue 1879. New York: J. W. Mason and Co., 1879. 140 pp. illus.

1808. ___ . Price List of J. W. Mason and Company...Chairs, Bedding, and Other Furniture. New York: J. W. Mason and Co., 1887. 48 pp. illus.

1809. ___ . Semi-Centennial Catalogue. 1893. New York: J. W. Mason and Company, 1893. 182 pp. illus.

1810. Merriam, Hall, and Company. Bed Room Furniture...Odd Dressers, Chiffoniers, Washstands, Samos and Toilet Tables. Mahogany Finish, White Enamel on Selected Maples, American Quarter Oak, Golden Oak, Dull Brown Oak, Weathered Oak. North Leominster, Mass.: Merriam, Hall, and Company, 1913. 27 pp. illus.

1811. ___ . Bed Room Furniture...Odd Dressers, Chiffoniers, Washstands, and Toilet Tables in Red Gum Circassian, Red Gum Mahogany,.... New York: Merriam, Hall, and Company, 1911. 22 pp. illus.

1812. Merrimac Mattress Manufacturing Company. Rome Beds, Manufactured by the Rome Metallic Bedsteads Company. Boston: Merrimac Mattress Manufacturing Company, 1911. 176 pp. illus.

1813. Miller and Company. Illustrated Catalogue of Extension, Breakfast and Centre Tables, Washstands, Candle Stands, and Whatnots. West Farmington, Ohio: Miller and Company, 1883. 12 pp. illus.

1814. Mills, F. B. Mills Supply Catalogue. Farm and Factory to Consumer. Catalogue Number 18 for 1905-1906. Rose Hill, N.Y.: F. B. Mills, 1905. Mixed pagination. illus.

1815. Minturn (Rowland R.) and Company. Catalogue of Valuable Furniture. New York: R. Rowland Minturn and Company, 1834. 21 pp.

1816. Mitchell and Rammelsberg Furniture Company. Illustrated Catalogue and Price List of Furniture. Cincinnati, Ohio: Mitchell and Rammelsberg Furniture Company, 1878. 62 pp. illus.

1817. Montoursville Manufacturing Company, Ltd. Illustrated Catalog and Price List of Wood Furniture Designs and Styles-in Ash, Imitation Mahogany and Walnut. Montoursville, Pa.: Montoursville Manufacturing Co., Ltd., 1886. 25 pp. illus.

1818. Moses (William B.) and Sons. Quaint Furniture. Washington, D. C.: William B. Moses and Sons, 1902. 8 pp. illus.

1819. ___ . Simple-Useful Furniture for the Artistic. Washington, D. C.: William B. Moses and Sons, c. 1910. 15 pp. illus.

1820. Moyer, Tufts, and Co. Illustrated Catalog of Beds with Price List. Philadelphia: Moyer, Tufts, and Co., 1880. 24 pp. illus.

1821. Murphy Chair Co. Spring Supplement. January 1st, 1906. Use in Connection with July 1st, 1905 catalog. Detroit, Mich.: Murphy Chair Co., 1906. 48 pp. illus.

 Also issued in 1907.

1822. ___ . 35th Annual Illustrated Catalog of Chairs. Detroit, Mich.: Murphy Chair Co., 1907. 184 pp. illus.

1823. Murray (Linn) Furniture Co. Linn Murray Furniture.... Grand Rapids, Mich.: Linn Murray Furniture Co., 1902. 13 pp. illus.

1824. Mutual Furniture Company. Illustrated Catalogue. No place: Mutual Furniture Company, 1887. 8 pp. illus.

1825. National Chair Manufacturing Co. Eighth Annual Catalogue. Elbridge, N.Y.: National Chair Manufacturing Co., 1888. 33 pp. illus.

1826. National Wire Mattress Co. Illustrated Catalogue of Brass and Iron Bedsteads, Cribs, Cradles,.... New Britain, Conn.: National Wire Mattress Co., 1879. 32 pp. illus.

1827. Nelson, Matter, and Co., Mfg. Illustrated Catalog. Grand Rapids, Mich.: Nelson, Matter, and Co., 1906. 158 pp. illus.

1828. ___ . Illustrated Catalog of Furniture-Bedroom Suites, Sideboards, Hall Racks, Furnishings, Etc. Grand Rapids, Mich.: Nelson, Matter, and Co., Mfg., 1884. 24 pp. illus.

1829. New Haven Folding Chair Co. Illustrated Price List of Childrens' Carriages, Baby Furniture.... New Haven, Conn.: New Haven Folding Chair Co., 1874. 4 pp. illus.

1830. ___ . Illustrated Price List of Folding Chairs for Invalids. New Haven: New Haven Folding Chair Co., 1880. 16 pp. illus.

 Also issued in 1884 and 1885.

1831. ___ . Nineteenth Annual Illustrated Catalogue and Price List of Folding Chairs and Invalid Rolling Chairs. New Haven, Conn.: New Haven Folding Chair Co., 1881. 82 pp. illus.

1832. Niemann and Weinhardt Table Company. _Tables. 27th Annual Catalogue_. Chicago: Niemann and Weinhardt, 1907. 64 pp. illus.

1833. Northern Furniture Company. _Furniture for the Bed Room, Dining Room, Library and Kitchen_. Sheboygan, Wis.: Northern Furniture Company, 1909. 78 pp. illus.

1834. ___ . _Supplement No. 23_. Sheboygan, Wis.: Northern Furniture Company, 1912. 32 pp. illus.

1835. Northwestern Furniture Co. _Office Desks and Tables_. Burlington, Iowa: Northwestern Furniture, c. 1890. 27 pp. illus.

1836. Novelty Rattan Co. _Rattan Chairs, Rockers, and Cribs_. Boston: Novelty Rattan Co., c. 1880. 6 pp. (Broadsides) illus.

1837. Old Hickory Chair Company. _Catalogue_. Martinsville, Ind.: Old Hickory Chair Company, 1903. illus.

1838. Olsen (O. C. S,) and Company. _Office Desks_. Chicago: O. C. S. Olsen and Company, c. 1880. 1 p. illus.

1839. Opin Brothers and Pond. _Spring Catalogue, 1884. Desks and Book Cases...._ Boston: Opin Brothers and Pond, c. 1880.

1840. Osgood and Whitney. _Catalog of Furniture, Carpets, Crockery, Ranges, Chamber Suites, Painted and Stenciled Platform Rockers, Grained Sets, Oriental Sofas, Ladies, Gents and Students' Chairs, Etc., with Ice Boxes and Ranges, Etc, to Boot_. Boston: Osgood and Whitney, 1880. 48 pp. illus.

1841. Ott Lounge Company. _Illustrated Catalogue of...Single and Bed Lounges and Ott's Patent Sofa Bed_. Chicago: Ott Lounge Company, 1890. 32 pp. illus.

1842. Paine's Furniture Manufacturing Company. _The Beacon Hill Collection_. Boston: Paine's Furniture Manufacturing Company, c. 1920. 115 pp. illus.

1843. ___ . _Catalogue of Artistic Furniture_. Boston: Paine's Furniture Manufacturing Company, c. 1890. 48 pp. illus.

1844. ___ . _Illustrated Catalogue_. Boston: Paine's Furniture Manufacturing Company, c. 1890. 159 pp. illus.

1845. ___ . _Illustrated Catalog of Furniture_. Boston: Paine's Furniture Manufacturing Company, 1893. 288 pp. illus.

1846. ___ . _Illustrated Catalog of Manufactured and Imported Furniture_. Boston: Paine's Furniture Manufacturing Company, 1885. 356 pp. illus.

1847. ___ . Illustrated and Priced Catalog of Furniture
Designs. Boston: Paine's Furniture Manufacturing Company,
c. 1878. 27 pp. illus.

1848. ___ . Illustrated Catalog of Walnut Suites in Gothic
and Roman Styles,.... Boston: Paine's Furniture Manufacturing
Company, c. 1880. 28 pp. illus.

1849. ___ . Suggestions to Those Who Would Furnish. Boston:
Paine's Furniture Manufacturing Company, 1888. 44 pp. illus.

1850. Palliser, Palliser, and Co. Palliser's New Cottage
Homes and Details, Containing Nearly Two Hundred and Fifty
New and Original Designs in all Modern Popular Styles....
New York: Palliser, Palliser, and Company, 1887. 144 pp. illus.

 Contains designs for both houses and furniture. Also
 issued in 1888 and 1891.

1851. Palmer, Chauncy, and Son. Illustrated Catalogue of
Ornamental and Architectural Iron Work. Utica, N. Y.:
Palmer, Chauncey, and Son, 1877. 64 pp. illus.

1852. Palmer, Embury, and Company. Illustrated Catalogue of
Palmer, Embury, and Company, Manufacturers of Parlor Suits,
Centre and Library Tables.... New York: Palmer. Embury, and
Company, 1875. 51 pp. illus.

1853. Palmer and Embury Manufacturing Company. Products.
New York: Palmer and Embury Manufacturing Company, 1905.
54 pp. illus.

1854. Palmer Manufacturing Company. Parlor and Library
Tables. Detroit, Mich.: Palmer Manufacturing Company,
1907. 52 pp. illus.

1855. Parker (Charles) Company. Catalog of Piano and Organ
Benches, Stools.... Meriden, Conn.: Charles Parker Company.
c. 1890. 36 pp. illus.

1856. Pearson, A. Catalog of Black Walnut Suites, Turkish
Suites, and Furniture for Dining Room, Bedroom, and Study.
Brooklyn, N.Y.: A. Pearson, 1876. 32 pp. illus.

1857. Peck and Hills Furniture Company. Catalogue. Brooklyn,
N.Y.: Peck and Hills Furniture Company, c. 1910. illus.

1858. Peters (Joseph) Furniture Company. Illustrated
Catalogue...Bed Room Suits. St. Louis, Mo.: Joseph Peters
Furniture Company, 1891. 17 pp. illus.

1859. Peterson (A.) and Company. Desks and Office Furniture.
Chicago: A. Peterson and Company, 1890. 56 pp. illus.

1860. Philander, Derby, and Company. The Automatic Foot-Rest.
Boston: Philander, Derby, and Company, 1880. 2 pp. illus.

1861. ___ . Taylor Double Cane Chairs. Boston: Philander, Derby, and Company, c. 1880. 24 pp. illus.

1862. Pick (Albert), Barth, and Company. Catalog C3. Furnishings and Equipment for Hotels, Clubs, Hospitals, Institutions, Public Buildings, Apartment Buildings, Schools and Colleges, Steam Ships, Restaurants, Cafeterias.... Chicago: Albert Pick, Barth, and Company, 249 pp. illus.

1863. Pierce, E. F. Chairs. Boston: E. F. Pierce, c. 1875. 64 pp. illus.

1864. ___ . Spring Price-List, Chairs. Boston: E. F. Pierce, 1882. 7 pp. illus.

1865. Pioneer Manufacturing Company. 1905 Catalogue of Reed Furniture, Go-Carts, Baby Carriages. Detroit, Mich.: Pioneer Manufacturing Company, 1905. 144 pp. illus.

1866. ___ . Reed Furniture Catalog. Reed Chairs and Rockers. Detroit, Mich.: Pioneer Manufacturing Company, 1906. 37 pp. illus.

1867. Pond Desk Company. Catalogue of Roll Top, Antique Oak Desks, Chairs.... Boston: Pond Desk Company, 1890. 16 pp. illus.

1868. Prairie Grass Furniture Company, Inc. Illustrated Catalog of Crex Grass for Parlor, Porch, and Lawn.... Glendale, N.Y.: Prairie Grass Furniture Company, Inc., c. 1900. 78 pp. illus.

1869. Princess Dressing Case Co. Oak Folding Beds, Tables, Wardrobes.... Grand Rapids, Mich.: Princess Dressing Case Co., c. 1880. 11 pp. illus.

1870. Prufrock, L. F. Catalog. No place: L. F. Prufrock, 1904.

1871. Rayl (T. B.) and Company. Illustrated Price List of Artificial and Natural Wood Ornaments, Carved Panels, Handles and Finials for Sideboards, Bureaus, Desks, Secretaries.... Detroit, Mich.: T. B. Rayl and Company, 1883. illus.

1872. Reischmann Company. Furniture for Hotels, Cafes, Clubs...Special Designs to Order.... New York: Reischmann Company, 1919. 48 pp. illus.

1873. Rhoner (Frank) and Company. Catalogue. New York: Frank Rhoner and Company, 1878. 2 pp. illus.

1874. Ring, Merrill, and Tillotson. Bedroom Suites. Saginaw, Mich.: Ring, Merrill, and Tillotson, c. 1880. 3 pp. illus.

1875. Robinson (C. H.) and Company. Illustrated Catalog and Price List of the Good Luck Parlor Mantel Bed. Boston: C. H. Robinson and Company, c. 1884. 20 pp. illus.

1876. ___. Everything to Furnish a Home. Illustrated Catalog of Parlor Suites in Walnut and Mahogany, Furniture Designs, and Everything Including Hand Painted Lamps. Boston: C. H. Robinson and Company, 1890. 192 pp. illus.

1877. Rockford Co-Operative Furniture Company. Illustrated Catalog of Furniture Designs for Every Room in the Home. Rockford, Ill.: Rockford Co-Operative Furniture Company, 1892. 70 pp. illus.

1878. Rockford Standard Furniture Company. The Standard Line. Rockford, Ill.: Rockford Standard Furniture Company, 1911. 59 pp. illus.

1879. Rockford Union Furniture Company. Illustrated Catalog of Furniture. Rockford, Ill.: Rockford Union Furniture Company, c. 1890. 40 pp. illus.

1880. ___. Library Cases, Bookcases, Secretaries...Desks, Tables.... Rockford, Ill.: Rockford Union Furniture Company, 32 pp. illus.

1881. Roda, A. Catalogue of Solid Wood Furniture Carvings, Carved Heads, Carved Drawer Handles...Brackets...Mouldings.... Rochester, N.Y.: A. Roda, c. 1879. 56 pp. illus.

1882. Ross, Joseph L. Desks and Chairs for Schools.... Boston: Joseph L. Ross, 1850. 1 p. illus.

1883. Ross' School Furniture Works. Illustrated Catalogue of Ross' Improved School Furniture. Boston: Ross' School Furniture Works, 1864. 70 pp. illus.

 Also issued in 1867.

1884. Ross, Turner, and Company. Catalog of Hammocks, Fancy and Plain, with Attachments. Boston: Ross, Turner and Co., 1884. 22 pp. illus.

1885. Roycrofters. A Catalog of Roycrofters Furniture and Other Items. Reprint. New York: Turn-of-the-Century Editions, 1981. 47 pp. illus.

1886. ___. The Roycroft Catalog of Books and Things. East Aurora, N.Y.: Roycrofters, 1905. 46 pp. illus.

1887. ___. A Catalog of Roycroft Furniture. East Aurora, N.Y.: Roycrofters, 1909. 38 pp. illus.

1888. ___. Roycroft Furniture. East Aurora, N. Y.: Roycrofters, 1905. 27 pp. illus.

1889. ___ . Roycroft Furniture. 1906. Reprint. New York:
Turn-of-the-Century Editions, 1981. 52 pp. illus.

1890. ___ . Roycroft Hand-Made Furniture: a Facsimile of a
1912 Catalog.... East Aurora, N.Y.: House of Hubbard, 1973.
61 pp. illus.

1891. St. Johns Table Company. St. Johns Cadillac Tables.
Cadillac, Mich.: St. Johns Table Company, 1914. 159 pp. illus.

1892. Salter and Bilek, Manufacturers. Catalog of Fancy
Music Stands, Cabinets, Desks, Tables, Clock Shelves, What-
Nots, Towel Racks and Brackets. Chicago: Salter and Bilek,
Manufacturers, 1889. 48 pp. illus.

1893. Samuels (M.) and Company. Fall Catalogue...of Folding
Beds. New York: M. Samuels and Company, 1890. 14 pp. illus.

1894. Sanital Mattress Company. Sanital Mattresses. Piqua,
Ohio: Sanital Mattress Company, 1893. 32 pp. illus.

1895. Sargent, George F. Rolling Chairs, Carrying Chairs.
New York: George F. Saugent, 1913.

1896. Sargent Manufacturing Company. Sargent's Reclining
Chairs. Muskegon, Mich.: Sargent Manufacturing Company,
c. 1890. 32 pp. illus.

1897. Sawin (L. H.) and Company. Catalogue. West Gardner,
Mass.: L. H. Sawin and Company, 1886. 30 pp. illus.

1898. Schermerhorn, J. W. Catalog of School Materials--Desks,
Bells, Clocks, Globes and General Furniture. New York: J. W.
Schermerhorn, 1871. 160 pp. illus.

1899. School Furniture Company. Church Furniture. Grand
Rapids, Mich.: School Furniture Company, 1880. 58 pp. illus.

1900. Schrenkeisen, M. and H. Catalogue of Parlor Furniture.
New York: M. and H. Schrenkeisen, 1877. 88 pp. illus.

1901. ___ . Catalogue of Parlor Furniture. Catalogue of
Parlor Furniture. New York: M. and H. Schrenkeisen, 1885.
31 pp. illus.

 Also published in 1882 and 1877.

1902. ___ . Supplement to Illustrated Catalogue. New York:
M. H. Schrenkeisen, 1881. 36 pp. illus.

1903. Seng (W.) and Company. Spring Price List of Bed Lounges
and Upholstered Furniture. Chicago: W. Seng and Company,
1873. 8 pp. illus.

1904. Shaw, Applin, and Company. The Celebrated Morris Chair. Boston: Shaw, Applin, and Company, 1904. 1 p. illus.

1905. ___. Church Furniture. Boston: Shaw, Applin, and Company, c. 1880. 22 pp. illus.

1906. ___. Lodge Furniture. Boston: Shaw, Applin, and Company, c. 1890. 72 pp. illus.

1907. ___. New Catalogue...of Parlor, Church, and Lodge Furniture. Boston: Shaw, Applin, and Company, 1879. 48 pp. illus.

1908. ___. Parlor, Church, Lodge Furniture. Boston: Shaw, Applin, and Company, 1881. 1 p. illus.

1909. Shearman Brothers. 11th Annual Catalogue. Jamestown, N.Y.: Shearman Brothers, 1891. 32 pp. illus.

1910. Shearman Brothers Lounge Factory and Upholstery Works. Catalog of Lounges and Chairs. Jamestown, N.Y.: Shearman Brothers Lounge Factory and Upholstery Works, 1888. 34 pp. illus.

1911. Sheboygan Chair Company. Chairs of All Designs and Styles. Sheboygan, Wis.: Sheboygan Chair Company, 1890. 255 pp. illus.

1912. Sheboygan Manufacturing Company. Illustrated Catalogue. Sheboygan, Wis.: Sheboygan Manufacturing Company, 189-. 305 pp. illus.

1913. Silver Creek Upholstering Company. Parlor Furniture. Silver Creek, N. Y.: Silver Creek Upholstering Company, c. 1880. 1 p. illus.

1914. Simmons Manufacturing Company. Catalogue. Chicago and Milwaukee: Simmons Manufacturing Company, 1906. 230 pp. illus.

1915. Sligh Furniture Company. Catalog of Furniture. Grand Rapids, Mich.: Sligh Furniture Company, No date. 95 pp. illus.

1916. Small (S. C.) and Company. Bond Patent Sanitary Washstand. Boston and Winchester, Mass.: S. C. Small and Company, c. 1880. 1 p. illus.

1917. ___. Catalog of Fine Furniture. Boston and Winchester, Mass.: S. C. Small and Company, 1883. 8 pp. illus.

1918. ___. Church Furniture. Boston and Winchester, Mass.: S. C. Small and Company, c. 1885. 56 pp. illus.

 Also issued in 1887.

1919. ___ . Illustrated Catalogue. Boston and Winchester, Mass.: S. C. Small and Company, 1883. 8 pp. illus.

1920. ___ . Lodge Furniture. Boston and Winchester, Mass.: S. C. Small and Company, 1887. 40 pp. illus.

1921. ___ . Supplementary Sheet--New Designs. Boston and Winchester, Mass.: S. C. Small and Company, 1880. 1 p. illus.

1922. Smith and Davis Manufacturing Company. Illustrated Catalogue...Springs Beds, Woven Wire Mattresses, Cots and Iron Bedsteads. St. Louis, Mo.: Smith and Davis Manufacturing Company, 1891. 7 pp. illus.

 Also issued in 1882.

1923. Snellenburg (N.) and Co, Need Furniture?.... Philadelphia: N. Snellenburg and Company, c. 1910. 2 pp. illus.

1924. Sparmann, Gustav E. Illustrated Catalogue of Iron Back Frames for Sofas, Lounges, and Chairs. New York: E. Gustav Sparmann, 1874. 20 pp. illus.

1925. Speyer Brothers. Supplement to Speyer Brothers' Illustrated Catalogue of Cabinet Hardware and Tools and Furniture Specialties. New York: Speyer Brothers, 1899. illus.

1926. Spokane Furniture and Carpet Company. Talk It Over. Cedar Rapids, Iowa: Spokane Furniture and Carpet Company, c. 1905. 4 pp. illus.

1927. Spurr, Charles W. Veneers, Hangings, and Marquetries. Boston: Charles W. Spurr, c. 1880. 1 p. illus.

1928. Squires (Sidney) and Company. Automatic Sofa-Bed. Boston: Sidney Squires and Company, c. 1880.

1929. ___ . Squire's Automatic Sofa and Cabinet Beds. Boston: Sidney Squires and Company, c. 1890. 11 pp. illus.

1930. Stein, Alexander. Catalog of Parlor Furniture. New York: Alexander Stein, c. 1865. illus.

1931. Steinman and Meyer Furniture Company. Supplementary Catalogue, No. 25. Cincinnati, Ohio: Steinman and Meyer Furniture Company, c. 1880. 18 pp. illus.

1932. Stickley, Gustav. Chips from the Workshops of Gustav Stickley. Syracuse, N. Y.: Gustav Stickley, 1901?. 46 pp.

 A second edition of this work was issued.

1933. ___ . Craftsman Furniture. New York: Gustav Stickley, 1907. illus.

 Also issued in 1906, 1909, 1912, 1913.

1934. ___ . Craftsman Furniture Made by Gustav Stickley.
Work of L. and J. G. Stickley. Reprint. New York: Dover
Publications, 1979. 192 pp. illus.

1935. ___ . Gustav Stickley. Reprint. New York: Turn-of-
the-Century Editions, 1981. 168 pp. illus.

1936. Stickley-Brandt Furniture Company. Satisfaction
Furniture at Factory Figures, Catalog No. A9. Binghamton,
N. Y.: Stickley-Brandt Furniture Company, 1906. 48 pp. illus.

1937. Stickley Brothers Company. Furniture Catalog No. 8.
Grand Rapids, Mich.: Stickley Brothers Company, No date.

 Number 40 was issued in 1915.

1938. ___ . Quaint Furniture. Reprint. New York: Turn-of-
the-Century Editions, 1981. 80 pp. illus.

1939. ___ . Quaint Furniture. Grand Rapids, Mich.: Stickley
Brothers, 1910. illus.

1940. ___ . Ye.Quaint Style. Grand Rapids, Mich.: Stickley
Brothers, 1908. 16 pp. illus.

1941. Stickley, L. and J. G. Handcrafted Furniture.
Fayetteville, N. Y.: L. and J. G. Stickley, 1910?.

1942. ___ . Works of L. and J. G. Stickley. Fayetteville,
N. Y.: L. and J. G. Stickley, 1910. illus.

 Also issued in 1912 and 1914.

1943. Stomps (G.) and Company. Catalogue...Chairs. Dayton,
Ohio: G. Stomps and Company, 1887. 164 pp. illus.

1944. Stow and Haight. Catalogue and Price-List of Tables.
Grand Rapids, Mich.: Stow and Haight, 1883. 13 pp. illus.

1945. Strader Cornice Works. Patent Extension Curtain
Cornices. Columbus, Ohio: Strader Cornice Works, C. 1880.
2 pp. illus.

1946. Strawbridge and Clothier. New Reasons for Buying
Furniture in the February Sale.... Philadelphia: Strawbridge
and Clothier, 1915. 9 pp. illus.

1947. Stuart, F. E. Chairs and Settees. Boston: F. E.
Stuart, C. 1880. 56 pp. illus.

1948. Sueme, Charles. Catalogue...Safes, Kitchen Tables and
Extension Tables. St. Louis, Mo.: Charles Sueme, 1891.
3 pp. illus.

1949. Sugg and Beiersdorf Furniture Manufacturing Company.
Catalog and Price List of Styles--Spool Beds, Fancy Base
Walnut Marble Top Tables, Heavy Carved Bedsteads, Chairs,
Stands.... Chicago: Sugg and Beiersdorf Furniture Manufact-
uring Company, 1875. 70 pp. illus.

1950. ___. Catalogue of Fine Furniture. Chicago: Sugg and
Beiersdorf Manufacturing Company, 1881. 67 pp. illus.

1951. Taft Company. Catalog of Natural and Artificial Wood
Carved Ornaments for Furniture. Hartford, Conn.: Taft
Company, 1886. 24 pp. illus.

 Also issued in 1887.

1952. Taylor Chair Company. Rockers, Hotel Arm Chairs,
Library Chairs.... Bedford, Ohio: Taylor Chair Company,
1890. 31 pp. illus.

1953. Teepe, J. Charles. Catalog of Plain and Fancy Hard-
wood Woodenware and Cabinet Work for Furniture and Furnish-
ings. New York: J. Charles Teepe, 1886. 48 pp. illus.

1954. Thompson, Perley, and Waite. Maple, Oak, and Walnut
Cane Seat Chairs. Baldwinville, Mass.: c. 1880. 1 p. illus.

1955. Tobey Furniture Company. Russmore Furniture. Chicago:
Tobey Furniture Company, 1903. 60 pp. illus.

1956. ___. Tobey Hand-Made Furniture. Chicago: Tobey
Furniture Company, 1904. illus.

1957. Trefry (Thomas) and Company. Wardrobes and Chif-
foniers. Boston: Thomas Trefry and Company, c. 1880.
1 p. illus.

1958. Tucker Manufacturing Company. Price List of Mantel
and Wardrobe Beds. Boston: Tucker Manufacturing Company,
1884. illus.

1959. Union Chair Works. Catalog of Chairs, Rockers, Sewing
and Childs', Tables.... Mottville, N. Y.: Union Chair Works,
1892. 20 pp. illus.

1960. Union Furniture Company. Catalogue of Dining Room
Furniture. Jamestown, N. Y.: Union Furniture Company, 1913.
71 pp. illus.

1961. Union School Furniture Company. Catalog of School
Furniture and Furnishings. Albany, N. Y.: Union School
Furniture Company, 1886. illus.

1962. United Crafts. Things Wrought by the United Crafts at
Eastwood, New York. Eastwood, N. Y.: United Crafts, 1902.
32 pp. illus.

1963. United Mills Manufacturing Company. Carpets, Rugs, Curtains, Furniture, Blankets, Hosiery.... Philadelphia: United Mills Manufacturing Company, 1912?. 80 pp. illus.

1964. United Society of Shakers. Catalog and Price List of Chairs, Foot Benches, Mats.... Mt. Lebanon, N. Y.: United Society of Shakers, 1874. 29 pp. illus.

Also issued in 1876.

1965. ___. Centennial Catalog of Chairs and Furniture. Mt. Lebanon, N. Y.: United Society of Shakers, 1876. 38 pp. illus.

1966. ___. Circular of Chair Designs. Mt. Lebanon, N. Y.: United Society of Shakers, c. 1870. 1 p. illus.

1967. Upham Manufacturing Company. Price List. Marshfield, Wis.: Upham Manufacturing Company, c. 1910.

1968. Vaill, E. W. Patent Folding Chairs. Worcester, Mass.: E. W. Vaill, 1879. 96 pp. illus.

1969. Van Sciver (J. B.) and Company. Furniture Catalog. Camden, N. J.: J. B. Van Sciver and Company, 19--.

1970. ___. Home and Art; and Hints of Furnishing. Camden, N. J.: J. B. Van Sciver and Company, c. 1890. illus.

1971. Victor Manufacturing Company. Catalogue. Chicago: Victor Manufacturing Company, 1899.

1972. Vornbrock Furniture Company. Illustrated Catalogue... Folding Beds, Center Tables, Hall Trees, Sideboards. St. Louis: Vornbrock Furniture Company, 1891. 17 pp. illus.

1973. Wakefield Rattan Company. Catalogue. Boston: Wakefield Rattan Company, c. 1890. 77 pp. illus.

1974. ___. Price List of Reed and Rattan Chairs and Tables. Boston: Wakefield Rattan Company, 1878. 24 pp. illus.

1975. Wanamaker, J. Catalogue of Furniture. New York: J. Wanamaker, 1911. illus.

1976. Watson, Karsch, and Company. Illustrations of Chairs. New York: Watson, Karsch, and Company, 188?. 40 pp. illus.

Also published in 1889.

1977. Wenter, F. Catalog of Brackets, Carved Tables, Stands and Shelves. Chicago: F. Wenter, 1877. 36 pp. illus.

1978. West Virginia School Furniture Company. New Sanitary Semi-Steel Desks. Huntington, West Virginia, 1917. 1 p. illus.

1979. Western Furniture Company. Illustrated Catalogue...
Desks, Cylinder Desks, Book Cases and Secretaries. St.
Louis, Mo.: Western Furniture Company, 1891, 4 pp. illus.

1980. White, Frank W. Looking-Glasses, Picture Frames,
Mouldings. New York: Frank W. White, C. 1870. 32 pp. illus.

1981. White, R. T. The Garfield Adjustable Cot Bed and
Stretcher. Boston: R. T. White, 1881. 1 p. illus.

1982. Whitney (O.) and Company. Illustrated Catalogue and
Price List of Chairs. Winchendon, Mass.: O. Whitney and
Company, C. 1880. 22 pp. illus.

1983. Whitney, W. F. Cane Seat Chairs. South Ashburnham,
Mass.: W. F. Whitney, 1883. 1 p. illus.

1984. Whittle, Charles P. Chamber Furniture. Boston:
Chalres P. Whittle, C. 1880. 1 p. illus.

1985. Wild, H. L. Catalog of Scrool Saw Designs for Fine
and Fancy Furniture. New York: H. L. Wild, 1889. illus.

1986. Willard Mirror and Frame Manufacturing Company,
Willard's Patent Cloak and Clothing Triplicate Mirrors,
Looking Glasses, Cloak and Clothing Racks, Hangers, Fancy
Hat Trees for Bar and Hallway. New York: Willard Mirror
and Frame Manufacturing Company, C. 1894. 12 pp. illus.

1987. Williamsport Furniture Manufacturing Company. Catalog
of Ash, Cherry, Maple, Antique Oak, Imitation Mahogany,
and Walnut Furniture, Finished and in the White, with
Mankey Patent Stencil Decorations for Parlor, Bedroom,
and Kitchen. Williamsport, Pa.: Williamsport Furniture
Manufacturing Company, 1886, 22 pp. illus.

1988. Wilson and Hechinger. Catalog of Chairs. Baltimore:
Wilson and Hechinger, 1892. 80 pp. illus.

1989. Wolf and Kraemer Furniture Company. Wardrobes, Wash-
stands, and Sideboards. St. Louis, Mo.: Wolf and Kraemer
Furniture Company, 1891. 7 pp. illus.

1990. Wolverine Manufacturing Company. Fall Supplement to
General Catalogue 61. Detroit, Mich.: Wolverine Manufactur-
ing Company, c. 1907. 1 p. illus.

1991. ___ . Wolverine Tables. Detroit, Mich.: Wolverine
Manufacturing Company, c. 1907. 100 pp. illus.

1992. Wooten Desk Company. Wooten's Patent Cabinet Secretar-
ies and Rotary Office Desks. Indianapolis and Philadelphia:
Wooten Desk Company, 1876. 24 pp. illus.

1993. Zeeland Furniture Manufacturing Co. Chamber Suits,
Dressers, Sideboards, Buffets, and Chiffoniers. Zeeland,
Mich.: Zeeland Furniture Manufacturing Co., 1906. 48 pp. illus.

APPENDIX

American Furniture Periodicals

1994. American Cabinetmaker and Upholsterer. Chicago.
1890-1904.

1995. American Furniture Gazette. Chicago. November 1880-
April 1902.

1996. American Furniture Manufacturer. Chicago. 1911-1925.

 Previously entitled The Furniture Worker.

1997. The Artsman. Rose Valley, Pa. 1903-1907.

1998. Cincinnati Furniture World. Cincinnati, Ohio.
1881-1885.

1999. Craftsman: An Illustrated Monthly Magazine in the
Interest of Better Art. Eastwood, N. Y. October 1901-Decem-
ber 1916.

2000. Daily Artisan Record. Grand Rapids. 1889-1924.

2001. Decorator and Finisher. New York. 1882-1898.

2002. Furniture--A Magazine of Education for the Home.
Grand Rapids. 1909-1912.

2003. Furniture Index. Jamestown, N. Y. 1900-?

2004. Furniture Journal. Chicago. 1888-1931.

 From 1888-1892 published as the Rockford Furniture Journal,
 united with Furniture Record to form the Furniture Record
 and Journal.

2005. <u>Furniture Manufacturer and Artisan</u>. Grand Rapids. 1880-1911.

Published as the <u>Michigan Artisan</u> 1880-1890.

2006. <u>Furniture Merchandising</u>. High Point, North Carolina. 1901-1931.

Published as Southern Furniture Journal, 1901-1930.

2007. <u>Furniture Retailer and Furniture Age</u>. East Strouds-burg, Pa. 1901+

Published as <u>Decorative Furnisher</u> in 1906; <u>Upholstery Dealer, and Decorative Furnisher</u>, 1901-1905; <u>Furniture Age</u> in 1956.

2008. <u>Furniture Retailer and House Furnisher</u>. Grand Rapids. 1913-1914.

Later published as <u>Good Furniture</u>.

2009. <u>Furniture Trade Review and Interior Decorator</u>. New York. 1880-1919.

Became <u>Carpet and Upholstery Trademan</u> in 1920.

2010. <u>Furniture West</u>. San Francisco and Seattle. 1918-1933.

Known as <u>Furniture Reporter</u> 1918-1932.

2011. <u>Furniture World</u>. New York. 1895-1930.

United with <u>Furniture Buyer and Decorator</u> to form <u>Furniture World and Furniture Buyer and Decorator</u>.

2012. <u>Furniture World Buyer and Decorator</u>. New York. 1870-1930.

Published as <u>Cabinet Maker</u>, 1870-1875; <u>American Cabinet Maker, Upholsterer and Carpet Reporter</u>; 1875-1884; <u>American Cabinet Maker and Upholsterer</u>, 1884-1899.

2013. <u>Furniture Workers' Journal</u>. New York. 1884-1891.

Superseded by <u>General Wood Workers' Journal</u>.

2014. <u>Furniture Worker</u>. Cincinnati and Chicago. 1883-1922.

Merged with <u>American Furniture Manufacturer</u>.

2015. <u>General Wood Workers Journal</u>. Baltimore. 1891-1896.

Supersedes <u>Furniture Workers' Journal</u>.

2016. <u>Good Furniture and Decoration</u>. Grand Rapids. 1913-1931.

 Published as <u>Furniture Retailer and House Furnisher</u>, 1913-14; <u>Good Furniture</u>, 1914-1919; <u>Good Furniture Magazine</u>, 1920-1029.

2017. <u>Grand Rapids Furniture Record</u>. Grand Rapids. 1892-1925.

 Published as Furniture Record after 1925. Merged with <u>Retail Management</u>.

2018. <u>St. Louis Furniture News</u>. St. Louis. 1889-1931.

 Published as <u>Furniture News</u> after 1924.

2019. <u>Woodcraft: A Journal Of Woodworking</u>. Cleveland, Ohio. 1904-1915.

 Published as <u>Patternmaker</u>, 1904-1905.

2020. <u>Wood-Worker</u>. Indianapolis, Ind. 1882-1960.

Manuscript Collections

2021. American Antiquarian Society Library, 185 Salisbury St., Worcester, Mass. 01609.

 Contains the Account Book (1854-62) of Stuart and Sons, East Princeton, Mass.; Account Book (1737-1760) of Boston, Mass.; Account Book (1806-1844) of Lansford Wood, Worcester, Mass.

2022. Connecticut Historical Society Library, 1 Elizabeth St., Hartford, Conn. 06105.

 Contains the Account Book (1796-1803) of Amos Denison Allen, Windham, Conn.

2023. Cornell University Library, Regional History Collection, Ithaca, N. Y. 14853.

 Contains an Account Book (1875-1918) of the Pierce Family; Account Book (1855) of the Frost and West Furniture Company; Diary (1864) of Luke Tuttle Merrill, Horseheads, N.Y.

2024. Delaware State Archives, Dover, Delaware. 19901.

 Contains the Account Book of John Janvier.

2025. Duke University, William R. Perkins Library, Durham, North Carolina. 27706.

Contains the Account Book (1860s) of John Jones of Edenton, N. C.; Papers (1848-1934) of William Alexander Smith.

2026. Essex Institute, James Duncan Phillips Library. 132-34 Essex St., Salem, Mass. 01970.

Contains a major collection of materials relative to Massachusetts craftsmen. Includes the Account Book (1725-1742) of Joseph Brown; Account Book (1736-1772) of Abraham Lunt; Samuel McIntire Papers; Sanderson Papers.

2027. Harvard Business School, Baker Library, Soldiers' Field Road, Boston, Mass. 02163.

Contains a large amount of manuscript material relative to American business. Includes the Account Books (1797-1827) of Edward Slead, Dartmouth, Mass.; Accounts (1822-1851) of Aaron Wright, Fishkill, N.Y.; Furniture Store Account Book (1833-1840) of J. L. Wayne, Cincinnati.

2028. Historical Society of Pennsylvania Library, 1300 Locust Street, Philadelphia, Pa. 19107.

Contains Papers (1759-1763) of Daniel Clark, Philadelphia; Book of Prices (1786) of Benjamin Lehman; Papers (1855-1866, 1500 items) of William J. Warren; Account Books (1774-1811) of David Evans.

2029. Kent Memorial Library, 50 North Main St., Suffield, Conn. 06078.

Contains the Account Book (18th century) of John Dewey; Account Book (18th century) of Thaddeus Leavitt.

2030. Library of Congress, Washington, D. C. 20540.

Contains an 1831 price book.

2031. Massachusetts Historical Society Library, 1154 Boylston Street, Boston, Mass. 02215.

Contains Papers of Capt. Nathaniel Colley and Thomas Jefferson, both of which contain information on furniture; Bill of Smith and Adams; Indenture (1827) between John G. Davis and Ezra Fay; Bill of Sale (1805) of Allen Smith.

2032. Michigan State Library, East Lansing, Mich. 48824.

Contains the Papers (1821-1940) of the Cortland Bliss Stebbins family of Vermont and Michigan.

2033. Milford Historical Society, Milford, Conn. 06460.

Contains the Account Books of John Durand, Samuel Durand, Jr., and Ephraim Strong.

2034. Minnesota Historical Society Library, 690 Cedar St., St. Paul, Minn. 55101

Contains the Eli Torance Papers which contains information on the Lugar Furniture Company (1803-1856).

2035. Missouri Historical Society Library, Jefferson Memorial building, St. Louis, Missouri. 63112.

Contains the Account Books of Wagner and Son.

2036. Monmouth County Historical Association Library, 70 Court Street, Freehold, New Jersey. 07728.

Contains the Account Book of the Lyle (or Lyell) Family.

2037. Moravian Archives, 41 West Locust St., Bethlehem, Pennsylvania. 18018.

Contains information on Moravian crafts and the Economy Community.

2038. New Jersey Historical Society Library, 230 Broadway St., Newark, New Jersey. 07104.

Contains manuscript material on John Hewett, Caleb N. Bruen, Abraham Hutchinson, Thomas Woodruff, Henry G. Lyon, and David Alling.

2039. New York State Historical Association Library, Cooperstown, N. Y. 13326.

Contains the Account Book (1784-1821) of Ezekieh Bennett, New York and Connecticut; Papers (c. 1790) of John Speir, New York and Nova Scotia; Account Books (1791-1882) of Chauncy Strong; Account Book (1813-1844) of William Bently, Otsego Co.; Account Books (1826-1849) of Augustus Towney, Binghamton and Ithaca, N. Y.; Manuscript Material of Samuel Stillman, Duanesburg; Papers (1821-1831) of Justus Dunn, Utica and Rochester, N. Y.; Papers (1821-1828) of Benjamin Miles, Cooperstown, N. Y.; Papers (1828-1839) of Jacob D. Page; Account Books (1829-1865) of Leonard Proctor, Hartwick, N. Y.; and Papers (1829-1831) of Robert Scadin, Cooperstown, N. Y.

2040. North Carolina State Department of Archives and History, Raleigh, North Carolina. 27611.

Contains the Sales Books (1912-1915) of W. E. Merritt Co., Mt. Airy, N. C. and Account Books (1798-1863) of William Little, Sneedsborough, N. C.

2041. Pennsylvania State Archives, Pennsylvania Historical and Museum Commission, William Penn Memorial Museum and Archives Building, Harrisburg, Pennsylvania. 17120.

 Contains the Records (1890-1969) of the Burns and Co. Furniture Store.

2042. Rhode Island Historical Society Library, 121 Hope St., Providence, Rhode Island. 02906.

 Contains the Ledger (1750-1770) of William Barker; Account Book (1790) of Rufus Dyer; Account Books (1773-1835) of William Proud.

2043. State Historical Society of Wisconsin Library, 816 State St., Madison, Wisconsin. 53706.

 Contains the Papers (1842-1918) of Thomas J. Bailey and Henry J. Bailey of Ft. Howard, Green Bay and De Pere, Wisconsin; Business Receipts (1812-1899) of Dawin Clark; and Papers of Halbert Louis Hoard.

2044. University of Georgia Library, Athens, Georgia. 30602.

 Contains the Records (1881-1945) of the Brumby Chair Company, Marietta, Georgia.

2045. University of Louisville Library, 2301 South Third St., Louisville, Kentucky. 40208.

 Contains the Papers of Anton Frederick Coldeway.

2046. University of Michigan, Michigan Historical Collection, Ann Arbor, Michigan. 48109.

 Contains the Papers (1882-1905) of Charles E. Rigley of the Estey Manufacturing Company; Records (1850-1927) of Charles Robert Sligh, Sr., Grand Rapids, Mich.

2047. University of North Carolina, Southern History Collection, Chapel Hill, North Carolina. 27514.

 Contains Records of James R. Brumby, Marietta, Georgia.

2048. University of Southwestern Louisiana Library, South-western Archives Collection, Lafayette, Louisiana. 70504.

 Contains the Records (1912-1965) of Ira Schreiber Nelson (Acadian Furniture).

2049. University of Texas Library, Texas Archives, Austin, Texas. 78712.

 Contains the Blackburn-Townsend Papers (1821-1918) which includes papers on a furniture business in Taylor, Tx. and the Papers (1889-1944) of John Hickman Brown, Corpus Christi.

2050. Waterloo Library and Historical Society, 31 East
William St., Waterloo, N. Y. 13165.

 Contains the Ledger (1850-1863) of Asa G. Story.

2051. West Virginia University Library, Morgantown, West
Virginia. 26506.

 Contains the Account Book of Henry Hammett, Parkersburg,
 West Virginia.

2052. Winterthur (Henry Francis du Pont) Museum Library.
Winterthur, Delaware. 19735.

 Contains the Downs Manuscript and Microfilm Collection of
 over 100 account books and related materials. Information
 is available on craftsmen from Connecticut, Delaware,
 Indiana, Kentucky, New Hampshire, New Jersey, New York,
 Massachusetts, Pennsylvania, Vermont, Maine, Maryland,
 and Virginia. The earliest account books in the collection
 are those of John Gaines II and Thomas Gaines of
 Massachusetts, 1712-1762. Because of the large number
 of items in this collection, it is not possible to
 list them.

CRAFTSMAN–BIOGRAPHICAL INDEX

The numbers following each heading
refer to the citation numbers.

Allison, Michael. Cabinet-
maker, Born 1773, Died 1855,
Active New York City 1800-
1855, Brother to Richard
Allison: 9

Allison, Richard. Cabinet-
maker, Born 1780, Died
1825, Active New York City
1780-1825: 10

Alms Manufacturing Co. Fur-
niture factory, Active
Cincinnati 1887: 1558

Amana Community. A utopian
commune, Active Iowa 1843-
1932: 11-14

American Desk Manufacturer.
Furniture factory, Active
New York 1873-75: 1559-60

American Grass Twine Company.
Furniture factory, Active
New York 1903: 1561

American Ottoman and Hassock
Company. Furniture factory,
Active New York 1885: 1562

American Seating Company.
Furniture factory, Active
Chicago 1911: 1563

American Shade Roller Company.
Manufacturing company,
Active Boston 1877: 1564

Andrews (A. H.) and Company.
Furniture factory, Active
Chicago 1876-1891: 1565-
1571

Anonymous. Cabinetmaker,
Active Carolina: 15

Appleton, Nathaniel. Cabinet-
maker, Active Salem, Mass.
1803-1806: 16, 435

Appleton, William. Cabinet-
maker, Baptized 1765, Died
1822, Advertised 1794-1804:
17, 18, 45

Archer Manufacturing Company,
Furniture factory, Active
Rochester, N. Y. 1880-
1890's: 1572-75

Arnold, C. N., Active Pough-
keepsie, N.Y. 1886: 1576

Art Bedstead Company. Furni-
ture factory, Active Chi-
cago 1907: 1577

Ash, Gilbert, Joiner, Born
1717, Died 1785, Adver-
tised 1759+ New York City:
19, 20, 1018, 1034,
1373

Ashe, Thomas. Windsor chair-
maker, Active New York
City 1785: 21, 85, 1271

Astens, Thomas. Made tables,
Listed New York City 1818-
23: 22

Atkins, Gibbs. Cabinet-
maker, Born 1739, Died
1806, Listed 1766 Boston,
Property confiscated
because he was a Tory: 1365

Atkinson (B. A.) and Company.
Furniture factory, Active
Boston 1870's and 1880's:
1578, 1579

Aude Furniture Company. Fur-
niture factory, Active St.
Louis 1891-1900: 1580,
1581, 1640

Aurora Colony. A utopian
commune, Active in Oregon
during the 19th Century:
23

Bachman, Jacob. Cabinetmaker,
Born 1746 in Switzerland,
Died 1829, Worked in Lam-
peter Township, Lancaster
County, Pa.: 24, 25, 26

Badlam, Stephen. Cabinetmaker
and looking-glass maker,
Born 1751, Died 1815,
Active Dorchester, Mass.
1790-97: 27, 432

Bagby Furniture Company.
Furniture factory, Active
Baltimore 1899: 1582

Bailey, Thomas J.. Tool maker
and cabinetmaker, Died
1891, Active Wisconsin
1842-1891: 2043

Baltimore Bargain House.
Furniture store, Active
Baltimore 1904: 1583

Banks, Morton C.. Furniture
maker, Active Baltimore
1878: 1584

Banta, Weart. Cabinetmaker,
Active New Jersey 1770's:
1365

Bardwell, Anderson, and Com-
pany. Furniture factory,
Active Boston 1884: 1585

Barjon, D.. Furniture maker,
Active Reserve, Louisiana
1830-1856: 876

Barker, William. Cabinet-
maker, Active Providence,
Rhode Island 1750-1770:
1178, 2042

Barry, Joseph B.. Cabinet-
maker, Born Dublin, Active
in Philadelphia before 1773
and after 1798, Active in
Savannah 1773-1798: 28,
853, 1089, 1105

Bates, Joseph. Joiner,
Active Ipswich, Mass.
1707-1712: 214

Baumann (Ludwig) and Com-
pany. Furniture factory,
Active New York 1890-191?:
1586-89

Baxter (C. O.) and Company.
Furniture factory, Active
St. Louis 1891: 1590, 1640

Baxter (Edward W.) and Com-
pany. Furniture business,
Active New York 1871-73:
1591

Beal (T. M.) and Company.
Furniture factory, Active
Boston 1886: 1592

Beares, Henry. Furniture
maker, Active Pittsburgh
1819-1841: 1367

Beldon, George. Cabinet-
maker, Born 1770, Died
1838, Active Windsor,
Conn.: 29

Bellamy, John Haley. Carver,
Born 1836, Died 1914,
Active Kittery, Maine: 30

Belter, John Henry. Furniture
maker, Born Germany 1804,
Arrived in New York 1844,
Died 1863, Active New York:
31-60, 281, 1354, 1398,
1497

Benjamin, Samuel. Cabinet-
maker, Active Medway,
Mass. 1825-30: 951

Bennett (Charles) Furniture
Company. Furniture Factory,
Active Charlotte, Mich.
1900-1906: 1593

Bennett, Cotton. Cabinet-
maker, Born 1786, Died
1859, Active Beverly,
Mass.: 61

Bennett, Ezekiel. Active New
York and Connecticut 1784-
1821: 2039

Bently, William. Active
Otsego County, N.Y. 1813-
1844: 2039

Berkey and Gay. Furniture
factory, Active Grand
Rapids, Mich., 1876-1917:
62, 956, 1594, 1595

Bertine J. Chairmaker,
Active New York 1790-97:
63

Bhumgara (F. P.) and Company.
Furniture business, Active
New York City c. 1890: 1596

Bishop Furniture Company.
Furniture factory, Active
Grand Rapids, Mich., 1910:
1597

Bishop Hill Colony. A utopian
commune, Active Bishop
Hill, Illinois 1846-1862:
64-67

Black, Robert. Cabinetmaker,
Died 1820, Active Dixon
Springs, Tenn.: 68

Black, William. Loyalist
cabinetmaker, Active Boston
18th century: 1365

Blake, Judson. Born 1790,
Died 1861, Active Pro-
vidence, Rhode Island:
1172

Bleeker and Van Dyke. Cabi-
netmaker, Active New York
1841: 1598

Blin, Peter, Joiner. Born
1639/40, Died 1740, Active
Wethersfield, Conn.: 69

Bliss, Pelatiah. Cabinet-
maker, Active Springfield,
Mass. 1800-10: 70

Blyth, Samuel. Painter and
Cabinetmaker, Active Salem,
Mass. 1760's-95: 71

Boardman, Langley. Cabinet-
maker, Born 1760, Died
1822, Active Portsmouth,
New Hampshire: 72, 73

Bonner and Paepke. Furniture
business, Active New York
1886: 1599

Booth Family. Consists of:
Joel Booth, Born 1769,
Died 1794, Active Newtown,
Conn.; Elijah Booth, Born
1745, Died 1823, Active
Southbury, Conn.; Ebenezer
Booth, Born 1743, Died
1790, Active Newtown,
Conn.: 74, 829

Boston Fancy Cabinet Co.
Furniture factory, Active
Boston 1884: 1600

Boston Willow Furniture Co.
Furniture factory, Active
Boston 1911: 1601

Bouvier, Michel. Cabinet-
maker, Born 1792 in France,
Died 1819, Active New York
1815 and Philadelphia 1819:
75-76

Bowen, Nathan. Cabinet-
maker, Born 1752, Died
1837, Active Marblehead,
Mass.: 77

Bowman, J. R.. Active New
New York 1807: 1602

Bradley, Amos. Cabinetmaker,
Born 1769, Died 1835,
Active East Haven, Conn.:
78

Bradley, Will H. Designer,
Born 1868, Died 1962,
Active early 20th century:
79-80

Bragg, Conant, and Company.
Furniture business, Active
Boston 1875: 1603

Brauwers, Joseph. Cabinet-
maker, Active New York
City, 1815-25: 81

Bright, George. Cabinetmaker,
Born 1727, Died 1805,
Active Boston: 82

Brimmer, Andrew. Cabinet
maker, Active Maine early
19th century and Boston
1789: 878

Brockway (C. A.) and Company.
Furniture factory, Active
1892-93: 1604

Brooke, J. C., Made church
and school furniture,
Active Cincinnati 1894:
1605

Brooklyn Furniture Company.
Furniture business, Active
Brooklyn 1873: 1606

Brooks, Thomas, Chair maker,
Died 1887 age 76, Active
Brooklyn 1856: 83

Brooks, Z. Willard. Decorator
and Stenciler, Born 1812,
Died 1906, Active Connect-
icut: 305

Brooks Brothers. Active
Rochester, N. Y. 1887: 1607

Brown, John Hickman. Cabinet-
maker, Active Corpus Chris-
ti, Tx. 1889-1944: 2049

Brown, Joseph. Cabinet-
maker, Died 1742, Active
Newbury, Mass. 1725-1742:
2026

Brown, Samuel, Furniture
maker, Active Greensburg,
Penna. 1801-1802: 1076

Brown, William, Jr.. Cabinet-
maker, Apprenticed to Dun-
an Phyfe 1818-1819: 84

Bruce and Dean. Cabinet-
makers, Active New York
City: 85

Bruen, Caleb N., Cabinet-
maker and brewer, Active
New Jersey: 2038

Brumby Chair Company. Chair
factory, Active Marietta,
Georgia 1881-1945: 2044

Bruner, Henry. Cabinet-
maker, Born 1810, Died
1870, Active New York City:
177, 295

Bub and Kipp. Upholsterer,
furniture maker, Active
Milwaukee 1887-88: 1608

Buckingham, John. Cabinet-
maker, Advertised Pitts-
burgh 1793: 1076

Buckstaff-Edwards Company.
Chair factory, Active
Oshkosh, Wisc. 1890: 1609

Bucktrout, Benjamin. cabinet-
maker, Active Williams-
burg, Va. 1765-1813: 1214

Budd, John. Cabinetmaker,
Active New York City 1817-
1840: 86

Buffalo Metal Furniture
Manufacturing Co. Made
metal furniture, Active
Buffalo, N. Y.: 1610

Buffalo Upholstering Co.
Furniture maker, Active
Buffalo 1880: 1611

Burgess, Joseph. Cabinet-
maker, Advertised Balti-
more 1785: 1442

Burkhart, George. Organ
case builder, Born Germany
1720/21, Died 1783, Active
Lancaster Co., Pa. 1750:
1141

Burling, Samuel. Cabinet-
maker, Active New York City
1805-1808: 10

Burling, Thomas. Cabinet-
maker, Freeman 1769,
Active New York City 1786-
1797: 87-90, 496, 1018

Burling William S. Cabinet-
maker, Advertised New York
City 1805-1808: 10

Burnham, Benjamin. Cabinet-
maker, Born 1729, Died
1799, Active Colchester,
Norwich, and Lisbon Conn.:
91

Burns and Company. Furniture
store, Active Pennsylvania
1890-1969: 2041

Buss, S. Furniture maker,
Active Rhode Island: 1453

Butler Brothers. Furniture
business, Active New York
City 1891: 1612

Cabinet Makers' Union. Active
Indianapolis, Indiana 1887:
1613

Cadillac Cabinet Company.
Furniture factory, Active
Detroit, Mich. 1902-1905:
1614

Cahoone, John. Cabinetmaker,
Active Newport, R. I. 1745-
65: 93

Carleton, Michael. Cabinet-
maker, Active New
Hampshire 1828: 1416

Carlile, John. Cabinetmaker,
Born 1762, Died 1832,
Active Providence, R. I.:
94, 1172

Carondelet Ave. Furniture
Manufacturing Co. Furni-
ture factory, Active St.
Louis 1886: 1615

Carpenter, Edward Jenner.
Active Greenfield, Mass.
1844: 95

Carrere and Hastings. Archi-
tects; John Merven Carrere,
Born 1858, Died 1911;
Thomas Hastings, Born 1860,
Died 1929; Active 1888-
1921: 96, 1247

Central Furniture Company.
Furniture factory, Active
Rockford, Ill. 1890: 1616

Central Manufacturing Com-
pany. Furniture factory,
Active Rockford, Ill.
1879-1889?: 1617

Cermenati, Barnard. Looking-
glass maker, Active New-
buryport, Mass. early 19th
century: 934

Champion Bed Lounge Company.
Furniture factory, Active
Chillicothe, Ohio 1911?:
1618

Chapin Family. Cabinet-
makers; Aaron Chapin,
Born 1753, Died 1834,
Active Hartford, Conn.;
Eliphalet Chapin, Born
1741, Died 1807, Son of
Ebenezer, Active East
Windsor, Conn.; Laetes
Chapin, Born 1778, Died
1847, Active Hartford:
97-103, 1548

Chappel, William. Cabinet-
maker, Active Danbury,
Conn. 1790-1830: 112

Chase Brothers and Company.
Iron furniture maker,
Active Boston 1855: 1619

Cheney, Benjamin. Carpenter,
joiner, and wheelwright,
Born 1721, Died 1760,
Active East Hartford,
Conn.: 820

Cheney, Silas E. Cabinet-
maker, Born Manchester,Ct.
1776, Died 1821, Active
Litchfied, Conn.: 104, 1548

Chestney, James. Chairmaker, Active Albany c. 1790's: 105

Chestnut, Jared. Cabinet-maker, Active Wilmington, Del.: 777

Chickering, Jonas. Piano maker, Born 1798, Died 1853, Active Boston: 106, 273

Chipman (George) and Son. Chair factory, Active Baltimore 1885: 1620

Chittenden and Eastman. Furniture business, Active Burlington, Iowa 1888-1918: 1621, 1622

Cilley (J. A.) and Company. Active Fairfield, Maine 1880: 1623

Clark (Carroll W.) and Co. Furniture business, Active Boston c. 1880: 1625

Clark, Daniel. Furniture Dealer, Active Philadelphia 1759-1763: 2028

Clark, Darwin. Furniture business, Active Wisconsin 1812-1899: 2043

Clark and Hatch Auctioneers. Active Boston 1851: 1628

Clark Brothers and Co. Active Philadelphia 1887: 1624

Clarke Brothers and Company. Furniture business, Active Cincinnati, Ohio 1882 1890: 1626, 1627

Clay, Daniel. Cabinetmaker, Born 1770, Died 1848, Active Greenfield, Mass.: 107-109

Clearfield Novelty Works. Made porch furniture, Active Clearfield, Pa. 1910: 1629

Clemens Family. Furniture maker, Born Germany 1749, Died 1857, Active Montgomery County, Pa.: 110

Cleveland, Jeremiah Clement. Furniture maker, Active Hartford 1794-1836: 111

Clodfelter, Jesse. Cabinet-maker, Active North Carolina: 1062

Cogswell, Francis. Joiner, Active Ipswich, Mass. 1730-31: 214

Cogswell, John. Cabinetmaker, Died 1818, Active Boston 1769-82: 113-115

Coit, Job. Cabinetmaker, Born 1692, Died 1741, Active Boston: 116

Coldeway, Anton Frederick. Cabinetmaker and banker, Active Kentucky: 2045

Colie and Son. Furniture business, Active Buffalo 1884: 1630

Collingnon Brothers. Furniture manufacturer, Westwood, N. J.: 1631

Collins, Mordica. Cabinet-maker, Active North Carolina: 1062

Columbian Adjustable Table and Desk Company. Active Chicago 1892: 1632

Comins (George T.) Manufacturing. Furniture factory, Active Boston and New York late 19th century: 1633

Comstock (William T.)
Company. Active New York
1878: 1634

Conant, Ball, and Company.
Office furniture factory,
Active West Gardner, Mass.
1900: 1635

Connant's (F. H.) Sons. Fur-
niture maker, Active
Camden, N. J. 1880: 1636

Connelly, Henry. Cabinet-
maker, chairmaker, Born
1770, Died 1826. Active
Philadelphia 1800-24: 117-
121, 484, 1271

Conner, Robert. Cabinet-
maker, active New York City
1842: 1637

Connersville Furniture Com-
pany. Furniture factory,
Active Connersville, Ind.
1907: 1638

Conrades (J. H.) Chair and
Parlor Furniture Company.
Active St. Louis, Mo. 1891:
1639,1640

Converse Manufacturing Co.
Bed manufacturer, Active
Grand Rapids, Mich.:
c. 1880: 1641

Coogan, James J. Furniture
maker, Active Philadelphia,
New York, Canton, Ohio
1873-76: 1642, 1643

Coogan Brothers. Furniture
factory, Active New York
1869-76: 1644, 1645

Cooper (James W.) and Broth-
ers, Manufacturers. Furni-
ture manufacturers, Active
Philadelphia c. 1870's:
1646, 1647

Cooper, Thomas. Cabinetmaker,
Active Long Island, N. Y.:
122

Cooper and Hall. Furniture
factories, Active Phila-
delphia 1876: 1648

Corey, Walter. Furniture
Manufacturer, Born 1809,
Died 1889, Active Port-
land, Maine: 123

Cox, Joseph. Upholsterer,
Active New York City
1756-1771: 124-126

Cram, Mr. Cabinetmaker,
Active Boston: 127

Crandall, Bennett, and
Porter Company. Furniture
manufacturer, Active
Montoursville, Pa. 1911:
1649

Crane (J. H.) Company.
Furniture Business, Active
St. Louis 1883: 1650

Crocker Chair Company. Chair
factory, Active New York,
Sheboygan and Elton, Wisc.
1913: 1651

Cron, Kills, and Company.
Furniture business, Active
Piqua, Ohio 1890-91: 1652,
1653

Crosman, Robert. Chest
decorator, Born 1707,
Died 1799, Active Taunton,
Mass.: 920

Currier, W. A. Furniture
business, Active Haverhill,
Mass. c. 1850: 1654

Curtis, Lemuel. Clock maker,
Active Concord, Mass. and
Burlington, Vt. 1810-19:
128

Cushman (H. T.) Manufac-
turing Co. Active North
Bennington, Vt. 1904-1905:
1655

Custine, P. Active Phila-
delphia 1867: 1656

Danforth, Job. Cainetmaker,
Active Rhode Island 1788-
1818: 129

Danforth, William. Cabinet-
maker, Active Billerica,
Mass. 1760: 130

Daniels, Eleazar. Cabinet-
maker, Born 1788, Died
1858, Active Medway, Mass.:
951

Daniels, Badger, and Company.
Furniture factory, Active
Boston 1860's-1880's:
1657-1659

Danner, John. Furniture
factory, Active Canton,
Ohio 1876-86: 1660

Davenport, A. H. and Co.
Chair maker, Active Boston
and Dorchester 1845-1906:
131

Davenport, Thomas. Cabinet-
maker, Born 1681, Died
1725, Active Newport,
R. I.: 1172

David and Brazill Bedding
Company. Furniture
Business, Active St. Louis
1891: 1640, 1661

Davis, Alexander Jackson.
Architect, Born 1803, -
Died 1892. Active New York
and Newark, N. J.: 132-36,
1441

Davis, "German." Cabinet-
maker, Active Athens,
Georgia late 18th century:
137

Davis, John G. Chair maker,
Active Princeton, Mass.
1827: 2031

Davis, Robert. Japanner,
Died 1739, Active Boston:
943

Davison, R. Garden furni-
ture maker, Active 1910:
1662

Day, Thomas. Cabinetmaker,
Active Milton, North
Carolina 1820-59: 138-
141

Deinzer (F.) and Son.
Furniture factory, Active
Detroit, Mich. early 20th
century: 1663

Dennis, John. Joiner,
Active Ipswich, Mass.
1728: 214

Dennis, Thomas. Joiner,
Born 1638, Died 1706,
Active Ipswich, Mass.:
142-146

Derby (George H.) and Co.
Active Boston 1881: 1664

Derby (P.) and Company.
Furniture factory, Active
Boston, New York, Jersey
City and Gardner, Mass.
1913: 1665

Derby and Kilmer Desk Co.
Active Boston 1880-85:
1666

Derby, Kilmer, and Pond Desk
Company. Active Somerville,
Mass. 1893: 1667

Detroit House of Correction.
Prison furniture shop,
Active Detroit, Mich.
1905: 1668

Dewey, John. Cabinetmaker,
Active Connecticut 1747-
1807: 2029

De Witt, John. Chair maker,
Active New York City 1796-
1798: 147

Egerton, Matthew, Jr. Cabinetmaker, Died 1837, Active New Brunswick, N. J. 1785: 170-171

Egerton, Matthew, Sr. Cabinetmaker, Born 1739, Died 1802, Active New Brunswick, N. J.: 169

Elastic Chair Co. Chair manufacturer, Active Williamsport, Pa. 1882: 1672

Elfe, Thomas. Cabinetmaker, Born in London 1719, Died 1802, Active Charleston, South Carolina 1747-1775: 172-176

Elliott, John, Sr., and John Elliott, Jr. Lookingglass makers: John Sr. Born Bolton, Eng., In America 1753, Died 1791, Active Philadelphia 1755-86; John, Jr., Active Philadelphia 1784-1809: 177-184

Ellis, Harvey. Architect and furniture designer, Born 1852, Died 1904, Active Rochester, N. Y. 1879-1883, After 1884 in the Midwest: 185-189, 1440

Emerson and Son. Furniture business, Active Milford, New Hampshire 1889-97: 1673

Emrich Furniture Company. Active Indianapolis, Ind. 1911: 1674

Engesarter, Erick. Cabinetmaker, Born Norway, Active Minneapolis 1870: 190

Enterprise Chair Manufacturing Company, Chair factory, Active Oxford, N. Y. 19th century: 191

Erskine-Danforth Corp. Furniture manufacturer, Active New York 1917: 1675

Evans, David. Cabinetmaker, Active Philadelphia 1774-1814: 192-195, 1308, 2028

Excelsior Furniture Company. Furniture manufacturer, Organized 1881, Active Rockford, Ill. 1881-1890's: 1676

Excelsior School Furniture Manufacturing Company. Furniture factory, Active Cincinnati 1874: 1677

Fairchild, Anson T. Cabimaker, Active Northampton, Mass. 1815: 196, 349

Farwell, Osmun, Kirk, and Company. Furniture business, Active St. Paul, Minn. 1913: 1678

Fay, Ezra. Chair maker, Active Princeton, Mass. 1827: 2031

Fellows, Israel. Carver, Born 1816, Died 1881, Active Essex County, Mass. 1837-64: 714, 916

Ferguson Brothers. Furniture business, Active New York 1890: 1679

Field (Marshall) and Co. Furniture dealer, Active Chicago 19th and 20th centuries: 1680

Finch. Amish furniture maker, Active 1837: 197

Finger, Adam. Furniture maker, Active Milwaukee, Wisc. 1856: 198

Fink and Schindler Co. Active San Francisco 1882-1958?: 199

Finlay, John, and Hugh
Finlay. Cabinetmakers, John
active Baltimore 1799-1833;
Hugh active Baltimore
1803+: 200, 201

Fisher, Andrew. Furniture
maker, Died 1918, Active
New York State: 202

Fiske, J. W. Iron factory,
Active New York 1875: 1681

Fitch, Isaac. Cabinetmaker
and builder, Born 1734,
Died 1791, Active Lebanon,
Conn.: 203, 204

Fogler (P. M.) and Company.
Furniture maker, Active
Boston 1880: 1682

Folan, J. and T. Chair
factory, Active Boston
late 19th century: 1683

Forest City Furniture
Company. Furniture Manu-
facturer, Active Rockford,
Ill. 1870-89: 1684

Foster, Jacob. Cabinetmaker,
Born 1764, Died 1838,
Active Charlestown, Mass.
1786-1810: 205, 703

Franklin Merchandise Company.
Dealer, Active Chicago
Ill. 1902: 1685

Fravel, George. Cabinetmaker,
Active Shenandoah County,
Virginia 1787: 1211

Fredericks and Farminton.
Chairmakers, Active
New York City: 206

Freeman and Saverin. Chair-
makers and upholsterers,
Active Pittsburgh 1786-87:
1076

French, Williams C. Furni-
ture manufacturer, Active
Boston 1898: 1686

Frick, Peter. Organ Case
maker, Born 1743, Died
1822, Active Lancaster
Co., Pa.: 1141

Frost and West. Furniture
Company, Active New York
State 1855: 2023

Frothingham, Benjamin.
Born 1734, Died 1809,
Active Boston and Charles-
town, Mass., Made block-
front furniture: 207-213,
907, 1354

Frothingham (Other than
Benjamin): 211

Furness, Frank. Architect
and furniture designer,
Born 1839, Died 1912,
Active Philadelphia: 456,
1106

Fussell, Solomon. Chair
maker, Active Philadelphia
1754: 1098

Gaines Family. Joiners:
George, Born 1736, Died
1808; John II Born 1677,
Died 1750; John III Born
1704, Died 1743; Thomas
active 1735; Active Ports-
mouth, N. H. and Ipswich,
Mass.: 214-217, 2052

Galatian, William. Windsor
chair maker, Died 1848
aged 76, Active New York
City: 147

Galusha, Elijah. Cabinet-
maker, Born 1803, Died
1871, Active Troy, N. Y.:
218

Gardiner, Samuel. Cabinet-
maker, Active Geneseo, N.Y.
c. 1825: 220

Gardner and Company. Furniture manufacturer, Included five brothers: William, Oliver, George, John, and Joseph, Active New York and New Jersey 1865-1888: 219, 1687, 1688

Gaylord, Wills M. Looking-glass maker, Active Utica, N. Y. 1826-1845: 221

Gear (A. S. and J.) and Co. Active Boston c. 1860: 1689

Geib, H. and W. Piano maker, Active New York 1804-1814: 498

George, David S. Furniture designer, Active c. 1909: 222

Gerrish and O'Brien. Furni-maker, Active Boston 1880: 1690

Gheen, James. Cabinetmaker, Active Rowen County, North Carolina 1778-1799: 223

Gilbert, Benjamin. joiner, Active Hartford 1652-1710: 69

Gillam, Charles. Cabinet-maker and decorator, Active Old Saybrook, Conn. 1703-1727: 224, 840

Gillingham, James. Cabinet-maker, Born 1736 in Bucks Co., Pa., Died 1781, Active Philadelphia: 225, 226

Gillingham, John. Cabinet-maker, Born 1710, Died 1793, Active Philadelphia 1735-1793, Uncle to James Gillingham: 227

Gilman, J. T. and L. J. Furniture business, Active Bangor, Maine c. 1880: 1691

Glass, Peter. Marquetry maker, Born Germany 1824, Died 1895, Active Leo-minster, Mass.: 228

Glidden, Albert G. Furniture maker, Active 1910: 229

Globe Furniture Company. Furniture business, Active St. Louis 1891: 1640, 1692

Goddard-Townsend. Cabinet-making family; John Goddard I Born 1723, Died 1785; Christopher Town-send, Born 1701, Died 1773; Job Townsend, Born 1699, Died 1765; John Townsend, Born 1732, Died 1809; There were at least 13 Townsend craftsmen and 20 Goddards, Active New-port, Rhode Island: 230-265, 474, 557, 560, 733, 1354, 1452

Gold Medal Camp Furniture Manufacturing Company. Folding furniture maker, Active Racine, Wisc. 1894: 1693

Goodell, David. Clock maker, Active Connecticut: 1355

Goodell Company. Chair manufacturer, Active Antrim, N. H. 1880: 1694

Goodhue, Francis. Joiner, Active Ipswich, Mass. 1733-1754: 214

Goodrich, Ansel. Chair maker, Born 1774, Died 1803, Active Northampton, Mass.: 266

Gordon, James, and David Gordon. Cabinetmakers, James Born 1815, Died 1865; David Born 1816, Died 1875, Active Black Mingo, S. C.: 267

Hale and Kilburn Mfg. Co.
Furniture manufacturer,
Established in 1867 as
Hale, Moseley, Goodman and
Co., Active 1876-c. 1880:
1703, 1704

Hall, John. Publisher and
furniture designer, Born
England 1809, Active Balt-
imore 1835: 286

Hall and Stephen, Active New
York 1882: 1705

Hammett, Henry. Cabinetmaker,
Active Parkersburg, West
Virginia: 2051

Hammett, J. L. Active Boston
1886: 1706

Hancock, William. Chairmaker,
Active Boston 1790-c. 1830:
287

Hannon, Walter W. Cabinet-
maker, Active Alexandria
Virginia: 788

Hanson (A. C.) and Company.
Furniture Business, Active
Racine, Wisc. 1905: 1707

Hanson, Faey Katherine. Fur-
niture designer, Active
1917: 288

Harrison, John. Made a pump
case, Active Philadelphia
1731: 289

Hartley Reclining Chair Co.
Chair manufacturer, Active
Chicago 1885: 1708

Hartshorne, Ebenezer. Cabi-
netmaker, Died 1781, Active
Charlestown and Concord,
Mass. 1739+: 290

Harwood Manufacturing Co.
Chair manufacturer, Active
Boston 1888: 1709

Haskell (William O.) and
Son. School furniture
maker, Active Boston 1870:
1710

Hawks, John. Joiner, Born
1643 in Windsor, Conn,
Died 1721 in Waterbury,
Conn., Active Deerfield
Mass.: 291

Hay, Anthony. Cabinetmaker,
Active Williamsburg, Vir-
ginia 1751-1779: 1214

Hayden William, and William
H. Stewart. Chair makers,
Active Philadelphia 1820-
1836: 292

Hayden Company. Reproduction
furniture manufacturer,
Active New York 1919: 1711

Hayes, Lewis S. Chair maker,
Active Cortland, N. Y.
1882-89: 1712, 1713

Hays, Benjamin F. Held a
furniture patent: 1538

Heal and Son. Furniture
business, Active New York
City 1853-1934: 1714

Hechinger Brothers and Co.
Active Baltimore c. 1900:
1715

Heilman (A. H.) and Co.
Furniture manufacturer,
Active Williamsport, Pa.
1876-86: 1716-1719

Henkels, George J. Cabinet-
maker, Born West Virginia
1819, Died 1883, Active
Philadelphia 1848-1877:
40, 294-297, 1720

Herenden (A. S.) Furniture
Co. Furniture manufactur-
er, Active Cleveland,
Ohio c. 1873: 1721

Herkimer Manufacturing Co.
Desk manufacturer, Active
Herkimer, N. Y.: 1722

Herrman, Henry. Furniture
maker and exporter, Active
New York City second half
of the 19th century: 297

Hersee and Company. Furni-
maker, Active Buffalo,
N. Y. 1836-c. 1880: 1723

Herter, Christian. Cabinet-
maker, Active New York
City 1840-1883: 298, 299

Hewitt, John. Cabinetmaker,
Died 1857 in New Jersey,
Active in Savannah 1801,
Active New Jersey and
New York 1809-1812: 300,
2038

Heyman, George. Bed manu-
facture, Active New York
City c. 1890: 1724

Heywood (Walter) Chair
Company. Chair maker,
Active Fitchburg, Mass.
1883-1895: 1729-1733

Heywood Brothers and Company.
Furniture manufacturer,
Active Gardner, Mass. 1883-
1893: 1725-1726

Heywood-Wakefield Company.
Furniture manufacturer,
Active Boston and Gardner,
Mass. 1826-1926+: 301,
1279, 1728

Higgins Furniture Manufactur-
ing Company. Active Indian-
apolis, Ind. 1874: 1734

Hildreth (G. W.) and Company.
Furniture Business, Active
Lockport, N. Y. c. 1875:
1735

Hill, Elliot. Cabinetmaker,
Active Concord, N. H. c.
1830: 977

Hitchcock, Lambert, Chair
maker, Born Cheshire, Ct.
1795, Died 1852, Owner
of Hitchcock Chair Factory
in Connecticut, Active
Hitchcocksville and Union-
ville, Conn. 1825-1846:
302-317, 766

Holiday Sheet Specialities.
Furniture dealers, Active
c. 1880: 1736

Holloway Company. Furniture
manufacturer, Active
Cuyahoga Falls, Ohio 1892:
1737

Holmes and Roberts. Chair
maker, Active Roberts-
ville, Conn. 1838-1840:
318, 319

Homer, Andrew. Cabinetmaker,
Active Boston and Maine
1780-1805: 320, 878

Hook, William. Cabinetmaker,
Born 1777 Salem, Mass.,
Died 1867 Roxbury, Mass.,
Active Salem: 321

Hope, Thomas. Cabinetmaker,
Born 1757 England, Died
1820, Active Charleston,
S. C.: 322

Hopkins, Gerrard. Cabinet-
maker, Died 1796, Active
Philadelphia 1767-1796:
323, 324

Hoskins and Sewell. Iron
and brass manufacturer,
Active New York City, c.
1895: 1738

Hosmer, John. Cabinetmaker,
Born 1752, Died 1814,
Active Concord, Mass.: 325

Hosmer, Joseph. Cabinetmaker,
Born 1735, Died 1821,
Active Concord, Mass.: 325-
329

Johnson (A. J.) and Sons Furniture Company. Furniture business, Active Chicago 1908: 1745

Johnson, Charles E. Furniture factory, Active New York City 1882: 1746

Johnson, Edmund. Cabinetmaker, Born 1722, Died 1811, Active Salem, Mass. 1793-1800: 357, 928

Johnson, John. Loyalist cabinetmaker, Active Baltimore 18th century: 1365

Johnson, Nathaniel. Active New York City 1868: 1747

Johnson Family. Chair makers, John died 1793; Thomas died 1846, Warner born 1817; Active Mecklenburg County, Virginia: 358

Johnston and Rea. Japanners, Active Boston 18th century: 359

Jones, George H. Arts and Crafts craftsman, Active 1903: 360

Jones, John. Furniture maker, Active Edenton, North Carolina c. 1860: 2025

Jones, Norman. Cabinetmaker, Born 1790, Died 1874, Active East Hubbardton, Vt. early 19th century: 361

Jordan and Moriarty. Furniture manufacturer, Active New York City 1883-86: 1748-1750

Josiah (Last name is not known.) Cabinetmaker, Active Green County, Kentucky 1776-1825: 362, 363

Kane (Thomas) and Company. School furniture maker, Active Chicago 1889: 1751, 1752

Karpen (S.) and Brothers. Active Chicago 1881-1907: 1753

Keating, M. Furniture manufacturer, Active Boston c. 1880: 1754

Kehr, Peter. Active New York City 1882: 1755

Keller, Sturm, and Ehman. Frame maker, Active Chicago 1883-85: 1756, 1757

Kellner, John A. Furniture business, Active New York City 1884: 1758

Kent Furniture Manufacturing Co. Furniture manufacturer, Active Grand Rapids, Mich. c. 1880-87: 1759, 1760

Kerwood, William. Furniture maker, Born Wales 1779, Died after 1803, In Morrisville, N. J. 1785, Active Trenton, N. J. 1803: 364

Key, William. Clock maker, Born 1754, Died 1819, Active Salem: 365

Kilborn, Whitman, and Co. Furniture manufacturer, Active Boston 1880-86: 1761-1763

Kimball, Abraham. Cabinetmaker, Born 1798, Died 1890, Active Salem, Mass. 1821-1845: 366

Kimball, J. Wayland. Active Boston 1876: 1764

Kimbel and Cabus. Furniture makers, Active New York City 19th century: 367

Kindel, George J. Bedding house, Active Denver 1889: 1765

King, William, Jr. Cabinetmaker, Born 1771, Died 1854, Active Georgetown, D. C. : 368

Klein (A. S.) Company. Mirror manufacturer, Active 1906-07: 1766, 1767

Knapp, Charles B. Held a furniture machine patent: 369

Kneeland, Samuel. Cabinetmaker, Chair maker, Born 1755, Died 1828, Was a partner with Lemuel Adams, Active Hartford, Conn. 1789-98: 833

Kneeland and Adams. Cabinetmakers, Samuel Kneeland born 1755, Died 1828, Active Hartford : 370

Knipp and Company. Active late 19th century and early 20th century: 1768

Knowlton, A. and H. C. Chair manufacturer, Active West Gardner, Mass. 1883-84: 1769

Knowlton, Caleb. Cabinetmaker, Active Salem 1780-1814: 371

Knowlton, Ebenezer. Cabinetmaker, Born Ipswich 1769, Died 1811, Active Boston 1796-1811: 372

Kohn, Jacob and Josef. Furniture dealer, Active 20th century: 1770

Krause, F. W. Chair manufacturer, Active Chicago 1876: 1771

Krause, Johannes. Cabinetmaker, Born Germany 1742, Died 1807, Active Salem, Mass.: 373

Kreimer (C. and A.) Company. Furniture business, Active Cincinnati 1888-90: 1772

Kunze, William. Furniture maker, Active Warren Co., Pa. 1865-1880: 971

Laconia Furniture Company. Furniture manufacturer, Active Laconia, N. H. c. 1880: 1773

Lamb, J. and R. Active New York City 1876-86: 1774, 1775

Lammert, Martin. Furniture business, Active St. Louis 1878-1895: 1776, 1777

Lane, Samuel. Joiner, Active Hampton, New Hampshire 1719: 374

Lanning, John. Cabinetmaker, Chair maker, Active Salem, New Jersey 1778: 726

Lannuier, Charles-Honore. Born France 1779, Died New York City 1819, Came to America c. 1790, Active New York City 1805-1819: 376-388, 496, 499

Lapp, Henry. Cabinetmaker, Active Lancaster Co., Pa. 1862-1904: 389

Lathrop, Stillman. Looking-glass maker: 390

Latrobe, Benjamin Henry.
Architect, Born 1764 in
England, Died 1820, Active
Washington, D. C. and
Philadelphia: 391

Lausch, Drew. Chair maker,
Active Pennsylvania: 392

Lawrence, William E. Furni-
warehouse, Active Ports-
mouth, New Hampshire c.
1833: 1778

Leavens (G. M.) and Son.
Chair manufacturer, Active
Boston c. 1880: 1779

Leaver, Gabriel. Cabinet-
maker, Active Savannah,
Georgia 1757-95: 393

Leavitt, Thaddeus. Active
Connecticut 18th century:
2029

Lee, Chapman. Cabinetmaker,
Born 1799, Died 1849,
Active Charlton, Mass.:
394

Lehman, Benjamin. Cabinet-
maker, Born 1760, Appren-
ticed to Jacob Knorr,
Active Philadelphia and
Germantown: 395, 396, 2028

Lejambre Family. Cabinet
makers, Born 1786, Died
1843, Active Philadelphia:
397

Leland, Levi Nelson, Cabinet-
maker, Born 1807, Active
Grafton, Mass.: 398

Leominster Furniture Manu-
facturing Company. Active
Leominster, Mass. c. 1880:
1780

Leominster Piano Stool Co,
Chair maker, Active Leomin-
ster, Mass. 1882: 1781

Lersch, Charles. Furniture
business, Active New York
c. 1880: 1782

Levenson and Zenitz. Furni-
ture manufacturer, Active
Baltimore c. 1910: 1783

Lewisburg Chair Company.
Chair maker, Active Lewis-
burg, Pa. 1910: 1784

Lilley (M. C.) and Company.
Furniture manufacturer,
Active Columbus, Ohio
c. 1910: 1786

Limbert (Charles D.) Co.
Furniture manufactuer,
Active c. 1905: 1787-1788

Lincoln, Thomas. Cabinet-
maker, Born 1778, Died
1871, Father to Abraham,
Active Hardin County,
Kentucky: 399

Lind, Conrad. Cabinetmaker,
Born 1753, Died 1834,
Active Lancaster Co., Pa.
18th century: 1141

Little, William, Cabinet-
maker, Born 1779 in
England, Died 1848, Active
Sneedsborough, North
Carolina 1801-1817 and
Charleston, South Carolina
1799: 400, 401, 2040

Lloyd, William. Cabinet-
maker, Born 1779, Died
1845, Advertised Spring-
field, Mass. 1802-1808:
402, 403, 908, 1453

Longacre, H. B. Active
1903: 404

Long, Jonathan. Cabinetmaker,
Active North Carolina:
1062

Lord, Nathaniel. Joiner,
Active Ipswich, Mass.
c. 1715: 214

Lord, Robert. Joiner,
Active Ipswich, Mass. 1723:
214

Luburg Manufacturing Company.
Furniture business, Active
Philadelphia c. 1892: 1789

Lugar Furniture Company.
Active Minnesota 1803-
1856: 2034

Lukens, Thomas. Cabinetmaker,
Acvertised Pittsburgh 1793-
1795: 1076

Lunt, Abraham. Furniture
maker, Active Mass. 1736-
1772: 2026

Lyell, Fenwick, (Also spelled
Lyle) Furniture maker,
Active Middletown, New
Jersey, 18th century: 405,
2036

Lyman, G. W. Active Charles-
town, Mass. 1881: 1790

Lyon, Henry G. Cabinetmaker.
Active Sussex, N. J. 1800-
38: 2038

McClees and Warren. Furniture
Manufacturer, Active Phila-
delphia c. 1879: 1791

McClelland, Isaac. Cabinet-
maker, Born 1805, Died
at age 82, Active Butler
County, Ohio: 406

McCormick, James. Cabinet-
maker, From Dublin,
Ireland, Advertised Balti-
more 1786: 895

McCracken, William. Cabinet-
maker, Born 1814, Died
1872, Active New Orleans:
407

McDowell, James, Cabinet-
maker, Died 1838, Active
Smyrna, Del.: 408

Macey (Fred) Company.
Furniture manufacturer,
Active Grand Rapids 1901:
1792, 1793

McHugh (Hoseph P.) and Co.
Active New York City 1901:
1794

McIntire, Samuel. Carver,
architect, Born Salem
1757, Died 1811, Active
Salem: 409-434, 910, 1271,
1300, 1354, 1375, 1441,
2026

McIntire, Samuel Field.
Carver, Born 1780, Died
1819: Son of Samuel
McIntire, Active Salem:
435

McKee and Harrington. Active
Kingsland, N. J. 1890:
1795

McKim, Andrew, and Robert
McKim. Chair makers,
Active Richmond, Virginia
1789-1820: 436

McKim, Mead, and White.
Architects, Active New
York City 1879-1910: 1247

McLanahan, Hawley, Crafts-
man, Worked at Rose Valley,
Pa. 1901-1909: 540

McLean (W. B.) Manufacturing
Company, Furniture manu-
facturer, Active Pitts-
burgh 1880-1921: 1796-
1798:

Maerckein (H.) and Company.
Active Hartford, Conn.
c. 1870: 1799

Magraph, Richard. Furniture
maker, Active Charleston,
South Carolina 1772: 1183

Mahoney, E. H. Furniture
business, Active Boston
1880-88: 1800, 1801

Mallard, Prudent. Cabinet-
maker, Born Sevres 1809,
Died after 1860, Active
New Orleans 1838-1860:
574, 875, 1227

Manhattan Reclining Chair Co.
Chair factory, Active New
York City c. 1880: 1802

Marcotte, Leon. Cabinet-
maker, Born in France,
Arrived in America in 1854,
Advertised 1860: 33

Marietta Chair Company.
Chair manufacturer, Active
Marietta, Ohio 1884-1912:
1803-1805

Marks, S. H. Furniture
maker, Active Canaan, N. Y.
c. 1830: 1453

Marsh, Charles. Windsor
chair maker, Active New
York City: 1452

Mason (J. W.) and Company.
Furniture manufacturer,
Active New York City 1877-
1893: 1806-1809

Mathews, Arthur, and Lucia
Mathews, Interior decorat-
ors, Active Oakland, Ca.
1906-1920: 437, 438

Meeks Family. Cabinetmakers,
chair makers: John born
1737, Died 1817; Joseph
born 1771, Died 1868;
John (Son of Joseph) born
1801, Died 1875; Joseph
Jr. born 1800, Died 1875;
Active New York City 19th
century: 5, 31, 38, 40,
55, 439, 444

Mellen, Moses, Jacob Smith,
and George Smith. Active
Boston 1821-53: 445

Merriam, Hall, and Company.
Active North Leominster.
1913: 1810, 1811

Merrill, Luke Tuttle. Active
Horseheads, N.Y.: 1864:
2023

Merrimac Mattress Manu-
facturing Company, Bedding
manufacturer, Active
Boston 1911: 1812

Merritt (W. E.) Company.
Active Mt. Airy, North
Carolina 1912-15: 2040

Metcalf, Luther. Cabinet-
maker, Born 1756, Died
1838, Active Medway,
Mass.: 951

Miles, Benjamin. Cabinet-
maker, Active Cooperstown,
N. Y. 1821-1828: 2039

Miller, George W. Cabinet-
maker, Active New York
City 1825-28: 446

Miller and Company. Furni-
ture manufacturer, active
West Farmington, Ohio
1883: 1813

Mills, F. B. Retail mail
order co., Active Rose
Hill, N.Y. 1905: 1814

Mills and Deming. Cabinet-
makers and chair makers,
Simeon Deming born 1769
and died 1855, Active New
York City 1753-97 and
E. Bloomsfield, N. Y. 1813:
496, 1548

Minturn (Rowland R.) and
Company. Active New York
City 1834: 1815

Mitchell and Rammelsburg.
Furniture manufacturer,
Active Cincinnati 1847-
1881: 447, 1816

Monroe, Daniel. Clock maker,
Active Concord, Mass. c.
1800: 1355

Monroe, Nathaniel. Clock maker, Active Concord, Mass. c. 1800: 1355

Montoursville Manufacturing Company, Ltd. Furniture manufacturer, Active Montoursville, Pa.: 1817

Moses (William B.) and Sons. Active 1902-10: 1818-1819

Moyer, Tufts, and Company. Furniture business, Active Philadelphia 1880: 1820

Mulford, Timothy. Joiner, Active East Hampton, Long Island 1749: 1021

Murphy Chair Company. Active Detroit, Mich.1905-1907: 1821, 1822

Murray (Linn) Furniture Co.: Furniture manufacturer, Active Grand Rapids 1902: 1823

Mutual Furniture Company. Active 1887: 1824

National Chair Manufacturing Company. Chair manufacturer, Active Elbridge, N. Y. 1877-1888: 1825

National Wire Mattress Co. Iron Manufacturer, Active New Britain, Conn. 1879: 1826

Needham, Jesse. Cabinetmaker, Active Randolf County, North Carolina 1770-1840: 449

Needles, John. Cabinetmaker, Born 1786, Died 1878, Active Baltimore 1808-1853, Apprenticed to James Neal of Easton, Pa.: 450, 451

Nelson, Ira Schreiber, Furniture maker, Active Louisiania 1912-1965: 2048

Nelson, Matter, and Co. Furniture Manufacturer, Active Grand Rapids 1876-1906: 956, 1827-1828

New Haven Folding Chair Co. Furniture Business, Active New Haven, Conn. 1879-1885: 1829-1831

Niemann and Weinhardt Table Company. Table makers, Active Chicago 1907: 1832

Northern Furniture Company. Furniture manufacturer, Active Sheboygan, Wisc. 1909-12: 1833, 1834

Northestern Furniture Co. Active Burlington, Iowa 1890: 1835

Novelty Rattan Company. Chair manufacturer, Active Boston 1880: 1836

Odgen, Benanial. Cabinet-maker, Active West Chester, Pa. 1796: 452

Ogden, Benjamin. Cabinet-maker, Active New York City c. 1770: 1365

Old Hickory Chair Company. Chair manufacturer, Active Martinsville, Ind. 1903: 860, 1837

Olsen (O. C. S.) and Co. Active Chicago c. 1880: 1838

Omer, Francis. Cabinetmaker, Born France, Active Independence Co., Ark. 1818-1888: 453

Pick (Albert), Barth, and
Company. Active Chicago
c. 1919: 1862

Pierce, E. F. Chair manu-
facturer, Active Boston
c. 1875-82: 1863, 1864

Pierce, Rufus. Furniture
maker, active Boston
early 19th century: 1367

Pierce Family. Active
New York State 1875-1918:
2023

Pimm (Also spelled Pim),
John. Cabinetmaker, Active
Boston 1736-53: 511

Pinterton Family. Cabinet-
makers and silversmiths,
Active McConnelsville,
Ohio 19th century: 512

Pioneer Manufacturing Co.
Reed furniture manufactur-
er, Active Detroit 1905-
06: 1865, 1866

Pitman, Mark. Cabinetmaker,
Active Salem, Mass. 1779-
1829: 928

Platt, George. Interior
Decorator, Born in England,
Active New York City: 513

Plympton, Calvin. Cabinet-
maker, Active Medway, Mass.
1775-1816: 951

Poignand, David. Cabinetmak-
er, Born in England,
Active Boston 1788 and
Kentucky 1814: 514, 515

Pond Desk Company. Desk
manufacturer, Active
Boston 1890: 1867: 1867

Porter, John. Cabinetmaker,
Died 1802 aged 29, Active
Hartford late 18th
century: 833

Prairie Grass Furniture Co.
Active Glendale, N.Y.
c. 1900: 1868

Prescott, Levi. Furniture
maker, Born 1777, Died
1827, Active West Boyls-
ton, Mass.: 1355

Prescott, R., and Co.
Furniture manufacturer,
Active Keeseville, N.Y.
1853-1954+: 516

Price, William. Architect,
Born 1861, Died 1916,
Active Rose Valley, Pa.:
540

Princess Dressing Case Co.
Active Grand Rapids c.
1880: 1869

Proctor, Leonard. Cabinet-
maker, active Hartwick,
N. Y. 1829-65: 2039

Proud, Joseph. Furniture
maker, Born Yorkshire
1711, Died 1769, Active
Newport, R. I.: 517, 1178

Proud, William. Furniture
maker, Active Providence,
R. I. 1773-1835: 1178,
2042

Prouty, Amariah T. Active
Kalamazoo, Mich. 1802-
1887: 1367

Prufrock, L. F. Active
c. 1904: 1870

Querville, Anthony G.
Cabinetmaker, Born in
France 1789, Died 1856,
Active Philadelphia 1820-
1856: 518-20, 1105

Radford Brothers. Cabinet-
makers; William born 1779,
Died 1870; Daniel born
1789, Died 1834?, Active
Portland, Me.: 521

Randall, William. Japanner, Active Boston c. 1715: 522

Randolph, Benjamin. Cabinet-maker, chair maker, Born Monmouth County, N. J., Died after 1792, Active Philadelphia 1762-1770: 523-527, 1155

Rank, Peter. (also spelled Ranck), Joiner, Born 1794, Died 1817, Active Jonestown, Pa.: 454, 575, 576

Rawson Family. Chair makers, Joseph J. died in 1835; Joseph, Jr. was born in 1788, Died 1870?; Grindal born 1719, Died 1803; Active Providence, R. I.: 523, 530, 1170, 1172

Rayl (T. B.) and Company. Wood working company, Active Detroit c. 1883: 1871

Reischmann Company. Furniture manufacturer, Active New York 1919: 1872

Renshaw, Thomas. Chair maker, Active Baltimore 1814-15: 884

Rhoner (Frank) and Co. Furniture business, Active New York City 1878: 1873

Richardson, Elisha. Cabinet-maker, Active Medway, Mass. 1743-1898: 951

Richardson, H. H. Architect, Born 1838, Died 1886, Active New York 1865-75, Brookline, Mass. 1874-86: 531, 532, 1441

Ridell, Crawford. Furniture maker, Died 1848, Active Philadelphia 1835-38: 1105

Rigley, Charles E. Vice-President of the Estey Manufacturing Co., Active Michigan 1882-1905: 2046

Ring, Merrill, and Tillotson. Active Saginaw, Mich. 1880: 1874

Roberts, Aaron. Joiner, cabinetmaker, Born 1758, Died 1831, Active New Britain, Conn.: 533-535

Roberts, Candace. Japanner, Active Boston 1785-1806: 536

Robertson, Alex. Furniture maker, Listed New York City 1786-1803: 1374

Robinson (C. H.) and Co. Bed manufacturer. Active Boston 1884-1890: 1875, 1876

Rockford Co-Operative Furniture Company. Active Rockford, Ill. 1888-92: 1877

Rockford Standard Furniture Company. Furniture manufacturer, Active Rockford, Ill. 1911: 1878

Rockford Union Furniture Co. Active Rockford, Ill. c. 1890: 1879, 1880

Rockwood, James. Cabinet-maker, Active Richmond, Virginia: 788

Roda, A. Furniture business, Active Rochester, N. Y. c. 1879: 1881

Rohls, Charles. Chair and furniture designer, Born 1853, Active Buffalo, N. Y. 1890's to 1920's: 537, 538, 539

Study, Benjamin. Joiner, Active Ipswich, Mass. 1733: 214

Sueme, Charles. Furniture business, Active St. Louis 1891: 1460, 1948

Sugg and Beiersdorf Furniture Manufacturing Co. Furniture manufacturer, Active Chicago 1875-81: 1949, 1950

Sweeney, John. Looking-glass maker, Active New York City 1820: 346

Sweet, Jebez. Joiner, Active Ipswich, Mass. 1711: 214

Swift, Reuben. Cabinetmaker, Born 1780, Died 1843, Active New Bedford, Mass.: 696

Swisegood School. Cabinetmakers, John Swisegood born 1796, Died 1874, Active Davidson Co., North Carolina: 697

Taft Company. Active Hartford c. 1886: 1951

Taylor Chair Company. Chair manufacturer, Active Bedford, Ohio 1816-1966?: 698, 699, 1952

Teepe, J. Charles. Furniture manufacturer, Active New York City 1886: 1953

Thomas, Elias. Looking-glass maker, Active New York City 1818-20: 700, 701

Thompson, Perley, and Waite. Active Baldwinville, Mass. c. 1880: 1954

Thurston, John. Joiner, Active Dedham, Mass. and Newport, R. I. 1761: 945

Timpson, Thomas. Active N. Y. 1801-5: 496

Tobey Furniture Co. Active Chicago 1903: 702, 1955-56

Todd, James. Looking-glass maker, Born 1794, Died 1866, Active Portland, Maine: 703, 766

Tolley, Thomas E. Active early 19th century: 707

Tollman, John. Piano maker, Active early 19th century: 304

Toppan, Abner. Cabinetmaker, Born 1764, Died 1836, Active Newburyport, Mass. 1790-1836: 704

Towney, Augustus. Cabinetmaker, Active Binghamton, N.Y. and Ithaca, N. Y. 1826-49: 2039

Townsend, see Goddard-Townsend

Tracy, Ebenezer. Chair maker, Born 1744, Died 1803, Active Lisbon, Conn.: 705, 706, 707, 1271

Tracy, Elisha. Chair maker, Born 1743/44, Died 1809, Son of Eliphalet Tracy, Active Scotland, Conn.: 705

Tracy, Robert. Cabinetmaker, Active New Hampshire 1829: 1416

Trefry (Thomas) and Co. Active Boston C. 1880: 1957

Trotter, Daniel. Chair maker, Died 1800, Worked with his son-in-law Ephraim Haines, Active Philadelphia 1786-1800: 708-710

True, Joseph. Carver, chair maker, cabinetmaker, Born Chichester, New Hampshire 1785, Died 1873, Active Essex County, Mass. 1809-1873: 712-714, 916

Truesdale, Mrs. Active c. 1916: 715

Trumble, Francis. Chair maker, Born 1716, Died 1823, Active Philadelphia 1754-1778: 716

Trute, Charles. Piano maker, Died 1807, Active Wilmington, Del. 1796-1897: 717

Tryon, Isaac. Cabinetmaker, Born 1741, Died 1823, Active Glastonbury, Conn.: 718

Tucker and Griffin. Cabinetmaker, Elisha Tucker active 1822-33, Asa Griffin active 1813-33, Active Boston Mass.: 1452

Tucker Manufacturing Co. Bed manufacturer, Active Boston c. 1884: 1958

Tufft, Thomas. Cabinetmaker, Active Philadelphia 1768-88: 719-722

Twyman, Joseph. Furniture designer, Born in England, Student of Morris, Died before 1905, Active Chicago: 723

Tygart, William. Furniture maker, Active North Bloomfield, Ohio 1820-30: 724

Union Chair Works. Chair manufacturer, Active Mottville, N.Y. 1865-1940: 1959

Union Furniture Company. Furniture manufacturer, Organized 1876, Active Jamestown, N. Y. 1876-1913: 1960

Union School Furniture Co. Active Albany, N.Y.1886: 1961

United Crafts. Furniture maker, Active Eastwood, N. Y. 1902: 1962

United Mills Manufacturing Company. Furniture and bedding manufacturer, Active Philadelphia 1912: 1963

Upham Manufacturing Company. Active Marshfield, Wisc.: 1967

Vail, Joseph. Chair maker, Active New York City 1790-1806: 725

Vaill, E. W. Chair manufacturer, Active Worcester, Mass. 1879: 1968

Vandoorn, A. Furniture maker, Active Brattleboro, Vt.: 177, 295

Vannevar, George. Cabinetmaker, Advertised Boston 1823: 1375

Van Sciver (J. B.) and Co. Active Camden, N. J. c. 1900: 1969, 1970

Victor Manufacturing Co. Furniture manufacturer, Active Chicago 1899: 1971

Vornbrock Furniture Company.
Furniture Business, Active
St. Louis 1891: 1640, 1972

Vose and Coats. Cabinetmaker,
Joshua F. Coats died 1819,
Active Boston 1805-18: 758

Wade, Thomas. Joiner, Active
Ipswich, Mass. 1725: 214

Wagner and Son. Active
Missouri: 2035

Wait, John. Joiner, Active
Ipswich, Mass. 1728: 214

Wakefield Rattan Company.
Furniture manufacturer,
Active Boston, N. Y.,
Chicago, and San Francisco
1878-91: 1973, 1974

Wanamaker, J. Retail store,
Active New York City
1911+: 1975

Wardwell, Solomon. Cabinet-
maker, Born 1743, Died
1822, Active Nelson, New
Hampshire: 977

Ware, Daniel. Chair maker,
Born 1814, Died 1901,
Active New Jersey: 726

Ware, John. Chair maker,
Son of Maskell Ware, Active
Bridgeton, N. J. 1826-50:
726

Ware, Maskell. Chair maker,
Born 1776, Died 1855,
Apprenticed to John
Lanning: Active Roadtown,
N. J.: 726, 727, 1002

Ware, Rueben. Chair maker,
Born 1806, Died 1880,
Active New Jersey: 726

Warner, Elisha. Cabinet-
maker, Active Lexington,
Kentucky 1818: 777

Warren, Hastings. Cabinet-
maker, Born 1780, Died
1845, Active Middlebury,
Vt.: 728

Warren, William J. Furniture
business, Active 1855-66:
2028

Watson, William. Cabinet-
maker, Died 1736, Active
Charleston, S. C. and
East Florida: 1365

Watson, Karsch, and Co.
Chair manufacturer,
Active New York City c.
1880: 1976

Wayne, Jacob. Chair maker,
Son of William Wayne,
Active Philadelphia
c. 1783-90: 729, 730

Wayne, J. L. Retail store,
Active Cincinnati 1833-
1840: 2027

Wayne, William. Chair maker,
cabinetmaker, Active
Philadelphia 1769-85: 565,
732

Wayne and Biddle, Looking-
glass makers and merchants,
Active Philadelphia 1811-
22: 731

Weaver, Holmes. Chair maker,
cabinetmaker, Active
Newport, R. I. 1769-99:
733, 1172

Welch, John. Carver, Looking-
glass maker, Active Massa-
chusetts: 734

Wells, John J. Cabinet-
maker, Advertised East
Hartford, Conn. 1798-1812:
735

Wenter, F. Hardware maker,
Active Chicago 1877: 1977

Western Furniture Company.
Furniture business, Active
St. Louis 1892: 1640, 1979

West Virginia School Furni-
ture Company, Desk manu-
facturer, Active Hunting-
ton, West Virigina 1917:
1978

White, Charles Haight. Chair
maker, Cabinetmaker, Born
1796, Died 1876, Active
Philadelphia 1820-40: 736

White, Frank W. Looking-
glass maker, Active New
York c. 1870: 1980

White (L.) Chair Company.
Chair manufacturer,
Active Boston 1864-69: 737

White, R. T. Active Boston
1881: 1981

Whitehead, William. Furniture
maker, Active New York
City c. 1810: 738

Whitelock, George. Cabinet-
maker, Chair maker, Born
1780, Died 1833: Active
Wilmington, Del: 739

Whitney (O.) and Company.
Chair manufacturer, Active
Winchendon, Mass. c. 1880:
1982

Whitney, W. F. Active
South Ashburnham, Mass. c.
1883: 1983

Whittle, Charles P.
Furniture business, Active
Boston c. 1880: 1984

Wild, H. L. Scroll work,
Active New York 1889: 1985

Willard, Aaron. Clock maker,
Active Grafton, Mass. c.
1770 and Roxbury c. 1798:
740

Willard, Simon. Clock maker,
Born 1765, Active Grafton
and Roxbury, Mass. to
1839: 741

Willard and Son. Chair
maker, Active Boston
early 19th century: 304

Willard Mirror and Frame
Manufacturing Company.
Mirror manufacturer,
Active New York City 1894:
1986

Willett, Marinus. Cabinet-
maker, Born 1740, Died
1830, Active New York City
1773-74: 1271

Williamsport Furniture Manu-
facturing Company. Furni-
ture manufacturer, Active
Williamsport, Pa. 1886:
1987

Wilmerding, Christian W.
Looking-glass dealer,
Born 1763 Brunswick,
Germany, Died 1832, Active
New York City 1783-1821:
742, 743

Wilson, David. Cabinetmaker,
Born Ireland, Settled in
Madison, Indiana: 744

Wilson, James. Chair maker,
Born Washington Co., Pa.
1826, Died after 1852,
Active Pennsylvania: 745

Wilson, Robert. Cabinet-
maker, Active Lexington,
Kentucky 1792-1825: 746

Wilson and Hechinger. Chair
manufacturer, Active
Baltimore 1892: 1988

Wing. Samuel. Furniture
maker, Born 1774, Died
1854, Active Sandwich,
Mass.: 757

AUTHOR–TITLE INDEX

The numbers following each heading
refer to the citation numbers.

Henkel, George J., 1720

"Henry Connelly, Cabinet and Chairmaker," 119

"Henry Herrmann, An American Manufacturer in London Furniture Trade," 297

"Henry Hubon, Last of the Salem Cabinetmaker," 343

Herenden (A. S.) Furniture Co., 1721

Herkimer Manufacturing Co., 1722

Hersee and Co., 1723

Heuvel, Johannes, 1216

Hewitt, Benjamin A., 1347

Heyman, George, 1724

Heywood (Walter) Chair Company, 1729, 1730, 1731, 1732, 1733

Heywood Brothers and Co., 1725, 1726, 1727

Heywood Brothers and Wakefield Co., 1728

Heywood Brothers and Wakefield Co., Makers of Reed and Rattan Furniture, 1728

Heywood-Wakefield Co., 301

Hickley, F. Lewis, 1348

Higgins Furniture Manufacturing Co., 1734

"Highboy of Samuel Wallis," 732

High Grade Chairs and Rockers, Catalogue, 1911-1912..., 1805

Hildreth (G. W.) and Company, 1735

Hill, Amelia L., 573, 873, 1349

Hill, Conover, 1350, 1351

Hill, John H., 355, 890, 924

Hilpert, Bruce, 793

Hipkiss, Edwin, 419, 420, 578, 1352

Hispanic Craftsmen of the Southwest, 790

"Historic and Documented Antiques from Maine," 878

Historic Family Furnishings of John C. Dacosta, III, 1281

Historical Society of York County, 1108

"History and Technique of Japanning and the Restoration of the Pimm Highboy, A," 924

History of American Furniture, A, 1239, 1490

History of American Manufacture from 1608-1860, A, 1241

History of Manufactures in the United States, 1607-1860, 1264

"Hitchcock Chair," 303, 306

"Hitchcock Chair, The," 312

"Hitchcock Chairs," 302

Hitchcock Chairs, 311

Hitchcock Chair: The Story of a Connecticut Yankee-- L. Hitchcock of Hitchcocksville, The, 309

"Hitchcock of Hitchcocksville," 314

Ladies, God Bless 'em--The
Women in the 19th Cen-
tury, 1464

"Lambert Hitchcock of Hitch-
cocksville, Connecticut:
America's Most Famous
Chair Maker and the Story
of His Original Manufac-
ture," 310

Lamb, J. and R., 1774, 1775

Lambourne, Lionel, 1383

Lammert, Martin, 1776

Lammert Furniture Co., 1777

"Lancaster and Other Pennsyl-
vania Furniture," 1137

Landis, Mary Ann, 297

Lane, Albert, 340

"Langley Boardman," 73

"Langley Boardman, Ports-
mouth Cabinetmaker," 72

"Lannuier Brothers, Cabinet-
makers, The," 384

"Lannuier in the President's
House," 385

"Lannuier Pieces in Hiding,"
376

Lapp, Henry, 389

"Late Classical Furniture in
the United States," 1496

"Late Hadley Chest Maker,
A," 671

Lawrence, Jennifer, 1194

Lawrence, William E., 1778

Lazeare, James, 1384

Leach, Mary James, 362

Leach, Mary Jones, 867

Lea, Zilla Rider, ed., 1385

Leavens (G. M.) and Son,
1779

Leibundguth, Arthur W., 1115

"Leland, Levi Nelson," 398

Lenox Library Association,
618

Leominster Furniture Manu-
facturing Co., 1780

Leominster Piano Stool Co.,
1781

Lersch, Charles, 1782

"Lesser-Known Rhode Island
Cabinetmakers: The Car-
liles, Holmes Weaver,
Judson Blake, The Rawsons,
and Thomas Davenport,"
1172

Levenson and Zenitz, 1783

Levy, F. N., 487

Lewisburg Chair Co., 1784

"Lexington Kentucky 1792-
1820. The Athens of the
West," 865

Library Cases, Bookcases,
Secretaries...Desks, Ta-
bles..., 1880

Lichten, Frances, 1116

"Life in Early America:
Southern Furniture Makers,"
786

Life-Time Furniture, 1785

Lilley (M. C.) and Company,
1786

Limbert (Charles D.) Com-
pany, 1787

Raeth, George Adolph, 1454

Raley, R. L., 391, 895

Ralston, Ruth, 125, 257, 282, 283, 733, 1455

Ramsey, John, 166, 759

Ramsey, L. G. G., 1456

Randall, Richard H., Jr., 77, 82, 290, 522, 581, 941, 942, 1457

Random Notes on Colonial Furniture, 1305

Random Notes on Colonial Furniture: A Paper Read Before the Connecticut Historical Society in 1922 and Now Revised, 816

"Random Notes on Hitchcock and His Competitors," 305

Ransom, Frank Edward, 965

Rattan, Chairs, Rockers, and Cribs, 1836

Rattan, Wood, Cane, and Upholstered Chairs, 1732

Rauschenberg, Bradford L., 175

"Rawson Family of Cabinetmakers, The," 530

Ray, Marylyn, 632, 633

Raycraft, Carol, 634

Raycraft, Don, 634

Rayl, (T. B.) and Company, 1871

"Reappraisal of Shaker Furniture and Society, A.," 632

"Recent Discoveries Among Rhode Island Cabinetmakers and Their Work," 1174

"Recent Discoveries in Boston Japanned Furniture," 943

"Recent Purchase: Piano Attributed to the Workshop of Duncan Phyfe," 498

Reclining Chairs, 1708

"Rediscovering the Furniture of Six American Architects," 1441

Rediscovery--Harvey Ellis, Artist and Architect, A, 188

Reed Furniture Catalog, Reed Chairs and Rockers, 1866

Reese, Richard Dana, 499, 1458

"Reflections Commemorating 50 Years of Progress in Making of Furniture," 276

"Reform in Philadelphia: Frank Furness, Daniel Pabst, and 'Modern Gothic'," 456

"Reform in Philadelphia: 19th Century Furniture," 1106

"Regency Side of Federal Furniture in New York and Boston, The," 503

Regional Characteristics in American Cabinetmakers, 1484

"Regional Characteristics of American Chairs," 1381

"Regional Characteristics of Inlay on American Federal Card Tables," 1347

SUBJECT INDEX

The numbers following each heading
refer to the citation numbers.